The Roots

of
Postmodernism

William V. Dunning
Central Washington University

Prentice Hall
Englewood Cliffs, New Jersey 07632

Dunning, William V.
 The roots of postmodernism / William V. Dunning.
 p. cm.
 Includes bibliographical references and index.
 ISBN 0-13-097387-4
 1. Postmodernism. I. Title.
BH301.P69D86 1995
750'.1--dc20

94-5936
CIP

Production supervision
 and interior design: Keith Faivre
Acquisitions editor: Bud Therien
Manufacturing buyer: Bob Anderson
Cover design: Sue Behnke
Cover art: Dan Rice, *Hell on Wheels* (1982).
 Oil on panel (120″ × 408″).

Printed in the United States of America
10 9 8 7 6 5 4 3 2 1

ISBN 0-13-097387-4

Prentice-Hall International (UK) Limited, *London*
Prentice-Hall of Australia Pty. Limited, *Sydney*
Prentice-Hall Canada Inc., *Toronto*
Prentice-Hall Hispanoamericana, S.A., *Mexico*
Prentice-Hall of India Private Limited, *New Delhi*
Prentice-Hall of Japan, Inc., *Tokyo*
Simon & Schuster Asia Pte. Ltd., *Singapore*
Editora Prentice-Hall do Brasil, Ltda., *Rio de Janeiro*

Table of Contents

PREFACE *v*
ACKNOWLEDGMENTS *xiii*

1 Finding the Invisible *1*

2 Painting as Document *18*

3 Painting as Scholarly Text *33*

4 Allegory and the Carnival Grotesque *46*

5 Using Light as Sign and Sign as Space *65*

6 Social Commentary *80*

7 Color and Image as Sign *92*

8 The Animated Iconic Sign *114*

9 Urinals (Colon) the Undescended Trajectories
 of Missile Dish Aims B. U. T. N. D. ¢ *131*

10 Fools, Dream Painters, and the Mad Muse *155*

11 The Post-Cartesian Concept of "Self" *182*

12 Science, Self, and the Sacred *196*

13 The Dragons of Postmodern Art and Science *213*

14 On the Shoulders of Giants *226*

15 Bindings *242*

16 Conclusion *268*

WORKS CITED *277*
INDEX *293*

Preface

The separate units we discover when we examine any topic must be related to one another through one heuristic device or another. These units must be thoroughly anchored in the matrix of theory. Werner Sombart put it simply: "No theory, no history." I think of these heuristic devises as purposeful lies that *help* us understand or examine complex truths that remain beyond our grasp. Such theories and devices structure our discoveries and ideas into unified, related, and useful models so they may be better understood as a whole. They expose the relationship between the microcosmic and the macrocosmic.

Major advances in society have seldom been triggered by adding more information to our already unmanageable accumulation of facts. Progress is more likely to be generated by the invention of new analogies and paradigms. This book is not designed to add new facts or knowledge to an already near-infinite informational system; it is intended to blur a series of artificially imposed temporal and conceptual boundaries by pointing out that recently developed categories and theories of art and criticism fit elegantly into ancient and abiding artistic traditions.

Therefore, in the spirit (if not the language) of the postmodernism this book examines, I intend to freely appropriate ideas, place them in new contexts, and create a collage of ideas, thus to form a new image through collaboration with other writers. This piecing together of ideas from other authors is an important aspect of this work: it lets me utilize a collective voice in the spirit of postmodernism—as opposed to the unique individual voice to which modernists aspired.

Painters, I contend, may be usefully divided into two categories: retinal painters (Duchamp's term) and signing painters. Retinal painters have traditionally focused primarily on the visual; their paintings have an immediate sensuous impact. Retinal painters usually consider the formal elements of a painting to be essential; they rely on illusion and visual structures that are

generated by an understanding of the way the eye and mind work, the psychology of visual perception. These visual structures include composition in dark and light, composition in warm and cool color, compositional climax, perspective, and illusion.

Because these aesthetic theories were based on human perception, they were believed to represent universal principles unrelated to the language, culture, or society of the viewer. The structure and mechanics of the eye and the way it is wired to the brain, the formalists reasoned, guarantee that each normal individual will perceive the pictorial depiction of illusion, space, and reality in a similar manner regardless of language or cultural background. But postmodernists are suspicious of any strategy that fails to take account of the context (time, language, religion, and culture) in the interpretation of any text, visual or verbal.

Signing painters, on the other hand, have generally intended to communicate to a more limited audience. Their paintings have traditionally demanded interpretation—often (but not always) into words. It may take longer to feel the impact of these paintings, and they often affect the intellect more than the senses. I find it a fascinating paradox that the more sensuous retinal aesthetic tends to be supported by advocates of logic and reason, while the more intellectual aesthetic of the signing painters tends to be supported by advocates of the irrational.

Because images that signify ideas beyond their obvious appearance or resemblance are intended to be translated into words—often words in a specific language—the reading they receive is recognized by postmodernists as dependent upon the language, society, and culture of the intended viewer. In other words, such signing images are not designed to be universally intelligible; they are best "read" by specific groups, groups that Charles Sanders Peirce called a "linguistic community" and Stanley Fish a "community of interpretation."

My first book, *Changing Images of Pictorial Space*, traced the formal structures of influential retinal painters from classical Greece and Rome, through da Vinci, then the impressionists, to their culmination in modern art. This book, *The Roots of Postmodernism*, traces the history of signing painters from the Middle Ages to the postmodern period.

Changing Images examined the history of painting from the vantage of perception and painterly illusion—pictorial space—which was the salient concern in southern European and then American painting from Giotto through de Kooning. In tracing the illusionistic aspects of painting through two millennia, that book explained the relationship between each century's image of pictorial space and its logical thinking (leading to and influenced by the Enlightenment) in science, philosophy, and economics. It was an examination of art's relationship to reason over successive periods.

Roots traces some of the signing aspects that were the dominant concern in painting during the Middle Ages, then in Dutch painting of the fifteenth,

sixteenth, and seventeenth centuries, and finally in postmodernism. It examines the relationship between painting and the following areas: the paradigm of painting as sign, economic structures, the sacred sciences and philosophies (alchemy and astrology), madness, the "carnival grotesque," and the psychiatric theories of Freud and Lacan. In short, this book examines art's relationship to the irrational.

I hesitate to use the terms *rational* and *irrational* because the first implies a positive view to some, while the second suggests a negative judgment. Still, the Age of Enlightenment has been called the "triumph of reason," while the postmodern paradigm—especially poststructuralism—is often called the "irrational school" because it tends to hold the rational or objective suspect. My intent, however, is to examine, not judge, so neither term should be construed as disparaging or commendatory.

These two books are the obverse of each other, two *apparently* different sides of the same coin. Each examines concerns to which the other is blind. Each point of view inverts the assumptions and priorities of the other. What one privileges, the other ignores. Just as the light that illuminates any scene is condemned to cast shadow as well as light, what one book illuminates, the other obscures. The two books are complementary, each supplying the other's lack. For it is shadows that allow us to see more clearly; a scene with no shadows is distorted by glare.

In *Changing Images* I established that the line of painting that originated in Greco-Roman civilization and was developed in southern Europe in the Italian Renaissance and in French impressionism and culminated in modern art in Europe and America centered on illusion and its attendant devices. I demonstrated that pictorial space changed in each successive century in tandem with changes in society's conception of space. The changing construct of space during each of these periods was chronicled in different languages: visually by artists, verbally by philosophers, and both verbally and mathematically by scientists. Each successive change in pictorial space was provoked by shifts in society's priorities. These shifts led to the destructuring (unraveling) and restructuring (reweaving) of the six principal elements of Renaissance illusion: the shading of volume, the unified light source, the separation of planes, linear perspective, atmospheric perspective, and color perspective. Each new permutation in the repeated restructuring of these perspectival elements created a new spatial image in painting.

Consequently, from the fifteenth century to the mid-twentieth century in South Europe and America, a formal concern with illusion or pictorial space, as well as composition, dominated the discussion, analysis, and critique of painting. The most highly regarded painters during this extended period won their positions of influence by means of illusionistic innovations, most of which were related to various two-dimensional representations and translations of the three-dimensional (later, four-dimensional) space that exists in the external world—the world outside the painting.

Then, sometime during the second half of the twentieth century, interest in retinal painting waned. Another factor began to dominate discussions of art: Saussure's linguistic metaphor.

Ferdinand de Saussure—inspired by the work of the American philosopher Charles Sanders Peirce—endowed us with a linguistic metaphor that has been profitably applied to all other academic disciplines. The most influential postmodern writers are those who have extended the scope of their disciplines by either adapting or questioning Saussure's linguistic metaphor: Jacques Lacan in psychiatry; Claude Lévi-Strauss in anthropology; Michel Foucault in social studies; and certainly Jacques Derrida, who gave us deconstruction—both the word and the strategy.

The early followers of Saussure were called "structuralists." Briefly, structuralism is based on a conviction that all forms of human communication—including myth, tribal ritual, painting, religion, and the clothes we wear—are embedded in an overall linguistic structure and are guided by all the rules, organization, and relationships between parts that are characteristic of linguistic structures. Consequently, the structuralists took linguistics as the model of a logical rigor and "structure" for their investigations in all fields. This linguistic movement is the foundation for all current academic methods of discursive inquiry, including poststructuralism, deconstruction, revisionism, and semiotics. (Even Russian literary formalism, as early as 1916, was heavily influenced by Saussure.) Readers can understand little of contemporary art criticism unless they are familiar with Saussure's linguistic model.

As structuralism evolved into poststructuralism, it was argued that a text by itself was incapable of communicating a complete truth; hence rigorous interpretations of meaning in any text were impossible. The poststructuralists insisted that even structuralist texts could not yield clarity or univocal (as opposed to equivocal) meaning because contradictions are inherent in the structure of any language. One important reason for these contradictions is that languages are compelled to favor one of two mutually exclusive elements (or binary oppositions) in a cumulative series of categories such as: absence versus presence; clarity versus opacity; multiplicity versus unity. Poststructuralists took fragments, quotes, and unconscious metaphors from texts and with deconstructive glee demonstrated the inescapable contradictions inherent in any attempt to be rational or objective.

New movements do not appear suddenly out of thin air. Every new idea is influenced by, or expands upon, ideas previously advanced. The terms we invent to label various strategies in criticism are usually new names for practices already in existence, sometimes for a very long time. (Da Vinci focused on formal elements in painting centuries before the term *formalism* was coined.)

Furthermore, artists in any culture tend to better understand and appreciate work done in those periods whose concerns and points of view they share. Since postmodern artists consistently demonstrate an interest in the art of the Middle Ages and the Netherlands, rather than in Greco-Roman works or the art of the Italian Renaissance, we can conclude that their concerns are similar to those of their medieval and North European counterparts.

The art world hosts a continuous "discussion" among artists, critics, art historians, and informed viewers. This discussion between active and informed participants always centers on specific concepts, which change from period to period. In order to join in this discussion, either actively or passively, the painter, critic, historian, or viewer must know what topics are under discussion. Those who investigate elements unrelated to the current discussion are likely to be ignored, just as astronomers who persist in discussing the sun's revolution of the earth (though that was once a paramount idea) cannot command an audience of their peers, no matter how beautifully or convincingly they write.

Contemporary artists are rarely interested in or influenced by artists of the Italian Renaissance or impressionism because these periods are firmly identified with the formal paradigm of illusion and perception. Today's artists tend to look to the signing artists of the Middle Ages, the Netherlands, and non-Western cultures for inspiration. For as our art has grown more linguistic, it has become more symbolic, mythic, and didactic, and these are the very qualities that stand out in the art of the Middle Ages and the Netherlands.

This book traces through several centuries some of the ideas important to the discussion now taking place between artists, critics, and knowledgeable viewers. But this is not a history of art. I record no life histories of individual artists, since I consider most biographical details about artists to be little more than gossip. I do not believe that being aware that an artist starved, drank to excess, was sexually promiscuous with either sex, or cut off an ear helps anyone understand the work in any important way. Furthermore, I do not cover all the important aspects of the works of each painter mentioned. I discuss only what is pertinent to the ideas that prompted me to begin this investigation as a balm to my own curiosity. In short, I trace the evolution of signing painters in a line that extends through the Middle Ages, the Renaissance in North Europe, Gauguin and his influence on German expressionism, then Duchamp and Dubuffet, to the period that is commonly called "postmodernism." I point out the relationship between changes in image and parallel changes in the concurrent philosophy and science.

When I began this book, I had two goals. First and foremost, I wanted to examine my own prejudices and assumptions. I have done that. This book did not develop into anything like what I originally had in mind. Furthermore, it has changed the manner in which I perceive a major portion

of the culture that surrounds me. Not that I understand anything any better. I never seem to discover whatever it is that generates understanding. My investigations only raise my level of confusion to successively more complex and interacting tiers: in my writing, I attempt to share my own current level of confusion. Second, I wanted to offer readers an overall sense of the interests, assumptions, priorities—even the thinking—of signing painters as a collective body.

Some may wonder why they should be interested in postmodern concepts, believing them to be nothing more than "ivory tower" ramblings far removed from everyday life. They fail to understand the relationship between the constant changes in society and the theorizing of our leading thinkers. For example, what has come to be called "the politically correct" is often a simplistic misunderstanding of the poststructuralist agenda. A recent example of this misunderstanding is Hillary Rodham Clinton's simplistic rejection of the modern Cartesian concept of the autonomous individual (which she thinks is alienating) in favor of a "politics of meaning" that recognizes the post-Cartesian postmodern construct that—in her words—"our lives are part of some greater effort, that we are connected to one another," and that "we are part of something bigger than ourselves." Such ideas permeate our society, and they must, therefore, be reflected in its artwork.

Mark Poster has observed that the protests of the 1970s centered around women (feminism), homosexuals (gay liberation), the insane (the antipsychiatry movement), and prisoners (prison reform)—the very groups that Michel Foucault, the definitive poststructuralist, has told us were victims of the previous discourses and practices of society: the insane in his *Madness and Civilization;* prisoners in *Discipline and Punish;* women and homosexuals in *The History of Sexuality;* and women again in *The Birth of the Clinic.* Foucault's writing also focuses interest on the fate of racial, ethnic, ecological, and antinuclear issues (Poster 1989, 106).

A comparison of ideas and attitudes in the medieval and the postmodern periods is a rich vein to mine, but because our first reaction is to compare things that are chronologically near each other, most writers have compared the postmodern to the modern. Postmodernism has generally been perceived in two ways. The first and most common perception treats it as a movement that followed and reacted against modernism (as indicated by its name). Thus it is considered the antithesis of modernism. (Would an artist like Duchamp then be pre-postmodern?)

The second perception sees the postmodern as simply another aspect of the modern. Frederic Jameson, for instance, writes: "Postmodernism is itself little more than one more stage of modernism proper (if not, indeed, of the even older romanticism)" (1984, 56). This takes postmodernism back to the late eighteenth century. He maintains that all the characteristics of postmodernism were already full-blown in such modern precursors as "Gertrude Stein, Raymond Roussel, or Marcel Duchamp, who may be considered out-

right postmodernists" (56). Toynbee wrote about the fourth stage of Western History as a post-Modern age.

Thus a close examination reveals that the modern cannot be discriminated from the postmodern by simple chronology. I will demonstrate that these two styles are better understood as recent manifestations of two persistent and parallel traditions: the retinal tradition of formal compositional images, supported by reason; and the verbal tradition of signing images, including the carnival grotesque, understood only through the irrational. My strategy in this book is to trace the constantly reemerging cycles of the "postmodern" attitude from the Middle Ages (I could easily have gone back to the Aztecs or perhaps even the Egyptians and the Mayans) to the early Dutch painters to the current manifestation that we call the "postmodern." If we believe in cycles, then we must perceive the recycling of new versions of old ideas.

All three analogies are useful: the postmodern as an oppositional successor to the modern; the modern and the postmodern as two aspects of the same recent phenomenon; and the two as ancient parallel traditions. But those who search should never lose sight of the fact that light, in actuality, is neither wave nor particle—though it may, under different conditions, clearly resemble either.

If Saussure's linguistic metaphor is to be applied to painting, it must be carefully examined in painterly terms. This book is not intended to answer questions; it is intended to ask them. Can the Saussurean metaphor be fruitfully applied to painting, or would the strategies of Charles Sanders Peirce, the most respected American philosopher, or Roman Jakobson be better suited to such a task?

William V. Dunning
Ellensburg, Washington
September 1993

Acknowledgments

Those who frolic with ideas desperately need a community of capable and generous peers who are willing to share their information, ideas, insights, and candid opinions. I am lucky enough to have access to such a community. Though it is small, it is exceedingly able. Once again, I owe thanks to my two colleagues in the English Department, Philip Garrison and John Herum. Without their help this book would not be the same.

I once wondered why so many writers bothered to dutifully and predictably thank their wife or family for allowing them to pursue their projects. Now I know why. Sandra Springer Dunning has encouraged me wholeheartedly while I obsess on one project after another. I owe her more than a simple thank you. I may even share the royalties.

1

Finding the Invisible

Wood and stone are obviously incompatible as building materials. Wood floats; stone sinks. Wood is flexible; stone is brittle. Wood shrinks as it ages; stone does not. Thin beams of wood are strong for their weight; they can span long distances. Stone has no such ability. But builders during the High Middle Ages stubbornly refused to choose one over the other. Consequently, in spite of the incongruous nature of the two materials, obstinate medieval builders combined wood and stone in the most precarious juxtapositions and created magnificent Gothic cathedrals such as those at Rheims, Chartres, and Amiens.

These organic structures are some of the most splendid ever created by human beings. Visible for miles, they dominate the entire countryside. Like great hens hovering over their broods of tiny chicks, these cathedrals rise nineteen stories over the huts that surround them. Their high delicate curtain walls of stained glass were designed to capture light. Few experiences on earth create a more religious feeling than looking up into the great interior of one of these cathedrals gorged with solid, palpable light—the very simulacrum of God. And this is specifically the feeling they were designed to conjure.

Richard Sullivan contends these incredible structures were designed to utilize the advantages of two incompatible materials, and thus they are the perfect metaphor for the High Middle Ages (1978, 23–24). Sullivan explains that Western cultures owe their dynamic pluralism to institutions that were generated in the Middle Ages. These institutions were designed to accommodate the oppositions and contradictions spawned by the pluralist society that emerged in the tenth century and came to full dominance in the thirteenth. Since the Middle Ages, this clash of opposites—reason and irra-

tionality, state and church, sacred and profane, individualism and communal responsibility—has repeatedly animated Western culture (24–25).

Out of the obviously incompatible elements generated by this pluralist society, Europeans and Americans built a most magnificent societal edifice tenuously balanced in the most precarious juxtaposition. And now, as the twenty-first century rapidly approaches, postmodern intellectual strategies such as poststructuralism and deconstruction are fueled by this rich fodder of conflict and paradox.[1] Sullivan goes so far as to suggest that the Western world loses its dynamism when it resolves the tension between these contradictions that are woven into its very fabric. When we attempt to stabilize society by choosing reason over the irrational, "state over church, equality over hierarchy, or national and cultural ethnocentricism over universalism," we lose our virility (1978, 25).

The Western world's choice of philosophers furnishes further evidence of this foundation of basic oppositions: Plato was the philosopher of quantity and measurable increments of time and space, while Aristotle dealt in qualities and essences. Plato was the philosopher of the ideal, Aristotle of everyday experience. Like twin suns orbiting each other, Plato and Aristotle—first one, then the other—illuminated human thinking and influenced the intellectual tides during the Middle Ages. When one of these philosophers came into full view, his method overpowered the waning light and influence of the other, almost invisible source. Hence Plato's works eclipsed those of Aristotle until the twelfth century; then Aristotle was rediscovered, and the new Latin translations of his works worked an enormous influence.[2] Aristotle's works dominated science during the late Middle Ages; in fact, his construct of a finite geocentric universe remained unchallenged until Copernicus.

When ancient societies had questions about their life, their world, or their universe, they looked to two principal sources for answers: their religion and their science. And through most of human existence religion and science could not be separated. Astrology and alchemy were sacred sciences, and the two were once much the same. Alchemical texts and figures are full of astrological symbols and ideas. Alchemists relied on astrology to determine the precise dates and times to execute the steps in their processes. At one time or another, most of the world's advanced cultures have practiced

[1] In *Post-Modernism and the Social Sciences* Pauline Rosenau tells us that although the terms *postmodernism* and *poststructuralism* are not entirely identical, they are often used synonymously because the differences between the two "appear to be of little consequence." She documents this with six references (1992, 3, n. 1). I use the broader term *postmodernism* most of the time. At those times when the other term is more correct, I use *poststructuralism*, which is actually an American term used to describe certain French writers: Deleuze, Barthes, Lyotard, Lacan, Baudrillard, Derrida, and, especially, Michel Foucault. Many of these writers, it should be noted, would reject this label.

[2] Latin scholars translated the complete works of Aristotle from Byzantine manuscripts in Constantinople in the middle of the thirteenth century.

some version of these sacred sciences, and eventually they evolved into the modern secular sciences of astronomy, chemistry, physics, and medicine. Even modern psychoanalysis owes much to these sacred sciences. Interestingly, many early alchemical texts were written by or attributed to women.

Alchemy and astrology are often thought to be secret doctrines written in cryptic codes and hieroglyphs. But Madeleine Bergman explains that signs in the original language of alchemy served the same function as those in modern chemistry. Perhaps these signs were not standard from writer to writer and text to text, but they were originally intended as abbreviations for chemicals. Only during the Renaissance were the images converted into intentionally secret codes. When alchemy suddenly became popular during the Renaissance, it attracted a host of casual practitioners. In order to avoid what they perceived as the vulgarization of their art, alchemists intentionally generated a multitude of signs to indicate each chemical substance. One substance might be signified by as many as forty or fifty different signs, so the casual reader no longer had any idea what they meant (Bergman, 1979, 43).

After the emperor Constantine accepted Christianity and his successors made it the state religion in the fourth century A.D., the pre-Christian astrological and alchemical signs and rituals did not suddenly vanish, although at first there appeared to be some conflict between Christianity and these sacred sciences. Christians believed in the omnipotence of the Creator rather than the omnipotence of the stars; and the Christian insistence that human beings had free will seemed at first incompatible with the fatalistic determinism of astrology. But within these limits early medieval Christians accepted a basic world view that had been shaped by astrologers and alchemists; and as was typical of the pluralistic medieval culture, these incompatibilities were tolerated and accommodated. After all, the basic principle of alchemy—the transmutation of base metals into gold by purification rituals—had always been intended as an allegory to signify the purification of the soul by separating it from the body prior to reuniting them in a chemical marriage. The sacred sciences were an integrated union of empirical science and mystical philosophy.

During the second century A.D. Ptolemy—whose Aristotelian model of a geocentric universe came to dominate all Europe—was a zealous astrologer; and astrology so prevailed in the early Middle Ages that it determined the date we celebrate as the birth of Christ. Alchemical and astrological signs and allegories were so pervasively appropriated by Christianity that by the time of the High Middle Ages it was no longer possible to separate Christianity from the sacred sciences. Introductions to alchemical and medical texts, for example, were always addressed to God, and they always ended with a glorification of God. Medieval alchemists hoped to save the macrocosm (the world) by healing the microcosm (the individual). As I will demonstrate throughout this book, this simultaneous focus on the micro- and the macrocosmic was also a principal characteristic of early Dutch society and painting and, later, of postmodernism.

Alchemy, like the entire structure of the Middle Ages, was built on a foundation of incompatible opposites. The four prime elements of alchemy out of which all matter was composed were two pairs of opposites: fire and water, earth and air. These are the same elements recognized by the Cabala, a mystic interpretation of the Jewish Scriptures developed by early rabbis; thus the mixing of alchemy with the Old Testament was already a solidly established tradition before Christ appeared on the scene. The three alchemical colors—black, white, and red—might not immediately seem to be opposites. But black and white are opposites, and color is the opposite of black and white—what hue signifies color itself better than red, the most aggressive of all colors?

By the late Middle Ages, astrology, alchemy, Christianity, and philosophy had been tightly woven into a single fabric for so long that it was no longer possible to unravel the whole cloth into separate and distinct fibers. By the thirteenth century, William of Auvergne was the only author who had not reconciled his Christian faith with these sciences, and a number of major fourteenth-century universities had chairs of astrology.

Until as late as the eighteenth century, the thinking of the entire Western world, in all the different disciplines, was shaped by the imagery, the philosophy, and the allegorical language of alchemy and astrology. These sacred sciences enjoyed a very long reign as the closest thing to a universal language, belief, or system of signs the world has ever known. Furthermore, as I will demonstrate, alchemy in particular continues to influence twentieth-century art and culture to a surprising degree.

Christianity, astrology, and alchemy are all driven by the archetypal: myth and mythic pictures. Jung tells us "all these myth pictures represent a drama of the human psyche on the further side of consciousness, showing [the human] as both the one to be redeemed and the redeemer": the first is Christian, the second is alchemical (1953, 293). Thus the archetypal imagery of these three systems originates in the enigmatic area of the collective unconscious.

Christianity quickly adopted and transmuted the pagan mythology and the archetypal imagery of the unconscious it took from the occult sciences to fit its own purposes. To take one of an endless series of examples, medieval Christian painters and writers used the alchemical symbol of the unicorn as an allegory for Christ and the Holy Ghost. The pagan unicorn signified purity and strength, and Christians retained this significance. Alchemists believed a virgin left in a field would attract a unicorn. Though it was wild and fierce by nature, it could be seduced to lie in the virgin's lap, where it could be captured. Similarly, Jung notes that Christ lay in the Virgin's womb, where he was trapped in human shape by those who loved him. The unicorn thus represents Christ's purity in medieval painting, and its horn his invincible strength (1953, 424). Furthermore, the alchemical myth of the Philosopher's Stone was also considered an allegory of Christ (Jung 1967, 123).

One of the most dynamic alchemical allegories—which Christianity appropriated and still uses—was the image of light or luminosity to signify revealed truth or divine presence. Jung insists that astrology and alchemy had long conceded a divine presence to light. The hidden light in both nature and humanity was the central mystery of philosophical alchemy. This light was equated with the spiritual presence of Jesus Christ (1967, 126). Western society has used light to signify divinity for so long now that it seems to us a natural association.

Umberto Eco, a semiotician who is also an authority on the philosophy of the Middle Ages, explains that medieval Christian painters accepted three categories of aesthetics: (1) light (or color); (2) proportion; and (3) symbol and allegory (1986b, 24). The most important of these three elements of the medieval aesthetic was the love of light and color. Scientific, philosophical, and religious thinkers were fascinated by the light of the sun and luminosity because luminous objects were held to be both noble and divine (1986b, 43–46, 60). Jung notes that light was actually considered a *simulacrum Dei*, the very image of God (1967, 151).

Alchemists had always perceived color as an integral part of an object's nature rather than as a separate and incidental quality. They felt that color was an essential quality thrown out by a center of life or power. Therefore color expressed the hidden qualities or powers in a person and was read as a sign, even a simulacrum, for light. So color, too, was a *simulacrum Dei*. Hence, Eco tells us, everyday life was full of color in the Middle Ages. Color was everywhere. Clothing, ornaments, even weapons were brightly colored; and this pure, brilliant color was equated to the brilliance of light (1986b, 45). Given this significance of light and color, many believed a highly colored painting of a saint was not only more beautiful, but also more holy.[3]

What better vehicle for worship than the great Gothic cathedrals with their curtain walls of stained glass producing a near physical ball of light? The luminous presence commenced at about the height of a ten-story building and continued straight up for the distance of another eight or nine stories. Furthermore, the light was in full color; thus it carried the divine significance of both light and color. God Himself: twice signed, twice simulated.

Eco insists that the ancient Greeks did not develop an inclusive theory of signs, as medieval scholars did, because of their focus on verbal language. The Greeks clearly saw little connection between verbal language and other sign systems. What we would call symptoms or indexes (animal calls, an elevated fever, or any cause-and-effect relationship) bore no relationship to language in their estimation. But the Roman Stoics began to connect these

[3]In the twelfth century St. Bernard of Clairvaux wrote in his *Apologia*: "The thoroughly beautiful image of some male or female saint is exhibited and that saint is believed to be the more holy the more highly colored the image is. People rush to kiss it, they are invited to donate, and they admire the beautiful more than they venerate the sacred" (Bernard 1125, 28; as reproduced in Rudolph 1990, 281).

two separate lines of thought, and St. Augustine fully sanctioned this connection for the Middle Ages. Consequently, medievals considered a wide variety of phenomena—symptoms, words, the mimetic gestures of actors, the sounds of a military trumpet—as species of signs (Eco et al., 1989, 4).[4]

Wendy Steiner tells us that medieval churchmen carried this idea to the point where they believed "the perception of the world is the perception of signs—thought accessed through the eyes" (1982, 34). Hence signs in sculpture, stained glass, and painting were used to examine and interpret biblical narrative.[5] Painting was a series of signs that created visual texts, which were intended to examine and interpret stories from the Bible. These painted signs functioned at the level of allegory—and what modern critics call "literary allusion."

Norman Bryson insists that visual images were permitted in medieval art only insofar as they communicated the Christian Word to those who could not read. The visual image was subservient to the Word.[6] Visual images were organized in a syntactical structure similar to hieroglyphs, ideograms, or written signs; and the *sequence* of images was important in establishing meaning. Medieval paintings placed more emphasis on the verbal aspects of art and on remembering the message than on the visual or retinal impact of the image (1981, 1, 3).

It is important to note that this sequencing of images in a linguistic syntax is hardly possible in more realistic paintings, where sequence is dictated by perspective rather than verbal considerations. In perspectival paintings the sequence of images is necessarily determined more by their relationship to each other in space than by linguistic syntax. Most attempts to combine the linguistic sequencing of images with perspective look contrived and artificial—with the notable exception of fifteenth- and sixteenth-century Dutch painting.

Ernst Cassirer, who so heavily influenced Erwin Panofsky with his concept of languages as symbolic form,[7] believes "the Word" is a primary force

[4]"Nevertheless, Augustine does not resolve definitively (even if he foresees lines of development which are of enormous theoretical interest) the dichotomy between the inferential relation, which links a natural sign to the thing of which it is a sign, and the relation of equivalence which links a linguistic term to the concept which it signifies or the thing which it designates" (Eco et al., 1989, 4).

[5]Cook and Herzman note that when a sixth-century bishop of Marseilles ordered the destruction of church paintings because he believed his flock was worshipping images, Pope Gregory I countermanded the order and instigated the "use of art in Christian instruction that became standard in the Middle Ages" (1983, 143).

[6]The story of Moses going up Mount Sinai to receive the tablets with the law written on them while his foolish people waiting for him below occupied themselves by creating a golden calf to worship might well be interpreted as a biblical demonstration that the Word is to be favored over the image.

[7]Panofsky's article "Perspective as Symbolic Form" (1924–1925) has probably had more influence on current writers than any of his other works, and it was written while he was a friend and colleague of Cassirer's. It has only recently become easily available in an excellent annotated translation published in 1991 by Zone Books.

that generates all "being and doing." Furthermore, this belief in the supremacy of the Word is a key to all mythical versions of creation. In almost all major religions the Word is identified with the Creator: it is either his primary source or his principal agent (1946, 45–46).[8]

Bryson contends that signing painters, who affect the viewer in a primarily verbal manner, tend to simplify the information in their images. In contrast, he contends that painters who intend a strong visual impact tend to cram their images with more information than is necessary for the verbal meaning (1981, 3). Medieval paintings certainly function as one of the best demonstrations of the relationship between the simplification of images and their propensity to signify at levels beyond the object depicted. But in the course of this book at least two important exceptions to Bryson's contention will be discussed: Dutch painting of the fifteenth to the seventeenth century, and Hogarth's painting in the eighteenth century.

Many medieval paintings even feature written words in the main image of the painting or around the borders. Bryson argues convincingly—using the stained glass windows in Canterbury cathedral as his example—that where writing occurs, words function to convert the image into allegory, riddle, or conundrum. Consequently, once the spectator determines the correct answer, the idea is complete and the visual aspect of the image serves no further purpose.[9] Because medievals used visual art to persuade or to teach verbal ideas, they felt it was important to establish closure: a recognizable end to the viewer's examination. Viewers were not supposed to study a work beyond that time necessary to glean the verbal meaning; hence they were not

[8]As one of many examples of confluence between Christianity and tribal myth, the Uitoto Indians paraphrase, in their cosmology, the opening passage of the Gospel of St. John: "In the beginning," they insist, "the Word gave the Father his origin" (Cassirer 1946, 45).

[9]For the sake of clarity and simplicity, I intend to use the more obvious, though still imperfect, terms *verbal* and *visual* (or *retinal*) in place of Bryson's *discursive* and *figural* to describe these two different aspects of painting. I am not fully comfortable with the literary *figural* and *discursive* when applied to painting because both terms are loaded with other meanings, and these meanings eventually become unwieldy when used to critique painting. *Figural* cannot escape the unfortunate verbal reference to three other ideas: *trope* or *allegory*; the visual depiction of objects or human figures in painting; and figure-ground relationships. And *discursive* not only has complex meanings relating to rationality and argument, but it also has the secondary meaning of digression and purposeless rambling.

The initial choice of terms is crucial in any discipline. I have always admired Heinrich Wölfflin, but painters still resent his appropriation of *their* term, *painterly*, to mean a loss of silhouette (1950, 18–41 passim). Every painter I meet either does not know, or stubbornly refuses to use, *painterly* to signify a loss of silhouette. They insist on using *painterly* to mean an expressive, fluid, wet-into-wet, sensuous quality of the material paint. There is no other satisfactory word: the term *wet into wet* is not nearly as rich in its connotations, nor is the French term *au premier coup*.

Even some art historians use *painterly* to mean expressive: Barbara Rose defines *painterly* as: "A quality in a work of art in which the paint itself—and its application—is the medium through which the artist expresses . . . feeling. Characteristics include blurred outlines, visible brush strokes, and summary 'impressionistic' paint application wherein one stroke does the work of many" (1969, 178).

encouraged to dwell on the independent visual aspects of the image (1981, 4).

Medieval writing and visual art were dominated by a fixed code, a standard iconography that endured for centuries. Such works as St. Augustine's *Confessions* furnished an iconography for both writers and painters. An audience that is unfamiliar with these works is doomed to understand little of medieval literature or painting.

Cook and Herzman note that St. Augustine clearly explained that all things should function to please God. Nothing, whether money, property, sex, or art, should be enjoyed for itself. Allegorical language, he insisted, was not intended to give pleasure, but to lead to intellectual truth—a concept generally described by medievals as finding the "invisible within the visible" (1983, 83). I will demonstrate that most signing painters, from the Dutch to the postmodern, strive to do the same.

Words and paintings, then, were intended to be used, not enjoyed. They were to be experienced as signs pointing to something else. Even when reading the Bible, Augustine insisted, one should seek the invisible spiritual truth hidden behind the obvious physical reality. In saying that words should never represent only the objects they refer to, he was rejecting a literal interpretation of Scripture in favor of allegory and allusion (Cook and Herzman 1983, 84).

Edgar De Bruyne tells us that when medieval scholars read the Bible, they interpreted even an apparently literal and descriptive sentence like "The Ark was built of well-squared timbers" as meaning that the Church was composed of perfect saints (1969, 75). They reasoned that the Ark, outside of which there was no salvation, stands for the Church, outside of which there can be no salvation; the well-squared timber is a symbol of the perfect man, and a perfect man can only be a saint (75).

Medieval artists never intended to mimic nature. They intended their art to be only a reminder of, sometimes merely a sign for, it. Bede Jarrett notes that Dante defined the purpose of sculpture (and this would certainly apply to painting as well) with two words: "visible speech" (1968, 254). It may even be true that the best medieval artists had the least manual skill and thus emphasized idea and concept. Skill was simply an "external condition" that had little effect on art (255). Certainly this attitude is echoed in the work of many postmodern artists.

For the medieval artist, almost anything recognizable as such could be used to represent a tree or a mother or a child or an angel, so long as it signified a spiritual truth. But they tried to prevent viewers from presuming that a tree was only a tree, an angel only an angel. They would have been annoyed by a viewer who saw no more than the objects depicted in their painted world. Often a single image represented a multitude of its kind: a building represented a city, a tree a forest. When the artist thought the reference to the collective intent of the image might be unclear, the sign was clarified with

words. For example, Meyer Schapiro notes that one stone carver chiseled the word "SISVA" (for SILVA) into a pier relief in the cloister of the Romanesque church at Moissac to indicate that a single palm tree was intended to represent an entire forest (1985, 33).

This medieval focus on the verbal rather than the visual or illusionistic aspects of art led medieval artists to ignore any geometric reference to the location of the viewer. Erwin Panofsky was prompted to write that medieval paintings were made with no reference to the viewer's visual processes; they did not even concede the existence of a viewer (1953, 17). He is correct in stating that medieval art ignored perception and the visual processes, but goes too far when he says these artists made no concessions to the viewer's existence. It is true that medieval artists did not imply or construct viewers (or a location for them) by geometry or perspective, as Renaissance artists would later do; nevertheless, they *did* imply or construct a viewer in the sense that an author constructs a reader. Like authors, medieval painters assumed their viewers shared certain collective knowledge and experiences; thus artists did have in mind a specific kind of audience or "reader." Umberto Eco insists in that chapter of his *Postscript to Name of the Rose* entitled "Constructing a Reader" that he used the first hundred pages of his novel "for the purpose of constructing a reader suitable for what comes afterward" (1984, 48). In this same sense, artists in the Middle Ages acknowledged and constructed a viewer.

The Name of the Rose is set in a fourteenth-century monastery. Eco opens the novel with a description of a young monk's experience when he first sees the entryway to the church at that monastery. Adso begins by commenting on the verbal aspects of the relief sculpture: "The silent speech [Dante's phrase, remember?] of the carved stone, accessible as it immediately was to the gaze and the imagination of anyone (for images are the literature of the layman), dazzled my eyes" (1983, 40). The young monk then launches into a six-page description of the images in which he asks and answers questions about their interpretation into verbal concepts: "What were they and what symbolic message did they communicate?" he asks (1983, 43).

> I saw . . . other visions horrible to contemplate, and justified in that place only by their parabolic [the adjective refers to parables] and allegorical power or by the moral lesson that they conveyed. I saw a voluptuous woman, naked and fleshless, gnawed by foul toads, sucked by serpents, coupled with a fat-bellied satyr whose gryphon legs were covered with wiry hairs, howling its own damnation from an obscene throat; and I saw a miser, stiff in the stiffness of death on his sumptuously columned bed, now helpless prey of a cohort of demons, one of whom tore from the dying man's mouth his soul in the form of an infant. . . . (1983, 44)

This is an excellent description of what Mikhail Bakhtin (1968) calls the "carnival grotesque" that permeated the art of the Middle Ages, as well as of such later artists as Bosch, Hogarth, Duchamp, and Dan Rice—and postmod-

ernism in general. This image of the carnival grotesque, and its connection with signing painters, alchemy, and the Apocalypse, will be explained more thoroughly as this book develops.

After continuing his description of every vile and fearsome thing he sees represented in the entryway, Adso offers this translation of the images, which he reads as signs:

> The whole population of the nether world seemed to have gathered to act as vestibule, dark forest, desperate wasteland of exclusion, at the apparition of the Seated One in the tympanum, at his face promising and threatening, they, the defeated of the Armageddon, facing Him who will come at last to separate the quick from the dead. (1983, 45)

A hemispherical fresco of *The All-Powerful,* or *Christ Pantocrator* (Figure 1.1), shows the Almighty Christ enthroned after Armageddon, holding the book of the Gospels in His left hand while His right is raised in the traditional gesture of the *benedictio latino*.[10] Moshe Barasch tells us that this gesture is typically used in depictions of Christ Pantocrator, and it still survives in Christian worship today in ritual signs of benediction. During the Middle Ages, however, the gesture was not a sign of benediction, as it is sometimes wrongly interpreted. Rather, it signified an act of solemn speech. This same gesture was used by orators while speaking as early as the second century A.D., and painters traditionally used the hand in one gesture or another to indicate the act of speech.

Constantine Cavarnos explains that Christ in the role of the All-Powerful or Pantocrator is always depicted as signifying great power and magnificence. In Figure 1.1, *The All-Powerful,* Christ is enclosed within a multicolored circle representing the rainbow in Revelation 4:3: "and there was a rainbow round about the throne, in sight like unto an emerald." His expression is intended to represent the omniscient merciful judge and lawgiver (1977, 37).

Medieval painters purposely distorted images and figures to signify their beliefs. Some parts of a figure would be exaggerated, while other parts were diminished. Because the head is the highest point on the body and associated with the heavenly—and also because the face is the most expressive part of the body—medieval artists often made the head disproportionately large in proportion to the body—which, being lower, is associated with the earth or sin. The eyes were often located above the center line of the head to make the face seem even larger. Cavarnos tells us that to signify spirituality the eyes were typically emphasized or enlarged, as is evident in the figures surrounding Christ in *The All-Powerful* (1977, 37).

[10]The *benedictio latino* is made either with the thumb and first two fingers parallel, as in Figure 1.1, or with the thumb curved over to touch the third finger.

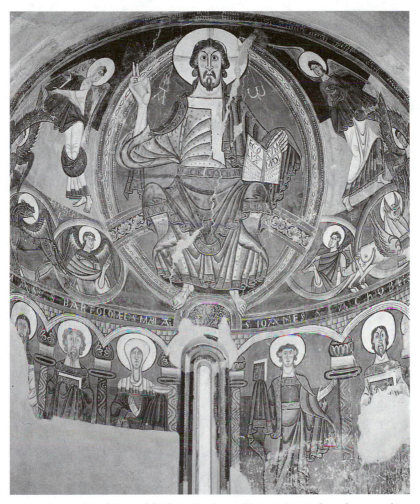

FIGURE 1.1 *The All Powerful* [Christ Pantocrator] (1123). Fresco from the apse of San Clemente, Tahul. Barcelona. Catalan Romanesque. Photo: Giraudon/Art Resource, NY.

Notice that the noses on the Virgin and the Apostles in the mosaic *Virgin and Child with Apostles* (Figure 1.2), as well as on Christ Pantocrator and his surrounding figures, are long and thin, the mouths are painted smaller than a real mouth, and the fingers are thin and elongated. These distortions were medieval artists' ways of representing the refined and spiritualized senses of a holy person who has been transfigured by faith. The figures were elongated to signify a denial of the materiality of physical mass in favor of an ephemeral appearance of spirituality (Cavarnos 1977, 37).

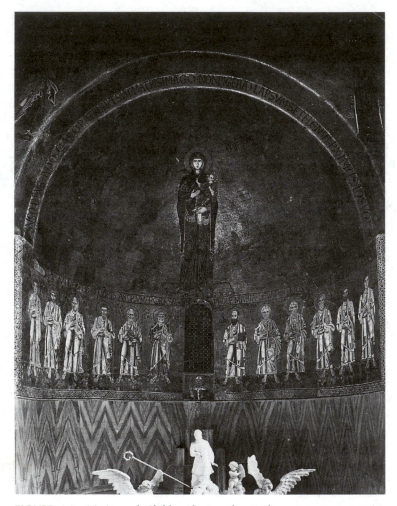

FIGURE 1.2 *Virgin and Child with Apostles* (12th-century apse mosaic). Duomo, Torcello (Venice). Photo: Alinari/Art Resource, NY.

It is evident in both works that medieval painters used little or no perspective or shading of volume. Figures are depicted flat rather than volumetric or spatial; again, this was deliberate, signifying a rejection of the material elements of volume and space in favor of more spiritual aspects. The flat, elongated figures were intended to appear two-dimensional and nonmaterial—suggesting a vision. Medieval painters did not depict light itself; to represent the light of holiness and divinity, they used pure saturate color, which signified, rather than illustrated, light (Cavarnos 1977, 37).

Renaissance painters, on the other hand, deliberately portrayed materiality: physical light (a unified light source), physical beauty, and material so-

lidity. Medieval painters would never have approved of religious paintings that used perspective and depicted space, color, light, and form as we are accustomed to seeing them in everyday earthly reality. The medieval icon was intended to take the viewer *beyond* anatomy and the material world to the spaceless and timeless realm of the spiritual (Cavarnos 1977, 38).

Medieval painters used other pictorial conventions to signify the individual traits of saintliness: faith, meekness, serenity, humility, and, finally, love—the highest of all the virtues and the most favored of saintly traits. The perfect Christian, they reasoned, had perfect faith; and it was this faith that generated meekness and the other virtues. Meekness was characterized by freedom from anger and inner agitation, even in situations that would generate anger and excitement in those of lesser faith. This freedom from agitation was supposedly manifest in the holy person as a steadfast gentleness. In the two paintings shown here, the virtue of meekness is signified by depicting the faces and the gestures of holy figures as beatifically calm, serene, free of all agitation (Cavarnos 1977, 43).

Faith, meekness, and serenity led to humility, the twenty-ninth of the thirty steps in the hierarchy of the Ladder of Divine Ascent that led to spiritual perfection. Humility was second only to love (Cavarnos 1977, 44). It was signified in holy figures by facial expression, posture, and gestures. Humble persons were depicted with a bowed head and body, or kneeling. Sacred figures—like the Christ, the Virgin, and their retinue—usually stare directly at the viewer; their serene expressions and large spiritual eyes are intended to signify honesty and openness. These straightforward stares of the holy indicate that they seek to hide nothing (44).

Barasch explains that it was possible to use gestures as signs because artists and the viewing community agreed that specific gestures would represent specific ideas. For example, when the hands were purposely covered—as are the hands of the middle saint at the bottom left of the painting *Christ Pantocrator*—it signified adoration directed toward the highest-ranking figure in the scene. It could also be read as an expression of awe (1987, 110).

In the fourteenth century Giotto was still observing this tradition of gesture as sign, but he used these gestures in a new manner to create a powerful image of the natural gestures of social intercourse (Barasch 1987, 13). I believe he was able to do this primarily because he rejected the convention of gestural restraint, serenity, and freedom from agitation that medieval artists were obliged to observe when depicting holy personages, no matter what the situation. No medieval painter, for instance, would have depicted the emotional agitation that Giotto displays in *The Lamentation over the Dead Christ*.

The twelfth-century fresco of *The All-Powerful* shows Christ surrounded by the four emblems that signify the four evangelists: the eagle held by the angel at the upper right corner represents St. John; the winged angel at the

upper left represents St. Matthew; the calf in the lower right is an emblem for St. Luke; and the lion in the lower left represents St. Mark.[11]

Like much medieval art, the four emblems are apocalyptic—and so is much postmodern art. On the first page of the first chapter of his seminal book *The Postmodern Turn*, Ihab Hassan (whom Jean-François Lyotard credits with coining the word "postmodern") tells us that an important characteristic of postmodernism is "the voice of the apocalypse" (1987, 3). In Revelation 4:7 John describes his vision of the four beasts surrounding the throne of God: "And the first beast was like a lion, and the second beast like a calf, and the third beast had a face as a man, and the fourth beast was like a flying eagle."

Halos were usually depicted as gold or yellow to signify the light of the sun, which, in turn, signifies holiness. In the mosaic in Figure 1.2 both the halos and the entire background surrounding the Virgin and the Apostles are gold. Like most medieval Christian iconology, all these signs are intended to signify on more than one level. The four emblems of the evangelists, as well as the gold halos, had originally belonged to astrology and alchemy. These two sacred sciences were so pervasive in medieval life that it is not unreasonable to assume that there are thinly disguised, but quite familiar, astrological and alchemical allegories in many Christian paintings of the Middle Ages. Certainly this practice was still alive and well in the sixteenth century, as Bosch's paintings testify. Furthermore, the practice of depicting multiple levels of allegory would be consistent with the medieval interest in the invisible within the visible.

For more than forty centuries astrology and alchemy had used four signs to represent the four basic elements—earth, air, fire, and water—out of which all matter was thought to be composed. These four signs and the elements they signified were also used to represent the four elementary types of human beings:

1. The practical, materialistic *earth* group (physical types) was represented by a thick-necked bull, Taurus. Note that the image representing Luke in Figure 1.1 looks more like the thick-necked astrological bull than the "calf" mentioned in Revelation.
2. The *air* group (intellectuals) was universally represented by a man's head or face (hence the angel in Figure 1.1).
3. The inspirational *fire* group (moral types) was represented by a lion.

[11]These four creatures are well-known emblems for the four evangelists and have been used throughout all periods and styles of Christian art, though Louisa Twining tells us that in the case of Matthew and Mark there were minor disagreements as to exactly which evangelist was represented by which image (1980, 89). Matthew was sometimes represented by a man rather than a beast to signify the humanity of his gospel.

4. The "sympathetic, sensitive, and often vindictive, emotional" *water* group (aesthetic types) was frequently represented by a scorpion in very early works, but came to be represented by an eagle by the time of classical Egypt and Rome.[12]

Like Figure 1.1 numerous alchemical illustrations also picture these four beasts in the four corners.

Identifiable parts of the four beasts were often combined to form a single image or animal, as in the Cherubim, the Assyrian winged lion, and the Egyptian Sphinx. The combination of these four psychological types in one image represented "human nature in general" to the alchemist. Each of these signs, of course, originally carried numerous complex additional connotations that could be combined in different contexts to create intricate alchemical and astrological allegories.

The practice of painting a circular halo around the head of holy personages might have originated in the timeless belief that highly spiritual people generate an aura. Moshe Barasch tells us that mystics from the Middle Ages to the seventeenth century believed that "manifestations of spiritual life" were signified by color (1990, 266). If this is so, we would expect blue halos, because those who claim to see auras identify the pale blue aura with the highest spiritual state. And some medieval paintings did represent halos as blue. For example, the fresco of *The All-Powerful* shown in Figure 1.1 depicts Christ and each of the eleven saints, angels, and evangelical signs surrounded by pale blue halos (except for the eagle, which has a red halo rimmed in gold).

But I suspect the more usual choice of gold and yellow for halos has an alchemical significance. In alchemy yellow and gold represent the sun; and because light reveals, gold signifies revelation and spiritual transfiguration. Both yellow and gold were also used as the insignia of the alchemist. Alchemists likened the psyche to gold that was covered with dirt: they sought to remove the dirt and filth of the world and expose the pure gold of the soul through the discipline of ritualistic distillation and purification. Hence yellow and gold signified the purity of the soul of a saint, a perfect person who has been transfigured by the light of revealed truth. The round version of the gold halo could therefore represent either the alchemical sun behind the head of the holy or a focused round beam of golden sunlight engulfing the mind and revealing truth to the holy. Either way, the halo would signify that the "dirt" of sin and imperfection had been washed away

[12]Consequently, Nicolas de Vore tells us, the four evangelists are associated with astrological signs: Matthew is an Aquarius representing knowledge; Mark is a Leo representing courage; Luke is a Taurus representing action; and John is a Scorpio representing silence—or wisdom and discipline (1947, 360). In China the four emblems were: a white tiger, a red bird, a black dragon, and a black warrior—a human sign again (358).

to reveal the pure gold of the soul beneath. Moreover, it is plausible that the gold halo was intended to imply that these holy persons had achieved their high spiritual status through some kind of alchemical process or revelation.

Medievals were primarily interested in what their painted objects signified. As the Renaissance spirit asserted itself, however, Italian painters began to mimic the appearance of objects. The flame sparked by Giotto was fanned by Masaccio, and Italian painters were soon consumed by that desire to render the material appearance of things, which we know as the Renaissance style.

Renaissance Italians focused on narrating specific isolated events derived from the Scriptures and Church literature. Sometimes the specific event was chosen as a subtle response to political circumstances, but Italian painters seldom attempted the elaborate allegory or the scholarly textual quality that was obvious in the work of Netherlandish painters such as van Eyck, Bosch, and Brueghel. Primarily interested in theory and classical form, Italian painters left out anything that was not necessary for simple narrative or perspective. When they had grown so enthusiastic about visible appearances as to forget the invisible meaning beyond the outward material appearance, medieval painting had come to an end in Italy.

Modern art was governed by concerns similar to those of the Italian Renaissance: theory, form, simplification, and abstraction. As I demonstrated in my first book, modern art was dominated by Italian Renaissance form: specifically dark-light composition, compositional congruence, and manifold permutations of the various isolated elements of illusion, which modernists derived from the more subtle elements of the Renaissance system of perspective. For instance, modern art often concentrated on atmospheric or color perspective, while rejecting the more obvious elements such as linear perspective and the shading of volume.

Alberti put into writing the paradigm that dominated Italian Renaissance painting. He explained the Renaissance model that deemed a painting analogous to a window—a framed plane section (very like a window) through the cone of sight. In other words, a painter looking through a peephole fixed at a specific location in front of a window would see an unmoving one-eyed view of the outside world. This arrangement fulfills the three requirements for an Albertian construct: the (picture) plane of the window, a one-eyed view, and a single specific location for the viewer. Tracing the outside scene on the surface of the glass just as it is seen from that one-eyed viewpoint would perfectly render the Albertian view.

This Albertian view dominated Renaissance, baroque, and even impressionist and modern painting. Even though modern art was primarily abstract, the cohesive monolithic image it embraced implied a single specific location for the viewer and maintained the integrity of the picture plane (the window). Modernists revealed their paramount concern for the integrity of the picture plane by insisting that a painting actually be what it appeared to

be—flat. And this flat picture was accomplished through *illusion* wrought by an expert knowledge of atmospheric and color perspective. (As Elaine de Kooning said, "flatness is just as much an illusion as three-dimensional space.") One of the primary principles of modern art was that illusion must agree with reality; hence this insistence on the flatness of the picture plane.

In contrast to the "window" of Italian Renaissance and modern painters, sixteenth- and seventeenth-century Dutch painters modeled their perspective after the image produced on the focal plane of a camera obscura or the retina of the eye. They envisioned no intercepting transparent plane in their construct. Svetlana Alpers tells us that the Dutch counterpart to Alberti was Jean Pélerin, called Viator. In *De Artificiali Perspectiva* (1505) Viator diagrammed the northern method of perspective, which became the standard for Dutch pictorial construction. Where Alberti insisted that the operation of the eye "is of no consequence to an understanding of . . . pictorial construction," Viator assumed that a picture replicates vision. Where Alberti placed the viewer external to the picture plane, Viator located the eye point on the surface of the picture itself (Alpers 1983, 53).

The Italian emphasis on form, simplification, and abstraction permeated Renaissance science, philosophy, and art. Its opposition to the Dutch penchant for empiricism, which favored carefully and complexly observed description, anticipates important oppositions between modern and postmodern art and society. As I demonstrate one point after another throughout this book, a clear image will begin to develop of a consistent relationship and affinity between the art and societies of the Middle Ages, northern Europe, and the postmodern period—just as my *Changing Images of Pictorial Space* demonstrated such a relationship and affinity between Greco-Roman, the Italian Renaissance, impressionism, and modern art.

2

Painting as Document

Two distinct styles vied for dominance in European art during the early fifteenth century: the "international" style, whose adherents depicted detailed reproductions of material objects; and the Italian Renaissance style of artists like Masaccio, who painted idealized versions of heavenly things. By the end of the fifteenth century, Masaccio's seminal direction had clearly prevailed in southern Europe.

In the Netherlands, however, Ludwig Baldass tells us, Hubert van Eyck struggled to depict *both* earthly detail and the heavenly ideal, and his younger brother, Jan, achieved just such a synthesis.[1] Jan van Eyck (1385?–1440) had an unparalleled ability to render worldly things and to arrange them within a syntax that served the glory of God (1952, 102). His direction dominated northern European art in the fifteenth century. By 1430, few advocates of the "international" style could be found in the Netherlands. Thus Masaccio in Italy and Jan van Eyck in the Netherlands exemplified the two remaining directions in European painting—that of the Italian Renaissance and the Dutch.

Van Eyck painted intricate works in near-microscopic detail, yet he never lost sight of the overall image. When his paintings are viewed from a distance, the parts and relationships are solid and structural in their formal

[1]Hubert and Jan van Eyck were traditionally assumed to be brothers, but Frederick Hartt notes there is no evidence earlier than the sixteenth century that this was so. It has been proposed that the van Eycks were unrelated and merely from the same village, and that Hubert, rather than being the painter who began the *Ghent* was not a painter at all but merely the sculptor who carved the elaborate frame for Jan's masterpiece. In this case, Hartt believes, Jan would "have painted the entire painting after his return from Portugal in 1429" (1993, 643).

(though not classical) aspects, as well as in their content and linguistic aspects.[2] Van Eyck controlled the value (darks and lights)—and thus the atmospheric perspective—of each object and so was able to stabilize its location in pictorial space. No part of an object "pops out" spatially in front of the plane it is supposed to occupy. In other words, nothing in the background visually asserts itself to spatially advance in front of a foreground object.[3] Consequently, van Eyck's paintings never look spatially volatile, or spotty and compositionally disorganized, as do medieval paintings and much of the work produced by the "international" school, in which shapes and objects appear to move back and forth in pictorial space as if hung on invisible strings tuned to respond to the viewer's shifting focus as wind chimes respond to the breeze.[4]

Jan van Eyck combined two pairs of fundamental opposites into one unified image: the careful description of earthly things combined with the representation of heavenly things; and the representation of microcosmic detail in harmony with the macrocosmic overall image. Remember, medieval alchemists had hoped to heal the macrocosm by attending the microcosm.

The northern empirical nature led the Dutch to trust many different ways of knowing the world, and each of these ways involved picturing of one kind or another: the telescope, the microscope, the camera obscura, painted pictures, and *maps*. Alpers tells us a surprising number of northern artists were engaged in map-making, and they were the first to produce maps as wall hangings (1983, 120–28). The postmodern emphasis on learning about the world by means of advanced microscopes and telescopes, as well as photographs in books, magazines, television, and movies, echoes this northern method of knowing through pictures.

The consuming North European interest in exploring the universe by all available means—especially by microscope and telescope—led to many

[2]Ludwig Baldass explains it this way: "The intensive representation of nature in Jan van Eyck's work can only be described as cosmic. Even in rendering details he strove to do justice to the whole of Creation. Every component part, whether direct, *i.e.* something provided by Nature herself, or indirect, *i.e.* something fashioned by the hand of man, must be conceived in its very essence. At one and the same time the artist shows us how the part in itself forms an entity and how, in the place where it belongs, it is subordinated to a higher entity. Jan carefully elaborates every leaf that Hubert would only have sketched in, and every single fruit, but at the same time he gives us the characteristic general appearance of the tree and the play of light amidst its foliage" (1952, 42–43).

[3]However, Baldass points out that since the painting was clumsily cleaned, the figure of Giovanna is "too bright and thus appears to advance too far towards the spectator, so that the original perfect equilibrium of all values as regards effect of depth has now been somewhat impaired" (1952, 76). For a complete explanation of the structural uses of value, see Dunning 1991a, 16–19, 30–31.

[4]Panofsky testifies that the northern movement preferred concrete specific realities as opposed to the Italian preference for formula and abstraction. Northerners recognized reality only in things "individual by virtue of themselves and by nothing else" (1953, 35).

discussions of the "two infinities": the infinitely small and the infinitely large. Erwin Panofsky, who pioneered iconographical studies in art history and has often been called "the Saussure of the visual arts," explains that the overall image of a face, hand, or tree was emphasized equally with the wrinkles and the individual leaves; and conversely, the wrinkles and the individual leaves were considered as important as the overall image of the face, hand, or tree (1953, 181). Few times in the history of painting have painters successfully prioritized both extremes in scale. This, too, is echoed by the postmodern interest in scale invariance introduced through the science of chaos and fractal geometry, which will be the subject of Chapter 13.

Alpers tells us that early Dutch pictures, such as those of van Eyck, "anticipated certain seventeenth-century ways of understanding the world" (1983, 22). The leading Dutch scientist in the seventeenth century, Christian Huygens, was an empiricist who believed the only way to understand the causes of natural phenomena was through experiment and observation. Both van Eyck's and Huygens's interest in observing the universe around them grew out of the original Dutch emphasis on empirical observation of the world. And both men placed equal emphasis on the micro- and the macrocosmic.

A driving interest in micro- and macrocosmic observation demands good instruments. Because of his friendship with the scientist Anton van Leeuwenhoek, Huygens was able to develop telescopes as good as any in Europe—certainly better than those available in southern Europe.[5] Huygens's twin interest in views of the most distant universe and views of the most minute near details was heralded by van Eyck's cosmic representation of nature. Van Eyck, perhaps more than anyone else in the history of painting, demonstrated the fruits of careful observation from both the micro- and the macrocosmic point of view.

In Italy, however, probably because they painted primarily in fresco, painters preferred the Renaissance technique of treating subjects so broadly that details were submerged in large simplified areas of light and shade. Panofsky explains that the "international" style painters who preceded van Eyck did not submerge details, but left each part distinct and separate from other parts; hence the details were visually unrelated to the whole. The fragmented image typical of the "international" style created either an impression of a "whole incompletely differentiated or of a mass of details incompletely unified" (1953, 181).

Van Eyck and his followers signified their understanding of the micro- and the macrocosmic structure of the universe by simultaneously stressing both detail and the overall image. They refused to sacrifice either, just as medieval builders before them had refused to choose between the incompatible

[5]Bell tells us that Huygens translated Leeuwenhoek's writings about microscopes into French in 1677 or 1678, and thus introduced the French to Leeuwenhoek's ideas (1947, 65).

materials of wood and stone. Panofsky notes that van Eyck's technique was so minute that, like infinitesimal calculus, the number of details approaches infinity and achieves a cohesive overall image in all visible forms, much the same as calculus achieves a cohesive numerical image: the small seems large in relation to the even smaller, and the large seems small in relation to the cosmic representation (1953, 181).

I will demonstrate later in this book that, like the fifteenth-century Dutch painters, the postmodernists explored that area between the micro- and the macrocosmic, the detail and the whole, the particular and the general. A concern that embraces both the micro- and the macrocosmic is one of the primary linguistic emphases in the Saussurean scheme of establishing meaning through the relationship of part to part and part to whole. For example, the meaning of a word is established by its relationship (similarities and differences) to other words in the language, as well as by its context within a text.

Masaccio and the Italian painters relied on the elaborate Renaissance system of perspective, and this system severely prejudiced what they perceived: they saw what they expected to see. The empirical van Eyck chose to paint what he saw rather than what he thought he knew. He carefully examined and depicted his world and the things in it exactly as he saw them. He also organized his description of minutiae within a systematic syntax to signify complex eschatological arguments.

Van Eyck was seldom guided by theory, rule, and form. Rather than using a strong dark and light side to shade an illusion of volume in figures and objects—as was consistent with Masaccio's theory and practice—van Eyck depicted the light as he observed it reflecting off the surface of objects. Consequently, his figures are more photographic; they do not exhibit the pronounced volume that Masaccio's do. Still, van Eyck's knowledge of the most important structural elements of the Renaissance system of perspective was better than is generally recognized.[6]

It was the interaction between culture, religion, science (alchemy), and economic circumstances in the Netherlands that generated the need and the opportunity to craft with equal rigor both the detail and the overall image, as van Eyck did so masterly. Jacob Burckhardt, perhaps the leading expert on Renaissance studies, wrote that during the Middle Ages people were conscious of themselves only as members of one general collective or another: "a race, people, party, family, or corporation" (1958, 143). This fog of generality first lifted in Renaissance Italy when people began to perceive themselves as individuals (1958, 143). This new perception of the value and importance of the specific individual within the general mass, which later came to be called the "Cartesian self," was closely related to painters' interest in depicting both the specific detail and the general overall image.

[6]For a full explanation of the Renaissance system of perspective and its influence on seven centuries of painting, see Dunning, 1991a.

Furthermore, Michel Foucault tells us that since the early Middle Ages the church had promoted the same attention to detail in both its theology and its asceticism. In the sight of God, churchmen were quick to state, nothing is so immense or so important as to diminish even the slightest detail; neither is anything so small that it has not been specifically willed by God. This tradition of valuing minutiae informed Christian teaching, scholastic philosophy and theology, and even military science. For the true believer, every detail is important because the marshaling of particulars was necessary to support divine power (1977a, 139–40).

While societal concerns such as these fostered attention to both detail and the overall cohesive image, it was the new technique of oil painting that rendered such a practice technically possible.[7] Van Eyck's ability to simultaneously develop both the overall image and the detail was heavily dependent on this new technique. Painters in fresco, such as Giotto and Masaccio, were forced by their medium of plaster to paint quickly and broadly, simplifying images and subordinating the detail to the whole. Those who painted with egg and glue on panel were also forced to paint quickly because the egg dried fast; they did not have the luxury to fuse the micro- and the macrocosmic, but were led to depict infinite but disjointed detail. Only oil paint allowed van Eyck and his successors the time to grant equal priority to both the whole and the detail.

Van Eyck was in the vanguard of exciting and far-reaching discoveries in the nature of representation that paralleled discoveries in the fields of map-making and economics. Fifteenth-century practitioners in both fields were simultaneously discovering deeper levels of abstraction, and both were learning to fuse the micro- and the macrocosmic.

Frederic Jameson tells us that prior to the fifteenth century the European concept of the world was concrete: each geographic diagram was limited to the experience or journey of an individual traveler. Early mapmakers marked several key features along their journey: oases, mountains, rivers, and monuments. Nautical diagrams noting coastal features of the Mediterranean were the most complex. Still, nothing was diagramed that had not been directly experienced. These records of individual journeys are not true maps, but are classed as "itineraries" or "diagrams" (1984, 90).

The invention of navigational instruments—compass, sextant, transit—triangulated the traveler's position relative to the stars, and thus established a network of relationships between the microcosmic individual, spe-

[7]Carel van Mander—a proto-art historian who was the northern counterpart of Italy's Vasari—believed that Jan van Eyck invented oil painting. Van Mander noted that van Eyck was well acquainted with alchemy and its distillation processes and reasoned that he concocted and experimented with many kinds of pigments until he perfected his method of oil painting (1969, 4–5). Modern experts, however, believe the medium had been around at least a hundred years before van Eyck. Nevertheless, van Eyck was certainly history's first great oil painter.

cific landmarks, and the macrocosmic geographic totality. In this second stage of abstraction in map-making, the simple itinerary was transformed into more cognitive mapping in which the position of the traveler was related by instrument to abstract conceptions of a geographic whole (Jameson 1984, 90).

These instruments and the new need to chart the world in macrocosmic totality as well as microcosmic detail led to two inventions: the first globe in 1490, and Mercator projection maps—of the world in 1538, of the terrestrial globe in 1541, and of the celestial globe in 1551. These two new methods of representing the world put an end to the naive concept of cartography as a series of mimetic icons that re-created the individual experience of a specific journey. Together, they launched map-makers into the third stage in the abstraction of mapping.

Comparisons of the new globe with Mercator projection maps forced map-makers to confront a fundamental dilemma about the language of representation: the unresolvable contradiction that is created when an attempt is made to represent the curved space of the earth on a flat chart. Consequently, cartography was thrust into a crisis concerning the nature of representational codes. (Jameson 1984, 90).

Paralleling these steps in map-making, the fifteenth-century climate of burgeoning capitalism created a desire for the rendering of painted iconic signs so real they could act as surrogates for material goods. This, too, reinforced the kind of painting that fused detail with a consistent and cohesive overall image.

In A.D. 1000 there was no indication that Western Europe would evolve into a world power. Having just emerged from the interminable economic depression of the Dark Ages, the entire European economy was as fragile as that of Eastern Europe and the remnants of the Soviet Union are today. But European society began to turn from ecclesiastical pursuits to materialism as early as the fourteenth century. In that century, Wallace Ferguson explains, the drastic loss of population due to wars and the Black Death caused wages to rise and rents to fall. Hence the population of peasants who survived were better off than the peasantry had ever been before. The expansion of commerce and industry generated a host of merchants, who formed a new, powerful urban middle class that came to dominate European culture. The decline of feudalism brought about the impoverishment of the nobility and the expansion of the power of the merchants and centralized state governments (1969, 117–22). The new materialism did not banish religious art, but it did transform it.

Fourteenth-century art was less opinionated and less spiritually didactic. Frederick Antal reasons that as the powerful new middle class began to look for closer ties to reality, they insisted on an art that reproduced material objects—the source and insignia of their new power—with more fidelity (1969, 187–88). Scholars now conclude—and this is an important point—that there is a direct relationship between the advent of illusionism in painting

and the beginnings of capitalism: when the new interest in material representation overwhelmed the medieval emphasis on the spiritual, it caused a drastic change in the art of the time.

A society's economic system affects all aspects of its life. Two of the more radical poststructuralist theorists, Gilles Deleuze and Felix Guattari, in their influential *Anti-Oedipus* insist it was the emphasis on commercial exchange and "commodification" initiated by capitalism that finally destroyed the feudal system and the guilds and replaced the idea of the feudal estate with the idea of private property. Capitalism thus freed workers from one kind of bondage, but only to ensnare them in another, for Deleuze and Guattari argue that capitalism created the illusion of the "Cartesian self"—an autonomous individual with a consciousness separate from the rest of society (1977, 222–60 *passim*). This poststructuralist opposition to the concept of a cohesive, autonomous individual consciousness is a key factor in postmodernism.

Fourteenth-century artworks were no longer produced by monks. The dominant producers of art were secular painters who reflected the materialism of the newly powerful middle class (Antal 1969, 183). With their interest in rational materialism—"a manner of thinking by which the world could be expressed in figures and controlled by intelligence"—merchants and financiers firmly believed they could control their own destiny. Art was now a commodity produced for them, and the new concentration of wealth made it possible for them to purchase vast amounts of this commodity (184, 121).

The sudden interest in faithfully depicting apparently "real" objects was related to the emerging focus on objects, or commodities, as the driving force of the economy and the society. By the beginning of the fifteenth century, artists, as well as the merchants and bankers who patronized them, were passionately interested in the depiction of the commodities upon which the new capitalist lifestyle focused. Panofsky explains that during the Middle Ages few people outside the nobility had any wealth. The nobility gave little thought to the coats of arms and the emblems of power they inherited because the untitled were powerless and did not dare to usurp these things. With the advent of capitalism, however, the newly rich and powerful became obsessed with competing with the nobles, and often surpassed them in extravagance. They bought and displayed small objects of enormous cost: "jewels, medals, ivory carvings, cut crystal and mother-of-pearl"; and they concocted fabulous hybrids by combining sculpture with the art of the goldsmith.[8] By 1417, so many of the newly rich in England were displaying counterfeit coats of arms and emblems of rank that King Henry V issued a special decree banning the practice (1953, 68).

[8]These hybrids, made of gold and covered with enamel so the gold showed only in details like hair and ornaments, were decorated with jewels. They were unknown before 1400 (Panofsky 1953, 68).

Jan van Eyck's paintings are known for their beautifully finished surfaces. Panofsky says they "duplicated with brush the work of goldsmiths in metal and gems" (70). These jewel-like paintings were intended as astonishing displays of opulence in the collections of the newly rich and powerful.

Derrida, among others, has pointed out that signs are substitutes for things that are absent. When we cannot hold or use or exhibit a thing, we signify it. Hence a sign is a substitute for "an original and lost presence": it serves until the time when we may encounter, consume, expend, touch, or see the actual thing (1973, 138).

But Panofsky suggests that a picture by Jan van Eyck demands to be considered as more than just a sign. It is a real object—"and a precious object at that"; it is a naturalistic representation that is also an actual "reconstruction" of the visible world (1953, 180).[9] A van Eyck painting qualifies as a simulacrum. The *Oxford English Dictionary* defines "simulacrum" as "A material image, made as a representation of some deity, person, or thing." The linking of "deity" and "thing" in this definition cues us to understand the near-religious devotion accorded to faithful reproductions of important precious commodities in this age. Remember, these things were the major source of power in this burgeoning society, and thus held very dear by the most successful players in the new capitalist game.

These fifteenth-century representations of commodities existed on a level somewhere between the picture of a Porsche on an adolescent's wall and an icon of a Madonna in a medieval church. Adolescents regard the picture of the Porsche as a substitute for something they cannot have. It is the *deus ex machina* (the machine as savior) that will fix their life. It offers freedom, social power, erotic mysteries, and the speed of (in Freud's words) a prosthetic god. They believe this machine will grant them the power to go wherever they wish, at amazing speeds, and attract intimates of both genders. What, then, do we make of adults who own Porsches, yet have an expensive scale model of the car sitting on their desks? Perhaps they wish to let others know about their possession and be reminded of it themselves. The model is a temporary substitute for the object they admire. It is there to remind them, and others, of the object's beauty, without having to go outside to see the actual car. Van Eyck's paintings may have fulfilled a similar function for their owners.

The medieval Madonna, on the other hand, *was* the Madonna. People were executed in the Middle Ages for defiling the image of Our Lady; some were even imprisoned or executed for damaging her likeness on a coin because the representation of the Madonna *was* the Madonna.

[9]Most of Jan van Eyck's frames (with the exception of that for the *Ghent Altarpiece*) are made of complex molding and painted to simulate marble or porphyry—an igneous fine-grained rock containing coarser luminous crystals (Panofsky 1953, 180).

Philip Garrison tells us that as late as the nineteenth century the two opposing armies in the Mexican War of Independence each carried into battle an image of the Madonna: the Royalists an image of the Madonna *Remedios,* and the rebel insurgents one of the Madonna of *La Guadalupana.* Each Virgin inspired a peculiar otherworldly loyalty among her followers. After successful battles each army bestowed higher and higher military rank upon its Virgin, until the Royalists finally promoted *Remedios* to general: "they even dressed her in a uniform" (1991, 130). For the entire ten years of the war, in battle after battle, the side that won would execute the soldiers of the other side by firing squad—the victors placed the loser's Virgin against the same wall and *shot her* alongside her hapless followers (130).

In the fifteenth century society had not yet reached the stage of monetary abstraction characteristic of later capitalism. Where we adore numbers on paper (stocks, junk bonds, and financial statements), the wealthy of that era venerated real treasures in their immediate possession. True misers in those days, we may imagine, anally hoarded treasures and regularly visited their counting rooms to view, handle, or swim in piles of real gold and jewels. Wealth was tangible enough to offer the direct pleasure a Porsche does today; and faithful representations of all the desirable things that wealth could furnish were pleasant reminders to those who owned and those who wished to own. (The pictured bison on the walls of the cave at Lascaux may have functioned in a similar fashion.)

Fifteenth-century Dutch paintings, like paintings from other times and other places, were signs. They signified the events and priorities of the culture that generated them. Artists depicted the new capitalist princes in the company of their commodities, which were the foundation of their power and the evidence of their importance in society. But not only did paintings *depict* commodities; they also *substituted for* those commodities. Finally, the paintings became commodities themselves, to be bought and sold as occasion demanded.

Perhaps a painting could also substitute for a document. If so, such a blurring of the boundaries of language would obscure the difference between the real and the signified, between object and metaphor. Van Eyck's *Giovanni Arnolfini and Wife* (Figure 2.1) may have functioned as just such a surrogate for a legal document. By the end of the twentieth century, with the accelerating interest in painting as sign, more had been written about the significance of this painting as a surrogate for a document than about any other painting.

Among the writers who have researched this painting there is considerable disagreement as to specifics, but most conclude that the double portrait functions as a record of van Eyck's role as a witness to some part of the wedding ceremony. Many—from Panofsky in 1934 to Seidel in 1989—argue that the painting also functioned as an official surrogate or replacement for a

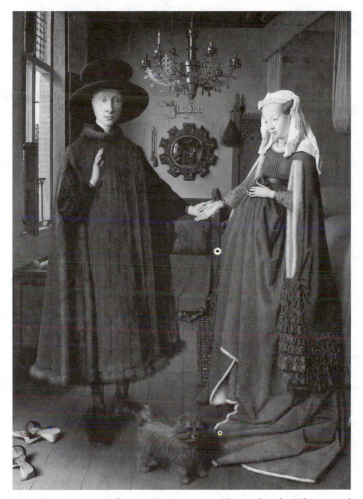

FIGURE 2.1 Van Eyck, Jan. *Giovanni Arnolfini and Wife.* Oil on panel (33″ × 22 1/2″). National Gallery London. Reproduced by courtesy of the Trustees.

legal written document.[10] In other words, in that picture-oriented Dutch society, a picture could function like words and signatures on legal written documents. Most authors, including Panofsky (1971, 198), agree that the inscrip-

[10]In Panofsky's words: "The circumstances of their marriage are peculiarly consistent with the unusual conception of the 'artistic marriage certificate.' Both of them had absolutely no relatives at Bruges . . . so that we can understand the original idea of a picture which was a memorial portrait and a document at the same time, and in which a well-known gentlemen-painter signed his name both as artist and as witness" (1971, 198–99).

tion on the wall just above the convex mirror, *"Johannes de Eyck fuit hic.* 1434,*"* is intended to testify to the painter's presence at the event.

Linda Seidel's account differs from Panofsky in interesting ways, and hers is well documented, representative, recent, and convincing. She says that the couple in this painting, Giovanni Arnolfini and Giovanna Cenami, were descendants of what had been the three largest non-Florentine banking families in Bruges in the late fourteenth century (1989, 73). Because of the rapid growth of the new capitalist economy, fourteenth- and fifteenth-century society became more and more commercialized; consequently, negotiation and transfer of the dowry was one of the most important aspects of the marriage ritual—though marriage was still more a domestic than an ecclesiastical event (62).[11] Elaborate safeguards were apt to be taken to make certain the dowry would not be surrendered to the groom until he was legally bound to the bride. The bride's family also considered it important to legally establish and record the exact contents of the dowry because it was the bride's sole inheritance and was supposed to be "attached" to her throughout her life. Her dowry was the only inheritance a woman could be certain of in the event of her husband's death (70).

Seidel explains that marriage arrangements usually began with a meeting between male members of both families at which a document was drawn up by a notary stipulating the financial terms of the marriage and the details of the dowry. The bride was absent during this stage of the ritual. A promised or an actual trade took place at each further step in the elaborate arrangements, and it was required that these transactions be recorded (1989, 63–64).

Seidel's interpretation of *Giovanni Arnolfini and Wife* considers the painting a witnessed record of Ring Day: The groom arrives at the bride's bedroom, leaves his thick-soled street shoes near the door, raises his right hand promising to uphold the terms of the contract, and extends his other hand to the bride as if to lead her back to his house and consummate the marriage. The bride accepts his hand and gathers up the train of her dress to follow. The rich furnishings pictured in the painting function as a record of the trousseau that will go with her (1989, 66–67). According to Tuscan custom, on Ring Day the groom received an official document certifying that he had satisfied all the stipulations so he could take possession of the dowry; the custom in Bruges was to accept the seal of an owner of urban land as legal witness to such a record. Jan van Eyck, as a recorded landowner in Bruges, would have been eligible to witness the transaction (69).

[11]Panofsky notes that before the Council of Trent (1545–1563) a marriage did not have to be witnessed by or performed by a priest in a church to be sanctioned. Any contracted marriage was recognized and often officially blessed by the Church, which taught that marriage was a sacrament performed by the bride and groom. The Church took upon itself the office of contracting marriages after the Council of Trent because so many tragic legal cases had resulted from the lack of adequate marriage records (1971, 198).

Seidel agrees with most critics that this fifteenth-century painting was intended to function in place of a written document. Craig Harbison, however, advises that "a work of art would not stand up as fact in a court of law in the fifteenth century anymore than it would today" (1990, 252). He rightly points out that van Eyck routinely signed his works elaborately—three of his paintings are dated to the specific day. If this portrait was intended to function as a legal document, Harbison asks, why was it not dated to the day also? He insists there is no firm evidence in either the painting itself or the customs of the day to indicate the portrait was intended as a legal document (250–60).[12]

So there is some controversy over whether the portrait functioned as a written document. The numerous articles that have been marshaled to support or contest this idea exemplifies the practice of current reader response theory—or more accurately, what Charles Sanders Peirce called a "linguistic community" or a "community of inquiry." Consequently, van Eyck's painting can be seen as a herald of the eventual reunion of writing and painting—an event avidly sought by many postmodernists.

In spite of the fact that all systems of writing can be traced to some earlier kind of picture writing, the relationship between painting and writing was overlooked for more than six hundred years. The modernists insisted that verbal ideas should be written, not painted: painting should be reserved for specifically visual ideas and statements. The statement that a particular painting was "verbal" by an art critic or professor in the 1950s or 1960s was an acid criticism. But after more than five hundred years of exploring the most exciting territories in the empire of perception and illusion—from the Italian Renaissance through modern art—many twentieth-century painters are searching for the lost bond between painted and written languages. Current thinkers are more interested in boundaries, those fuzzy aporetic areas between opposing ideas, than in clearly separated categories.[13] In order

[12]Harbison suggests that the painting signifies more sensual matters, as was the custom in that era. He lists the following signs and symbols: above the couple's clasped hands is a pair of mocking gargoyle figures, back to back; the inscription on the lost frame is reported to come from Ovid and hints that this couple had deceived each other; the man has removed his shoes, which is a traditional sign for marital union and fecundity; the oranges and cherries on the windowsill and chest are often used as signs for marriage and fertility; Giovanni raises his hand in greeting and his wife lifts her gown as a sign that she is receptive to his advances; and throughout the Middle Ages a picture of a dog often signified carnality and fertility (1990, 261–65). But sometimes the dog in Dutch painting also signified the education of children.

[13]The word *aporia*, for which *aporetic* is the adjective, means doubt, particularly concerning boundaries or beginnings. The term first acquired philosophical meaning in the works of Plato and Aristotle. Aristotle defined it as an "equality between contrary deductions." Thus *aporia* referred to a problem that could not be solved because it contained a contradiction, either in the object itself or in the concept; Zeno's paradoxes are examples of *aporia*. *Aporia* suggests, then, a sense of reversal in the primacy of cause and effect or origins.

to recognize the boundaries and the limitations our visual thinking is heir to, we are obliged to study painting as we would study a verbal language. Consequently, in the last half of the twentieth century, primarily because of the influence of Charles Sanders Peirce and Ferdinand de Saussure, painters and critics are engaged in a discussion that centers around the linguistic aspects of painting.

W. J. T. Mitchell points out that just as literature is beginning to be analyzed in terms of spatial form, the visual arts are being explored as linguistic systems. He says this concern amounts to more than just talking about the arts. It is a new attempt at integrating art theory and practice with our constructs for understanding the real world. Microcosmic specialization and the separation of fields of study—such as painting and writing—are now yielding to integration of various fields in a more interdisciplinary approach (1986, 295–96).

Wendy Steiner supports this contention when she notes that during the last half of this century the comparison of painting to literature has become a major topic or concern at conferences sponsored by institutions of literary studies. She concludes that the spread of structuralism and semiotics since the 1960s, and the growing interest in linguistic and aesthetic issues among philosophers, constitutes a revolution in critical thinking (1982, 19). Hence painting is now perceived as sign. Late in the twentieth century, writing and painting, which long headed in opposite directions, seem to be fusing once again.

Each discipline has its strengths and weaknesses; and concerned thinkers have long wanted to synthesize the best of the two directions. Since Saussure, the pure arbitrariness of spoken languages and languages that are written phonetically has been considered their most characteristic quality.[14] Emil Benveniste corroborates that every discourse on the essence of language notes the arbitrary character of the linguistic sign. He insists this principle is so important there can be no thinking about any part of linguistics without it (1971, 43).

The two basic types of signs inherent in writing and painting are: the sign proper in writing, which is chosen arbitrarily; and the iconic sign in painting, which resembles the thing it signifies. (The indexical sign is an interesting alternative in painting, but it is not encountered as often as the iconic sign.) Most words in all languages are signs proper: that is, any other sound could function just as well to signify the animal represented by the word "cat"—and other sounds do so in other languages. But English speakers have arbitrarily agreed that the animal in question will be represented by that particular sound. Hence signs proper are arbitrary. Shaking hands as a

[14]But Saussure perceived the arbitrary quality of the sign proper to be a strength. He insisted that arbitrary signs are most characteristic of language, and thus better suited as a base for Charles Sanders Peirce's invention, the science of semiology. This is why Saussure proposed to use the linguistic sign proper as the "master-pattern for all branches of semiology" (1959, 68).

form of greeting is an example of an arbitrary sign outside of language; other cultures have used other greetings.

Most (though not all) painting has employed the iconic sign. When painters choose to depict a human being, a cat, or a tree, they paint an image that more or less resembles a human, a cat, or a tree. These signs are usually concrete nouns (person, place, or thing), and they are considered to be "motivated signs" because their choice is motivated by their resemblance to the person, place, or thing they signify. An image of a cat, for instance, does not easily come to represent (denote) another object like a tree. But a cat may sometimes represent (connote) some quality associated with cats: lust and laziness have traditionally been associated with the image of a cat. When a cat icon is used to mean "lust," it functions as an abstract noun.

The principal advantage of the iconic sign is its more universal meaning. Speakers of French, Ewe, Swahili, or English may all understand an image that resembles a cat—though subtler connotations derived from a specific culture may be lost outside that culture. Its principal disadvantage is that the painted iconic sign, particularly at the most obvious level of denotation, communicates a much less precise meaning than the spoken or written sign proper.

Ernst Gombrich explains that the human mind is geared to generate allegory and metaphor. We perceive new experiences as modifications of our previous experiences: hence we perceive similarities between apparently dissimilar things and events. Consequently, we often substitute one experience for another: "Warmth, sweetness, and light provide us with early and intense experiences of gratification, and so we speak of a warm friendship, a sweet child, a shining deed" (1963, 14). Our speech and writing would be much more impersonal and limited without the use of allegory and metaphor.

A lion, for instance, may be used to represent several different qualities. What these different qualities have in common is that each is derived from what we perceive to be true about actual lions. We believe the lion is courageous, noble, and fierce. We consider it the King of the Beasts. So in the right context it serves well to signify courage, nobility, ferocity, or regal qualities (Gombrich 1963, 12–14). "When anthropologists say 'upright poles are phallic symbols,'" Gombrich notes, they mean more precisely that: "'upright poles lend themselves so well to use as phallic symbols that their use for this (conscious or unconscious) purpose is exceedingly widespread'" (13).

Remember, though, that Bryson argues that as the painted image accrues arbitrarily assigned meanings that can be translated into verbal equivalents, it tends to become more simplified, more abstract, as it did in the Middle Ages. Conversely, as the painter attempts a more realistic depiction, the assignment of arbitrary verbal meaning diminishes (1981, 3). I would add that the more realistically an image is depicted, the more likely it is that other cultures will be likely to recognize it; and conversely, the more the image accrues arbitrarily assigned meanings, the less likely it is to be understood by other cultures.

Bryson's observation is a useful guide at times, but it should by no means be taken as a hard rule, as the works of Jan van Eyck and the later abstract expressionists demonstrate. That van Eyck's *Giovanni Arnolfini and Wife* is a highly verbal painting is evidenced by the abundant articles concerning its verbal, even documentary, qualities; yet the double portrait is also a fully realized illusionistic painting, done in painstaking detail. Abstract expressionism, on the other hand, seems simplified and abstract, yet Bryson lists it at the opposite end of the verbal (discursive), as the closest thing to the purely visual (figural) (1981, 255, n.31). I do not point out this discrepancy in Bryson's theory to prove him wrong; I think he might well agree with these exceptions.

Van Eyck, like all notable artists, was a product of his time, and the time demanded that he fuse the micro- and the macrocosmic in his pictorial investigation of the world. His concerns were also highly verbal: his Arnolfini double portrait purportedly functioned as a surrogate for a legal document. In the next chapter I will demonstrate that his *Ghent Altarpiece* functioned as a complex scholarly and eschatological discourse.

3

Painting as Scholarly Text

The *Ghent Altarpiece* (1432) has been translated into one of the most complex scholarly texts in the history of painting. It is one of the few single works that has proved complex enough to generate several entire books: Bosch's *Garden of Delights* and Duchamp's *Large Glass* are two other works that have made it into this elite circle.

Van Eyck's altarpiece is the most comprehensive single piece produced in the Netherlands—or in France for that matter—during the fifteenth century. The main panel, *The Adoration of the Lamb* (Figure 3.1), exemplifies both the formal and the linguistic aspects favored by Dutch painters over the next two centuries.[1] The linguistic aspects are of special interest now because northern concerns with the linguistic aspects of painting parallel the concerns of postmodern artists.

We have seen that van Eyck did not emphasize the same formal elements of painting that Masaccio did—volume and dark-light composition, along with linear, atmospheric, and color perspective—but he constructed a far more complex arrangement of the ground plane. As was typical of southern European painters until the late nineteenth century, Masaccio—in *The Tribute Money* (Figure 3.2), for example—used the Albertian viewpoint, a low viewpoint that positioned the horizon near or below the midpoint of the painting. This Italian construct left little room for the ground plane upon which the figures stood. *The Adoration of the Lamb*, on the other hand, exem-

[1]When I use the terms *formalism* and *formal aspects*, I intend them in the sense generally understood in the visual arts, not in the sense of formalism in linguistics or literary criticism. I refer to paintings that are earnestly concerned with elements of human perception: abstract visual codes, gestalt closure, pictorial space, illusion, proportion, composition, and so forth.

FIGURE 3.1 Van Eyck, Hubert and Jan. *The Adoration of the Lamb.* Panel from *The Ghent Altarpiece* (1432). Detail of the lower panel. Oil on panel (134.3 × 237.5 cm.). Anvers. Musee d'Art. Photo: Giraudon/Art Resource, NY.

plifies the typically northern bird's-eye view, in which the horizon line is located near the top of the painting. Consequently, most of the surface of van Eyck's painting is occupied by ground plane.

Masaccio's shallow ground plane offers little area upon which to locate multiple groups of figures at different depths or spatial levels. His "simultaneous narrative" shows three separate instances in time and demands three separate scenes or groups of figures; nevertheless, the two major groups are located along the same frontal plane, which places their feet near the bottom

FIGURE 3.2 Masaccio. *The Tribute Money.* 1427. Fresco (width, 266 cm.). Brancacci Chapel, Florence. Photo: Alinari/Art Resource, NY.

of the painting. All these figures are positioned at approximately the same distance from the viewer and the background. (However, St. Peter in the first scene is located slightly higher on the ground plane at the far left, thus farther back in distance.) Acceptance of the Albertian skimpier ground plane guided Italian Renaissance painters toward representing just a few large figures, most of them at approximately the same depth, or distance from the viewer.

Van Eyck's choice of a high viewpoint, in contrast, offers a generous ground plane, which then demands to be filled with smaller and more numerous images. This northern viewpoint encourages the construction of multiple figures, groups of figures, trees, and other objects that are represented at decidedly different depths and distances from the viewer, as indicated by their placement at higher and lower positions on the ground plane.[2] Hence pictorial depth and spatial location are signified by their location on the ground plane, rather than generated by illusion and its attendant perspectives. Van Eyck's ground plane arrangement allows a full view of a greater number of images. Italian (and French) painters seldom used this high vantage point with its ample ground plane until the nineteenth century, when painters such as Degas began to raise the horizon in order to flatten pictorial space.

In other words, the Italian model was a human-centered composition that created little ground plane and displayed only patches of landscape or interiors peeking out around the edges from behind the larger main figures; monumental human images filled most of the rectangle of the painting. The Dutch model was a landscape with many small figures, or groups of small figures, scattered across the surface; the landscapes typically diminished the human element. The Dutch practice of filling the painting with many small figures integrated with their environment suggests that human beings are mere distortions in the overall fabric of the universe, while the Italian anthropocentric practice of filling the painting with a few monumental figures dominating their environment signifies the Italian Renaissance belief that God set human beings at the center of His universe.

The landscape, particularly the bird's-eye view typical of Dutch landscape, is by nature anti-Albertian. In fact, the nineteenth-century impressionists would focus on landscape, and Degas would use the bird's-eye view, to launch a direct attack on the Albertian tradition.[3] Landscape, as the impressionists discovered, negates Albertian linear perspective because linear perspective depends on straight and parallel lines, which are found only in human creations; Nature creates no such lines.

[2] Alpers quotes Michelangelo's written comment that Flemish painting pleases women, monks, nuns, and certain noblemen "who have no sense of true harmony. . . . They paint stuffs and masonry, the green grass of the fields, and shadow of trees, and rivers and bridges, which they call landscapes, with many figures on this side and many figures on that" (1983, 223).

[3] For further explanation of Degas's use of the horizon line, see Dunning 1991a, 124–29.

So the Dutch tendency to construct landscapes from the vantage of a bird's-eye view, with complex arrangements of many separate groups of figures, stood in direct contrast to Italian painting practices. Modern painters, like their Italian Renaissance precursors, also subordinated detail to the search for a monumental, cohesive, single image, but the postmodern image, like the Dutch, often features fragmented and complex juxtapositions of multiple figures and objects.

The perceptionist James Gibson has thoroughly investigated the psychological significance of the ground plane structure. Contrary to previous theories of spatial perception that assumed space is perceived as an array of objects in space, Gibson suggests that human beings understand physical space primarily as objects resting on receding horizontal planes that slant away from them—especially the surface of the ground. In the external world these receding planes furnish support and indicate movement, which aids the viewer's equilibrium and adds stability to perception (1950, 6). Van Eyck's *Lamb* panel offers a substantial ground plane, and thus tends to stabilize pictorial space. This stabilizing factor is a necessary element in Dutch painting, as a counter to the destabilizing factor of the implied multiple viewpoints.

Masaccio used the Albertian construct to stabilize his paintings. He was careful to maintain a single viewpoint—all his figures and objects are seen from exactly the same location, the same angle—and this stable viewpoint is in full agreement with the ground plane. This consistency in viewpoint was intended to generate unity: a cohesive image in which each object is related spatially to every other object throughout the painting. But van Eyck implies that the groups of figures and objects in his paintings are seen from multiple locations or viewpoints.

Had van Eyck used Masaccio's single-viewpoint construct, the figures in the foreground of his painting—the two groups at the bottom—would be seen more from above than are the distant group of angels around the altar. But in van Eyck's multiple-viewpoint panel the foreground groups and the distant groups are depicted as if they were both located near eye level. This is, of course, not possible in the world outside the painting.

In an Albertian single-viewpoint construct, the individual figures in the foreground of van Eyck's panel would be shown from above in order to agree with the angle from which the ground plane is seen, and they would demonstrate more foreshortening from head to foot than the figures at the rear of the ground plane. But though the fountain in the foreground is foreshortened as if it alone were seen correctly from above, the human figures in the foreground are depicted as if they were seen at eye level. Furthermore, the distant figures are depicted in the same manner as those in the foreground, as if the viewer moved to view each group from a different location. This combination of high horizon line with small figures, near and far, that are apparently seen at eye level is often called *rising perspective*.

In rising perspective the pictorial space that is constructed by the placement of the figures on the ground plane is in dynamic disagreement with the apparent perspectives and viewpoints of the figures themselves. But the instability of this arrangement is countered by the stability offered by the ample ground plane—one of the viewer's most important contacts with reality. Formally, this tension between stability and instability in rising perspective adds a strong dynamic quality to the best northern painting.

Postmodern painters no longer avoid references to linear perspective as their modern counterparts did; but their interest in multiple viewpoints gives them little motivation to perfect the complex accuracy of a unified and consistent single-viewpoint perspective. Consequently, many current paintings exploit rising perspective to create a dynamic pictorial space that is similar to that of the early Dutch painters. Figures and objects are often arranged spatially on a ground plane in combination with individual objects that are depicted from different viewing locations.

The groups of figures in *The Tribute Money* occupy the near foreground. The vanishing point—that single point on the horizon where all assumed parallel lines going in the same direction meet—is located in the head of Christ. In Italian Renaissance painting, the vanishing point determines the location of the horizon line and the heads of the painted figures are located at the level of the horizon line. Alberti insisted that since the horizon line represents the eye level of the viewer, placing the heads at the level of the horizon line implies that the figures are positioned at the eye level of the viewer; thus they appear to be standing on the same ground plane with the viewer.[4] Directly behind the figures in Masaccio's painting is a sudden drop back to the mountain. Thus the painting is abruptly divided into foreground and background in agreement with Italian convention.

In van Eyck's panel some groups of figures and trees are located high on the ground plane, and some are located lower, near the bottom. Yet each figure is represented as if its head were located on or near the horizon line, although none of them are. While Masaccio pops the viewer's attention directly from foreground to background in one abrupt step, van Eyck contrives to slow the imaginary progress of the viewer's visual trip in a complex, controlled transition from foreground to background. Van Eyck offers a host of possible avenues along the ground plane for the viewer to explore. Thus he

[4]Alberti wrote: "This [centric] point is properly placed when it is no higher from the base line of the quadrangle than the height of the man that I have to paint there. Thus the beholder and the painted things he sees will appear to be on the same plane" (Alberti 1966, 56). John Spencer, who annotated this version of Alberti's book, insisted that "This concept of observer and observed seeming to be on the same plane is most important for Alberti's aesthetic. By this means actual and represented space are seemingly one, and the observer's identification of himself with the painting is heightened" (in Alberti 1966, 109–10n.).

creates as dynamic, complex, and interesting a trip as possible while simultaneously stabilizing the scene with his expansive ground plane.

Human minds excel at recognizing pattern, and the structuring of the ground plane is one of the most important of these patterns. When our distant ancestors walked through forests, they constantly scanned the ground for passages through which they could continue their progress with as little backing up and retracing of their steps as possible. When we walk the streets of a city, we habitually and unconsciously scan the groups of people and obstacles in front of us for just such a continuous passage. A broken field runner in football excels at something quite similar.

Designers of theater sets automatically take advantage of these human abilities. They avoid placing any large frontal plane in the foreground of center stage because it would block the view of most of the action. If there are painted panels at the front sides of the stage, they generally slant back toward the rear so the audience's attention is focused toward the center and middleground of the stage.

Similarly, van Eyck offers many alternative visual passages across the ground plane. His maze invites the viewer to take an imaginary stroll from foreground to background. There is a slim passage on each side of the fountain in the foreground, which then opens up to offer several alternatives: a quick trip to the altar; an oblique turn to the right or left and a passage directly behind the foreground groups; then a return to the center, and another oblique turn to move again toward the center; or two possible pathways that turn obliquely toward the wings. More observation turns up more variations and numerous passageways. Bruegel, in the late sixteenth century, perfected this approach to spatial composition.

Van Eyck's bird's-eye view implies a maplike view of the world as the Albertian view does not. Van Eyck's painting might actually be read as a map of a landscape because the spatial clarity of his ground plane invites viewers to mentally construct a floor plan of the scene. (In fact, Jan van Eyck painted a *Map of the World* in geographic scale with measurable distances.) During the sixteenth century Bosch and Bruegel also exploited this high maplike image of the landscape, and Chapter 5 will demonstrate further connections between seventeenth-century Dutch painting and map-making.

As noted in Chapter 2, Dutch painters were obsessed with examining their universe through all the visual means available, and they painted both visual description and linguistic sign to discuss their environment. But southern painters focused more on illusion and the narration of monumental events. After Leonardo invented his most important painterly structural device—composition in dark and light—early in the sixteenth century, darklight compositional structure came to dominate composition in Italian painting as well as in sculpture (Dunning 1991a, 77–82). This is one of the principal reasons that sculptors rejected the practice of polychroming sculpture

after that period.[5] Composition in dark and light stresses lateral proportions and relationships and generates a compositional strategy that is primarily flat in concept, though it easily accommodates deep pictorial space.[6] So while the Italians exploited the illusion of volume and depth by means of linear, atmospheric, and color perspectives, their primary compositional strategy stressed the flatness of the picture plane.

As if in calculated opposition, the Dutch did not emphasize these elements of the Renaissance system of perspective. They created no illusions of deep space, but their primary compositional strategy—the organization of the ground plane—was essentially spatial. Thus the Italians typically stressed deep pictorial space in tension with flat compositions, while the Dutch stressed flat pictorial space in tension with spatial compositions. Pictorial space in Dutch painting was generated *primarily* by sign (the placement of the figure signifies its distance from the viewer, as in some medieval styles), while the Italians created pictorial space *primarily* by the convention of illusion.

In her book devoted exclusively to the *Ghent Altarpiece*, Elisabeth Dhanens insists that van Eyck's unique iconography must have been created by a scholar. This unidentified "scholar-poet" must have had a profound knowledge of medieval literature in order to arrange and interpret the complex texts, as well as compose new ones (1973, 16, 89). Masaccio, on the other hand, painted clear narratives of simple events. In *The Tribute Money* the middle group shows the tax collector asking Jesus and his disciples to pay a fee to enter the temple and Jesus telling St. Peter he will find the money in the mouth of a fish. The separate figure on the left depicts St. Peter retrieving the coin from the fish, while the two figures on the right depict St. Peter paying the tribute to the tax collector.[7] While Masaccio's painting narrates one simple event, van Eyck's altarpiece orchestrates a complex scholarly argument.

[5]For further explanation, see Dunning 1991a, 79–80, n. 4.

[6]In his book *The Principles of Painting*, even Roger de Piles—the principal champion of the supremacy of color in the seventeenth century—acknowledged the importance of Leonardo's method of composition when he advocated *claro-obscuro* (light and dark) as "the art of distributing advantageously the lights and shades, both in particular objects, and generally throughout the picture; but it more particularly implies the great lights, and great shades, which are collected with an industry that conceals the artifice" (from Holt 1958, 182).

[7]Though the event narrated is quite clear to anyone familiar with the Gospel, scholars have found a variety of possible motivations in Masaccio's choice of this specific subject. Most believe *The Tribute Money* was a response to the new tax known as the *catasto*. An equally valid interpretation is that the mendicant Carmelites for whose chapel the fresco was done chose that particular story in order to emphasize Christ's poverty in opposition to the opulence of papal Rome. The advocates of either interpretation, however, would be in agreement as to the specific event depicted in the painting.

No such brief explanation of the *Ghent Altarpiece* (or, for that matter, of Bosch's *Temptations of St. Anthony* or Bruegel's *Battle Between Lent and Carnival*) would be possible.

Van Eyck does more than create a complex discursive apocalyptic text. Like medieval artists, he does not hesitate to include numerous examples of the written word to clarify or paraphrase the iconography of the visual images. Dhanens explains that the fountain in the foreground is the *Fons Vitae*, the Fountain of the Water of Life (the parallel to the alchemical elixir of life is hard to miss). The water in the fountain flows toward the front of the painting, down toward the church altar beneath, where mass was said. Thus the *Fons Vitae* is "a symbol of the mass which pours forth grace without ceasing" (1973, 56). Written on the sides of the fountain in Latin is an apocalyptic message from the Book of Revelation: *HIC EST FONS AQUE VITE PROCEDENS DE SEDE DEI + AGNI*, or "This is the fountain of the water of life proceeding out of the throne of God and the Lamb" (56). Medieval and Dutch painters were far more inclined than Italian painters to use apocalyptic content, which reminds us of Ihab Hassan's comment about postmodernism and "the voice of the apocalypse."

On frames throughout the original altarpiece were written labels or concise explanations of the subject (and sometimes short paraphrases of the scene). And throughout the altarpiece there are written theological explanations, lofty praises, the words of a hymn, and even spoken words issuing from a mouth. At least eighteen representations of books appear in the *Ghent Altarpeice;* in many of them the writing on the page is legible.

Dhanens tells us the main sources for iconography were the Bible, writings from the Church Fathers, and texts from classical antiquity. But the arguments developed in the altarpiece cannot be understood simply by knowing such texts, for much of the material came from medieval texts about these texts (1973, 89)—in other words, meta-text.

The medieval practice of using images to signify complex texts died out far more slowly in the Netherlands than it did in Italy. Dutch painters maintained a strong interest in images that generated verbal meanings, and they continued to create allegory that could be translated into elaborate scholarly and scriptural arguments. But they hid these medieval allegories behind more naturalistic images arranged within believable contexts and empirical relationships, so the new allegory was far more subtle than the obvious signification and rigid syntax of the Middle Ages.

Panofsky concludes that Jan van Eyck created a fusion of medieval iconography and realism in which each depends on, and is a part of, the other (1971, 201). Although van Eyck never lost sight of iconographical significance, he did not allow it to contradict empirical realism. In his paintings the signified verbal aspects are absorbed into the realistic image, and the realism itself creates a flow of religious and mythic denotations and connotations determined by medieval iconography.

Throughout the body of his work van Eyck uses natural-looking artifacts as allegory: a carved monkey on the arm of a chair signifies the undesirable traits that led Eve to bring about "the Fall of Man"; a wash basin suffices to represent the "well of living waters," the most frequently used sign for the Virgin's purity (Panofsky 1953, 143). Every candle, flower, color, or piece of furniture could be interpreted as an allegorical reference.

Panofsky tells us that such disguised allegory was unknown in the Middle Ages. Medieval artists made no attempt to depict the real: they bothered with neither unity of space nor unity of time. This unconcern for empirical probability left them free to use any image in any order needed to signify their messages. When medieval painters wanted to signify the Pelican in Her Piety, for instance,[8] they simply painted a Pelican sitting on the cross—even though there was no discernable reason for its presence in the painting.[9]

Once the Italians and the Dutch decided to depict the external world as visual reality within the kind of pictorial space we all experience in the everyday external world, they could no longer tolerate contradictions between what is seen in the picture and what is likely to be seen in the world. This brought to a logical end the possibility of an organized grammar or syntax that depended on the arrangement of images. Henceforth, if images were to be related to one another in grammatical sequence according to linguistic dictates, they could not also be arranged in a realistic sequence according to spatial dictates. In other words, if one image is positioned above another within a realistic painting, viewers must assume that its position is determined by perspective rather than grammatical considerations. Consequently, the significance of positioning for linguistic syntax was lost.

When van Eyck wished to refer to the Pelican allegory, then, he cleverly depicted it as a small brass group on the armrest of a throne rather than a real

[8]George Ferguson maintains that the legendary pelican was reported to have the greatest love of all creatures for its brood. It was believed to pierce its own breast to feed its offspring with its blood. Out of this belief came the use of the pelican to signify the crucifixion—the offering of Christ's blood as a sign of love for all mankind (1961, 23). In a book first printed in 1852, however, Louisa Twining maintains that the pelican was also known to bring its young to *life* with its blood. Consequently, the pelican may also represent the Resurrection as well as the crucifixion, and also the Eucharist, by which Christians are nourished with the blood of Christ. The pelican is one of the few emblems still allowed in modern churches, where it is often placed near the altar to represent the blood that was "shed for many" (1980, 175).

[9]What John of Salisbury said of medieval writing in *The Metalogicon* (1159) was equally applicable to the didactic visual arts: "Take care to avoid crude figures that are hard to interpret. What is primarily desirable in language is lucid clarity and easy comprehensibility" (from McGarry 1962, 56). This counsel is, of course, in strong opposition to the medieval compulsion to "find the invisible within the visible," as well as to the medieval propensity to signify alchemical elements subtly. However, as mentioned earlier, it was typical of medievals not just to allow, but even to nurture, such oppositions: they embraced both poles of a paradox.

pelican perched on the cross. Panofsky was prompted to ask: When we know a pot of lilies, perfectly at ease on a table, signifies chastity, to what extent are the other objects in the picture—which may also look like nothing more than still-life elements—also signifying? (1953, 142). In other words, if we know some objects or details represented in van Eyck's painting can be read as hidden signs for something else, can we still assume that other painted objects are simple direct representations with no intentional hidden significance? How can we tell which normal-looking objects are intended to signify something beyond themselves and what objects are intended to signify yet another sign, which may in turn signify an allegory? In short, where in van Eyck's painting is the boundary between: (1) the painting as an object; (2) the objects depicted in the painting; and (3) the concepts or allegories those depicted objects signify?

This abstraction of signs in the visual language was perhaps motivated by a parallel abstraction of signs in other aspects of Dutch society. The economy had reached a second stage in the abstraction of value, and this had a direct bearing on the abstraction of signs in painting. During the Middle Ages religious art revolved around an economy that stored value directly in precious metals such as gold and silver. Gold and silver were minted into coins, which could be exchanged for material goods, a two-step mental construct. Each coin was configured as a sign, but that sign only indicated the specific weight—thus the exact relative value—of the metal from which it was made. Value was always present, not deferred. The value of the coin did not depend on the sign: the metal was itself a valuable object. The coin's value was therefore real, not abstract—direct, not subtle. And, in direct agreement, so were the medieval painted signs.

During the fifteenth century art came to be influenced by a new economy that depended on bank notes—paper money. These bank notes were mere signs that promised they could be exchanged someday for something valuable (gold or commodities) stored somewhere else—value once removed, a three-step mental construct. Perhaps because this experience of money had taught them to understand the concept of deferred value, painters began to represent religious value and presence also by signs once removed. For example, when medieval artists wanted to signify chastity, they depicted a spear through the heart of the Madonna; but when van Eyck wanted to signify chastity, he painted a vase of spear lilies—a sign once removed.

Ingvar Bergström, who has closely investigated the abstraction of signs in van Eyck's paintings, finds an excellent example of signified meaning at multiple levels of abstraction in van Eyck's *Saint Jerome in His Study* (Figure 3.3). His interpretation of the apothecary jar with an apple resting on it at the extreme right edge of the painting is interesting and complex. The inscription on the jar reads: "Tyriaca." Tyriaca was a medicine made from various in-

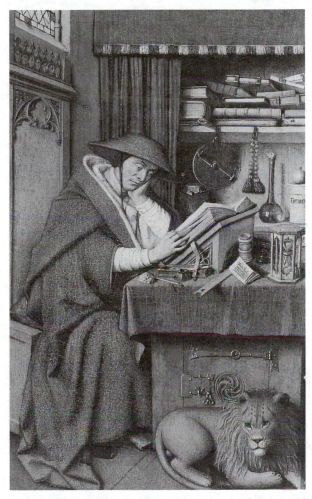

FIGURE 3.3 Van Eyck, Jan. *Saint Jerome in his Study* (1435). Oil and tempera on wood panel (8 1/2″ × 5 1/4″). Detroit Institute of the Arts. City of Detroit Purchase.

gredients, the most active of which was the ashes or meat of serpents. Concocted by alchemical apothecaries, Tyriaca was ranked first among all the medicines; it was considered a cure-all, but was thought to be especially useful for bites of insects, snakes, and dragons. Snakes, of course, signified the Fall, the apple signified original sin (which was instigated by the serpent), and dragons often signified the Devil or evil (1957, 5–7). The apple sitting on the jar of Tyriaca (the only antidote for a serpent's sting) is thus an oblique reference to a cure for "original sin, acquired sin, disease, and death, the only remedy for which is Christ" (1957, 7).

After van Eyck, in the fifteenth and sixteenth centuries Christ and Mary were often associated with the idea of the "true medicines" in both northern and southern European paintings (Bergström 1957, 8). Laurinda Dixon says that in alchemical references Christ and the Virgin came to signify "a universal medicine capable of creating a new Eden" (1981, 69). In Chapter 12 I will demonstrate that Anselm Kiefer's postmodern images are intended to revitalize this healing aspect of alchemy. The Virgin had often been linked metaphorically to medicine in fourteenth-century literature, but it was apparently Jan van Eyck who began to represent this idea in visual art. This is another reminder of his close relationship to scholarly texts.

In appropriating and assimilating what they knew of the Greco-Roman and medieval cultures, the Italians created one set of priorities and the Dutch another. Italian society prioritized the Greco-Roman concept of ideal beauty and the medieval love of theory to create a classic art of theory, form, and narrative. Dutch society focused more on the scholastic aspects of medieval iconography and an (almost) Greco-Roman empirical approach to realism to create a realistic art capable of signifying complex discursive themes.

The signification was not obtrusive. As Panofsky points out, the viewer is not expected to be aware of the complexity of the iconography in van Eyck's paintings. In fact, the power of his image depends on its *not* irritating the viewer with a "mass of complicated hieroglyphs" that must be deciphered in order to be appreciated. Instead, van Eyck invites viewers to lose themselves in a *"transfigured reality"* (1971, 200–01). Baldass says that van Eyck was the first painter to combine a clear and faithful depiction of nature with the idealism of the Middle Ages, all the while maintaining a constant awareness that his image signified "the truth of salvation, instead of merely reproducing faithfully some chance event" (1952, 47).

In short, van Eyck disguised the sign as reality and the real as sign. He created an image that Bryson might consider a synthesis of the visual and the verbal (in his words, the "figural" and the "discursive"). Perhaps better than any other painter, Jan van Eyck presages an important postmodern strategy—the eventual reunion of the two sign systems: writing and painting.

Since Van Eyck kept the details in his paintings compatible with the whole, viewers do not notice these details until they are physically near the painting. What is salient from a distance is the overall image and structure of the composition, yet, on close examination, the painting is loaded with enough detail to satisfy an avid viewer with a magnifying glass. Consequently, van Eyck's paintings sustain two entirely different sets of priorities that viewers control by means of the distance they choose to stand from the painting: the micro- and the macrocosmic. Here again, Dutch painting differs from Italian painting. Where the geometry of Italian painting constructs a specific single viewpoint outside the painting, Dutch painting implies or constructs multiple viewpoints in several different ways: by perspective, multiple eye levels, and relationship of detail to whole. Some of

these multiple viewpoints may even be implied to exist within the world of the painting itself.

Alpers states that northern painting is constructed so that the eye of the "viewer inserts itself directly into the world [the world depicted in the painting], while the southern viewer stands at a measured distance to take it all in" (1983, 85). Panofsky agrees with this conclusion, but his reasoning is different from Alpers's. He notes, for instance, that the Arnolfini painting is a slice of infinity; the "walls, floor and ceiling are artfully cut on all sides so as to transcend not only the frame but also the picture plane so that the beholder feels included in the very room" (1953, 7).

Add to this distinction the multiple viewpoints and fragmented image, as well as the previously mentioned displacement of time, and the Dutch image more and more resembles the postmodern image—which also constructs (in both painting and literature, as I will demonstrate in Chapter 11) a pluralist non-Cartesian viewer.

4

Allegory and the Carnival Grotesque

Few artists have produced a body of painting that has generated so many entirely different and often unrelated interpretations as Hieronymus Bosch (ca. 1450–1516). A host of writers, from Carl van Mander in the seventeenth century to Laurinda Dixon in the late twentieth century, have expressed their confusion at the riddles of Bosch's imagery and proposed their solutions. They have based their various interpretations on the Bible, theological texts, witchcraft, the heretical Adamite sect, occult societies, alchemy, Dutch aphorisms and folklore, and even Freudian psychology.

Though Bosch was popular during his lifetime, his reputation waned quickly after his death. By the early seventeenth century, viewers no longer understood his images, and Bosch's bewildered seventeenth-century countryman Carel van Mander wrote: "Who will be able to tell of all the weird and strange ideas which were in the mind of Jeronimus Bos . . . ? He painted gruesome pictures of spooks and horrid phantoms of hell" (1969, 65). Stanley Meisler notes that within twenty years of Bosch's death a monk in Spain was called upon to defend the paintings against charges of heresy; Bosch's works were called "absurd rubbish" and ridiculed as "nothing but devils, buttocks and codpieces (1988, 55). Still, Bosch's work was recognized as outstanding by his contemporaries, and he was the most important influence on Bruegel in the sixteenth century.[1] Because of their chaotic visionary nature, his paintings seemed almost contemporary to twentieth-century surrealists and those

[1] Bruegel's early work was so strongly influenced by Bosch that it could be mistaken for Bosch's. Margaret Sullivan notes that Bruegel's print *The Big Fish Eat the Little Fish* was first published by Hieronymus Cock as a Bosch print, even though the original drawing in Vienna is signed by Bruegel (1991, 441).

who came after. Many postmodern artists cite Bosch as an important influence on their work. When the sources of Bosch's images are studied, they are so patently verbal allusions to aphorisms and myth that the postmodern connection is obvious.

Perhaps there is also a kinship between the pessimism and violence of Bosch's era—the late fifteenth and early sixteenth century—and our own. That period was haunted by pestilence, miserable poverty, mind-numbing tortures, religious wars the murder of leaders, the pillaging of unprotected houses and farms, and the slaughter of peasants by marauding soldiers. The world seemed a dark and ominous place full of demons, little better than hell. Similarly, the postmodern age is haunted by AIDS, the misery of the poor, horrifying torture and rape, political assassinations and terrorism, and the slaughter of peasants by marauding soldiers, drive-by shootings, carjackings, riots, starvation, and "genetic cleansings." Our world, too, seems hellish.

Like the postmodernists, many late fifthteenth- and sixteenth-century northern painters—most notably, Bruegel, Grunewald, and Bosch—showed a consuming interest in the relationship between iconic signs (which signify by resemblance) and signs proper (words). Dirk Bax's *Hieronymus Bosch* is one of the best known and most authoritative examinations of the verbal origins of Bosch's images. Bax specializes in the civilization, language, and culture of the Dutch during Bosch's era; his compendious knowledge of the popular, intellectual, and professional culture of Bosch's time gives him unmatched insight into the connections between Bosch's images and Dutch aphorisms and folklore.

Bax insists that Bosch is best compared, not to other painters, but to a fifteenth- and sixteenth-century group of cerebral writers and poets called the Rhetoricians.[2] The Rhetoricians enjoyed cryptic devices such as: the rebus, a representation of words by pictures of objects or symbols whose names resemble the words; the *incarnation*, a rhymed couplet in which the numerical value of the letters is equal to the date of the event mentioned in the poem; and the *chessboard*, lines of verse arranged in sixty-four squares so that they could be read in different sequences in order to create a host of different poems (1979, 374). Like Bosch (and later Duchamp), the Rhetoricians took great delight in bizarre and erotic subjects[3] and in themes with coded mean-

[2]The Rhetoricians were called *Rhétoriquers* in Paris and *Rederijkers* in the Netherlands. Jan Steen did a painting called *The Rhetorician* in the seventeenth century.

[3]Arcimboldo, for example, a sixteenth-century court painter, painted images of human heads with lace collars and hats, all composed of strategically placed plants, fruits, and vegetables. Roland Barthes maintains these paintings were produced as parlor games of riddles, metaphors, and metonymies in the court of the German emperors. He says Arcimboldo's work is also based in linguistics and exploits the curiosities of language: the painter combines signs, permutes them, and deflects them, just as the practitioner of language does. "A shell stands for an ear: this is a *Metaphor*. A heap of fish stands for Water—in which they live: this is a *Metonymy*. *Fire* becomes a flaming head: this is an *Allegory*" (1985a, 136). Consequently, Barthes insists that Arcimboldo is a *Rhétoriquer* as well (1985a, 129–31).

ings layered one over another. Like Bosch they were satirical, didactic, and moralizing. In English morality plays the Rhetoricians combined the comic, the symbolic, the sensual, and the diabolic; and "many of Bosch's demons consist of the same combination" (374). Bax considers Bosch the *best* of the Rhetoricians, and goes on to compare him to the sixteenth-century philologists, who also borrowed from proverbs, sayings, and word plays (374). It is striking that when identifying Bosch's nearest artistic kindred, one of the foremost authorities on his work chooses not to compare him to other painters but to word merchants: philologists and the Rhetoricians.

In tracing the images in Bosch's paintings, Bax finds their original sources hidden in proverbs, aphorisms, and adages—which assumed a sudden new importance in the late fifteenth century. Margaret Sullivan notes that these sayings became a means for disseminating learning: knowing proverbs and how to use them was the mark of a strong education. Thus many books of proverbs were printed. When Erasmus (ca. 1466–1536), one of the two best known Dutch scholars in history, published his *Adages*, the book enjoyed printing after printing and became a bestseller throughout Europe (1991, 435).

Earlier authors had simply compiled lists of sayings without comment. Erasmus traced each saying through as many sources as he could, back to classical antiquity whenever possible, and commented on the saying's meanings, both figurative and literal, as well as on the custom, myth, or event that had generated it. He advised the learned to sprinkle these sayings throughout their speech and writing to make their language sparkle with jewels from antiquity. Among the educated in Europe, it became a custom to compile notebooks full of adages discovered while reading the ancient authors and to use them as Erasmus advised (Sullivan 1991, 435–37). Erasmus was so convinced these adages were an indispensable part of education that he suggested they be printed on cups and rings (435).

Numerous editions of adages besides Erasmus's were published and made available to readers in Bosch's locale. That there were so many readers for these books suggests there was a knowledgeable audience for adage in painting (Sullivan 1991, 439).

Bosch became the first artist to make proverbs an important part of painting (438), probably incited by the same stimulus that caused Erasmus and a host of others to place so much value on adages. He may even have known Erasmus personally, since the great scholar lived in the same small town ('s Hertogenbosch) as the painter during the 1480s, when Bosch was in his thirties.

One of my favorite examples from Bax's translations is that of the strange figure with large head joined directly to a pair of legs that is located just right of the middle in the center panel of Bosch's Lisbon triptych *The Temptations of Saint Anthony* (Figure 4.1). Bax explains that the right foot thrust forward represents the Dutch saying: "That is thrusting out its leg" (1979, 52)—an idiomatical reference to a person or thing in a miserable situ-

FIGURE 4.1 Bosch, Hieronymous. Detail from center panel (51 5/8" × 46 7/8") of *The Temptations of Saint Anthony*. Triptych (Oil on panel). Museu National de Arte Antiga, Lisbon. Photo: Art Resource, NY.

ation (Americans might substitute "Up a creek without a paddle"). The mug resting on the creature's knee illustrates the Dutch rhyme "*Arme Lieden eten op de knieën* [Poor folk eat on their knees]" (52)—meaning the poor use their knees for a table because they lack furniture and fancy utensils. The image signifies poverty. The figure also has a bare butt, referring to the saying "It is but a bare little bum," meaning "poverty reigns" (52). The most obvious thing about this painted figure, however, is that it has no body. "The man is without a body" was an idiomatic saying that meant something was insignificant or trivial. (We might say "Where's the beef?") Bax thinks it also connotes a diabolic element: "The devil is a poor fellow: he has neither body nor soul" (53). The creature's larger than normal head might mean "he is

short for [the size of] his head" (53)—an obvious comment about his lack of mental ability.

The painted figure wears a high boot on his right foot and a sock on the left. This may illustrate the idiomatic expression "On shoe and slipper," meaning "in poor circumstances" (Bax 1979, 53). Or it may refer to such sayings about heavy drinking as "We once drank away the shoes from our heels" and "He has on a high boot," meaning he is so drunk he cannot stand (53). Bax says the high boot was associated in Middle Dutch with a funnel, which also stood for heavy drinking.

Bax notes that numerous medieval images show a head joined to a leg, thighs, or a naked butt, and others depict headless figures with eyes, nose, and mouth on the chest and stomach. Bax says the latter images may represent the monster without a head—that people from classical antiquity through the Middle Ages believed actually existed. He posits this as the possible origin of the expression "Head on rump" (1979, 54). Mikhail Bakhtin also notes an old belief in a creature known as a "leumans" who had no head; his face was on his chest (1968, 344).

Dirk Bax has generated all these meanings from just one, almost insignificant figure in Bosch's painting. He follows the same procedure for most of the other figures scattered across Bosch's Lisbon triptych. But Bax interprets each figure separately; he fails to relate the images to one another in a grammar of overall meaning or discourse.

Laurinda Dixon believes that this is the problem with so many translations of Bosch's work: they fail to relate the separate images in the paintings, although Bosch certainly did. She compares this kind of interpretation to recognizing letters in a strange alphabet, yet being unable to form the letters into words and phrases (1981, 1).

My personal choice as the most appropriate fable to illustrate the postmodern concern with the limitations of texts is the story of the seven blind men and the elephant. Each blind man correctly describes a specific part of the elephant as he feels it, and each argues that his description is the right one, but none succeeds in describing the overall configuration of the elephant. Similarly, postmodern writers warn that any text is analogous to only one part or one aspect of a truth. No text, no matter how thoroughly it represents a particular aspect or part, can ever fairly represent all parts and all aspects of the entire elephant. Each text is but a supplement to the whole; none contains a complete truth.

In her book *Alchemical Imagery in Bosch's Garden of Delights*, Dixon emphasizes how relationships between images create a complex overall text, which reinforces the linguistic and allegorical nature of Bosch's painting.[4]

[4]Three notable precursors to Laurinda Dixon are Wilhelm Fränger ([1951] 1983), Clément Aymès (1975), and Madeleine Bergman (1979). Fränger argues that Bosch and his imagery were related to the Adamites, and he suggests at several points that this sect and its imagery are related to alchemy. Aymès finds signs of Rosicrucianism (a branch of alchemy) in the imagery. And Bergman makes the full transition into alchemy, though not as thoroughly as Dixon.

She offers an elegant and convincing interpretation based on alchemical signs, which seem to be the key to his overall theme.

Dixon lists three compelling facts that indicate Bosch was probably quite familiar with alchemy. First, the Netherlands surpassed all Europe in the production of printed books; and Bosch's home ('s Hertogenbosch) was dominated by a scholarly organization, the Devotio Moderna, whose primary aim was to facilitate learning by mass-producing manuscript copies.[5]

Second, Dixon shows how investigators looking for Bosch's connection with alchemy, as well as an artistic tradition in his family, have missed the fact that many of his in-laws were apothecaries. She notes that fifteenth-century alchemy, led by Paracelsus, had shifted its goal from creating gold to distilling a healing elixir of life—that is, to doctoring and the making of medicines.[6] The same apothecaries who made these medicines sold artists' paint pigments, many of which they concocted through alchemic processes (1981, 3).

Third, alchemical manuals of the time are full of fantastic figures and imagery that are almost identical to Bosch's images. In the alchemical manuals these images were allegories for the practice of distillation.

Dixon offers persuasive verbal and visual documentation for the alchemical meaning of individual signs in Bosch's painting. Using illustrations from alchemical texts, she demonstrates that his bizarre human constructions and distortions bear an uncanny resemblance to the distillation apparatus used by alchemists. She shows medicinal implements thinly disguised as fruits and animals, and she explains that Bosch's hybrid plant-animal creations signify the prime elements in the process of transmutation. She makes her point quite clearly without having to stretch a single resemblance.

Then Dixon demonstrates that each sign functions on at least two levels in the grammar of Bosch's visual language to create both an obvious Christian message and a hidden alchemical argument. Her interpretation suggests a plot as complex and as layered with both obvious and hidden meanings as any novel. She finds enough figural, metaphorical, and allegorical significance in Bosch's work to incite the envy of any medieval writer or artist intent on finding the invisible within the visible. Moreover, her elegant verbal translation embraces the interpretations proposed by other modern authors. She demonstrates that alchemy had been such a ubiquitous paradigm for so long—shaping Christianity, science, magic, legend, and philoso-

[5]The Netherlands produced 1,882 printed books in the fifteenth century, as compared with 743 in Paris and 393 in all of England (Dixon 1981, 7).

[6]Dixon believes that the goal of alchemy in the fifteenth century could be accurately described as much the same as that of modern medicine and science: "to discover a way to create life artificially and prolong it by stopping the natural aging and weakening of an organism" (1981, 3). As early as the thirteenth century, Roger Bacon had defined alchemy as a science that teaches "how to make and procure a certain medicine, called the *Elixir*, which being thrown upon metals, or imperfect bodies, reduces them to absolute perfection" (from Dixon 1981, 10).

phy so thoroughly—that it would be impossible to establish what form these disciplines might have assumed in the sixteenth century if all the alchemical elements and influences could somehow be distilled out.

Dixon explicates Bosch's use of signs to create four layers of overall significance in his *Garden of Delights* triptych (Figure 4.2) First, the obvious Christian meaning of the triptych seems to be a typical moralizing sermon about Man's weaknesses and the terrible fate he is doomed to suffer. Second, the thinly disguised alchemical signs interlock like pieces of an elaborate puzzle to form a rigorous allegorical grammar that is used to argue elegantly for "a universal medicine capable of creating a new Eden" (1981, 69). Third, the creation of Eden is an allegory for the process of distillation. Finally, distillation is itself an allegory of the cyclical creation and destruction, re-creation and re-destruction, of the world (13).

Haughty alchemical scholars were known to compare their own work to God's cyclic creation and destruction of the world. They imitated this creation and destruction in an endlessly repeated four-step cycle. The first stage, as signified in the left panel of the triptych, was the marriage of opposites: elements such as sulphur and mercury signified the opposition of male and female (often represented by Adam and Eve) and were joined in a chemical marriage (Dixon 1981, 13).[7]

In the second stage, as signified in the center panel, the mixing of those volatile elements produced a dramatic and colorful bubbling in the flask. During this bubbling stage, the elements multiplied chemically to create various other new elements—a colorful chemical activity that was often called "child's play" and was an allegory for mating and producing children. These "children" then continued to multiply and eventually became the peoples of the earth (Dixon 1981, 13).[8] An overall view of the three panels visually reinforces the conviction that Bosch had this bubbling stage of the alchemic process in mind when he produced the middle panel. It is more colorful, elaborate, active, and fragmented than the side panels; with its rising and floating parts, it seems to be echoing the volatile commotion in the alchemist's bubbling flask.

[7]Dixon explains that alchemists believed substances reproduced themselves in a mystical marriage that resembled human marriage. In alchemical manuscripts marriage was depicted as the consummation of opposites: opposites such as Adam and Eve, Sol and Luna, wet and dry, vile and precious, simultaneously confronted each other in enmity and attracted each other in love (1981, 15).

[8]In Dixon's words: "The mating of the two opposites produced a transmuting agent capable of changing 'sick' metals into gold and healing human bodies on contact. The alchemists compared this 'elixir,' sometimes called the *Lapis*, or *Mercurius*, to Christ. They equated the rising and condensing of vapors during distillation to the death and resurrection of Jesus. The power of the 'elixir of life' to unite the opposites of 'above and below' in the process of distillation was compared to the power of Christ to unite the opposites of heaven and hell" (1981, 15).

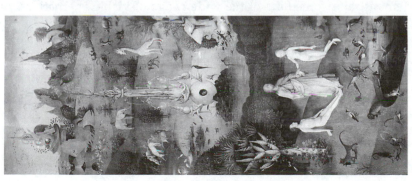

FIGURE 4.2 Bosch, Hieronymous. *The Garden of Delights.* Three panels of triptych (1500–1505). Oil on panel (wings 86 3/8″ × 38 1/8″ each; center panel 86 5/8″ × 76 3/4″). The Prado, Madrid. Photo: Alinari/Art Resource, NY. Foto Marburg/Art Resource, NY.

The third step in the cycle, signified by the Hell panel on the right side of the triptych, was the putrefaction process. When the lively activity in the flask had ceased, the remnants settled into a sodden, cold, dead solution. This stage signified death and the rotting of the bodies of the parents and children (Dixon 1981, 13).

The fourth and final step in the cycle was purification, the washing and blanching of the putrefied material in a retort—a glass bulb with long neck bent downward that was used for washing, distilling, or decomposing a substance by heat. Thus the end of the process was similar to the beginning, an allegorical demonstration that alchemic process was recursive and self-perpetuating, just like the cyclic rhythm of Nature.[9] The end result was union with God, represented by a circle or globe. This Bosch signified by the transparent globe on the front of his closed triptych (Figure 4.3).

This four-step process is described in every alchemical treatise since the thirteenth century. The creation of the world was commonly used as an allegory for the creation of an elixir—sometimes called the Lapis or Mercurius, and often signified by the image of Christ—that was capable of restoring the Garden of Eden (Dixon 1981, 13). The unexpected and unnatural deep-rose hue of Christ's face and the red of his garment in the first panel are surprisingly strong in the original painting. Dixon explains that the red robe establishes Christ as an alchemical doctor, for doctors wore red robes in the Middle Ages. He is shown taking Eve's pulse, which was a common diagnostic procedure in the fifteenth century. The doctor represents the healing properties of the elixir, and red is the color of the legendary "tincture" of Mercurius (16).

I find no conflict between Laurinda Dixon's elegant (in the scientific-aesthetic sense of the word) translation of Bosch's paintings and previous translations. Her version is inclusive, using the ideas of others as supplements to reveal still additional layers of meaning. It succeeds in fusing the entire triptych into two overall arguments—one Christian and one alchemical, one visible and one invisible—that make sense in the context of Bosch's time and place. Dixon has come quite close to describing the whole elephant.

Comparing Bax's proverb-based rendition to Dixon's alchemical translation demonstrates something of the wide range of viable alternatives for translating the iconic signs in Bosch's paintings into allegory. Take, for example, the translations by Bax and Dixon of the dominant image just above the center of the right *Hell* panel—the large white hollow upper torso of a man with a flat disk and a bagpipe resting on his head (Figure 4.4).

[9]Throughout this book I will use the word "recursive" in the linguistic tradition of Chomsky and Wittgenstein, not in the mathematical sense. According to the *Oxford English Dictionary*, in linguistics the term may be "applied to a grammatical feature or element which may be involved in a procedure whereby that feature or element is repeatedly reintroduced."

FIGURE 4.3 Bosch, Hieronymous. *The Garden of Delights* (1500–1505). Exterior of triptych with the shutters closed (86 5/8" × 76 3/4"). Prado, Madrid. Photo: Scala/Art Resource, NY.

In the shape of the man's torso and right leg (or arm), Bax sees a hollow tree that resembles the oval body of a goose with its neck hanging limply down (the right arm reads as the neck of the goose), as if served up for a feast at Carnival or strung up for a "goose-pull." (This image can be perceived, but it is somewhat of a stretch.) Goose-pulling, Bax explains, was a contest performed after a feast by revelers in the goose riders' guild. They tied the legs of a live goose to a rope stretched between two trees, about nine feet above the ground. The dangling neck of the goose was lathered with oil or soap, and the goose-pullers rode their horses at full gallop under the rope between the trees and tried to pull the bird's head OFF. Goose-pulling

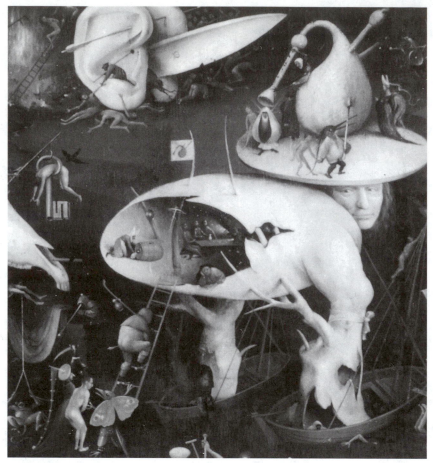

FIGURE 4.4 Bosch, Hieronymous. *The Garden of Delights,* detail of Hell (86 3/8″ × 38 1/8″). Prado, Madrid. Photo: Foto Marburg/Art Resource, NY.

remained a favorite sport for centuries in spite of many prohibitions—in response to the rowdy character of the contestants, not the cruelty to the goose (1979, 239).

The merrymakers in the painting, he continues, are gathered in the shell of the figure: "*schil*" in Dutch means either "shell" or "hull" (also the bark of a tree), which corresponds to a Dutch idiom for "a quarrelsome group." The legs of the hollow man are planted in boats, and the Dutch word "*boot*" once meant "boat," "shoe," and "wine cask." Bax concludes that the hollow man wears the boats (or shoes), which heave on the waves and represent the wobbly walk of a drunk (a reference to the wine-cask meaning), who also looks like a goose—a stupid waddling animal (1979, 239–40).

Dixon, on the other hand, insists the body of the creature is a broken egg (a near-inescapable perception), signifying the condition of an egg during the putrefaction stage in alchemy. She notes that the egg symbol was pervasive in alchemy, and that it appears in all four parts of the triptych. It is shown here in Hell, and Hell is an allegorical reference to the putrefaction stage. The colors of the figure—whom she calls "the alchemical man"—are red (for the color of the elixir), black (for putrefaction), and white (for purification): the three alchemical colors. Flames glow inside the broken shell to signify the egg's role as a furnace, which is a common sign in the language of alchemy (1981, 51).

Dixon sees multiple meanings in the bagpipe on the alchemical man's head. The bagpipe was the instrument of peasants and beggars; it was made from the bladder or stomach of an animal; its raucous sound and visual resemblance to the male sex organ designated it a prurient image; the bagpipe often accompanied dancing, a sin in the fifteenth century; and it was reputed to be the Devil's own instrument. So the bagpipe is the instrument of the lower classes, made from the more repulsive parts of an animal, "nasty" looking, and it commonly accompanies sin and the Devil; thus it is easily at home in Hell (1981, 49–50).

The shape of the bagpipe on the head of the alchemical man is the same as that of the alchemical distillation retort. This retort was used in the conjunction phase, as part of a circulating apparatus called the *coitus,* and also in the putrefaction stage, or Hell, where Bosch places it (1981, 50–51). Fred Gettings notes that alchemists used many strangely shaped bottles (often called *alembics*) that were intended to echo or signify parts of the human body, within which the "secret Sun" (the innocent soul) was hidden. The innocent soul hidden in these alembics was prepared to fly (like a bird) into the world (1987, 147).

Inside the eggshell body of the alchemical man people sit at table, one on a large salamander-like amphibian. Salamanders were a common alchemical sign for the putrefaction stage because they were thought to be generated in dung by fermentation (Dixon 1981, 51). They were also believed to be impervious to fire. I might add that the overall color of this triptych is burnt umber, the color of dung. Dixon's exhaustive translation of this one image continues for another twelve pages.

Postmodernists insist that our "reading" of any text is shaped by the culture in which we live. Bosch's paintings are loaded with signs, but there is no correct single reading of any image. The way Bosch's contemporaries saw his images was conditioned by the various aspects of sixteenth-century Dutch culture. Margaret Sullivan tells us their literature, their ceremonies, their science, and their ubiquitous proverbs disposed these viewers to read multiple and related meanings into images. More was better, "and the greatest pleasure was derived from those images that were most richly associative" (1991, 465).

The Dutch scholar Johan Huizinga is often considered a twentieth-century counterpart to the sixteenth-century Erasmus, the Great Rotterdammer. Huizinga's biography of Erasmus has always intrigued me; it seems almost an autobiography—as if he were reconstructing his own reincarnation through a window to the past. Erasmus wrote his influential *Praise of Folly* in 1509, and Huizinga says this text portrays the world as a spectacle of universal folly. Folly is an affirmative image; it is that element which makes it possible for people to live comfortably among others. Folly is embodied in Erasmus's main allegorical character, whom he names Stultitia, and she proceeds to praise herself (1957, 69). Stultitia claims the world could not exist for a moment without her. No society or cohabitation would be pleasant without an appreciation of folly. Huizinga says that Erasmus—who seems to be giving voice to the collective thoughts of his age—equates Folly with "worldly wisdom, resignation and lenient judgement" (70).

Erasmus's vision of Folly wears a fool's cap and bells, and she is indistinguishable from madness. This is a vision that dominates the sixteenth century. In Erasmus's and Bosch's time imbeciles, madmen, and madwomen were often used as jesters to entertain the rich, and Erasmus, like most people in his day, makes no distinction between the foolish and the lunatic, between the comic and the ridiculous (Huizinga 1957, 76–77). In the same century in Spain, however, Miguel de Cervantes does make a careful distinction between foolishness and insanity in *Don Quixote*, which some consider the first novel. Sancho Panza was represented as merely foolish, but Don Quixote was a brilliant man who went mad "because he read too many books."

Twentieth-century society no longer shares a common language with madmen. Michel Foucault reminds us, however, that madness was not declared a mental illness until the eighteenth-century Enlightenment, when the insane were banished from the cities to fill many of the 19,000 empty leprosariums throughout Christendom. Foucault insists that long before Hieronymus Bosch, the connection between Reason and Madness was a focus of communication in Western culture, as well as a source of its originality, and furthermore that this connection continues to tender communication and originality today (1965, x–xi).

Bosch was shaped by the same culture that produced Erasmus, and his images are no less focused on the lunatic and the stupid. Consider his many images of naked people (nakedness was considered ridiculous) engaged in the most asinine actions: a man on all four with birds flying out of his ass (the released bird was often an alchemical sign for the soul freed from its earthly prison); a man climbing a ladder with an arrow protruding from his ass; people eating the most vile food; even the clergy are engaged in the most embarrassing acts. T. G. A. Nelson notes that in David Lodge's novel *Small World*, when one of the characters is asked to name the organ of comedy, she

replies: "The anus" (1990, 33–39). And Bax reminds us that what we might consider crude in Bosch's images simply reflects the unrefined and uninhibited speech of both carnival and the market (1979, 372).

Salient throughout Bosch's work is a demand for hermeneutics, the art or science of interpretation or meaning, which originated in the Middle Ages and has been revitalized to become an important concern in much current writing. His work may be considered primarily verbal for the following reasons: Bosch shuns simple narrative in favor of complex discourse and argument; his images must be interpreted in one manner or another as verbal equivalents; Bax associates him with writers, the Rhetoricians and the philologists, more than with other painters; his work is compared to proverbs, adages, and aphorisms; and he works with complex, layered metaphor and allegory. Furthermore, Bosch himself wished his work to be perceived as similar to that of the Italian poet Merlin Coccaie (Guillaud and Guillaud 1989, 23).[10] Finally, in order to be fully understood, Bosch's work must be "read" by someone who knows the sixteenth-century Dutch language.

Bosch renders unending images of Folly, which loomed large over the entire Renaissance. The ugly and the deformed were linked to Folly, and in *The Name of the Rose* Eco offers an explanation of why ugly images were admired. The principal character, a wise monk and teacher, explains to his pupil Adso:

> "But as the Areopagite teaches," William said humbly, "God can be named only through the most distorted things. And Hugh of St. Victor reminded us that the more the simile becomes dissimilar, the more the truth is revealed to us under the guise of horrible and indecorous figures, the less the imagination is sated in carnal enjoyment, and is thus obliged to perceive the mysteries hidden under the turpitude of the images. . . ." (1983, 89)

Bosch has an immediate and strong impact on viewers the first time they see his images. His paintings are fascinating because imagination, horror, fear, comedy, puns, and jokes run rampant through them. Moreover, these apparent opposites—horror versus comedy, and fear versus jokes—are but different aspects of the same emotion. Laughter and comedy have traditionally been rooted in malevolence and sadism: the Germans even have a word for the joy we feel when we witness another's catastrophe: *"Schadenfreude."*

[10]Coccaie was resigned to the fact that he would never be able to compete with the old masters in poetry, so he invented an ingenious nonsense rhyme be called "macarronica." As the poet used artificial means to create an original style that placed him outside the old master tradition, Guillaud and Gillaud conclude—perhaps somewhat too easily—that Bosch, too, feared remaining "in the shadow of greats such as Patinir and Metsys," and so focused on creating a new style rather than on becoming a great painter (Guillaud and Guillaud 1989, 23).

Though Bosch has been compared to various writers and schools of writing, his most obvious counterpart seems to have been largely overlooked. Bosch's imagery is so akin to that of the French writer Rabelais, who came along forty years later, that the two might have been twins.

Rabelais has often been deemed comparable to Dante, Shakespeare, and Cervantes. The Russian literary critic Mikhail Bakhtin contends that these four writers (note that three of them lived in the sixteenth century) produced works of what he calls "grotesque realism" or the "carnival grotesque"—which stands in direct contrast to the classic. Only Rabelais and Bosch, I think, are true exemplars of the carnival grotesque. Both emphasized images of the lower body and focused on anal humor and sexual metaphor; and both were later accused of being gross artists of the "flesh" and "belly."

Bakhtin is a rare find—a structuralist who offers a "good read." He explains that the pervasive carnival activities and Fools plays of the Middle Ages and Renaissance were consecrated by tradition and generated hearty laughter. They were entirely separate from the official world of feudal, ecclesiastical, and political activities: they were "a second world and a second life outside officialdom" (1968, 5–6). Carnival was not a performance the people watched; it was a second life they lived (7). Neither the cultural consciousness of the Middle Ages nor the culture of the Renaissance can be understood without this concept of the two separate worlds (6).

Peter Glum notes that carnivals and Fools plays featured the following images: clerics wearing animal masks and disguising themselves as "women, pimps, jugglers"; blood sausages and shoes burnt as incense; revelers singing dirty songs and eating fat sausages as surrogates for the Eucharistic Host; provocative dancing; and young people appearing naked outside churches after church plays were over to amuse the crowd with nasty speeches and obscene gestures (1976, 49). Perhaps Bosch's paintings were simply a normal response to his irrational era.

Bakhtin notes that for a thousand years comic imagery developed under the license of carnival, and that this composed the entire recreational art of the Middle Ages (1968, 13). The carnival grotesque images featured giants, monsters, coarse scatological and anal humor, exaggerated sexual organs, and the degradation of ecclesiastical and secular officials. Bakhtin also notes that every carnival had a set called "hell," and this "hell" was solemnly burned at the peak of festivities (91).

The essential overall principle of grotesque imagery was degradation, but this degradation was not intended in the negative sense we associate with the word today. It did not mean to destroy so much as to descend to the earthly sphere of "the reproductive lower stratum, the zone in which conception and a new birth take place. Grotesque realism knows no other lower level; it is the fruitful earth and the womb. It is always conceiving" (Bakhtin 1968, 21). These grotesque parodies were actually selected from "all the de-

grading, earthy details taken from the Bible, the Gospels, and other sacred texts" (20).

To the literal mind of the Renaissance the cosmic meaning of "up" meant heaven and "down" meant earth; and earth is the world of death and graves. It swallows up. But it is also the place of birth, the womb, and maternal breasts. The bodily meaning of "up" was the face or the head, while "down" implied the belly, the buttocks, and the genital organs. (Bakhtin 1968, 21). People of that age understood that feces made things grow. They had often observed the fertility of a field where many people had encamped. They believed that early pagans had grown into giants because their mothers abandoned them to play in their own excrement. The principle of the lower regions is that of victory; "for the final result is always abundance, increase" (62). And the lower regions were funny. Furthermore, in medieval and Renaissance folk art the element of terror was represented only by "comic monsters, who were defeated by laughter. Terror was turned into something gay and comic" (39).

T. G. A. Nelson tells us that laughter is generated by psychic release: when fear is aroused, then suddenly grounded, laughter follows the realization that the fear was ridiculous and pointless (1990, 6–7). Those who make others laugh seem to have an acute sense of the illogical and the unjust, the pure horror of the absurd world around them. Nelson reports an evening in which Charlie Chaplin took an abrupt emotional dive into an almost pathological abyss of melancholy and began to fume about comedy, sadism, masochism, Shakespeare, and the Infinite. And he cites W. D. Redfern's observation that he believed only one generalization about comedy: that "laughter is one of the only three phenomena which occupy our total attention: the other two are the sneeze and orgasm" (17).

It is also worth noting that laughter has never been used as an instrument of oppression; it has always been used as a weapon against tyranny. Bakhtin says that the sixteenth century, with its carnival grotesque, represents the historical summit of laughter, and that the high points on this summit were Rabelais's novels (1968, 101) and Bosch's paintings. The grotesque did not become an expression of darkness and terror until the arrival of romanticism in the late eighteenth century (41).

Bosch's imagery is dominated by images inspired by alchemy, the carnival grotesque, and the biblical Book of Revelation. These three images are closely connected, and as I will demonstrate later in this book, the connection has been revitalized in the postmodern age.

Bosch continues the Dutch tradition of the high horizon and rising perspective established by van Eyck in the *Ghent Altarpiece*. But Bosch seems to construct a viewer who is even more distant than van Eyck's because his images are smaller and thus appear farther away than his predecessor's. The bird's-eye view, from the height Bosch suggests, is also more robust in main-

taining a believable perception than is the Albertian view.[11] In the Albertian view, viewers appear to be at the same height as the painted figures. Generally, these figures seem to be arranged along the same ground plane upon which the viewer stands, and there often appears to be considerable space between the painted figures and the background.

Every time viewers move, even slightly, their perceptual apparatus expects movement parallax (a change in the position of the figures relative to the background behind them). When the viewer moves, objects that are closer to the viewer and farther from the background evidence a marked change in their position relative to the background; but objects that touch the background (or that are proportionately closer to it) show little change in their relationship to the background. Consequently, when viewers do not see the movement parallax that they expect to see when images are closer to them and farther from the background, each move serves to remind them that the scene is not real but merely painted images on a flat surface.

In a bird's-eye view from an apparently significant height, however, viewers feel as if they are quite distant from the depicted objects and the objects appear to be in contact with the ground behind them. Consequently, viewers anticipate little or no movement parallax, even with considerable movement on their part. Such a scene does not remind them with each move that it is merely painted, so they find it easier to suspend their disbelief and enter the reality of that painted world.

Bosch exploits the bird's-eye view in his triptych to create a robust image that suggests viewers are floating somewhere above the painted scene; the image even seems to imply they may be falling into it. This must have been highly effective during Bosch's time—especially in the Hell scene—but movies and a diminished belief in religion have rendered twentieth-century viewers immune to such effects in painting.

Rising perspective also tends to flatten the painting, and it provides Bosch with a large expanse of ground plane upon which to arrange his signing images—though the compositional method he employs seems more related to the *horor vacui* of some periods in the Middle Ages than to the care-

[11]M. H. Pirenne (1970) often uses the term *robust* to describe that quality in perspective that causes it to maintain its illusion or believability even when the viewer does not stand in the right location. The more dislocation the perspective is able to withstand, the more robust it is. I use this term to refer to the fact that perspective also tends to maintain believability even when the viewer *moves:* in a willing suspension of disbelief, the perceptual faculties apparently tend to ignore (to some extent) the absence of movement parallax when the viewer moves about. Obviously, some paintings are more robust than others. For instance, the most robust paintings depict entirely flat content, like the nineteenth-century letter-rack paintings of William Harnett, and *Letter Rack* (1658) by Wallerant Vaillant. These paintings depict papers and envelopes held flat to the wall by tape. Because Bosch's paintings often depict small objects resting on a flat surface, they too are robust.

ful organization of visual pathways practiced by Jan van Eyck. But that Bosch does attend to the pictorial space is signified by his placement of figures on the ground plane. This is most evident in the elliptical arrangement (an ellipse represents a circle on a receding plane) of animals and figures in the middle of the central panel.

Like van Eyck, Bosch seldom foreshortens his figures to allow for the fact that the ground plane—as well as each figure—is seen from a bird's-eye view. In typical rising perspective, he offers little indication that his figures are seen from above, as the ground plane indicates they should be. With rare exceptions, each image is depicted as if it were viewed from eye level, no matter how far below the ground plane appears to be.

Bosch uses an additional spatial device that was also employed by the ancient Japanese to accommodate this dichotomy between the low eye level of the figures and the high eye level of the ground plane. Margaret Hagen calls this device "spheres of being" or "time zones" (1986, 142). The Japanese often used clouds to separate these different spheres or zones (typically three in each such painting). The height of the zone in the painting signifies its distance: the lower scenes are supposed to be closer, and the higher zones more distant. In the left and center panels of his triptych, Bosch depicts three separate spheres of being or time zones, floating one above the other, separated from each other as if they were in separate worlds. Each area depicts different events. The lower zones are near, and the higher zones are more distant.

Although Bosch sometimes allows his figures to diminish a little in size as they recede into the distance, their size seldom diminishes in rigorous proportion to their distance from the viewer, as they would under the hand of a painter bound by the strict limitations of linear perspective. And there are many instances in Bosch's paintings when figures that are placed higher on the ground plane show no decrease in size relative to the figures in the lower part.

He also tends to place objects that resemble figures in shape and proportion in the deep background, and these anthropomorphic objects are often approximately the same size as the figures in the foreground. This minimizes the effect of diminishing size and tends to make the painting read like a flat plane. Bosch actually uses a modified version of medieval hierarchical perspective: he sometimes makes important images larger regardless of their distance from the viewer. The "alchemical man" is the most flagrant example.

It is Bosch's verbal approach to painting that demands this rising perspective and bird's-eye view. His many iconic signs require a large surface upon which they can be located. Each sign must occupy an area in the painting, and usually this area must be somewhere on the depicted ground plane; the only alternatives would be to either float the images in the sky or construct a multistoried architecture for the images, as Hogarth did in a later century (his method will be demonstrated in Chapter 6). Bosch's high vantage

point allows most of the painting to be covered with ground plane, which furnishes plenty of room for his many images. He conceives of each image as a sign carrying its own important message, and makes sure the viewer has an unobstructed view of each of these signs. That is why, in contrast to van Eyck, Bosch seldom allows one image to obscure another; doing so would conceal part of the sign and cloud some of its significance. Furthermore, when Bosch chooses to disregard the perspectival element of diminishing size as objects recede into the distance, it enables him to depict distant objects large enough to be easily recognizable; thus they retain their ability to signify.

In the *Adoration of the Lamb* panel, on the other hand, van Eyck depicted groups of saints crowded so close together that the only fully visible figures in each group are those in the front row. Just the heads are visible in the figures situated behind the front row, and in the more distant groups, only the tops of the heads are visible—like so many oranges on a platter. Van Eyck accepts this limitation because in an "all saints" painting the individual identity or significance of each figure is not germane to his message.

As Bryson has pointed out, painters who intend a primarily verbal impact tend to simplify images, while those who want more visual impact tend to cram images with more information than is necessary for verbal meaning. That information least necessary in signing paintings is usually perspectival information. Thus Bosch's focus on the verbal significance of his images compels him to grant less priority to perspective or the foreshortening of individual images. Simply put, less care and skill in rendering are required to depict standing images from eye level than to foreshorten them; and Bosch—with his consuming interest in allegory, aphorisms, and folk sayings—had little need to complicate the recognizability of his images with elaborate perspectives or foreshortening, just as many verbal postmodern painters do not find it necessary to stress the techniques of perspective or the academic rendering of figures.

But the construct of rising perspective and the folk humor of such artists as Bosch, Rabelais, Cervantes, and Shakespeare came to an end. With this ending Europe reached an important turning point. No other marker so clearly divides the Renaissance from the Enlightenment as the fact that educated audiences after the sixteenth century had little interest in, or ability to understand or appreciate, the humor of the carnival grotesque. What had once been hilarious became terrifying. And there was little evidence of any revitalization of this lost understanding until the advent of Duchamp and the postmodern.

5

Using Light as Sign and Sign as Space

Modern science—chemistry, physics, astronomy, and medicine—was conceived in the fourteenth century. It took embryonic shape during the fifteenth and sixteenth centuries, and it was born in the seventeenth, the unholy child of the ancient sacred sciences.

These newborn secular sciences inherited their empirical method from the ancient sacred sciences, and their efficient explanatory theses and demonstrations from medieval scholasticism. Customarily, modern historians have considered only those elements of thinking from the Middle Ages, the Renaissance, and the seventeenth century that they perceive as leading to eighteenth-century rationalism—as if the modern scientific revolution had leapt fully clad from the fiery bowels of alchemy. But such oversights contradict and disguise the facts. The process of severing the secular from the sacred sciences was a gradual one that extended over several centuries.

Mircea Eliade alerts us to the fact that traditional historians who search the ancient texts of sacred sciences for the primitive beginnings of modern chemistry, astronomy, and medicine assign exaggerated importance to their own two empirical priorities: observation and experimentation. They hunt for specific evidence of the modern "scientific method," methodically ignoring instances in which the alchemical or astrological point of view is valuable in itself (1962, 13).

In the twentieth century we see the evolution from alchemy and astrology to modern science as an inevitable and undisputed example of progress. We find it difficult to understand that to the alchemists and astrologers this evolution was a corruption: they saw their rigorous purifying spiritual discipline degenerating into a pragmatic science concerned with nothing more than worldly materialism.

When Copernicus's new model of a planetary system that orbited the sun finally began to be accepted during the seventeenth century, the sacred sciences were, of course, dealt a blow—but not a mortal one, by any means. Scientists such as Christian Huygens, Francis Bacon, Johann Kepler, and Galileo throughout the seventeenth century, and even Newton in the early eighteenth century, continued to practice astrology and alchemy quite zealously. Descartes himself was an alchemist and a pioneer in the mystic order of Rosicrucians (a spinoff from the philosophical and mystical aspects of alchemy); he was convinced that he owned both a Philosopher's Stone and a vial of *elixir vitae*, which he believed would assure him of a life span of 100 years.

The two leading seventeenth-century scientists, Christian Huygens and René Descartes, knew each other. Huygens was Dutch; Descartes was French. Each influenced the other, and their methods were in many ways similar. But they differed in one important element, and this element exemplified the basic difference in the constitution of their two cultures. While Descartes and southern Europe leaned heavily toward theory and abstraction, Huygens and northern Europe preferred a more mechanist and empiricist method. This difference between Huygens and Descartes, because it grew out of fundamental conflicts between the attitudes of North and South European cultures, also mirrors an important difference between van Eyck and Masaccio. And these conflicts had been obvious as early as the fourteenth century.

Descartes invented an elegant system that combined philosophical theory with natural science and focused on the nature of matter and space; and this system would become the foundation of both science and painting in Italy and France. He shunned observation and experiment because he believed human intelligence was sufficient to gain a satisfactory understanding of Nature through philosophy and reason. Driven by an interest in theory and abstraction, the culture of southern Europe encouraged Italian and French painters toward an approach that was also dominated by theory and abstraction. This theoretical and abstract approach eventually generated classical form—a theory of aesthetics and proportion that was well expressed in writing and organized by the abstract interrelated system of Renaissance perspectives.

Huygens began as a follower of Descartes. He wanted to combine the Cartesian (DesCartesian) belief that Nature had an ultimate design with Galileo's mathematical method. At first he sought only to correct Descartes's more glaring errors, but he ended as one of the most convincing of the many critics of the Cartesian method. These errors in Descartes's method have continued to plague writers from the seventeenth century through postmodernism, and Chapters 11 and 12 will focus on them more substantially.

Northern society in general was ambivalent toward the Cartesian method. On the one hand, the Netherlands was suspicious of Descartes's phi-

losophy because it was based on Aristotle, and Aristotelian philosophy was identified with the Jesuits and thus heavily opposed in Protestant lands. On the other hand, his method enjoyed some approval in the Netherlands because it offered a deterministic approach to celestial mechanics, and Protestants considered that a welcome alternative to Copernicus's mechanistic "Godless" method.[1]

During the last half of the seventeenth century, with every tick of the accurate new pendulum clocks, the relentless approach of the Enlightenment could be heard tapping down the avenue of Newton's recently invented linear time. Owing to proofs offered by mathematicians such as Galileo and Kepler, all Europe had finally come to accept the sun as the center of our solar system—more than sixty years after Copernicus first proposed the idea. Thus began the age of deterministic math-based logic and reality, led by Bacon, Kepler, Huygens, Descartes, and, later, Newton. Reason and mathematics ruled. Lurking quietly beneath this thin veneer of reason was a continuing interest in the irrational—alchemy and astrology were still heavily practiced by the best and the brightest—but the new light of reason promised to eradicate the remaining shadows of superstition, the sacred, and the irrational, even in the Netherlands. The practical philosophy of the Renaissance was replaced in the seventeenth century by Descartes's theoretical philosophy. Seventeenth-century philosophers granted hegemony to formal written proofs over oral rhetoric; universal principles over the particular; abstract theory over local history; and the permanence and timeless over the timely and the specific. Henceforth, the Renaissance consciousness which had spawned the humor of the carnival grotesque grew dim and faded into oblivion.

The revival of classical scholarship in the sixteenth century led to the rediscovery of the ancient Greek concept of atomism, the proposition that all matter is composed of smaller units called "atoms." This atomistic paradigm prompted a strong shift away from Aristotelian theory as well as the alchemical belief that all matter is composed of fire, water, earth, and air. Scientists began to question the literal—though not the figurative—concept of alchemical transmutation. The encyclopedic accumulation of chemical facts discovered by alchemists through the millennia began to be reinterpreted, and this generated the beginnings of modern chemistry. Alchemy's influence on the arts was at its weakest during the seventeenth and eighteenth centuries.

The seventeenth-century attitude toward the new rational approach to knowledge and understanding might be described as an excited but wary an-

[1]The seventeenth century was dominated by a struggle between two opposing views: the deterministic or teleological view that the universe was created according to some ultimate design—probably divine in origin—and the mechanistic conviction that everything in the universe is produced by matter in motion.

ticipation of the fulfillment of a promise that sounded perhaps too good to be true: Descartes's promise that human beings would discover all the knowledge of the universe within two generations. Still, the scientific leaders—including Descartes himself—hedged their bets, as evidenced by their reluctance to surrender the security of the sacred sciences and the old ways. Nothing better demonstrates this mixture of hope and apprehension than the seventeenth-century *sturm und drang* image of tenebrism, which dominated the painted image in both North and South Europe. Numerous painters—starting with Caravaggio in Italy and followed by Rembrandt in the Netherlands—depicted figures in dark interiors, made visible only by artificial light, usually a candle.

Figures were rendered visible and volumetric where they emerged into a dramatic and revealing light. But these painterly figures remained partially obscured by the ominous dark background, as if the light of reason had promised to reveal more of the world than it had yet been able to deliver, and people harbored a shapeless horror of what was now perceived as the dark ignorance of the past (the "Dark Ages"). Or was the horror inspired more by the logical terrors yet to be revealed by the harsh new mathematical light? Were they more apprehensive of the unpredictable new light, or the familiar darkness of the past? Rembrandt and many other Dutch painters even moved their dark scenes—with parts of images thrust forward into the revealing light—outside into the mysteries of the night to create "nocturnes," such as Gerrit van Honthorst's *Adoration of the Magi* (Figure 5.1).[2]

Seventeenth-century Dutch painters were expert at exploiting the effects of light to create an illusion of space, volume, and solidity in line with the new rational materialism. But some, such as Rembrandt and Gerrit van Honthorst, also used light to signify a divine luminosity in paintings like the *Adoration of the Shepherds* (Figure 5.2) and the *Adoration of the Magi*. This luminosity was intended to signify holiness or revelation.[3] Furthermore, the flatness of the luminous area denied such material aspects as physical volume and space, so these painters still managed to hang on to a powerful element of almost medieval spirituality.

Painters cannot create an illusion of both volume and luminosity in the same area of a painting. These two illusionistic images are binary oppo-

[2]Madlyn Kahr notes the earliest examples of these nocturnes were sixteenth-century Dutch, but the practice extended to northern Italy and was well developed in Holland by the seventeenth century (1978, 25).

[3]The image of light emanating from a luminous Christ was painted as early as the fifteenth century by painters such as Geertgen tot Sint Jans. Rembrandt also used a modified version of this luminous effect in *Night Watch* to represent the figure of someone remarkably similar to his wife—who is prominently, though apparently inappropriately, positioned in the middle of this commissioned portrait of the civic guardsmen. Perhaps this represents an old man's appreciation of a "divine" young wife.

FIGURE 5.1 Van Honthorst, Gerrit. *The Adoration of the Magi.* Oil on canvas (235 × 195 cm). Pitti Palace, Florence. Photo: Scala/Art Resource, NY.

sites—mutually exclusive. Hence painters are forced to choose one over the other. The illusion of volume demands strong dark-light contrast within the volumetric area, while a luminous effect requires the exclusion of darks from the entire luminous area. Though it may be surrounded by darkness, an area that appears to glow with its own interior light must be painted flat, in an overall light value (almost white), as if it were made of hollow, translucent plastic and lighted from within.

The lantern held by the three Wise Men on the right in Rembrandt's *Adoration* is obviously not the source of light in the painting. The Infant Jesus

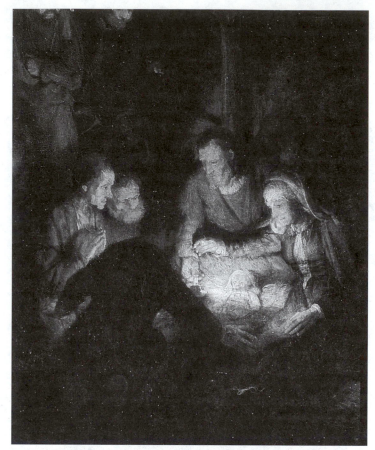

FIGURE 5.2 Rembrandt. *Adoration of the Shepherds* (1646). Oil on canvas (97 × 71.3 cm.). Alte Pinakothek, Munich. Photo: Giraudon/Art Resource, NY.

is the light source, and the other figures are lit by His divine light. The Infant is painted flat in high-key light colors all in the same value. Though the scene takes place at night, He is painted as if He were lit by the midday sun. If isolated from the obscuring dark that permeates the rest of the painting, the area occupied by the Infant and his swaddling clothes looks almost as if it could have been painted by Monet in his nineteenth-century examination of the image of sunlight on the surface of objects. Bright as sunlight, the light emanating from the Infant signifies the revealed truth of Jesus's holy countenance. Light as a metaphor for divinity originated with alchemy, but it had been so integrated into Christian iconology by the seventeenth century that it no longer necessarily indicated any intentional reference to the sacred science unless supported by more evidence.

The location of the Netherlands provided the Dutch with good harbors and positioned them to control trade between northern Europe and the Mediterranean countries. Madlyn Kahr notes that Holland then—like Europe and America now—was inundated with refugees and immigrants from many other countries. Amsterdam was one of the largest cities in Europe. While other European countries were centralizing power in order to form nation-states, Holland was governed by a decentralized government that tolerated differences, even in religion, and thus fostered a strong cultural diversity. Holland had enjoyed more than two hundred years of the most affluent society in the history of Europe, but Dutch affluence was drawing to an end. The country was in decline: it went to war with England three times during the seventeenth century; accumulated too much national debt; and expanded its empire beyond its ability to supervise.

Dutch painters did not depend on the nobility for patronage; they sold their work primarily to the diverse middle class. They were, in effect, painting commercially. Because members of the new Protestant sects believed they should read the Bible regularly, Dutch citizens as a whole were exceptionally literate. Religion, especially in its moral aspects, had a central function in the new Protestant literature and art. Madlyn Kahr tells us the Calvinist majority tolerated two apparently opposite views of the world: they believed all worldly life was evil, yet they nurtured a strong appreciation for the beauty of God's world.

In seventeenth-century Holland a strong interest in nearly all kinds of subject matter was generated by these three characteristics: a tolerance of pluralist points of view and cultural diversity; a tendency to make works for the general public; and an accommodation of paradox, such as the belief that worldly life was evil but the beauty of the world should be appreciated (1978, 8–10). Dutch painters produced religious paintings, history paintings, portraits, historical portraits, paintings of everyday life, landscapes, *vanitas* still lifes, and *vanitas* flower paintings. Many modern writers have come to believe that all these paintings are allegories, no matter how mundane the subject matter may appear at first glance. The constant wars and diseases, like restless maggots in the collective consciousness, generated an abiding awareness of death. In six months during 1635, for instance, the plague killed 14,582 citizens in the small city of Leiden alone; and Leiden became the center of *vanitas* painting.

The serious Protestant point of view left room for little more than an echo of the carnival grotesque humor. The transitory quality of human pleasures and the brevity of life were often signified in still life by such images as: spoiled fruit and fallen flower petals; empty seashells, depleted of their occupants, reminding the viewer that life must end; globes or maps warning that worldly things should be ignored; half-eaten fruit or bread cautioning viewers to avoid earthly pleasures in favor of spiritual nourishment; flowers from all seasons that could not be seen together in the real world, implying both the cyclical nature of the seasons and the transitoriness of all beauty.

In short, Dutch art constantly inspired in its viewers the fear of impending death; and when fear triumphs, there is little room for the carnival grotesque. Zirka Filipczak tells us that simple genre scenes—say, of a person sharpening a pen—that are almost photographically rendered are allegorical images that were understood by the linguistic community of contemporary viewers (1987, 7). Many typical images were morality polemics: ribald scenes of carousing and debauchery (the most obvious remaining image of the carnival grotesque) were intended as statements against the very life they depicted.

Alpers reminds us that because only North Europeans had accepted the distortions wrought by various lenses, the examination of the universe through a lens of one kind or another took place almost entirely in northern Europe. In southern Europe only Galileo is known to have used lenses. This Dutch interest in discovering the world through pictures and lenses was supported by parallel theories concerning knowledge and language. On a more practical level, the emphasis on picturing was supported by theories of education. Comenius, for example, believed students should be taught to discriminate one thing from another in order to name them (1983, 91–93). His argument consisted of two parts: since we store what we have seen in visual images, visual acuity is basic to education; and since language is a representation of all the things in the world, it is heavily dependent on visual images (95). The importance of visual images stored in memory would become an abiding influence on signing painters—including Hogarth, Gauguin, Burchfield, and Dubuffet—after the seventeenth century.

Alpers notes that, unlike the Italians, northerners did not believe art was a progressive tradition that advanced to higher and higher levels of achievement. In fact, most artistic traditions have emphasized what is stable and permanent in art, not what changes (1983, xxv). Consequently, like postmodern art—which encourages the tendency to appropriate elements from the work of others—Dutch art was highly eclectic: "Well-cooked turnips make good stew," is a well-known Dutch proverb (Alpers 1988, 74). Like the maker of a good stew, the maker of a good painting collected elements from the work of others and combined these elements so well that the borrowings could no longer be distinguished as separate parts, or "flavors."[4]

Within the unprecedented diversity of Dutch painting were some overall traits that generated an identifiably Dutch image. This similarity looks forward to Ludwig Wittgenstein's theory of "family resemblances," which I will explain more fully in Chapter 9. Like postmodern paintings, none of these

[4]We have recently determined that a host of paintings once attributed to Rembrandt were not painted by him after all. Alpers shows in detail that many Dutch artists painted very like Rembrandt—and often just as well: hence some of what were once considered his *best* paintings have recently been reattributed. The concept of the singular lone genius is giving ground to the concept of Rembrandt as the most "representative Dutch artist of the preclassical age" (1988, 44).

seventeenth-century Dutch paintings displays all the various features of painting of its time and place, but each exhibits enough characteristic features to be recognized as a member of the "family" of Dutch painting.

Protestant churches were not decorated with paintings, and in response to this lack of interest in religious art, Dutch painters concentrated on natural and human subjects. But the Dutch were religious, and they appreciated spiritual and moral messages if they were presented in the guise of everyday reality. This appreciation of the hidden message demonstrates the continuity of the allegorical spirit of Jan van Eyck more than two hundred years later.

The Dutch delight in images that carried more than one meaning is testified to by the popularity of Emblem books in Holland during the seventeenth century. The ideal emblem is a print or an illustration of an ordinary everyday subject. An adage, an aphorism, or a folk saying, often in rhyme, accompanies the scene; but the connection is seldom obvious until the viewer reads the additional accompanying text, which may be either prose or verse. These emblems demonstrate the same combination of visual image and writing found in the traditional Dutch art of van Eyck and Bosch, though in these artists' paintings every object was likely to have hidden meanings.[5] As these Emblem books were exported, they began to influence artists in other countries, particularly eighteenth-century English literary artists like William Hogarth.

Albert Blankert maintains that Jan Vermeer (1632–1675) was not an innovator in either style or concept. His eclectic style and subject matter were common among his contemporaries. He quickly appropriated the geometric unified compositions—featuring two or three figures—that were popular in Holland after 1650. He borrowed de Hooch's clarity and illusionistic pictorial space; and he learned his refined technique from van Mieris (1978, 60). Vermeer constructed a collaborative, well-designed image, simplified in composition, perhaps somewhat similar at the first glance of an unwary eye to the formal paradigm of Italian painters. But the simplified Italian clarity of image is fragmented by the more descriptive Vermeer into complexity by means of such devices as a multiplicity of objects and the elaborate patterns and details on fabrics and floors.

Vermeer painted *The Artist's Studio* (also called the *Art of Painting*, Figure 5.3) when both he and what some have called the "golden age" of Dutch painting were drawing to a close. This is the clearest example of *everyday* subject matter loaded with allegory that Vermeer ever painted. Like many contemporary Dutch painters, Vermeer is assumed to have gleaned the allegorical imagery and syntax from Cesare Ripa's *Iconologia*—a four-volume

[5]Alpers notes that word and image are combined in the Emblem books more the way Comenius used them in *Orbis Pictus*—like a picture language rather than an attempt to hide meaning (1983, 231).

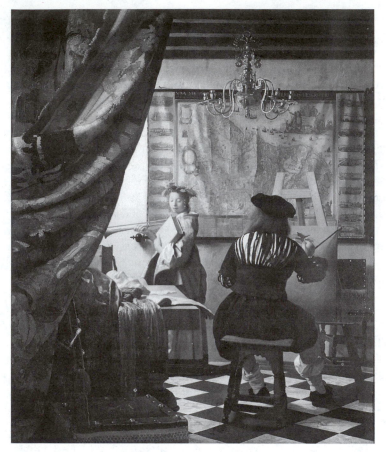

FIGURE 5.3 Vermeer, Johannes. *The Artist's Studio* (1662). Oil on canvas (51 1/8" × 43 3/4"). Vienna, Kunsthistorisches Museum. Photo: Foto Marburg/ Art Resource, NY.

work written by an uneducated court cook and caterer that had been available in Dutch translation since 1644.

Ripa arranged in alphabetical order each abstract noun, from *Amore* to *Vita,* and included a woodblock illustration of the allegorical figure (usually female) that represented each idea. Each word and illustration was allotted a page or two of text that explained the source and meaning of the figure and the implements accompanying it.

Ripa's work was so popular throughout Europe that it went through numerous reprintings in Italy, England, Germany, France, and Holland during the seventeenth and eighteenth centuries. The *Iconologia* was the primary source of allegorical imagery in European painting during these two centuries. Erna Mandowsky, in the "Introduction" to the 1970 Italian language reprint, notes that Ripa's volumes were a necessity for artists during this period: Lebrun, Annibale Carracci, Tiepolo, Bernini, Poussin, Boucher, and

Reynolds were all known to consult the *Iconologia* in their work. Johann Winckelmann goes so far as to call the *Iconologia* the "artist's Bible." So Ripa's books are a prerequisite to understanding the iconology of seventeenth-, eighteenth-, and even much nineteenth-century painting and sculpture.

The young woman who serves as the artist's model in Vermeer's painting wears a laurel wreath and holds a large book and a trumpet. George Richardson's 1779 two-volume reprint of Ripa's work (itself reprinted in 1979) tells us that the combination of laurel wreath, book, and trumpet show that the young woman represents Clio, the Muse of history ([1779] 1979, 1:43). Because laurel is evergreen, Ripa decided it should signify history's ability to perpetuate past events (1:43). The trumpet (which is also held by Ripa's figure of Praise [2:127]) represents the full-throated praise announcing celebrity and fame (2:127). The trumpet is also connected with Euterpe, the Muse of joy and pleasure; both emotions are generated by lyric poetry and music (1:43). Hence the trumpet in Vermeer's painting has been interpreted by some writers as a reference to poetry and music. The laurel wreath on the woman's head has sometimes been interpreted as a reference to Calliope, the Muse of heroic poetry, who holds laurel garlands in her hand in Ripa's work (1:46).

The objects on the table in *The Artist's Studio* may represent other Muses. The stack of books could be interpreted as an oblique reference to Polyhymnia, the Muse of rhetoric (Richardson 1979, 1:44). What looks like the plaster cast of a face suggests a mask, which could refer to the Muses of comedy and tragedy: Thalia, who carried a mask in her hand; and Melpomene, who was often represented beside masks (1:43–44). Or the sculptured mask could signify the imitation of painting, since Ripa indicated that the mask (like the ape) signified an imitation of human activities. Kahr mentions that the plaster cast of a face may also represent the art of sculpture (1978, 292).

Slatkes thinks that the brushes on the table may also signify imitation, and the tapestry-like drape near the picture plane at the upper left may be a reference to Pliny's well-known story of the painting competition between Zeuxis and Parrhasios (1981, 78).[6] The imported drape could also refer to Holland's affluence in the seventeenth century.[7]

[6]Two fifth-century B.C. Greek painters competed to see who could paint the most realistic painting. Zeuxis pulled back the drapery that covered his painting of grapes, and they were so lifelike that birds flew down and tried to eat them. Confident that he had won the contest, he asked Parrhasios to pull back the drapery from his painting, only to be told the drapes *were* the painting. Even Zeuxis agreed that Parrhasios won the contest because he had fooled, not dumb birds, but his fellow painter.

[7]Bryson notes that luxury goods were more in demand in the Netherlands than in any other European country. Amsterdam shops were flooded with: "*Persian rugs,* Chinese porcelain, Japanese Lacquer, Venetian glass, Spanish taffeta, Italian maiolica [emphasis mine]" (1990, 110).

The seated painter is not depicted in contemporary seventeenth-century clothes. His costume is an older "antique" style called "Burgundian." The Burgundian style of dress was common in Dutch paintings of this period, and immediately alerts the viewer that the painting is probably an allegory since this clothing style often refers to some form of classical subject matter (Filipczak 1987, 67). The painter represented in the painting is in the act of painting an image of the Muse of history, who is, in turn, inspiring the painter.

Kahr maintains that Vermeer considered himself a history painter, and she says that the trumpet signifies that history painters were more noble than painters of a lesser Muse; therefore history herself would eventually trumpet their praises (1978, 292). But Alpers does not believe this is a persuasive interpretation because we "do not think of Vermeer as a history painter" (1983, 166). She contends instead that Vermeer depicted Clio as raising her trumpet to praise Dutch *descriptive* painting (1983, 166), as history has indeed done.

The position of the two people in the painting, and the direction in which they are facing, might also be read as significant. The woman faces the man; the world she can see (or has access to) is the tame and limited microcosmic domestic space of the small interior, suggesting perhaps that this is the proper world for women. Her gaze is directed at the table inside this small room. She faces away from both the map and the world that must be visible through the window that is implied by the strong entering light. Thus the outside world is beyond her scope of vision, suggesting that women are not (should not be?) free to wander the seventeenth-century macrocosmic exterior world.

The man faces away from the viewer, who sees only his back, implying that in some sense he is not entirely present. The world outside the window, as well as the map, are directly within his visual scope. In light of the fact that Holland was a merchant nation, a nation of travelers, it is reasonable to assume that Vermeer is here advocating man's role as explorer of the larger world. Thus Vermeer sanctions (consciously or unconsciously) seventeenth-century sentiments regarding the assigned roles for men and women.

The large map depicted on the back wall has also generated a host of possible interpretations connected to painting. Vermeer depicts it as signed by Nicloaus Piscator, the Latin name of two famous cartographers from Amsterdam, but he also places his own name on it: "I [for Jan] Vermeer." Alpers notes that Vermeer identified himself with map-making in other paintings. For instance, the only two male figures he allowed to occupy an entire painting alone—*The Astronomer* and *The Geographer*—were by profession makers of maps; between them, they encompassed heaven and earth. Map-makers were often referred to as "world describers," which echoes the Dutch painters' penchant for describing the world around them (1983, 122).

Earlier painters had used the image of a globe to signify worldly concerns, but seventeenth-century painters began to use maps to signify the *van-*

itas theme that worldly pleasures should be ignored in favor of thoughts of the eternal (Kahr 1978, 281). Blankert explains that this particular map shows the seventeen provinces of the Netherlands as they had been almost two hundred years earlier, when still part of the Habsburg Empire. The Netherlands had later been partitioned into two separate countries—Protestant Holland and Catholic Belgium—but artists and scientists refused to recognize this partitioning: Huygens, for instance referred to people in both countries as "fellow Netherlandish countrymen." Hence the map may refer to the fame of Dutch painting, past and present (1978, 48); it might also advocate the reunification of the Netherlands.

The map may also indicate a nostalgia for the old days before the political division, or even pride in the maritime prowess of the United Provinces. Kahr notes that its exact appearance is carefully and expertly depicted, with folds and cracks to indicate its age, perhaps suggesting a reverence for the past (echoing the presence of Clio, the Muse of history).

Northern painters had, in fact, painted maps since the time of Jan van Eyck, and many painters (Bruegel is the best example) constructed elaborate ground planes that were very maplike. There has probably never been another time or place where the relationship between painting and map-making was so clearly evident. Alpers attributes this to the common belief that knowledge was both acquired and disseminated through pictures and a shared interest in the micro- and the macrocosmic investigation of the world (1983, 11): drawing a map is the polar opposite of drawing a fly. In fact, both the microscope and the map render visible things that are otherwise invisible (133), in the best spirit of the Middle Ages.

Northern artists and map-makers shared the perception that a picture was a surface upon which they could depict the world rather than "a stage for significant human actions," which was the Italian model (Alpers 1983, 137). Both painters and map-makers customarily created images for the printed page, and both commonly used inscriptions, labels, even calligraphy. Thus the two disciplines were related through their interest in picturing the world, as well as through their interest in supplementing their descriptive pictures with writing (136). In short, maps and Dutch paintings are iconic images of the world. Each resembles a particular aspect of what it signifies, and each combines image with writing and stimulates further visual images in the imaginative mind to supplement the iconic image.

Both a painting and a map are iconic signs for space. But the space signified by the map is by no means illusionistic, nor does it usually signify depth. A map is a surrogate for a flat macrocosmic space. Vermeer uses the map to signify one kind of space, and he uses Viator's perspective to signify another. Pictorial space—illusion—is created by the following devices in *The Artist's Studio*: the checkerboard squares on the floor and the perspective of the table; the diminishing size of the figures (the seated artist is taller than the standing woman in the background); and the diminishing size of the furni-

ture (the seat of the chair in the left corner is almost twice the size of the seat on the artist's stool). This pictorial space is near-photographic and caresses the details at a microcosmic level. The near-photographic depth is an illusion and can, under some circumstances, fool the eye into mistaking it for an event in the real world.

Thus, in the spirit of van Eyck and Huygens, Vermeer combines in one painting a micro- and a macrocosmic representation of his world. Vermeer's painting of the map is also a painting of a painting. Furthermore, the original map itself is flat, allowing Vermeer to juxtapose two entirely different treatments of pictorial space within the same painting. The pictorial space surrounding the map is an illusion of depth, while the map, both the original and its painted image, is, and appears, flat.

Vermeer's painting and a few others, such as Wallerant Vaillant's *Letter Rack* (1658), are early examples of works in which artists represented flat images in order to hold the illusion of a large area, the painting itself, flat. Later, as the flat picture plane became a paramount concern in modern art, several artists would use this illusionistic device to flatten the image of the entire painting. Three of many possible examples are: Monet's paintings of the near-flat façade of Rheims Cathedral; Jasper John's paintings of signs (numbers, letters, and maps); and the photorealist paintings of flat photographs. The photorealists' images are illusionistically and spatially complicated because they purposely selected a flat image that itself contained additional illusions of depth (some seen through a transparent surface, some reflected in lustered surfaces, and some seen directly).

Maps, our sign systems for macrocosmic space, are just as responsible for our image of the world as any other signed or pictured information. The world as a whole is more familiar to us in the form of a map than as real experience. Furthermore, maps, like paintings and photographs, attempt to persuade an audience to see the world in a particular manner. Paintings are convincing in one way, while photographs and maps are convincing in another. Maps and photographs often convince more efficiently than paintings because they appear to be objective.

In his history of map-making, John Wilford quotes John Glenn saying as he was finishing his orbit around the Earth in 1962: "I can see the whole state of Florida just laid out like on a map" (1981, ix). Wilford notes that the early astronauts, and later the audience who saw the photographs from space, were amazed that the real Florida peninsula, the wandering Mississippi River, the British Isles, and the boot of Italy looked precisely like the images in the maps they had grown up with. They had taken it for granted that maps were faithful reproductions of a geographic reality, but still they were amazed that "reality turned out to be true to the maps" (1981, ix–x). We all have etched in our minds amazingly accurate images of entire countries—even the whole world—and we have acquired these accurate images from maps.

While Alpers insists that the primary characteristic of Dutch painting is its propensity to describe, she notes that E. de Jongh maintains that the meticulous description in Dutch painting is merely intended to disguise allegorical meaning (1983, 229). The fact that two such polarized arguments can both seem reasonable shows that seventeenth-century painting is another important exception to Bryson's contention that the more detailed and realistic a painted image, the less it tends to signify, and vice versa. Vermeer and a host of his contemporaries executed near-flawless, almost-photographic realism, yet their work is loaded with hidden signs that are organized in an elaborate grammar to signify complex allegorical arguments.

6

Social Commentary

The rational spirit of the Enlightenment engulfed Western Europe during the eighteenth century. Newton's math-based reality became society's reality. The new logic and reason appeared to be so self-evidently true that, like Renaissance perspective in an earlier era, they seemed to be the only possible avenue to truth. Therefore Europeans assumed that their newly discovered reason must be a universal perception, and this is precisely the attitude that poststructuralists denounce. But occasionally in the eighteenth century, the faint supplementing voice of the irrational could be heard above the din of reason. After all, Newton himself was a serious alchemist and astrologer: he wrote 650,000 words on alchemy alone.

Newton demonstrated his understanding of the limitations that our languages impose in a manner that would do any postmodernist proud. Realizing that no single notational system was capable of expressing the order of the universe, Robert Markley tells us, he invented a strategy of supplementary languages (1991, 134). He added theology, chronology, history, optics, astrology, and alchemy to his basic mathematical approach, and discovered through his complex use of these supplemental semiotic systems that "mathematical order was not a closed system of representation but a provisional inquiry that, by its very nature, can never be finalized" (137).

When Newton could not find a language to fit his purpose, he invented a new one. For instance, when he needed a better vehicle to explore the effects of gravity, he invented calculus. And, perhaps anticipating Heisenberg's uncertainty principle, or even chaos theory, Newton discovered that as his method grew more complex, it also became less stable. The philosophical and mystical forces of alchemy began to retrench and reform under the banner of the Rose-Croix: Rosicrucianism.

When two countries engage each other in war, one of the permanent results of that warfare is cross-cultural influence. Both the victor and the vanquished learn, and are compelled to assimilate, the ideas and customs of the other. For instance, both Europe and the Middle East were permanently changed by the exchange of information and customs during the Crusades in the Middle Ages; and the United States and Japan also permanently influenced each other after World War II.

Similarly, the wars between Holland and England during the seventeenth century generated a lively exchange of ideas and images between these two countries—which had always had more in common than is often realized. The English, Dutch, and Frisian (Friesland is now a province in Holland) languages had split off from the same Germanic source less than a thousand years earlier. The connection between Frisian and English is so close, in fact, that some linguists believe there may have once been an Anglo-Frisian dialect. Furthermore, both cultures preferred the empirical approach to both painting and science. The Dutch had been heavily influenced by Francis Bacon's empirical arguments and instructions, and, in return, English art reflected the influence of Dutch moral allegories as well as the system of signs in the Emblem books that flooded into England. By the eighteenth century, this influence was obvious in English painting, especially in the work of Hogarth. Moshe Barasch tells us that eighteenth-century Italy, the homeland of classical art theory, was a captive of its own glorious past. France was still under the sway of the Academy and had little new to offer. Most of the important art theory of the period came from England and Holland (1990, 53).[1]

William Hogarth (1697–1732) was one of the first major painters of social commentary; he, and Daumier in the nineteenth century, are still the two painters who immediately come to mind when such painting is mentioned. Like Newton, Hogarth brought as many different languages to bear on his system as he could imagine. He appropriated Charles Le Brun's physiognomy of facial and figural gestures. No one before Hogarth had captured the pursed-lip condescension; the comedy of a disdainful noble looking as if he had just sniffed an unusually large pinch of snuff; the silly, effete look of the sissy young noble; or the painfully debauched appearance of men and women on the alcoholic slide to ruin. This exaggeration of facial gesture that was employed to indicate character, often in a humorous vein, was called "grimace" in the eighteenth and nineteenth centuries. Daumier is definitely the father of political cartooning, but Hogarth must be considered the grandfather.

[1]The two books that best represented the prevailing thought of the early-eighteenth-century painter were: *Het Groot Schilderboek* by the Dutch painter Gérard de Lairesse's and *Essay on the Theory of Painting* by the English painter Jonathan Richardson (Barasch 1990, 55). Hogarth's *The Analysis of Beauty* would become an important book later in the century.

In addition to Le Brun's facial gestures, Hogarth borrowed numerous aspects of the system of signs used in Dutch prints and paintings, as well as many ideas from Dutch Emblem books. He had been apprenticed to a print-maker, and he made strong use of his early training in the elaborate significance of images from the "monsters of Heraldry." The writer who knows Hogarth best, Ronald Paulson, notes that the first English edition of Cesare Ripa's *Iconologia* came out in 1709, and Hogarth, like other artists of his day, used it as a standard lexicon (1975, 15). This "primitive linguistic system" with its "elementary syntax" was "addressed to orators, poets, painters, and sculptors," but Ripa's allegories were familiar to educated audiences as well as to artists (14). His semantics and syntax dominated the literary and the visual arts at the beginning of the eighteenth century.

Second only to Cesare Ripa's volumes in influence throughout Europe was the Emblem book by Andreas Alciatus first published in 1531; Hogarth must have been familiar with it.[2] Hogarth combined elements from all these signing systems with the spatial structure of the Dutch high-horizon line and extensive ground plane. He also used the complex Dutch arrangement of multiple figures and groups of figures. Out of all these elements he created his own complex personal language of visual signs.

Since the primary thrust of Hogarth's painting is verbal, he has often been compared with writers rather than painters. David Bindman says that in the eighteenth century Hogarth was regarded as a great humorist, second only to Shakespeare, and that his prints record a view of his era that compares with Shakespeare's picture of Elizabethan England (1981, 7). Hogarth influenced English writers from Fielding to Dickens, and he was also a powerful influence on the nineteenth-century literary painters in England. He has been called the "Father of British Painting."

Paulson points out that English painting in the eighteenth and nineteenth centuries was more a branch of literature than of art. Hogarth himself signified this in his self-portrait that hangs in the Tate Gallery: he depicted his palette resting on a pile of books by Shakespeare, Milton, and Swift (1982, 3–4). He was, in fact, far more familiar with Shakespeare than with the paintings of the old masters, and "the word and the concept were privileged in various ways over the image in [Hogarth's] act of painting" (4).

Thus Hogarth demands to be judged primarily by literary standards. Like many other signing painters, he has seldom commanded respect as a retinal painter. Paulson notes that his painting and engraving techniques are merely adequate vehicles to communicate his verbal ideas (1982, 7). If his works are judged solely against the retinal paintings of continental contemporaries such as Chardin and Tiepolo, Hogarth will seem little more than a

[2]Alciatus's book of Emblems has been reprinted many times in different languages over the last four and a half centuries. The latest printing was in 1985.

second-rate provincial; but if they are measured against *both* the art and the literature produced on the Continent during the eighteenth century, "he will rank very high indeed" (3). In fact, Paulson tells us, the English tradition of literary painting opened with Hogarth, "the first artist of English descent to achieve an international reputation" (5).

The tendency to deemphasize the retinal properties of painting is a common trait among signing painters and serves as a reliable indication of their priorities. (Recall Bryson's contention that the rendering of detail and perspective is inversely related to the verbal significance of the images.) Paulson tells us Hogarth had worked out a notational system that allowed him to capture the basic form of a scene in a few strokes of "linear short-hand," which he associated with an alphabet (1991, 43). When a friend asked him about something he had seen him draw on his thumbnail, Hogarth showed him a whimsical likeness of a person some distance away. The technique was a mnemonic device, and in his own written account of his life, Hogarth stresses the importance of memory (43). He wrote that he retained in his "mind's eye" a linear impression of objects that interested him. He drew and painted a collection of retained visual images, which he could summon up whenever he needed them (46).

In his apprenticeship to a printmaker, Hogarth had been trained to copy images from French pattern books, which offered almost every imaginable design. His familiarity with these images gave him a fluent understanding of mythological subjects, iconology, and allegory. Explaining his interest in this direction, he wrote: "It is a pleasing labour of the mind to solve the most difficult problems; allegories and riddles . . . afford the mind amusement" ([1753] 1974, 24). In addition to the sources previously mentioned, Hogarth was heavily influenced by Dutch engravings of fairs and partying carousers (Paulson 1991, 49–51).

Hogarth's paintings are a fictionalized version of contemporary events. He often depicts a series of scenes that show a change from one state to another in the principal characters: from wealthy to poor; from powerful to powerless; from healthy to sick; from respected to despised; and so forth. For instance, the sniviling teenaged bride in the first painting of one series has become a sensual woman in the second painting. This change from one state to another is the classic intent of narrative, but Hogarth's narrative was exceedingly complex and elaborate. He often used a series of six or more prints or paintings to tell a story through an elaborate system of signs that functioned on multiple levels. Consequently, the narratives he produced should not be confused with the simpler focused and immediate narrative of Italian Renaissance painters.

Hogarth's system is so elaborate and functions on so many separate levels that it can also be classified in many other categories—all of them more commonly discussed in reference to writers than to painters. He moralized so heavily against such behaviors as pretense, hypocrisy, infidelity, and irre-

sponsibility that his painting often functions editorially as well as allegorically. And, like medieval, Dutch, and postmodern painting, his work is often apocalyptic.

Though Hogarth, like his contemporaries, was surely familiar with Ripa's *Iconologia,* he did not, like other painters, employ it as a "closed" system. Paulson explains that modern linguistic theory distinguishes between closed and open systems. Closed systems are those that allow for a relatively small set of prearranged messages (1975, 35). Most other animal species communicate through a closed linguistic system. Gibbons, for instance, have approximately twenty-five separate calls, and a recording of any of these calls elicits the same response from other gibbons each time it is played. This is an example of a closed system: all the meanings are prearranged, and signs cannot be combined to create new meanings.

However, Roger Fouts tells me he has taught Washoe (the first signing chimpanzee, who lives just across the street from the art building where I teach) approximately 240 root signs in American Sign Language—with potential for many more meanings when modified by inflection. Washoe is able to generate new terms and new sentences, which she has not previously heard. I will cite one simple illustration of many possible examples: when Washoe saw her first duck floating on the water, she had no sign for it, so she combined two signs and named it "water bird." This is an example of an open system of communication—one that can adapt to new situations. Linguistic theorists have shown that the individual's ability to combine signs in a creative, open-ended manner to create new sentences with new meanings is the primary characteristic of human language.

Hogarth used the standard iconology from history painting to establish just such an open system of communication. Paulson explains that the entire closed system of iconography and rigid structure of genres had become tiresome, especially in England, where indigenous artists were content to repeat at second and third hand the orchestrations of signs they copied from painters on the Continent. As early as the first decade of the eighteenth century, a significant journal, *The Spectator,* had called for a rejection of the old iconography "of Greek gods and heroes and their pursuit of nymphs" and urged artists to develop a more relevant and contemporary approach (1975, 36). Hogarth did just that: he combined current subject matter with the established iconography of history painting to fulfill *The Spectator's* recommendation (36).

One of Hogarth's best known painting series is the six paintings—later made into prints—titled *Marriage à la Mode,* which tell the story of a contracted marriage between the son of an Earl, who needed money, and the daughter of an Alderman, who had money and wanted a title. The story continues through the death of the old Earl and (because of flaws in the two families, which are subtly signified in the first painting) ends with the death of the two married partners, as well as the death of the lawyer who arranged the ill-fated affair. Of the five original principals, only one, the father of the bride,

is left alive at the end of the tale. Such series, told in separate pictorial frames, may be seen as a harbinger of comic strips and graphic novels (straightforward combinations of graphic images and written dialogue).

Hogarth wrote that actions could be defined in painting by "a sort of language" that might "come to be taught by a kind of grammar rules" (from Cowley 1983, 22). In fact, Hogarth's writings indicate that his concerns in painting were far more linguistic than retinal. His involvement in freemasonry had added to his knowledge of esoteric signs, and he was so literate in signs, emblems, and myth that his references to any event, like Bosch's, extended far deeper than the obvious subject matter into multiple levels of allegory (23).

For example, Hogarth expected his viewers to recognize parallels between his work and Callot's prints titled *Misère de la Guerre* in the same way that Alexander Pope expected his readers to recognize in *The Rape of the Lock* parallels with the *Iliad* and *Paradise Lost* (Paulson 1991, 71). He was constantly disappointed that only a few viewers were capable of finding the invisible within the visible in his work. Unfortunately, time has rendered his nuances even less comprehensible (Cowley 1983, 23).

The tragedy that unfolds in the *Marriage à la Mode* series can be briefly summarized as follows. The first painting, *Signing the Contract* (Figure 6.1),

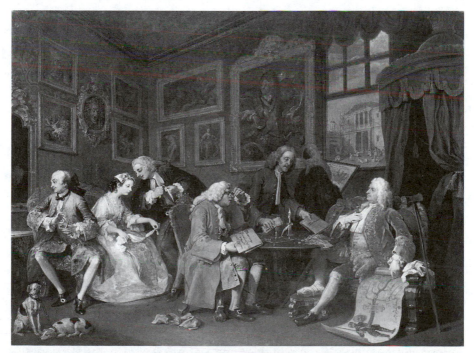

FIGURE 6.1 Hogarth, William. *Marriage à la Mode: Signing the Contract* (ca. 1743–45). Oil on canvas (28″ × 35 7/8″). National Gallery, London. Reproduced by courtesy of the Trustees.

shows the bored young couple on the left; the lawyer who will eventually se-
duce the young wife whispers in her ear; next is the overdressed Alderman
(father of the bride to be); then the second lawyer; and finally the grand fig-
ure of the Earl.

The second picture shows the couple in their own rooms and indicates
that the husband has been out all night while his wife spent her evening at a
card party. Robert Cowley, who has devoted an entire book to the six paint-
ings in the *Marriage à la Mode* series, interprets each sign and emblem in the
paintings as rendering infinite narrative detail and complex allegory. He
notes that the second picture hints at the husband's future adultery and
shows the protagonists, wearied by their night's activities, hardly aware of
each other's subterfuge and surrounded by rude servants (1983, 80).

The third picture shows the young Viscount taking a young woman to
a quack doctor. This is probably at least his second visit because he seems to
be complaining that the pills are useless.

The fourth painting indicates that the Earl has died, and the new Earl
and his Countess now have a baby. The painting demonstrates that they ne-
glect the child and have begun to spend heavily. Cowley notes that the lawyer
is present again, attempting to lead the Countess into adultery (1983, 120).

In the fifth painting in the series, the cuckolded young Earl has caught
his Countess in a rented room and forced the lawyer into a duel to avenge his
adultery. Inept at dueling, as at everything else, the Earl is depicted as mor-
tally wounded by the lawyer, who, Cowley notes, is so inexperienced that he
killed his adversary rather than maiming him in the customary manner. As
the landlord and the constable burst into the room, the lawyer tries vainly to
escape through a window, which is too high off the ground. Rather than il-
lustrating each event in simultaneous narrative, as Masaccio did in *The
Tribute Money*, this picture offers all the evidence necessary to reconstruct
three sequential events (1983, 124).

Instead of limiting his language to iconic signs, Hogarth makes use of
the less common indexical sign. What may be called "evidence" is often an
indexical sign. The blood on the Earl's shirt, for instance, indicates (was
caused by, or offers evidence of) the earlier sword thrust. The indexical sign
demonstrates cause and effect—that is, the indexical sign is caused by that
which it indicates. A footprint in the mud may indicate that a person or an
animal has passed that way. Thus a simple drawing of a bear paw print may
serve as an indexical sign for "bear," as a bloody shirt may indicate violence.

In the sixth picture, the Countess has just committed suicide after learn-
ing that her lover, the lawyer, has been executed.

Such a brief summary offers absolutely no hint of the complexity of
Hogarth's system of signs. He fills each painting with elaborate evidence and
allegory, signifying and compressing events in the past, present, and future
into one image. Subtly interpreted, each painting hints at the events de-
scribed by the others. Each painting thus features self-referential images—
more a writer's than a painter's device. Hogarth wrote that his work was de-

signed as a series and had "something of that kind of connection that the pages of a book have" (from Cowley 1983, 1).[3] Perhaps a partial description of Cowley's translation of the signs related to just one figure, the old Earl, in the first painting will give some indication of the pervasive and significant van Eyckian detail that Hogarth employed.

Cowley explains that the first picture signifies a future conflict imposed on two unwilling participants by fathers from two different levels of society—levels that are normally hostile to each other. The wealthy Alderman, father of the future bride, brings his own lawyer, who will eventually seduce the daughter to break the contract he was hired to negotiate. He is to be the principal agent of the catastrophe—the wife's seducer and the husband's hapless assassin. Irresponsible pleasure seeking, which is signified at many levels in the first painting, will bring on the eventual downfall. Weakness of mind and flesh, combined with the old-fashioned attitudes of the old Earl, will influence and dictate future events (1983, 53).

The grand old Earl sits on the right of the painting in a double seat large enough to hold two people; in fact, one just like it does hold both the prospective bride and the groom on the left side of the painting. The Earl assumes a regal posture, with his gouty foot propped prominently on a stool. His right hand rests lightly on his chest, as actors then were taught to do when affecting an air of self-importance. The little finger of that right hand is bent, which indicates high birth and also exhibits the signet ring that will be used to seal the contract (Cowley 1983, 27).

Remember, Hogarth was heavily influenced by the ideas of Le Brun, the seventeenth-century French painter, about physiognomy. Hogarth found it reasonable that "the natural and unaffected movements of the muscles, caused by the passions of the mind" might in "some measure" shape an adult's face and thus indicate character; in fact, he wrote, an entire language must be "written therein" (from Cowley 1983, 22). Bryson explains that by the eighteenth century French painters had developed Le Brun's ideas into a lexicon of gestures—involving the position and shape of body, hands, nostrils, mouth, eyes, brows, even the pupils and the state of the veins—so elaborately detailed that our ability to read the language of the human body in these paintings has almost been lost (1981, 49–52).[4]

[3]Hogarth also regarded himself as an author and used the term "to invent" at a time when "inventor" could mean a novelist as well as an artist or innovator (Cowley 1983, 1).

[4]Speaking in Paris, Lebrun explained the depiction of "Anger": "When anger takes possession of the soul, he who experiences this emotion has red and inflamed eyes, a wandering and sparkling pupil, both eyebrows now lowered, now raised, the forehead deeply creased, creases between the eyes, wide-open nostrils, lips pressed tightly together, and the lower lip pushed up over the upper, leaving the corners of the mouth a little open to form a cruel and disdainful laugh. He seems to grind his teeth, his mouth fills with saliva, his face is swollen, pale in spots and inflamed in others the veins of his temples and forehead and neck are swollen and protruding . . ." (from Holt 1958, 163).

To indicate the Earl's pride in his ancestry, Hogarth shows him pointing with his left hand to his family tree. Note that the tree in the scroll is shown growing out of the *belly* of his ancestor, William the Conqueror. Perhaps this hints at the genetic source of the Earl's obvious gluttony. Hogarth plays on the theme of flawed magnificence throughout the series, and the family tree demonstrates one source of these flaws (Cowley 1983, 28).

From the branches of the family tree hang twenty fruits with coronets (small crowns that signify nobility). The Earl's index finger rests near an uncrowned fruit on the main branch to indicate his son's direct noble lineage. Though this is the first time a direct descendant has been required to marry beneath himself, the broken branch on one side of the tree does indicate some connection to a family of obscure descent. The top of the chart is still partly rolled, implying that the lineage is nearing an end; and the story Hogarth tells in later paintings of the series will prove this to be true. (Cowley 1983, 28).

The Earl's red velvet coat trimmed in gold lace and his elaborately fringed waistcoat were considered slightly old-fashioned at that time, and the too-long cravat as well as the "full-bottomed" wig are about ten years behind the times. Still, the dated wig lends the Earl an air of shrewdness and dignity (Cowley 1983, 27), though this is qualified by the gouty foot. Gout was common among prosperous males in the eighteenth century and thought to be caused by gluttony and sexual excesses: thus Hogarth draws immediate attention to flawed magnificence and indicates a family penchant for sensuality that will drive future events in the series.

Even the Earl's crutches are stamped with coronets—as if he is perversely proud of his gout as a disease worthy of his station—implying that perhaps the earldom itself is crippled (Cowley 1983, 28). The idea that the earldom is crippled will surface again in the image of the grandson and heir. Mikhail Bakhtin notes that gout, like syphilis, was essentially connected with the lower body areas, and the image of gout was widely represented in the carnival grotesque (1968, 161). There are many similarities between the images of Bosch and Hogarth: the orgy scene in the brothel in *The Rake's Progress*, for example, is loaded with dirty jokes.

The Earl's display of French medals—the order of the Golden Fleece and the *Saint Esprit*—indicate his vanity and hypocrisy: no Englishman had been awarded these orders of chivalry in the previous decades, so the Earl is claiming honors he has not earned (Cowley 1983, 42). Though at first the old Earl seems impressive in appearance, Hogarth is offering subtle evidence that he is a hollow braggart and liar.

Through the window behind the Earl can be seen a courtyard, which is dominated by the façade of an ineptly designed building in the Palladian style of the Roman revival: four Ionic pillars rest on three Corinthian pillars, which echoes the comic inversion of good sense that reverberates through the rest of the series. The building is supported by scaffolding, indicating that it, like the Earl, is flawed, merely propped up. The Earl's servants in yellow liv-

ery dawdle in the courtyard, signifying the Earl's poor credit and need of the Alderman's money (Cowley 1983, 30).

Though his skinny son, the sissy Viscount, physically appears to have little in common with the Earl, there are subtle indications of shared weaknesses. For instance, the father's dignity is tainted by a gouty foot, his son's by a large plaster bandage on the neck. Cowley thinks this plaster probably indicates scrofula, a tuberculosis that attacks the lymph glands in the neck. He notes that Hogarth's contemporaries, who had little understanding of the etiology of diseases, would read this as a sign of congenital veneral disease (1983, 40).

The character of the Earl is as fully developed and psychologically complex as a participant who appears only once in a narrative could be: this handsome, dignified, noble gentleman becomes, upon close reading, a boasting, self-indulgent, arrogant, sensual spendthrift (Cowley 1983, 31). But these subtleties are discovered only through a patient study of detail: Hogarth's painting hides the invisible behind the visible as deftly as any medieval or Dutch painter.

The top two-thirds of the left side of the painting are dominated by ten paintings from the Earl's collection. The content of these pictures indicates the Earl's sexual preoccupations (Cowley 1983, 49). Each painting (though slightly changed from the original) is also recognizable as an example of what Hogarth called the "historical sublime." Each painting functions as a complex allegorical supplement that not only relates to the present scene but also portends future events (42). In each painting in *Marriage à La Mode* Hogarth's compression of past, present, and future is reminiscent of the postmodern tendency, particularly among writers, to imply cyclical rather than linear time through the same device: the compression (or refusal to separate) past, present, and future.

Hogarth's print *Southwark Fair* (Figure 6.2), clearly demonstrates the influence that Dutch prints depicting fairs and debauchery had on him. It shows a collection of actors, acrobats, showmen, prizefighters, and so forth trying to convince passers-by to enter their booth or tavern to see a performance. These advertised attractions, along with the leading stage company productions, compete with peepshows (lower right) and Punch and Judy shows for the spectator's attention. Most of the specific scenes allude to contemporary entertainments and theater personalities.

Many of the scenes dwell on "falls," both literal and figurative. Some obvious examples are: The top center is dominated by a sign advertising *The Fall of Troy*. Slightly to the right is a sign showing Adam and Eve and the serpent. Above that sign a man is falling from the crenelated tower. To the right of the Troy sign is a slack-rope walker in danger of falling. In the center, just to the left of the peepshow, a make-believe Roman emperor falls into the clutches of a real English bailiff. On the far left, the actors hawking the *Fall of Bajazet* suffer a literal fall onto a china shop as their stage collapses.

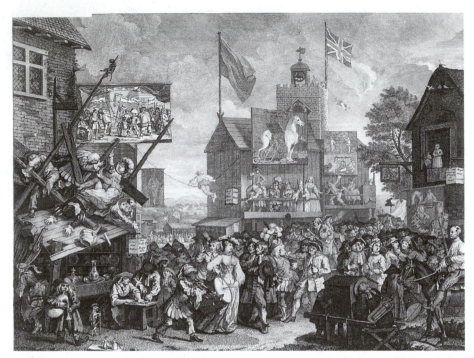

FIGURE 6.2 Hogarth, William. *Southwark Fair* (13 1/2″ × 17 13/16″). Etching and engraving. Copyright British Museum.

Every image in the print can be interpreted as a sign for something beyond the obvious image itself. The trained dog in the lower left might be read as a variation of the Dutch dog sitting on its haunches; the Dutch depicted such dogs as an allegorical reference to education and the training of well-bred children. The two small puppets controlled by the left foot of the musician (who is playing a strange bagpipe that might have been taken right out of Bosch) could be an extension of this educational allegory, or they could be a reference to the way people are manipulated. Remember, Bosch used the bagpipe to represent the urinary tract, sex, human depravity, and the Devil—all of which are in agreement with Hogarth's message here. Climbing a pole in the upper left corner is another traditional sign of the biblical Fall, a monkey. Panofsky notes that the monkey signifies the undesirable qualities in human beings that led to the original Fall (1953, 133). Richardson's eighteenth-century English revision of Cesare Ripa's book also holds the monkey as a sign of impudence, lasciviousness, and indecency (1979, 1:80, 2:114).

It is a reasonable assumption that Hogarth developed his cluttered picture from the Dutch prints he knew so well. Though he seldom positioned a vanishing point near the top of his prints and paintings, as van Eyck and Bosch had, he often placed the horizon near or above the center; and this afforded him ample room in which to arrange his multiple figures and objects

on a ground plane. Hogarth augmented the capacity of his ground plane in exterior scenes like *Southwark Fair* by utilizing three- or four-storied buildings to stack his images in multiple layers. He placed figures on the towers and balconies, and hung them out of windows. He filled space with flags and banners and often showed large signs painted with elaborate scenes composed of multiple figures—like the sign at the upper left of *Southwark Fair*—which furnished him with additional space for still more groups of figures.

Though Hogarth constructed interior scenes in the simple but adequate geometry of one-point perspective, his exterior scenes, such as the *Southwark Fair* print, required more elaborate perspective. In these prints he was likely to depict each building with its own separate vanishing point. This device, though perhaps unintentional, created a subtle tension and fragmentation more akin to the postmodern practice of multiple viewpoints than to the modern interest in cohesive space and monumentality.

Hogarth's spatial images and compositions are essentially conventional. They have been of little interest to the more retinal formalists, who focus primarily on illusion, visual perception, and unified pictorial space. Hogarth's image, with all its falls, debaucheries, moral warnings, allegories, and signified arguments, as well as his *horror vacuii* (the abhorrence of empty space that leads him to litter the entire picture with strange small images), creates an overall effect that is similar to that created by the sixteenth-century Dutch images of Bosch and Bruegel.

Consequently, Hogarth's work was rarely noted with respect by modern artists and critics, who considered it too complex, too cluttered, too illustrative, too literary, and too verbal. But Hogarth should now be of more interest to postmodern painters, who share many of his concerns: political polemics, a content rich in allegory and argument, multiple viewpoints, complexity, and an emphasis on the verbal rather than the retinal aspects of painting.

William Hogarth developed a language that spoke about current topics of interest to the man in the street. In doing so, he gave up any pretensions to the classical, timeless, universal meaning that the poststructuralists would later perceive as ethnocentric and totalitarian.

7

Color and Image as Sign

Paul Gauguin pulled his pistol, pointed it at Armand Séguin, and threatened to shoot him if he continued to mix his colors together. Later he once again pulled his pistol and threatened to shoot Séguin—who was paying Gauguin to teach him to paint—if he continued to contrast complementary colors in the manner of the impressionists. Wladyslawa Jaworska reports that when Séguin told this story, he confessed that Gauguin had scared him. He had followed instructions with exceeding care after that (1972, 38, 140).

A member of the Pont-Aven school, Gauguin's direction has been described as ideist, symbolist, and syntheticist—often at the same time. The term *plagiarism* was first used in the seventeenth century, but it was not considered a crime until the nineteenth. Paul Gauguin (1848–1903), however, had a much stricter definition of the term *plagiarism* than most: "If I did what has already been done, I would be plagiarist," he told Eugène Tardieu in an interview in 1895. "I'd rather be a scoundrel than a plagiarist" (Gauguin 1978, 110). Still, Gauguin rushed to plagiarize every interesting idea and image from his friends and acquaintances—especially from Émile Bernard. As a matter of fact, before he met Bernard, he had appropriated his direction first from Pissarro and then from Cézanne.

Several changes in nineteenth-century society motivated artists to move toward abstraction rather than the traditional illusion. Two of the most powerful changes took place in the economy and the religion.

The industrial revolution created riches beyond any previous comprehension, but Michael Gibson notes that its increasing growth demanded projects of such scope that they were beyond the wealth of even the immense new private fortunes (1988, 23). Ambitious projects like the building of a national network of railroads led to large capital financing. Nineteenth-century fi-

nanciers—the most powerful economic collective in history—invested other people's money rather than their own. There was an unprecedented concentration of wealth in the hands of a small number of people, but these financiers were not free to use the money as they might wish, for the shareholders in the groups they managed demanded high dividend payouts. Therefore, financial power became depersonalized, abstracted (23–24). Later in this book it will become apparent that this may be the precise moment in history when the Cartesian concept of the autonomous "self" as an indivisible, cohesive, and unique individual first began to deteriorate, finally to be replaced by a more fragmented and collective identity.

Power itself was suddenly collective.

The pilots of this collective power used a simplistic interpretation of Charles Darwin's discoveries to create a new morality. They proclaimed a pragmatic new rationale: "survival of the fittest" and the "struggle for life" (Gibson 1988, 24). Since there was as yet no legislation to limit financial power, and no set of ethics to cover the new reality of impersonal economic power, "money obeyed no other law than that of profit, which seemed reasonable enough as long as one ignored the price paid in human suffering" (24).

I reiterate that payment during the Middle Ages was made in gold, and gold itself was an abstract method of storing goods and services. Money was abstracted to a second level when the bank note was invented early in the Renaissance. But the nineteenth-century concentration of financial power in the hands of nameless collectives placed still another barrier between coveted commodities and the relatively straightforward value of gold.

Money was thus abstracted to a third level.

Large amounts of money were manifest only on paper. Money was no longer incarnate in material form: there were no more great treasure chests brimming with gold and jewels. At the beginning of the nineteenth century there were two hundred million people in Europe. That number tripled by the beginning of the twentieth century. With such an increase in population, the size of cities rapidly grew beyond any previous comprehension. Art thrived, but God found little welcome in these enormous new cities.

In *The Disappearance of God* J. Hillis Miller insists that we have, for the last hundred years or more, nurtured a perception that God has distanced himself from us; and since the nineteenth century, this "God-in-hiding" has been experienced as a "terrifying absence" (1975, 2). Miller contends that when human beings concentrate in cities, they experience what it means to live without God. Of course, modern art and literature demonstrate this perceived absence of God even by the structures they assume: the arts, like the concept of God, become more and more abstract. One of the important themes of modern art was isolation and alienation, and many nineteenth-century artworks searched for answers to the two following questions: How can modern men and women find meaning outside themselves? Where will

pact of the work itself, not by representing a subject (1972, 130). Maurice Denis said that Sérusier took Gauguin's slightest utterances and fleshed them out into convincing arguments; and Gauguin's ideas, as expressed by Sérusier, impressed the group (124). But it was Maurice Denis who put into writing the ideas of Sérusier and the Pont-Aven group.

Denis was thoroughly knowledgeable in philosophy, and he organized the group's various opinions into a cohesive image. His famous essay in 1890 began like this: "Remember that before it is a war-horse, a naked woman or a trumpery anecdote, a painting is essentially a flat surface covered with colours assembled in a certain order" (from Jaworska 1972, 149–50). In the late 1960s Frank Stella was still using the Pont-Aven group's statement that painting was just color on a flat surface to explain his own stripe paintings.

Actually, the philosophy of Gauguin himself was a thin soup of ideas from Schopenhauer, Swedenborg, and the Orient; but he did have a facility for extracting, from slight exposure to any philosophical system, conclusions that were relevant to his painting. He could hear a cursory mention of any interesting philosophy and immediately construct a theory of his own that justified the way he was painting. Gauguin is reported to have said: "Philosophy is a dead weight unless it is in me instinctively" (from Jaworska 1972, 232). Gauguin's approach demonstrated the well-known adage: Philosophy is a rationale for what I was about to do anyway.

Gauguin had little use for traditional religion, particularly Catholicism. He wrote: "The Catholic Church is like a dirty stick: we really do not know by which end we should grasp it" (1978, 167).[1] But he was heavily influenced by alchemy. Alchemy had split into three different directions in the eighteenth century when the sacred and the philosophical aspects had been severed from the scientific aspects of alchemy. The result was three entirely different practices: the science of modern chemistry and medicine, Rosicrucianism, and alchemy proper.

By the nineteenth century, there were still many alchemists left. The symbolists in Paris, led by Joséphin Péladan, were Rosicrucians, members of the Paris society of the Rose-Croix. The gallery where they exhibited was called the ROSE+CROIX. Jaworska says several of the Pont-Aven group were influenced by their philosophy, and this shared metaphysical interest was one of the important elements of the group (1972, 169). At least one member of the Pont-Aven group, Charles Filiger, who considered himself a religious painter, maintained close ties with the Paris society of the Rose-Croix as well as with some of the pure alchemists (237).

[1]This refers to the stick that was used in many outhouses before Joseph Gayetty first marketed toilet paper in 1857. Entering a privy in the dark, it was easy to pick the stick up by the wrong end. The American idiomatic expression "I got the short end of the stick" has been cleaned up. Gauguin was obviously comparing the Church to excrement.

Gauguin himself painted a series of works that featured subject matter derivative of alchemy of one kind or another: most obviously, *The Yellow Christ* and *The Agony in the Garden* (Jaworska 1972, 169). In his notebook he wrote: "When the alchemist comes home from Mass he will find his crucible filled with gold; at night, through his telescope, the astronomer will see the moon stopped in its tracks, will see it jeering, laughing at the astonishment of the fellows at the Observatory. Because . . . oh, I don't know—God's will, maybe?" (Gauguin 1978, 163).

Perhaps Gauguin used Rosicrucianism only as a muse to stimulate the invention of images and allegory. Still, the hermetic tradition of sign and symbol in alchemy and Rosicrucianism was one of the principal reasons the Pont-Aven group was motivated to use image and color as sign. Jack Lindsay tells us that alchemists perceived color as an integral part of the nature of objects rather than as an incidental surface quality. There has always been a close connection between the Neoplatonists and alchemy. Plotinus, the great third-century Neoplatonist, had also felt that color was an essential quality thrown out from the center of a life force. He perceived color as an expression or revelation of being (1970, 51). Hence Gauguin and the Pont-Aven group became interested in the linguistic aspects of color and painting through the sources of alchemy and Neoplatonism.

In 1891 Gustave Aurier wrote that these painters did not consider the object as an object, but always as the "sign" of an idea. He wrote a critique of Gauguin's painting insisting that his was the perfect art, then described this perfect art:

A work of art, as I have chosen to evoke it logically, will be:

1. *Idéiste*, since its unique ideal will be to express the idea;
2. *Symbolist*, since it will express the idea through forms;
3. *Synthetic*, since it will present these forms and *signs* in a commonly intelligible fashion [emphasis mine];
4. *Subjective*, since the object will never, in the work of art, be considered as an object, but as the *sign* of an idea perceived by the subject [emphasis mine];
5. (This is a consequence) *decorative*—for decorative painting, properly speaking, as the Egyptians and quite probably the Greeks and the Primitives understood it, is nothing other than a manifestation of art that is at once subjective, synthetic, symbolist, and idéiste. (1891, 154–55)

But the "sign of an idea" that Aurier referred to was not the iconic sign. Spoken languages were intelligible, the group reasoned, yet they were not limited to onomatopoeic words—words that sounded like what they meant ("meow," "hiss", etc.). The group compared onomatopoeia with mimesis in painting, which, like a camera, mimicked the appearance of objects. The painters at Pont-Aven intended to use painted signs in the same manner that "organized sounds are employed in language"—that is, to express ideas that have no visual connection with those signs (Jaworska 1972, 233). Thus they

advocated a painted image that functioned as an arbitrary, unmotivated sign proper. Gauguin himself said he thought of his paintings as signs.

The propensity to conceive of a painting as another object among objects, as opposed to as a text conceived in signs, is called *reification* by postmodernists; and reification is considered a characteristic of modernism. Modernists held that painting does not remain separate from the exterior world even while representing objects from that world; the painting is just another object in that exterior world. Because Gauguin's paintings are primarily signs, they are not reified; thus they fail to demonstrate an important element expected of modern painting.

The Pont-Aven painters attempted to free themselves from the purely optical aspects of nature, which the impressionists had explored so well in their retinal paintings.[2] Pont-Aven painters felt it was better to sift nature through memory and thus cast out superfluous detail. Gauguin advised: "Art is an abstraction, let yourself dream in front of nature in order to derive this abstraction and then think rather of the creation which is to be the outcome" (from Jaworska 1972, 231).

Gauguin and his friends intended to capture the *essence* of an idea so clearly that it would be capable of affecting the viewer far more powerfully than any mere description of objects could. They demolished, simplified, synthesized, and removed everything that might come between the painter and the lucid perception of a scene. They tried to correct anything they felt had a tendency to deceive them about reality (Jaworska 1972, 237). It might be fair to say they looked at a scene, destructured it by filtering it through memory, combined it with other images and scenes, and finally restructured it from memory.

Gauguin and the Pont-Aven group were among the first important South European painters since the Middle Ages to reject the use of illusion to create pictorial space in painting. They composed in flat color pattern; they did not tone each color to maintain its "correct" visual placement in a unified pictorial space.

Gainsborough had used color spatially when he purposely reversed the classic color theory (the Renaissance variant of color perspective) in *Blue Boy* in the eighteenth century: he had placed a figure dressed in cool blue in the foreground against a warm background. Degas had also used color spatially in paintings like *Miss La La at the Cirque Fernando* (1879): he had reversed the

[2]Gauguin wrote: "Then came the Impressionists! They studied color, and color alone, as a decorative effect, but they did so without freedom, remaining bound by the shackles of verisimilitude. . . . [T]hey did not build their edifice on any sturdy foundation of reasoning as to why feelings are perceived through color.

"They focused their efforts around the eye, not in the mysterious center of thought, and from there they slipped into scientific reasons. There are physics and metaphysics" (1978, 139).

classic color theory and experimented with every combination of color in perspective that he could imagine.

Later the fauves manipulated the *spatial* qualities of color perspective (as opposed to the classic color theory) when they executed multiple reverses in color temperature by establishing a warm ground, placing on this warm ground a large cool figure, which then became a cool ground for a smaller warm figure, and so on. Each contrast of warm to cool established another figure-ground relationship.[3] Matisse's *Woman with a Green Nose* is an excellent example of this reversal of temperature for spatial placement. Gauguin, however, appears to have largely ignored the formal, "visually structured" spatial characteristics of color. His claim that he was concerned only with public decoration supports this contention: a rigorous structuring of pictorial space has seldom been expected in decorative painting.

Gauguin was interested in the signing qualities and the psychological and emotional impact of shape and color rather than the formal aspects of spatial structure. Like the impressionists, he seldom used the more obvious aspects of linear perspective, such as parallel lines converging toward vanishing points. He had learned from Pissarro to avoid straight lines, which are the foundation of linear perspective.

Gauguin rejected color perspective, atmospheric perspective, and sometimes even value control. He used warm and cool color for compositional and rhythmic reasons rather than for spatial reasons. His saturate bright color and hard-edged flat shapes negated atmospheric perspective. He often used strong value contrast in the background as well as in the foreground, though he did at times tone down the color and value of smaller figures to integrate them into the background, which effectively caused them to recede spatially.

Still, Gauguin used only vestiges of the three major Renaissance perspectives—linear, atmospheric, and color perspective. A few figures were toned down to match the value or the color of the background; and this echoes atmospheric and color perspective. Some figures and objects in the background were smaller than those in the foreground, echoing linear perspective, but the size of his figures never diminished in geometrically accurate increments as it would have under a rigorous system of linear perspective. Thus he did not use linear perspective; he merely gave it a nod now and then to admit its existence.

Gauguin was interested in color as sign. The French Revolution at the end of the eighteenth century had been trumpeted as the triumph of reason, but this "triumph" was quietly accompanied by the birth of an important countertrend: the discovery of the irrational unconscious. By 1898, Freud's thesis of the irrational powers of the unconscious had been broadly ac-

[3]For further explanation of reversals of the classic color theory, see Dunning 1991, 124–29, 107–14.

knowledged in the name of science and reason. This alerted the rationalists to the idea that there were other viable methods for organizing thought. Gauguin was in sympathy with these new irrational forces, and hoped to use color, the most irrational of elements, to signify emotion.

One of the most fundamental schisms in the history of art was the seventeenth-century debate between the Poussinists and the Rubenists: *le debat sur le coloris*. Charles Le Brun and his advocates (the Poussinists) insisted that line and form were the most important elements in art. Against them, Roger de Piles and his advocates (the Rubenists) maintained that color was supreme. Under the influence of Le Brun, the French Academy came to be dominated by the anticolor dogma that visual structure in painting lay primarily in the drawing—sometimes described as "line" or "composition." Color was considered devoid of rational significance, and thus inferior to drawing.

A disciple of Descartes, Le Brun argued that drawing demands reason, but color appeals only to the senses; therefore drawing is as superior to color as human reason is to the animal senses. Furthermore, Bryson tells us, Le Brun contended that the materiality of color degraded the spirituality of the image, and that the challenge of the Rubenists threatened the rational Cartesian elements of the sign in painting (1981, 60). Gauguin and the entire Pont-Aven group, of course, were diametrically opposed to Le Brun's view.

Roger de Piles, on the other hand, argued that painting was dependent upon other disciplines for most of its knowledge and expertise: specifically, anatomy for drawing the figure and optics for perspective (Barasch 1985, 356). De Piles maintained that only the "modulation and tuning of color" were unique to the painter (356).[4]

The seventeenth-century debate initiated by Le Brun and de Piles continued unabated into Gauguin's time, but with new leaders: Ingres and Delacroix had replaced Poussin and Rubens as the standard bearers. Nineteenth-century painters knew well both arguments of the great color debate. The impressionists tried to strike a balance between the two sides: they held that line and drawing were as important as color—and vice versa.

But Gauguin insisted that de Piles, the advocate of color, was the undisputed winner of the debate. He opposed the impressionists' compromise with characteristic intensity: "The characteristic feature of nineteenth-century painting is the great struggle for form, for color. For a long time two sides fought to gain the upper hand; today there is a third faction [the impressionists] . . . which settles combats of this sort by a compromise, as

[4]It should not be assumed that because these two painters disagreed so avidly on this fundamental point that they were enemies. When de Piles listed all the important painters in history and ranked them by assigning them points to indicate the overall quality of their work, he ranked Le Brun highest with a total of fifty-six points. Leonardo rated only forty-eight points (from Holt 1958, 185–86).

would a judge." The impressionists seem to wonder, Gauguin continued, "why not add to this fine linear work another element, color, which would complete and enrich it, making a masterpiece still more of a masterpiece? I have nothing against this, but I would like to point out that in that sense it is not another element; it is the same element; this would be colored sculpture, so to speak" (1978, 138).

Toward the end of the eighteenth century, Kant had declared that reason operates on the information we receive through the senses, thus he endowed the experience of the senses with the respectability of reason. The combination of de Pile's arguments and Kant's philosophy freed Gauguin to appropriate the sensuous delights of pure color freely. Thomas Hess reasons that when Monet wished to use a dash of crimson in the rose window at Rouen Cathedral, he justified it by close observation at 5:45 in the afternoon. Gauguin, he says, reasoned differently: "Why not use crimson, or pure cerulean, or the brightest green wherever needed—or wherever possible? Bright color is wanted, and why not want it everywhere?" (1951, 67).

Bernard had explained to Gauguin that when color is mixed or broken into its component parts, it loses its intensity and becomes grayer and dirtier. Only color straight out of the tube remains strong, and it can be made stronger yet by surrounding each shape with a blue-black border.[5]

"Pure color! and everything must be sacrificed to it," wrote Gauguin. Then, appropriating Cézanne's famous statement, he added: "And since a kilo of green is greener than half a kilo, then in order to achieve the equivalent (your canvas being smaller than nature) you have to use a green that is greener than the one nature uses" (1978, 144). Gauguin paid little attention to the spatial significance of color. He appears to have devised his own formula for a personal color image. In his later paintings he often used lavender, hot pink, and indigo—and chrome yellow, the color of alchemy, madness, and New York taxicabs. None of these brilliant shapes of color maintained a consistent visual placement in pictorial space in Gauguin's paintings. As in medieval painting, each shape appeared to be positive and salient when the viewer focused on it, but became a recessive, negative shape when the eye inevitably wandered to another shape, which itself then became a salient positive shape.

Gauguin used pure, powerful color to signify powerful emotion. But assigning specific categories to various instances of sign and symbol is often an arbitrary choice—particularly in painting—and the relationship between color and precise sign categories is a murky one for analysis. Each painted color mimics a color that exists somewhere in the world outside the painting; hence Derrida insists that color maintains an irreducible connection with re-

[5]The practice of selling paint already prepared in tubes, was a nineteenth-century invention. The fact that color appears brighter and more saturate when surrounded by black has come to be called the *bezold effect*.

ality (1978, 49). Since color establishes a paradox between mimesis and sign, there is a nearly unresolvable ambiguity in assigning specific categories of sign to any color in the context of painting.

Color may simultaneously function to denote and to connote meaning.[6] Red, for instance, may denote the concrete color of an apple or fire or blood, since red is the usual color of those items. But precisely because it *is* associated with fire and blood, viewers perceive red as loaded with further connotations: hence red has become a sign for assertiveness, sacrifice, war, and revolution.

There may be either an assigned significance or a logical relationship between a color and its perceived meaning: consequently, color may function as iconic sign, indexical sign, sign proper, or even symbol. When a friend and I arbitrarily agree that red will indicate what is mine (personal property or game pieces) and blue what is hers, color is functioning as sign proper. But when I take a round shape to represent an apple because that shape is red, color is functioning as iconic sign because it resembles the color of the apple.

When, however, I feel that red signifies violence, color may be functioning as index and/or symbol. The question is: does red denote or connote, violence? Charles Sanders Peirce, who initiated semiotics, wrote: "In so far as the Index is affected by the Object, it necessarily has some Quality in common with the Object, and it is in respect to these that it refers to the Object" (1960, 143). Red-signifying-violence, therefore, might be classified as index because it is the assertive quality of blood, and blood is often a part of violence. A red stain on a shirt (real blood or a painted image) may indicate blood, just as a bear paw print may indicate "bear." The indexical sign may well be thought of as evidence: when trackers in the woods read "sign," they invariably read indexical signs.

Peirce defines a symbol as "a sign which refers to the Object that it denotes by virtue of a law, usually an association of general ideas, which operates to cause the Symbol to be interpreted as referring to that Object" (1960, 143). Thus the association of "red" and "blood" may also qualify the color to function as a symbol of violence.

Briefly, then, a symbol establishes a logical relationship between signifier and signified: balance scales represent the concept of "justice" because we perceive them as logically associated with "the balance of justice." If the image of a chariot should be used to represent justice, it would not qualify as symbol, because no logical connection has been established. "Chariot" would function as sign proper in this case because it is arbitrarily assigned to signify

[6]Meaning is "denoted" by naming or indicating: blood denotes (indicates) a probable injury; "cat" denotes (names or designates) a small four-legged arrogant animal. Meaning is "connoted" in a more subtle relationship: a Mercedes Benz connotes wealth; a placid lake may connote a peaceful, relaxed mind. For instance: pain is connoted by an injury, but pain is denoted by a twisted facial expression.

"justice." If, however, the chariot were intended or perceived to represent the naive concept of the *swiftness* of justice, then "chariot" might be considered a *symbol* for "justice."

Color's chameleonlike ability to assume the properties of all four major categories of sign grants it unusual potential: it can both denote and connote a multitude of meanings. Color is by nature polysemous. But classifying its various signifying functions is confusing: for example, Blueberries are Red when they are Green.

The Pont-Aven group learned to use color for psychological impact—to signify mood or emotional state—largely because one of the group, Louis Anquetin, lived in a house that had a door with different-colored panes of glass. When visitors looked out through the different-colored panes, they noticed that the landscape assumed different moods that were unrelated to the actual time of day: "yellow produced an impression of sunlight; green of dawn; blue, of night; red, of twilight" (Jaworska 1972, 14). The relationship to painting was obvious. Cool colors create a gloomy effect, warm colors seem joyous, and so forth. Jaworska notes that "This apparently childish, simple deduction was the origin of modern colour symbolism in painting" (228).

The text of Gauguin's paintings can be translated into words, though—as is characteristic of signing paintings—they render a more ambiguous and poetic meaning than any exact expository prose. Gauguin himself put into words a description and partial translation of his 1897 painting *Where Do We Come From? What Are We? Where Are We Going?* (Figure 7.1):

> The two upper corners are chrome yellow, with the inscription on the left and my signature on the right, as if it were a fresco, painted on a gold-colored wall whose corners had worn away. In the bottom right, a sleeping baby, then three seated women. Two figures dressed in purple confide their thoughts to one another; another figure, seated, and deliberately outsized despite the perspective, raises one arm in the air and looks with astonishment at these two people who dare to think of their destiny. A figure in the middle picks fruit. Two cats near a child. A white she-goat. The idol, both its arms mysteriously and rhythmically uplifted, seems to point to the next world. The seated figure leaning on her right hand seems to be listening to the idol;[7] and finally an old woman close to death seems to accept, to be resigned [to her fate]; . . . at their feet, a strange white bird holding a lizard in its claw represents the futility of vain words. (1978, 160)

This painting is obviously an allegorical text "written" in a series of signing images and colors. Perhaps the exact meaning of each sign is difficult to pin

[7]To indicate this figure is listening to the idol, Gauguin cuts her eyes to the side in the direction of the idol. He also indicates listening by raising the pupil slightly, depicting a slight upward cast. He once wrote to Bernard: "A duck with its eye turned upward listens" (from Chipp 1968, 59).

down, but with the help of the wordy title and Gauguin's writing, the general sentiment is strongly communicated.

Wayne Andersen interprets the painting as representing the progression from infancy to old age and death: "The central figure, like the ringmaster in Eden, plucks an apple from the fatal tree, thus animating all the other figures to take their places at each stage in the cycle" (1971, 245). Just above the center of the painting, and slightly to the Idol's right, is a small figure of a mummied woman who is "bound like a fetus" and represents cyclical regeneration (245).

The young woman leaning on her hand—to the left in the painting— wears an arm bracelet, Andersen continues, which marks her as a domestic animal in the same manner the collar indicates the goat's domesticity. The young woman listens to the statue of the goddess Hina, who speaks in favor of humanity's right to exist. The old gray-haired woman in the lower left corner holds her hands over her ears so she will not have to listen to these "vain words." Andersen concludes that Gauguin hopes to prove rationally, aesthetically, and completely "that life is a sweet lie that withers on the vine" (1971, 245).

Much of this painting can also be read as a Tahitian allegory of the Bible. After completing the painting, Gauguin wrote that he had "finished a philosophical work on a theme comparable to that of the Gospel" (from Andersen 1971, 245). He may also have included some alchemical imagery. The "gold wall"—which is revealed at the corners where Gauguin says the "fresco" has "worn away"—might well refer to alchemical gold: the hidden purity of the soul that is exposed when earthly life has been washed away.

The idol in the upper left is similar to statues of saints found in Catholic churches. The white bird in the lower left corner might hold triple significance: Gauguin said it "represents the futility of vain words." George Ferguson, in *Signs and Symbols in Christian Art,* tells us that (and this goes back to ancient Egypt) birds were often used to represent the winged soul, thus the spiritual (1961, 12). This is certainly in keeping with the theme and meaning of Gauguin's painting. Alchemists originated the idea, later appropriated by Christian artists, that birds represent the soul freed from its earthly prison; and Gauguin would certainly have had some knowledge of both alchemical and Christian signs.

The goat in Christian painting represented the damned—the Gospels say that Christ will come again at the end of the world to separate the sheep (good) from the goats (evil) (Ferguson 1961, 19). The fruit in the hand of the small girl at the bottom of Gauguin's painting might be interpreted as affluence and/or fertility—or as an echo of Adam and Eve's original sin. The combination of birds, fruit, and goat might also represent an abundance of food—thus affluence in a hunter-gatherer society.

The dog has often been used to signify loyalty, and a black-and-white dog (particularly one running into the picture suddenly, as here) often rep-

resented the Dominicans (Ferguson, 1961, 15).[8] (Perhaps Gauguin decried the role of Dominican missionaries in the islands.) Or the dog and the other animals taken together might imply the biblical gift of human dominion over the animals. Gettings notes that the running dog as shown here is also an alchemical sign for "uncontrolled astral manifestation"—powerful emotions that cannot be controlled by the mind—and thus represents the corrupt earthly desires of humans on earth (1979, 142–43). Again, this is consistent with Andersen's interpretation.

Cats, like the two at bottom center, were often used in Christian art (secular Dutch art also) to imply lust or laziness (Ferguson 1961, 14). The brilliantly colored bird near the center of the painting might represent several ideas. Gauguin had used a bird in *Spirit of the Dead Watches* as a "literal manifestation of the *spirit* of the dead, the unholy ghost, the winged messenger who delivers the word from Satan" (Andersen 1971, 184). Its brilliant colors suggest it might also represent Gauguin's idea of a Tahitian peacock—and the peacock is a well-known Christian symbol for both immortality and vanity. Gettings notes that in alchemy the phoenix represented eternal life, reincarnation, or spiritual growth, and that alchemists often used a peacock to represent the phoenix. The peacock became so common an alchemic symbol, in fact, that the alchemists adopted it as a sign of their trade (1987, 150).

The two distant standing figures to the right of center look like statues of saints or madonnas. The seated woman with infant, in the lower right corner, could also represent a madonna (Gauguin often painted halos over the heads of island women as if he considered them madonnas). And it is difficult to miss the biblical significance of the tall bright yellow woman near the center who reaches up to pick the red fruit (the apple?).

Is Gauguin's painting, then, an example of the search for a system of motivated signs (signs that are not arbitrarily assigned) that, we will later see, Bacon and Comenius sought? Perhaps. But these signs have more arbitrarily imposed meanings than are at first apparent. If the goat, for instance, simply meant "goat," which it resembles—no matter how simplified or stylized— then it would be a motivated iconic sign. But the goat here, because it wears a collar, refers to domestication. The goat does not mean "goat" and the collar does not mean "collar": the meaning of "domestication" is arbitrarily assigned, so the collared goat is a sign proper. Or, if a logical relationship is perceived between the collar and domesticity, this figure might be called a symbol. So these signs are not merely iconic; they can be interpreted as either signs proper, indexical signs, or symbols.

[8]Black and white was the color of the Dominican habit. Also, Kathleen Beehler explains that a slight change in the pronunciation of "Dominicans" renders *"domini canes,"* Latin for "hounds of God," a nickname that refers to Dominican tenacity (1993, 52).

The idea that blue signifies a certain kind of emotion is so familiar to us today—after our experience with blues singers, blue Mondays, and Picasso's blue period—that few will miss the significance of Gauguin's decision to depict most of the painting in shades of blue. The cool blues and greens immediately move the viewer to a mood of contemplation, even melancholy. The dark value of the color sets a "somber" mood. In fact, just after completing this painting, Gauguin took a large dose of arsenic in an attempt to kill himself—but he took too much and vomited it up.

The large areas of yellow and the smaller areas of bright red are intended to relieve this melancholy before it reaches the heavy stage of despondency or depression. They also offer contrast, thus intensifying the impact of the cool. The luminous blue of the idol (the one place where white is noticeably added to a color mixture) implies divinity, and the two large upper corners of bright yellow might be taken as an optimistic suggestion of the revelation of a better world "beyond"—beyond the visual barrier, or the "beyond" that Gauguin said he intended the blue idol to signify.

Gauguin seldom mixed white into pure color. Like painters during the Middle Ages, he used the purity of color as sign. Consequently, his paintings show little value control. The chosen color predetermines the value; thus even when his paintings are reproduced in black and white, the viewer can decode most of the value areas into their respective colors. The light baroque shape on the ground plane at the extreme left in *Where Do We Come From? What Are We? Where Are We Going?* is white, the lightest value in the painting; the next lightest colors, the upper corners on the right and left, are yellow; slightly darker than the yellow corners, the light halftone figures are yellow ocher; the halftones on the bird in the middle, the fruit, and the two distant figures on the right are red; and the darker values of the ground are predominantly blue and green.

As in medieval paintings, when Gauguin chose blue for an area, that area would usually be dark; when he chose yellow, that area would usually be a light value. And like other painters who use painted images as signs, Gauguin simplified the information (and the perspective) in the images, which is consistent with Bryson's observation that signing images demand less information than realistic images. Hence Gauguin's figures and objects are painted flat with a minimum of modeling.

Also, like other signing painters, he was forced to exploit rising perspective—the more figures he used, the higher the horizon. In fact, he was often compelled to place the horizon higher than he would have liked. When discussing one painting, he wrote: "but here's the hitch: the rules of perspective are going to force me to place the horizon very high up and my canvas is only two meters [a little over six feet] high" (1978, 134). Since he had little use for perspective in the traditional sense, he must have meant he needed the high horizon of rising perspective to create a large ground plane to accommodate his signs. Like van Eyck and Bosch, Gauguin does not foreshorten his

figures as if they were seen from above, which would be consistent with the high horizon and ample ground plane. Rather, he represents them as if they were seen at eye level, not well below it.

So Gauguin's work shares several similarities with medieval painting: he exploited rising perspective; his color demonstrated little of the value control so pervasive in Western art since Giotto; his images were signs; and his color signified rather than described.

Gauguin painted his figures as separate, hard-edged, flat, linear areas of local color. Sharp, distinct, unintegrated silhouettes move back and forth in space at the whim of the viewer in an almost medieval manner—a kaleidoscope of figure-ground reversals. There are no neglected shapes in Gauguin's paintings. All shapes are equally weighted with interest, color, and contrast. Each shape and each color signifies an emotion or a psychological state. And in Gauguin's nonanthropocentric painted world, the shape of a human carries no more importance than the shape of a puddle, a flower, a leaf, or the pattern on a piece of cloth.

No major idea—with the possible exception of the zipper—has ever sprung full-blown from the head of a single person. Usually, there is "something in the air," a unified awareness in the collective mind that permeates all disciplines, including art. Ideas accumulate slowly until they saturate (or supersaturate) a society.

Hot water can be slowly induced to accommodate considerably more dissolved salt than can cold water. What is more, as motionless water cools, the salt will resist the tendency to precipitate out; it will remain in the supersaturated solution so long as there is no hint of even the slightest disturbance. But create the most imperceptible disturbance, introduce just a speck of dust, and the salt will immediately precipitate out of solution to form a crystalline network. And that network will appear to emanate from that insignificant speck of dust, so that an unknowing observer might well conclude that the tiny speck had miraculously grown, suddenly and explosively, into an intricately organized edifice of crystalline salt. Just so, upon the slightest disturbance, the separate fragments of collective ideas that supersaturate a society will seem to suddenly crystallize around an individual.

It was Gauguin's friends, combined with influences from a variety of other sources in the culture, that generated his style. For example, the writings of Jean-Jacques Rousseau heavily influenced Gauguin's social philosophy. Kirk Varnedoe tells us that Rousseau's most famous text, *Discourse on the Origins of Inequality*, indicated the smugness of the European concept of societal progress and scorned organized Western society. Rousseau's praise for humanity's rich life "in an earlier, simpler state gave a newly cogent and emotional impetus to primitivist patterns of thought" (1984, 180). Only twenty years after Rousseau published this discourse, the island of Tahiti was discovered, which seemed at first to validate his vision.

Gauguin's entire life in painting demonstrated that he was entirely captive to Rousseau's naive eighteenth-century construct of the perpetual inno-

cence and happiness of the "noble savage." Gauguin was part Peruvian Indian and had lived in Peru for four years when he was a child; perhaps this had some bearing on his fascination with Rousseau's romantic construct of tribal life in contrast to the civilization of "degenerate" Europe. Gauguin claimed to have returned to the primitive state: he even called himself a "savage." But the primitivism he embraced was more believable as a return to a primitive or childlike conception of space than as a re-creation of any tribal style or consciousness. Such a metamorphosis would be next to impossible for a man raised primarily in a technological culture.

Andersen tells us interest in the "primitive" was a sign of the times. Most of Europe shared Gauguin's fascination with the "savage." In *Novembre* Flaubert paraded a chain of exotic subjects through his work: hosts of cannibal women; tigers seizing prey; savages paddling canoes with prows decorated with bloody scalps; poison arrows causing agonizing death (1971, 4). In the Marquesas Islands Gauguin held a "beatific discussion with an elderly cannibal about the taste of human flesh" (4). Actually, Gauguin himself associated the "savage" with satanism, and this diabolistic aspect appears regularly in his paintings. In *Self-Portrait with Halo and Snake* (Figure 7.2), for instance, painted when he was still living in Brittany, he casts himself as the heroic fallen angel. Refusing to despair after his ejection from heaven, he assembles the minions of evil for an assault on the Garden of Eden in the tradition of Milton's *Paradise Lost* (11).

But Varnedoe tells us Gauguin's paintings show more compositional influence from Manet and Ingres than from the exotic sources to which he paid lip service. Furthermore, the alchemy and the arcadian spirit of the symbolist painter Puvis de Chavannes is obvious "in Tahitian masterworks such as the murallike *Where Do We Come From? Who Are We? Where Are We Going?*" (1984, 179–80).

Japanese wood-block prints were pervasive in France in the late nineteenth century, as were folk art prints from the commune of Épinal. Renewed interest in medieval art and public decoration also saturated France at this time. Jaworska notes that Émile Bernard collected reproductions of scenes from the Middle Ages as well as examples of the Épinal prints. Even his earliest attempts at syntheticism flattened the picture plane, raised the horizon, and simplified human figures in a manner reminiscent of medieval and folk art. That Brittany—where the Pont-Aven group worked—was almost medieval in atmosphere, Bernard testified. When he first moved there, he said: "I thought I was living in my beloved Middle Ages" (from Jaworska 1972, 13–16).

In addition to the influences already mentioned, Gauguin's work exhibited elements from non-European sources in India, Egypt, Java, Persia, and Cambodia. He strongly advised Bernard to avoid the classical Greek influence and pay more attention to the Persian, the Cambodian, and the Egyptian. Kirk Varnedoe notes that artists before Gauguin may have known about eccentric art forms, "but Gauguin was the first to appreciate in such

FIGURE 7.2 Gauguin, Paul. *Self-Portrait with Halo and Snake* (1889). Oil on wood (31 1/2″ × 20 1/2″). National Gallery of Art (Chester Dale Collection). Washington, D.C.

forms a significant, potentially transforming challenge to Western ways of depicting the world. In the compressed and oddly proportioned forms of folk art and exotic foreign objects he found not deficiency but independent, alternative force and creativity" (1984, 179). This valuing of the work of those outside the mainstream of European society would also be strongly championed by Dubuffet in the twentieth century.

Gauguin "appropriated" his direction from Bernard, his thoughts were enthusiastically translated into words by Sérusier, and his rationale was put into writing by Denis. Though, like Gauguin himself, his paintings were stronger and more assertive than the paintings of the other artists at Pont-

Aven, his work looked much like theirs. From the right perspective, Gauguin's style begins to look inevitable. His use of color as sign was neither complex nor elaborate, but in the late nineteenth century it was effective, bold, and fresh; and Gauguin knew it. He flaunted it with all the condescension and arrogance of one convinced he is an authentic genius. But though Gauguin thought of himself as the epitome of individual genius, he is an excellent example of collaborative effort and collective awareness.

Recently, after thirty years, I read once again R. G. Collingwood's book *The Principles of Art*. I was caught off guard by how up-to-date the ideas in this book, written in 1938, seem today. Collingwood continues the aesthetic direction of Hegel and Benedetto Croce. He demonstrates few influences from Saussure, yet he practices a method of criticism that focuses on the linguistic rather than the perceptual aspects of art.

Long before the terms *postmodern* and *poststructuralist* had been uttered, Collingwood explained and challenged the modern construct of "genius," and he explained his objections to that construct as well as any postmodern writer. I have reconstructed his argument to create a comparison of the differences between the modern and the postmodern construct of an "artist."

Modernists perceived artists as geniuses—self-contained, entirely unique personalities who were the sole authors of their work. The emotions they expressed were presumed to be their own personal and unique emotions, and their products were considered to be expressions of the individual "self" (1961, 316). In Gauguin's words: "The turning point of the times, in art = a mad search for individualism" (1978, 148). (Thus his words, but not his actions, have the ring of modernism.)

Consequently, Collingwood continues, critics searched for the artist behind the work. They tried to reconstruct the personalities and opinions of important artists: "But what," they asked, "is the 'real' [fill in name: Van Gogh, Johnny Carson] like?" Gossip aped history and criticism. Modernists spoke of artists as Creators (after Collingwood 1961, 316), granting them preternatural powers. Gauguin himself had said he was not satisfied with being a mere innovator; he demanded the adulation due a Creator-God (Andersen 1971, 10). The modern cult of the individual considered each work the product of one artist alone, in no way related to the work of other artists. Emotions and the method of expressing them were obliged to be unique—in Frederic Jameson's well-known words, "as personal as a fingerprint."

Collingwood explains that modernists judged a poem or a painting great when it expressed "a great personality." Those who harbored this opinion were often shocked to find that Shakespeare's plays, including *Hamlet*, were adapted from other writers' plays: "scraps of Holinshed, Lives by Plutarch, or excerpts from the *Getsa Romanorum*"; Handel incorporated whole movements by Arne into his own works; Turner habitually lifted his compositions from Claude Lorrain (1961, 318). Such works are collaborations: part from the artist, part from those whose images or ideas are bor-

rowed (318), and part from the ghosts of numerous artists and thinkers whose ideas we can trace step by step to a distant past.

The modern cult of the individual constructed an audience that struggled to understand art through the act of reconstructing the artist's emotions, imagination, and experience. Viewers can, of course, achieve such a reconstruction only piecemeal and incompletely, for such a construct treats the artist as transcendent genius, far too mysterious for the simple grasp of mortal viewer (after Collingwood 1961, 311).

But many postmodern artists, like artists during the Middle Ages, consider themselves at one with their audience. They express emotions and sentiments they hold in common with others in their society. Rather than egocentrically struggling to lead an audience through the dark labyrinth of their own mind, they speak for their contemporaries, expressing what their audience feels but cannot say unaided. Rather than assuming the manner of genius and imposing upon the world the task of understanding each of their works, postmodern artists strain to understand their world. Furthermore, they help it to understand itself. They hope to generate more than mere communication between artist and audience; they initiate a mutual collaboration (after Collingwood 1961, 313). Any statement the postmodern artist makes is then implicitly preceded by the statement "We feel"—not "I feel." Postmodernists do not expect their audience to passively accept a work; they invite their community to reconstruct the work to suit themselves (after Collingwood 1961, 315).

Artists have always collaborated with their predecessors and their peers. Remember, plagiarism was not illegal until the nineteenth century. Collingwood is an adamant advocate of plagiarism (or appropriation). Those who object to others stealing their ideas, he insists, "must be pretty poor in ideas," more concerned for their own reputations than for the intrinsic value of the ideas themselves; "I will only say that this fooling about personal property must cease. Let painters and writers and musicians steal with both hands whatever they can use, wherever they can find it" (320). If some do not want their precious ideas borrowed, they are welcome to keep them to themselves. It is quite simple: Don't publish (320). Like Collingwood, poststructuralists— as I will eventually demonstrate—contend that ideas and language belong to no one because the very concept of ownership depends on an obsolete concept of the individual "self."

Andersen insists that "Few men have worked harder at creating an image than Gauguin did" (1971, 3). Modigliani is purported to have said: "One good painting is worth anybody's aunt." But if Modigliani said it, Gauguin dedicated his life to demonstrating it. Gauguin believed himself the very embodiment of the modern genius. He decried "plagiarism" and claimed to allow himself no influences from traditional painting. But all the while he furiously poached ideas and images from his friends.

Perhaps because he touted himself as a genius, simplified his image, and abstracted his paintings, Gauguin has commonly been considered a

modernist. I had originally planned to devote a chapter to him in my first book, which traced the origins of modern art. But he did not fit. Now I find he fits elegantly, like the missing piece of a puzzle, into the postmodern construct. I realize that no artist exhibits all the characteristics of any style or period, but consider the following five indications of Gauguin's postmodern practice and attitude as "family resemblances":

1. As if he had been coached by Collingwood, Gauguin stole his ideas and his direction from Bernard and the Pont-Aven group. He never hesitated to filch any idea or concept that interested him. Bernard confided bitterly to Renoir: "I was twenty and he was forty. It was easy for him to look like the innovator when he had merely stolen something from me" (from Gibson 1988, 39).

In a letter to Maurice Denis in June 1899, Gauguin admitted: "I have really 'stolen' so much from Émile Bernard, my master [in] painting and sculpture, that (he himself has said it in print) he has nothing left" (Gauguin 1978, 186). Because of the indispensable collaboration with, and the heavy influences Gauguin received from, painters around him—as well as his conscious readiness to steal ideas from them—Gauguin's style, direction, and product readily qualify as a collective effort.

2. Gauguin was also guided by the collective awareness of his French culture: he was quick to adopt the current "supersaturated" interest in simplification, "primitivism," folk art, medieval images, and the occult interests of the Rosicrucian symbolists.

3. He had little interest in traditional European art—"avoid the Greek," he advised. He tried hard to acquire his influences from non-European sources: Java, Egypt, and India. One of the most severe postmodern criticisms of history and art history is the accusation that they are too Eurocentric. Gauguin was one of the first to attempt to remedy this.

4. Gauguin had little interest in illusion: neither his image nor his color functioned to control or organize pictorial space. He bragged that his work was decorative—an utter disgrace to any respectable modernist.[9] Though he constructed a picture plane that avoided any consistent illusion of depth, it had nothing of the cohesive illusionistic elements that Monet or de Kooning used to maintain an illusion of flatness. Elaine de Kooning's significant comment that "flatness is just as much an illusion as three-dimensional [pictorial] space" does not apply to Gauguin's paintings.

5. Gauguin intended his painting as sign, not as another reified aesthetic object in the exterior world. Both image and color were intended as signs to communicate with and affect the viewers. Jaworska contends that both symbolist and syntheticist writers and painters agreed that the objects depicted in painting were important only insofar as they "were the signs of

[9]Thierry de Duve notes that it was from the decorative arts that abstraction had been promoted as the "essential domain of the ornamentalist." They had claimed the absolute autonomy of color "as an expressive language detached from all forms of naturalism" (1991, 120).

ideas, that the visible was a manifestation of the invisible, and that sounds, colours and words possessed an absolute value independently of all inter-pretation and even of their literal meaning" (1972, 129).[10] And Gauguin's concern with the "visible as a manifestation of the invisible" assertively echoes the Middle Ages.

When these five cumulative points are considered, Gauguin fits more comfortably into the puzzle as a precursor to the postmodern than as an early modern. Thus that line of art that is concerned with words and the irrational drifted momentarily to France before moving north again to its traditional home among the expressionists in Germany, Mondrian in Holland, Munch in Scandinavia, and Kandinsky in Russia. And finally, Jaworska insists "we have what may be called the most formidable *coup d' État* in the history of art" (1972, 240). He asks: What is the direction pioneered by Kandinsky, Malevitch, and Mondrian "if not the outcome of that decorative autonomy of form and of the picture-surface, which latter [sic] according to Denis, 'is es-sentially a flat surface covered with colours assembled in a certain order'?" (240).

Furthermore, both Mondrian and Kandinsky were serious theoso-phists, and theosophy had grown out of Rosicrucianism, the modern version of alchemy. Mondrian was an ardent member of the Theosophical Society, and the only relief from the clean line and simple shape in his studio—which was composed in severe rectilinear shapes like his paintings—was a larger-than-life photograph of the most influential theosophist of the nineteenth century: Madame Helena Blavatsky.[11]

Gettings tells us that several abstract artists of the early twentieth cen-tury (as well as many who worked in science, such as Thomas Edison) were also heavily influenced by the teachings of Madame Blavatsky. Kandinsky was not actually a member of the Theosophical Society, but in his own pro-fuse writings he quotes heavily from both Blavatsky and Rudolf Steiner, who helped develop the Society (1979, 130).

[10]Bryson notes that Saussure's interest in the arbitrary quality of the sign is in direct con-trast to Gauguin's interest in something more like a pictogram that hovers between image and word, between icon and symbol, "a form of sign halfway between convention and natural re-semblance" (1991a, 95).

[11]Meyer Schapiro corroborates that Kandinsky and Mondrian were theosophists (1978, 204, 246). Blavatsky's theosophy started with alchemy as a base and added mystical elements from Hinduism, Buddhism, and Christianity. Mondrian and Kandinsky were particularly caught up in the theosophical interest in sacred geometry. In *The Secret Doctrine* Blavatsky gives detailed attention to the significance of geometric shapes, such as the cross, circle, square, and triangle. For instance, she insists: "The triangle played a prominent part in the religious sym-bolism of every great nation; for everywhere it represented the three great principles—spirit, force and matter; of the active (male), passive (female), and the dual or correlative principle which partakes of both and binds the two together" (from Davis 1992, 101).

Kandinsky painted the first important nonrepresentational painting in 1913, which he titled *First Abstract Watercolor,* while trying to paint the "astral plane." Early theosophists took very seriously this attempt to capture—thus control—the astral plane (Gettings 1979, 131–36).[12] Kandinsky's fundamental concept, "that the artist should disregard the physical appearance of matter in favour of the psychic reality of the spiritual" (137), is similar to Gauguin's advice that the artist should disregard the physical appearance of objects in favor of their psychological significance.

After a close examination of Gauguin and the Pont-Aven school, the roots of postmodernism begin to be apparent. At this juncture, art split into two distinct camps. The impressionist direction developed into modern art—which Duchamp would later decry as "retinal" painting—culminating in the work of de Kooning, Kline, Pollock, and Newman. Gauguin's direction, however, developed into a pursuit of painting as sign, symbol, and expression, culminating in Duchamp, Dubuffet, The Hairy Who, Funk, Warhol, and Anselm Kiefer—in short, in postmodernism.

Modern retinal painting in general tends to demonstrate a preference for the following elements: retinal over cerebral; optical experience as immediate visual impact over optical communication through signs; sensuous impact through color, composition, and sensitivity of proportion over the intellectual impact of verbal meaning; history over myth; linear sequential time over cyclical time; single viewer over multiple viewers; cohesive images over fragmented images; and narrative over discursive. Postmodern signing painters, however, find little use for, and have little interest in, the first element of each of these oppositionary pairs.

[12]For a complete explanation of the influence of Theosophy on the development of abstract painting, and Kandinsky's work, see S. Ringbom, *The Sounding Cosmos. A Study in the Spiritualism of Kandinsky and the Genesis of Abstract Painting* (1970).

8

The Animated Iconic Sign

In the beginning, painting and writing were the same. There was no differ-ence between the two. The first signs were iconic: they resembled what they were intended to signify. In later phonetic writing, the sign proper was chosen arbitrarily. Postmodern art critics are fascinated by such ideas and in-trigued by the possibility that we might once again unite the long-ago sepa-rated languages of painting and writing to find a system of motivated signs that can incorporate the syntactical and grammatical structures of a phonetic language.

After human beings learned to represent the world around them with painted and graven images, some of these images eventually developed to-ward illusion to become what we know as painting. But some were simpli-fied in order to communicate verbal ideas, and these signs eventually evolved into writing. The illusionistic images were executed in increasingly exacting visual detail and depicted, more or less faithfully, things and events in the external world—the world outside the painting. This direction usually demonstrated little connection with words.

In its ancient beginnings, the relationship between painted images and speech was tenuous. Derrida tells us these painted images became "a closed and mute system within which speech had as yet no right of entry" (1976, 283). Painted signs did not signal specific words or concepts. First came mnemonic devices, then pictographs, then ideographs, logographs, rebus writing, hieroglyphics (hieroglyphics also developed into a phonetic form), and, finally, a fully phonetic alphabet.

The first mnemonic devices may have been nothing more than sticks notched to aid memory, like notches on the grip of a gunfighter's pistol. Later, pictographs and ideographs were used to communicate general mean-

ing, perhaps not much more accurately than gesture languages. Then more advanced mnemonic images developed that identified animals, events, objects, songs, proverbs, and, finally, individual persons. Even during World War II pilots painted simplified iconic images of airplanes, trucks, or ships to record their successes in battle. And an example of a mnemonic device still used by the Ewes in Togo is the depiction of a needle and a piece of cloth to represent the proverb: "The needle sews great cloth." Many writing forms have used a mixture of pictographs and ideographs.

Certainly representational painting may sometimes communicate an event better than a pictograph or an ideogram, but the representational picture is always limited as communication because it is dominated by established conventions of art or craftsmanship. Consequently, with the exception of medieval and Dutch painting, European (and then American) representational painting demonstrated little interest in writing until the postmodern era.

Pictograms and ideograms are drawn or painted, as are paintings, but their primary purpose is to communicate or to aid memory, so they gradually become more stylized. Once the relationship between signs and objects, or actions, has been established, it is no longer necessary to paint a picture of a man hunting a deer. The signs for man, hunt, and deer carry the same message. Then the sign for man and hunt may be combined: a stick figure of a man holding a bow—like those found in the petroglyphs at the Columbia River in Washington State—may indicate both at once. Then ten horses come to be represented by two signs ("horse" and "ten") rather than ten pictures of horses.

But no logographic (one pictorial sign = one word) practice has ever evolved into a fully developed system of writing. The possibilities of logographic systems are severely restricted by the insurmountable task of creating and memorizing thousands of words and names. Only when a phonetic value that is independent of the sign as a word is established can such a method develop into a complete system. This phoneticizing of the sign is the most important step in the development of writing as we know it.

One method by which the sign can be phoneticized is rebus writing. For instance, if rebus writing had developed from the English language, a pictogram such as the paw print of a bear might originally be used as an indexical sign for "bear." Then the paw print might come to signify "naked" because "bear" sounds the same as "bare." Then, through obvious connections, it might come to mean "alone," and finally, "defenseless." Ultimately, certain signs would be combined: the painted paw print that signified "bear" might be combined with the sign for "ring" to signify "bearing," as in bearing a load or ball-bearing. Thus associations are quickly established between signs and spoken sounds.

In *Orality and Literacy* Walter Ong tells us the Summerians, around 1500 B.C.—two thousand years after the invention of cuneiform—were the

first to use abstract signs to represent specific sounds (syllables) (1982, 89). They began by keeping records: they recorded an item, its number, and a sign for the specific owner or buyer: sheep, ten, X. As the area became more populous, names proliferated, and they soon found it necessary to write personal names in an exact phonetic manner to avoid confusion. Thus the Summerians created a syllabary system, and this phonetic system enabled them to break away from representational depictions—iconic signs (91). The need to write individual names seems to be the motivation for the development of phonetic alphabets: the Summerians, the Egyptians, and the Aztecs all began to develop phonetic signs for this reason.

The Summerian system used one sign to represent the sound of one consonant; the vowel sound was usually left out, though it was sometimes indicated by a separate sign. The alphabet was invented only once in the history of the world, by the Summerians; it was from this first alphabet, later improved by the Greeks, that all other known phonetic alphabets were derived. The Greeks initiated the use of a separate sign for each vowel sound, and theirs was the first completely phonetic alphabet. For millennia—until late in the first half of the twentieth century—Western writing and painting continued to move in separate directions.

After the Chinese improved the quality of paper in the second century A.D., they came to consider calligraphic writing a form of high visual art. Because writing was executed with a brush and considered a high art, it was reunited with painting in China; in fact, only those who were proficient with the brush in writing were allowed to paint. The best of Chinese painting was done in the spirit of Tao; hence it was painted from memory, as Émile Bernard would later recommend in the nineteenth century, rather than from direct observation.

But Western artists wrote with pens, and with few exceptions the pen and the brush continued in separate directions. Western critics studied and analyzed writing linguistically, while they studied and analyzed painting in terms of perception, illusion, and space.

Signs proper, as used in speech and therefore in writing, are arbitrary: there is no apparent reason for choosing one particular sound to represent any object or concept. Consequently, different languages use different sounds to denote the same thing (for example, "cat" in English, "gato" in Spanish). This arbitrary quality of the sign proper has long been a worrisome trait to many concerned with the structure of language.

During the Middle Ages St. Augustine and other theologists believed the original Word of God had been immediate and universal, and it remained eternally unchanged. Human speech, on the other hand, unfolded as a succession of sounds in time, and the significance of these sounds depended on social convention. From the Middle Ages through the sixteenth century, language was not perceived as the arbitrary system that Saussure spoke of. Instead—as Foucault tells us—language was perceived as a mysterious,

opaque, self-contained puzzle. A sign was considered an index or a secret to be deciphered, and language was thought of as a part of the world. Worldly things seemed to hide and manifest their own puzzle much like a language, and words themselves were offered to human beings "as things to be deciphered" (1973, 34–35).

The medievals believed that certain letters possessed specific virtues, which attracted, and demanded to be grouped with, certain other letters. These same virtues repelled certain letters. Hence certain letters were foreordained to group together to form syllables, as specific syllables were predetermined to group together to form words. This is the same process the medievals observed in Nature: certain marks attracted or repelled each other. Nature, they insisted, was a secret composed of relatively easily decipherable signs that revealed its intentions (Foucault 1973, 35). For example, they believed that plants that possessed the power to heal the head or the eyes or the liver always resembled the specific organ they were intended to benefit (33). Aconite, for instance, was used to treat diseases of the eye. This medical gift would never have been discovered except for one important clue: its seeds "are tiny dark globes set in white skinlike coverings whose appearance is much like that of eyelids covering an eye" (27).

The medievals believed God had originally endowed human beings with a natural language composed of absolutely certain and transparent signs that resembled the things they named. But God had willfully destroyed this transparency as punishment for human pride in erecting the Tower of Babel. When He separated the languages, signs were mutilated—rendered arbitrary and incompatible with one another. But because God wanted men and women to remember His punishment, He left subtle evidence of that original transparency in just one language: "Hebrew therefore contains, as if in the form of fragments, the marks of that original name-giving" in order to remind us that "it was once the common language of God, Adam, and the animals of the newly created earth" (Foucault 1973, 36). Medievals thus believed that the (undesirable) arbitrary quality of the sign was God's punishment for human pride.[1]

During the late sixteenth and early seventeenth centuries, Svetlana Alpers tells us, English and northern thinkers—men like Leibniz, John Wilkins, Francis Bacon, and the educational reformer John Amos Comenius (and later Newton)—flushed with a newfound materialistic pride and

[1]Augustine wrote: "These signs could not be common to all peoples because of the sin of human dissension which arises when one people seizes the leadership for itself. A sign of this pride is that tower erected in the heavens where impious men deserved that not only their minds but also their voices should be dissonant" (quoted in Vance 1986, 39, from *De doctrina christiana* II.iv.5).

courage, grew increasingly dissatisfied with the arbitrary quality of phonetic signs. This arbitrary manner of selection seemed neither necessary nor logical to them; it was irrational. Bacon experimented with the "Characters Real" of China (Chinese writing has often fascinated those who are dissatisfied with the arbitrary character of the written sign), and his followers set out to invent a pictographic system of writing called "real characters" that would use simple signs that had obvious pictorial references to the objects and concepts they signified. They hoped a new, artificially invented language would forge a common link to unite humanity in peace (1983, 96).

Robert Markley explains that during the seventeenth century the authority and meaning of the Bible were challenged by political radicals and philosophers such as Hobbes and Spinoza, and that the resulting multiplicity of competing and contradictory interpretations made it impossible for Christians to unite around it any longer. Newton and others became fascinated by the idea that "real characters" and "philosophical languages" might replace the lost biblical authority with an ideal system that imposed order on "natural phenomena by the simple act of naming them" (1991, 129).

These futile attempts to invent a written language of iconic signs inspired the acid pen of Bacon's countryman Jonathan Swift. In the third book of *Gulliver's Travels* Swift satirically described a method of conversing invented by the people in the imaginary country of Balnibarbi: "Since words are only names for *things*," Swift wrote, it would be more convenient if people carried with them a bundle of such *things* "as were necessary to express the particular business they are to discourse on." He argued that "Another great advantage proposed by this invention was that it would serve as an universal language to be understood in all civilized nations, whose goods and utensils are generally of the same kind, or nearly resembling, so that their uses might easily be comprehended" ([1726] 1984, 164). But Swift foresaw one small problem with this system: the more intelligent people and those who spoke on a large variety of topics would be penalized by having to carry a larger bundle of *things* (163).

Postmodernists reason that a reunion of painting and writing has the potential to solve this problem since the iconic signs used in painting do resemble the concepts they signify, just as Bacon suggested. But we seldom manage a gain without suffering a corresponding loss. In spite of the resemblance established between the sign and the signified object in painting, there is *usually* no way to establish syntax: that set of rules that organizes the sequence and relationship of signs and allows for precise communication.

Though different periods have assigned arbitrary meanings to painted images—thus combining the resemblance factor of an iconic sign with the arbitrary quality of the sign proper—only alchemy and medieval painting established an accepted and long-lasting assignment of verbal and allegorical meanings to iconic signs. During the Renaissance, however, alchemists

learned to keep the meaning of their signs a secret from the uninitiated, and ambiguous even to many of the initiated. Perhaps this accounts for some of the postmodern interest in both medieval and alchemical images, as I will demonstrate later.

Francis Bacon's concern was echoed in the principal tenet of Ezra Pound's twentieth-century imagism in poetry. Pound initiated imagism in an attempt to create a poetry that depicted reality through the use of pictograms (again, modeled after Chinese writing) rather than the sign proper. Wendy Steiner says Pound believed Chinese writing was universally intelligible, and he praised his friend Henri Gaudier because Gaudier claimed to understand Chinese ideograms without having studied the language (1982, 24).

Pound discovered an article about Chinese characters written by Ernest Fenollosa, who died in 1908, translated it from the original Italian, and published it in English. He was so interested in Fenollosa's ideas that he set out to learn Chinese and proclaimed: "The time when the intellectual affairs of America could be conducted on a monolingual basis is over" (1967, 3).

Fenollosa insisted that the only thing required for poetic form "is a regular and flexible sequence, as plastic as thought itself. [Chinese] characters may be seen and read, silently by the eye, one after the other" (1967, 361). He argued that thought could be denoted by symbols that did not need to be translated into words, and that Chinese characters prove this. If we understood these signs, "we could communicate continuous thought to one another as easily by drawing them as by speaking words" (362). Fenollosa maintained that Chinese characters are natural signs: the sign that means "to speak," for example, retains the image of "a mouth with two words and a flame coming out of it," and the sign meaning "to grow up with difficulty" maintains the rudimentary image of grass with a twisted root (364). Rudolf Arnheim has noted that the iconic meaning of Japanese writing still maintains its pictorial roots, so that even after thousands of years "a modern Japanese in a thoughtful moment can still see the sun rise behind the tree when he looks at the kanji sign for east in the word Tokyo, which signifies the eastern capital" (1986, 92).

But Fenollosa was interested in more than just the idea that these signs were semi-iconic: he was fascinated by the fact that the Chinese language does not separate nouns from verbs (1967, 364). In Chinese, for instance, "bird flying" is a single character or word, and it is different from the character or word for "bird eating" or "bird at rest." Chinese uses one character to denote both object and action, while English requires two words, each remaining unchanged: that is, the word "bird" remains "bird" no matter what action it takes. English has few words that convey the idea of both object and action: one example is "fist," which *denotes* "hand doubled up." But the word "fist" *connotes* far more than the words "hand doubled up." "Fist" connotes self-defense, violence, revolution. It is a far richer image than "hand doubled up."

Fenollosa pointed out that the isolated nouns of European languages do not exist in the natural world. Things are merely the meeting points for actions. Neither is a verb, a purely abstract action, possible in nature (1967, 364). For these reasons, he maintained, Chinese poetry consolidated the "vividness of painting and the mobility of sounds" (363). It is this very fusion of writing and painting that postmodernists seek so avidly. Though Arnheim does not readily embrace all the attitudes of postmodernism, he does write: "Although image making and writing grew indivisibly out of each other and have never been wholly separate, their recent mutual attraction has come like the healing of a wound that had torn them unhealthily apart" (1986, 90).

While Ezra Pound was pursuing Fenollosa's idea, of a language "as plastic as thought itself," Charles Ephraim Burchfield (1893–1967), artistically isolated in the Midwest, was busy inventing just such a language. Unique, I believe, in the recorded history of art, Burchfield's language—like Chinese characters—often did not separate nouns from verbs, and it combined the vividness of painting with the mobility of sound. Furthermore, his language could be well (if not completely) understood by many uninitiated viewers. When I was a painting student at the University of Illinois, I spent an afternoon at the Krannert Art Museum. I still remember my reaction when I first came across *The Four Seasons* (Figure 8.1) by Burchfield.

As Hiram Williams so aptly put it near the end of *Notes for a Young Painter*, Burchfield's paintings "stick like burs to the memory" (1963, 100). Suspicious of subjective assertions about an individual's reactions to paintings, which are so pervasive in art schools, I nevertheless knew I was "sensing sound." I was aware of an inaudible combination of groans and creaks and chirps, embedded in a background matrix of something like organ music—a kind of deep, imperceptible infrasound that the best organs produce, sounds heard only at the unconscious level that can profoundly affect the listener. This was the first time I had ever been really affected by a work of art (beyond the normal interest in narrative or admiration for crafted skill).

I heard no actual sound, of course; there was only a sensation of sound, in the same manner, though perhaps more pronounced, that depth is sensed but not seen in Cézanne's paintings. Cézanne called this his "little sensation." If I had to explain sound to someone born entirely deaf, I would take them to see a good Burchfield painting.

I immediately went to the library to find books with more paintings by Burchfield. Of course, I was disappointed that what I saw in books affected me nothing like the real painting. Thus I discovered early that reproductions are no more works of art than a photograph of a hamburger is a meal. But I did learn from the authors of those books that I was not alone in sensing sound in Burchfield's paintings.

The space between the trees, where they come together at the top in *The Four Seasons*, suggests the vaulted arches of Gothic cathedrals, and Burchfield's elaborate detail suggests the organic, sculpture-encrusted sur-

FIGURE 8.1 Burchfield, Charles. *The Four Seasons* (1949, 1960). Watercolor on pieced sections of paper, mounted on board glazed with plastic (55 7/8″ × 47 7/8″). Courtesy: Krannert Art Museum, University of Illinois, Champaign.

faces on those medieval cathedrals. Thus he establishes a metaphor: nature's cathedral. Perhaps the cathedral reference is the element that generates the background sense of organ music, but it is the subtler detail that creates the foreground sound: the formations of small black birds rising above the distant trees read like materialized musical notations rising from the muzzles of the metaphorical organ pipes. The flocks of birds are echoed below by symmetrical dark shapes that represent the spiky remnants of broken limbs on the same distant trees. These shapes start low on the trunks as recognizable

stumps of limbs, but as they move up, they detach, grow darker, and gradually assume the shape of black flying birds—rising like rapidly bubbling eighth and sixteenth notes from their implied instruments. Rounded oval shapes suggest the fuller, more rounded tones of the clouds and skies, while abrupt spiky shapes seem to indicate the staccato chirps and twitters on the forest floor.

Charles Burchfield began his search for syntax and a set of grammatical rules—like those of such interest to Hogarth and the postmodernists—that might establish the kind of sequences and relationships between painted signs that make more precise communication possible in speech and writing. He started experimenting with graphic signs for sound, mood, and, finally, movement in 1915, when he was twenty-two. Burchfield was fascinated by the sound of crickets and other insects, and he began to express these sounds in paintings like *The Insect Chorus* (Figure 8.2) as early as 1917. Reminiscent of

FIGURE 8.2 Burchfield, Charles. *The Insect Chrous* (1917). Watercolor with ink and crayon (19 7/8″ x 15 7/8″). Munson-Williams-Proctor Institute, Museum of Art, Utica, Edward W. Root Bequest.

the Chinese writing that Ezra Pound would soon come to admire, Burchfield's ideograms often did not discriminate between object, action, and sound: each group of signs simultaneously denoted object, action, and sound. Furthermore, these signs speak directly with no translation into words. Fenollosa, remember, had believed that such ideograms had the potential to communicate through drawing as easily "as by speaking words."

Like Hogarth, Burchfield began to use shorthand notations in his notes and preliminary drawings in order to save time. Matthew Baigell tells us Burchfield created about twenty notational devices, which he called "Conventions for Abstract Thoughts." These shorthand notations began to dominate his paintings (1976, 76). John Baur tells us that Burchfield penned in his notebooks his intention to "write down a landscape in graphic shorthand" (1982, 132). And later he would inform his New York dealer, Frank Rehn, that he would furnish him with painted "sounds and smells and dreams," which, he said, called for the invention of new "signifying elements" as well as the use of old ones (from Baur 1982, 205).

Like Hogarth and Gauguin, Burchfield tried to capture the essence of an idea by using childhood memories as a source. The moods as well as the fears of his youth dredged up images that represented his sense of awful black north and cold winds: "A day could become an evil thing and sounds could ring alarmingly in the woods, even though the grown man knew there was only silence" (from Baigell 1976, 76).

As empirical as any Dutch painter, Burchfield merged aspects of bird and insect presences, which he had experienced in the woods, to signify nature's moods as well as his own. The suggested movements of birds and insects emphasized both his mood and nature's mood (weather). He distorted both the internal shapes and the perimeters of objects: woodpecker noises vibrated throughout a thicket or multiplied the movements of tree limbs; a chorus of katydids augmented the lazy aura of a summer day or portended the arrival of a summer storm. His paintings signify the melding of the spirit with the patterns of nature and the weather (Baigell 1976, 26). In short, Burchfield's signs operate in an important area: human experiences that cannot be named. Wittgenstein asks: "Can I not say a cry, a laugh, are full of meaning?" (1958, 543). Such expressive sounds and signs are valuable to us precisely because they share and express experiences that cannot be named, or even explained, within the nominative theories of language.

The sharp angles that form the green bent blades of grass in *The Insect Chrous* echo the thin black angles that suggest the antennae, sharp movements, and sharp chirps of crickets. Sharp, short angular lines suggest sharp, short sounds in the higher ranges; while full, looping, hemispherical shapes and lines suggest rounder, fuller bass tones and larger shapes suggest still lower, slower tones. The repetition of curved lines at the bottom right of the painting suggests the lower, duller scraping sounds of sluggish insects dragging and pulling themselves along.

Both the sharp and the round imply threat in Burchfield's painting. The repeated spiky shapes are perceived as sharp, suggesting immediate physical violence like barbed wire; the rounder dark shapes—particularly when combined with the periodic appearance of pointed, clawlike images—suggest a more patient, mysterious malevolence lurking just out of sight. Baigall interprets the repetitive strokes that energize leaves, grass, and insects as reminders of lengthy sessions that we all spent observing and contemplating a single blade of grass or a falling leaf (1976, 76).

The Insect Chorus combines indexical, iconic, and "semi-iconic" signs to suggest: the sharp creaking sound of fresh grass bent by heavy step; the staccato chirps and startling leaps of crickets and other insects; and the dragging bass sounds of larger, slower insects or small, sluggish animals. The green angular shapes resemble blades of grass—iconic signs. The blades appear to have been bent and broken by something heavy—indexical signs. The sharp angles formed by the thin black lines "seem to resemble" the antennae of crickets or grasshoppers—"semi-iconic" signs. Burchfield used line, shape, repetition, and color to signify the movements and noises created or suggested by everything seen or known to be in a landscape. Everything in his paintings is a sign. Even his signature—or more accurately, his "chop"—was used to signify his interest in astrology. It was composed of a sign of the Zodiac (Aries) combined with his three initials. His paintings might be described as wordless essays on the landscape—an ineffable discourse.

A close look at Burchfield's paintings reveals that he often refused to distinguish between the object and its action or function—just as Fenollosa had recommended. The angular lines that suggest crickets never actually look much like crickets, but they do create the impression of a cricket's sharp chirp or a cricket's jump—sharply up, then sharply down.

As I mentioned, I had forgotten about Burchfield's paintings for several years. Then an incident while I was viewing some paintings done by the signing chimpanzees across the street from the building where I work brought his painting back into my mind.

Along with the old matriarch Washoe, Roger Fouts keeps several other chimpanzees who also communicate by signing in American Sign Language (Ameslan). Kathleen Beach, one of my former students, has worked with the chimps in their signing and painting activities for several years. She explained that after the chimps make a painting, one of the attendants asks them to sign a name for it in Ameslan. Then, on the back of the painting, the attendant writes the "title" that the chimp signed: "Bird," "Ball," "Tree," and so forth.

In looking at some of these paintings, it puzzled me that only a few seemed to resemble the object named in the title; I saw no immediate connection between most of the images and their titles. One of the paintings by a young chimp named Moja was an angular series of up-and-down brushstrokes. This painting looked nothing like its title, "Ball" (Figure 8.3). Then

FIGURE 8.3 Moja. *Ball* (1982). Tempera on paper (8 1/2" × 11").
Collection of Roger Fouts.

Kathleen suggested that the drawing was not intended to resemble the static ball, but the action the ball makes when it bounces—the essence of the ball. A painting named "Bird" that had previously looked like two symmetrical and adjoining series of scribbles, suddenly seemed to suggest the action that a bird's two wings make in flight.

These "activities" of an object are often more arresting, and more salient in the memory, than the simple static appearance of the object. And they resemble the way Burchfield often represents things in his paintings. Such signs do not fit into Ferdinand de Saussure's category of sign proper since they are not arbitrarily chosen. They are motivated signs. Yet they are not indexical signs because the sign itself is not caused or created by the object signed, in the manner that a bear leaves a paw print or a bullet leaves a hole. They are in some manner iconic; they do actually resemble some aspect or characteristic of the object, if not the object itself.

But iconic signs are generally static: they signify concrete nouns, a person, an animal, a tree, regardless of the activity that may presently engage that noun. Rarely, they represent abstract nouns—darkness, brilliance, anger—but even abstract nouns are difficult to signify clearly in painting. Hence the term "iconic sign" implies stasis. It is a static sign.

Our language has terms that name those situations in which a noun acts as a surrogate for another noun. When reporters say "the White House said today," "White House" substitutes for the president (a metonymy). When someone uses a part to label a whole—"I like your wheels" to mean "I like your car"—this is a synecdoche. To "verbalize" can mean to use a noun as a verb—I "foxed" him or the dog "treed" the cat. Our language often turns verbs into abstract nouns: "the runner" refers to a person who runs; "the fight" refers to an activity or event. But our language rarely, if ever (except perhaps in a few cases of local dialect), uses a pure verb to represent a concrete noun: we do not refer to a ball as a "bounce"; we do not call Larry Bird "shoot" or Air Jordan "jump." Hence we have no term to describe this situation.

Perhaps the kind of signs Burchfield and Moja created might profitably be called "animated iconic signs." Such signs resemble the action associated with a particular object rather than the object itself. When marks resemble the action associated with a particular object without a sign for the object itself—and consequently substitute for the missing object—they might be called "animated iconic signs."

I cannot think of another artist who explored so thoroughly the territory of the animated iconic sign. Balla's famous running dog, with its multiple images of legs suggesting movement, still resembles a dog; it fits into the common English construction of "dog running." We see the concrete noun "dog" modified by a verb (the signified movement of the legs). Similarly, Duchamp's *Nude Descending a Staircase* is still a case of concrete noun and predicate ("nude" and "descending"). The concept that the brush strokes in an abstract expressionist painting signify the action, and therefore the presence, of the absent artist comes close; but the marks are actually made by the artist (just as a paw print is made by a bear), so this sign must be classified as an indexical sign.

Burchfield was on an interesting track with these animated iconic verbs. Nouns alone do not make a language. The painted verb allows painting to move from simple narrative to discourse. Foucault goes so far as to insist that "the verb is the indispensable condition for all discourse; and wherever it does not exist, at least by implication, it is not possible to say that there is language" (1973, 93). Nominal propositions simply camouflage the invisible presence of a verb (93).

It is puzzling that so little interest has been shown in the animated iconic sign in light of the current consuming interest in painting as sign—particularly since the animated sign seems to be so natural: chimpanzees and

children invent these animated iconic signs without being taught. When lawnmowers were still the old-fashioned reel-type push mowers, children often made overlapping oval scribbles (suggesting the circular path of the blades) to represent lawnmowers. Children also represent the act of looking or seeing by drawing either arrows or dotted lines from an eye to the object seen, but this example again muddies the category because the arrows and lines typically emanate from an eye—again pairing a concrete noun and verb ("eye" and "look"). Furthermore, Louis Marin explains that "in Benveniste's sense, the minimal unit is the sentence, and the heart of the sentence is the verb" (1988, 70). How can painting establish a grammar or syntax without verbs?

Animated iconic signs seem more related to Chinese characters, which do not separate noun and verb; they signify "bird flying" and "bird eating" with entirely different characters. Still the two are not entirely the same. The Chinese characters still translate (as I understand it) as a combination of a concrete noun and a verb: "bird flying." (Burchfield's signs are often of this type also.) Furthermore, the Chinese signs must be strenuously taught to both writer and reader.

Animated iconic signs also seem loosely related—though I cannot explain precisely why—to the tribal practice of capturing the essence of an object's active abilities. For instance, David Summers explains that when tribal societies take a stone to stand for a person or even a deity, the stone is given eyes—not to make it resemble what it is intended to signify, but to endow it with the same animated powers of sight as the person or deity it represents (1991, 253).

Like Gauguin, Burchfield used color as sign; he even used it to signify sound. He used color to signify the sounds made by specific things—the chirps of insects, a leaf in its drifting fall, the drum of rain, the singing of railroad tracks, the strained, twisting growth of tree bark, and even the inaudible sound of falling snow—rather than to represent the surface color of those objects.[2] Like van Eyck and Vermeer, Burchfield was an empiricist. He carefully observed the movements and sounds of nature and formulated a set of conventions and grammar that was intended to express the cumulative mood and sound orchestrations of nature.

Burchfield was so intent on the connection between his paintings and the elements they signified that he referred to his drawings as "idea notes" (Burchfield 1968, 7). Often he wrote, rather than drew, his ideas. "The awesome August north that looms with the cricket chorus is the first impression

[2]Certainly some people do actually feel a distinct impression of a precise note when they see a specific color, and vice versa: this is called *synesthesia*. Some even connect the sense of smell to color and sound.

of the hideous black midwinter north pushing into summer," he wrote before painting *The August North.* "A memory of Childhood—Tall grass by a window . . . August dusk is coming down cricket's chorus commences; the child becomes awed, afraid." And finally: "The noise of Silence—Sitting motionless in a room looking out a black doorway—the air commences to ring; it grows louder and louder . . . the door grows more and more evil. . . . The floor creaks as with a heavy footstep" (from Baur 1982, 68).

Like Gauguin, Burchfield used color as sign. He limited his palette. "I devised a simple formula," he explained. "Everything was reduced to the twelve colors of the color wheel plus black and white, with minimum modifications. Thus sunlit earth would be orange; shadows on it red-violet; sunlit grass, yellow; shadows, blue or blue-green [cast shadows were red-violet] and so on. They were executed in flat pattern with little or no evidence of a third dimension" (from Baur 1982, 31).

Some of his later images were almost nonrepresentational, merely suggesting the trembling of the grass, bushes, weeds, flowers, hills, and rays of sunlight as they touched the earth, as if feeling the pain of growth or creation. He wrote: "Growth is painful to the plants—they writhe" (from Baur 1982, 87). Baigell notes that the swarms of small strokes stopped short of identifying particular objects; the marks only partially revealed the objects, and this generated a pulsating quality in Burchfield's paintings (1976, 120). The only figurative elements in these paintings are the horizon line and occasional references to flowers (191). This way of almost-describing promises something that it is careful never to deliver—like a well-performed striptease. When Burchfield focuses attention on elements of the landscape, he promises a glimpse of something substantial, but he never delivers on that promise. He never displays the promised image. Roland Barthes explains that a viewer of a striptease is thrust "into the all-pervading ease of a well-known rite" that exploits props to hide the object of attention from sight (1982, 86). In the same way, Burchfield evokes the dignity of sacred ritual by distancing viewers from their recognition of the subject matter. He camouflages objects with motivated "semi-iconic" and animated iconic signs that bring the absent signified near the point of materiality without ever actually bringing it into sight. Hence he denies materiality, even as painters in the Middle Ages were wont to do.

Burchfield's paintings are so notational that they suggest other notational systems, such as written musical notes or the choreographer's graphic shorthand methods that are designed to chart the individual movements of a dance.[3] His paintings fuse linguistic meaning, which exists in time (like mu-

[3]"Laban" is the name of the American system (sometimes called "Labanatation"). "Benesch" is the name of the English system.

sic and poetry), with the sudden immediacy of retinal impact in a manner that Bacon, Comenius, Pound, and Fenollosa would have envied.

In 1917, when Burchfield began to depict houses instead of landscapes, Baigell contends, he was influenced by American writers like Sherwood Anderson and Sinclair Lewis. His work, like theirs, revised American myths and brought before the public what Lewis Mumford called "the pathology, not the heroism of the pioneer" (from Baigell 1976, 92). Burchfield shared another attribute with these writers: their art was less personal and introspective than collaborative and collective. It developed out of the collective public consciousness in a manner that would have pleased Collingwood. Finally, in the spirit of the postmodern, Burchfield was more concerned with sign and content than with technique.

His houses expressed a "carnivorous quality"; they signified the lives they held (Baigell 1976, 87). He gained a reputation as the artist best able to signify the introspective quality of small midwestern towns. His work was compared with writing: he was often called the "Sinclair Lewis of the paintbrush" (123).

Burchfield was also one of the early ecologists. In 1921 he began to paint industrial scenes and machinery. He hated the effects that industrialization had on the Midwest. He agreed with John Burroughs's appraisal that the unbridled effects of scientific development had produced an American civilization that was "the ugliest and most materialistic that any country or age ever saw." Burchfield wrote that he would hate with his last breath "modern industrialization, the deplorable conditions in certain fields such as steel works and mining sections" (from Baigell 1976, 31). He concentrated on the geometrical shapes of industry as if aware of Foucault's later thesis that society exploits geometry to control its citizens, to *Discipline and Punish* (1977a).

Hiram Williams contends that no other paintings capture the drab industrial North and Midwest like Burchfield's, and he finds it amazing that the same painter could also capture so successfully the lyrics of the wind and the unfurling of a flower, the bleakness of winter and the darkness of a swamp. The metaphor Burchfield created was dynamic because it established a contrast of opposites: the luminous against the dark, the lyrical against the threatening (1963, 102).

In 1944 Burchfield returned to landscape and continued this direction for the rest of his life. Baigell tells us that in order to recapture the fantasy of his youthful imagination, he started reworking his old studies and paintings (1976, 169). he restructured the impressions of his youth: a cricket's rasp set off a host of childhood associations, and he depicted the woods as a fearsome place again. As both Hogarth and Gauguin before him had counseled, Burchfield made his art "a remembrance of things past" (71–73). Thus he appropriated himself.

When reworking his old studies, he sometimes added new sections of paper to work on. Working in a similar style, he added new elements and de-

tails so the new served both to reconstruct and to join the old. Refusing to distance himself from the past, or even to distinguish between past and present, he compressed the two temporal constructs into one. Burchfield appropriated and compressed his own past and present into recursive cycles. He was quite familiar with Chinese scroll paintings, and was interested in the way they telescoped time: "My great idea was this," he said: "to show in continuity the transitions of weather and of the seasons; such as the development of a thunderstorm from a calm clear day, and then its passing and perhaps a moonrise following. I termed them 'All-day Sketches' " (from Baur 1982, 28–29). He sometimes represented the events of a day, or even a year, on one canvas, a practice that is now sometimes referred to as *cinematic time*. He also read Hindu and Buddhist myths for the way they personified natural phenomena (Baur 1982, 31).

Unfortunately, Burchfield painted during the wrong period for him. Baigell notes that even though his paintings "honor the modern shibboleths of relative spacelessness, disruptive perspective, arbitrary color handling, minimal modeling, and raw application of watercolor pigments," they do not resemble other modern paintings (1976, 81). And Hiram Williams observes that it must have been "terribly unnerving to violate 'period vision,' the conventions of an age" (1963, 99).

Burchfield's paintings share more interests with the postmodern than with the modern. They are concerned with: non-European ideas; myth; the compression of time; content; and the signification and orchestration of sound, movement, and mood. They demonstrate little concern with formal problems and compositional organization, though the consistency of Burchfield's ideas (which are more linguistic than formal) serves as a rigorous organizational system. Furthermore, Burchfield worked in watercolor when oil painting was still the privileged medium. During the 1930s his would often be the only watercolor in a collection or national exhibit.

Few painters have found their direction at such a young age, and few have produced so consistent a body of painting over such a long period of time. All the parts in Burchfield's paintings sustain their relationship to one another within an overall system to create their own consistent and logical world. Burchfield invented a unique system that used marks and color to signify sound, mood, cyclical time, metaphor, allegory and movement. He was more interested in collaboration and a collective message than in establishing his own personal identity; he appropriated his own work (even his own past life) and compressed past and present (nature's and his own); he offered a political message, focused on his concerns about the ecology, and he did it in a medium that was considered a "minor art" at the time. Finally, he developed a new grammar and syntax that relates each sign to the other and began the process of reuniting painting and writing.

Urinals (colon) the Undescended Trajectories of Missile Dish Aims B.U.T.N.D.¢

Though Picasso launched the first important challenge to the idea of beauty as a necessity in art, it was Marcel Duchamp (1887–1968) who changed the traditional meaning of the word "beauty" and henceforth our response to the word "aesthetic" would never be the same.

"Beauty" is rarely used in critical discourse now, and the use of "aesthetic" is dwindling and changing. When we do employ either of these two words, we no longer use them in the traditional sense. "Aesthetics" no longer refers to the study of theories of beauty. To the postmodern theorist these two words signify something more akin to the rigor of the artistic structure, or the manner in which pieces fit snugly together in complex relationships of part to part and part to whole—a fusion of the micro- and the macrocosmic—like the parts of speech in a language. These words now point to the beauty of a puzzle solved or of an insightful question asked.

Throughout the history of art, artists have explored the boundaries of reality, but they have proposed more questions than answers concerning the nature of that reality. Socrates taught us to seek answers through penetrating questions; and Edwin Land, who has recorded more patents than anyone other than Thomas Edison, has stated that any problem is 95 percent solved when the question has been correctly stated. These thinkers appreciated the beauty of an elegant question. In the late twentieth century we explore reality through an investigation of the language that explains it; thus artists' questions have come more and more to probe the structure of language.

Postmodern artists, critics, and viewers *collaborate* on collective areas of interest. The word "elegance" in the sense that it is used in science best represents what artists and critics now mean when they say "aesthetic." Scientists and artists are engaged in attempting to make sense of the universe

around them. They are both working toward expanding our concepts of reality. In order to make sense of the puzzle of universe, scientists and artists must first recognize and expose contradictions and pieces that do not properly fit.

Scientists, for instance, know that light travels neither in waves nor in quanta (particles). Where one mathematical discourse uses the wave construct to predict how light will act, another uses the particle construct. The analogies or constructs of wave and particles are simply the best current images for predicting the behavior of light. Both analogies are nothing more than heuristic devices. Light obviously travels in some illusive form that sometimes behaves like particles and sometimes like wave phenomena. If someone should invent a new theory that incorporated the behavior of both wave and particle into one clear analogy that could function mathematically to solve all the complex equations concerned with the behavior of light, scientists would label this an "elegant" theory.

This recognition of elegance in theories and solutions is precisely the manner in which Duchamp used the word "beauty." During one period he announced that he was giving up art for chess. He told Truman Capote: "A chess game is very plastic. You construct it. It's mechanical sculpture and with chess one creates beautiful problems and that beauty is made with the head and the hands" (from d'Harnoncourt 1989, 39). He appreciated the elegance of an efficiently played endgame. When interviewed by Pierre Cabanne, Duchamp said chess players were madmen in the way artists are supposed to be (1987, 19).

In 1980 the postmodern artist Joseph Beuys insisted that "The word 'aesthetics' does not exist for me" (1990, 68). And in 1993 even Robert Hughes, who often shows little sympathy for some elements of postmodernism (especially poststructuralism), after using the word "aesthetic" in an article in *Time*, was moved to quip parenthetically: "(that repressive, icky word again!)" (1993, 68).

Robert Motherwell once wrote that Duchamp's greatest accomplishment was to move art "beyond the merely 'aesthetic' concerns that face every 'modern' artist." Motherwell coined the phrase "the despair of the aesthetic" to refer to the problems that are encountered in the contemporary application of aesthetic theory to modern painting, and he asserted that Duchamp had found "an ethic beyond the 'aesthetic' " (1969, 11). Perhaps we could label this "aesth*ethics*," for postmodern "aesthetics" has come to be related to ethical concerns, such as political justice, ecology, and the redress of past wrongs.

Duchamp created an alloy of visual illusion and verbal puns, and he treated them as interacting equals. He created elaborate and elegant relationships between spoonerisms, verbal puns, visual puns, and optical illusions, all of which may have served to camouflage his interest in myth and alchemical allegory. He carefully interlocked these apparently incompatible

pieces into a rigorous matrix of complex relationships and thus forced interested viewers to investigate, interpret, and respond on both a visual and a verbal level.

Neither the visual nor the verbal stood alone in his work. Duchamp worked in footnotes. Not unlike Derrida, he put ideas together in interlocking apostrophes, each part a footnote fitting into the overall image as a piece in a puzzle slides elegantly into the waiting notches surrounding it. This snug, elegant fit told him when a piece was the correct statement of a specific question—not necessarily the answer to a problem.

Thus Duchamp rescued painting from what he called its purely "retinal" response, where "aesthetic" was in some manner related to sensuous beauty, and determined to return it to the service of the mind. He often spoke of his resolution to bring "gray matter" back to painting and to destroy the differences between painting and writing—a continuing theme in postmodernism. He considered both visual languages to be equally efficient optical methods for the transfer of information,[1] but for himself rejected the retinal play of form and color. Instead, he searched for signs that are equally significant, whether letters, lines, or colors.

Heavily influenced by the symbolists, dada, and surrealism, Duchamp generated a profusion of rigorous notes on linguistics. He lists simple rules to establish a new phonetics, morphology, and syntax, then uses traditional grammatical methods to violate every rule of syntax and sentence construction in order to demonstrate the limitations and inadequacies of the language. In this sense, Duchamp's approach was postmodern, Wittgensteinian, even deconstructionist.

Not even Bosch created the complex mental puzzles or manifold layers of meaning that Duchamp did. (Certainly Duchamp was less understood by his contemporaries than Bosch was.) Perhaps Dirk Bax would consider Duchamp, too, a member of the Rhetoricians. The two artists had much in common: each created images that depend on both word and visual image. But in the work of Duchamp, more even than Bosch, the image sustains little interest without the word.

Foucault contends that during the nineteenth century literary and art criticism began to seek alternatives to judging literature and painting by the yardstick of "good taste." Critics began to perceive art and literature as a language to be interpreted (1972, 42). Both Bosch and Duchamp create puzzles that depend on the vernacular in their native language. Viewers who do not

[1]Duchamp explained: "Since Courbet, it's been believed that painting is addressed to the retina. That was everyone's error. The retinal shudder! Before painting had other functions: it could be religious, philosophical, moral. If I had a chance to take an antiretinal attitude, it unfortunately hasn't changed much; our whole century is completely retinal, except for the Surrealists, who tried to go outside it somewhat" (from Cabanne 1987, 43).

speak the Dutch vernacular of Bosch or the French vernacular of Duchamp have great difficulty understanding these artists' messages, even with the help of elaborate translations.

Duchamp came as close as any artist before him to joining the verbal and the visual. In an unpredictable manner, unforeseen by anyone, he closed the gap between the two halves of the circle that had opened millennia ago when painting and writing had split to head in apparently opposite directions. Michel Sanouillet tells us Duchamp's direction comes from an old French oral tradition that is still alive in the Parisian argot of the common people: in jokes and puns, lewd words and metaphors, and the language of pamphlets, ads, and almanacs (1989, 53).

Duchamp was particularly influenced by the *Vermont Almanac*, a journal composed of French humor in the coarse tradition of the sixteenth-century writer François Rabelais, who was Bosch's soul mate. Published since the 1880s, the *Vermont Almanac*—like the last member of a dying race—is the last major official representative of the ancient tradition of the carnival grotesque. It still entertains millions of households in the language of the common people. In a period when polite society affected a mannered preciosity of speech, Duchamp seems to have been alone in his understanding of the collective sensibility of normal working people (Sanouillet 1989, 53). The *Vermont Almanac* today publishes exactly the kind of linguistic games that abound in Duchamp's writing and painting (54). With his scatalogical humor that concentrated once again on the lower regions of the body, Duchamp fanned to life the last dying ember of the tradition of Bosch, Rabelais, and the folk humor of the carnival grotesque.

Most viewers who do not speak French catch only a glimpse of Duchamp's orchestration of multiple interlocking verbal meanings. When he quit painting what he called "retinal art," he began to claim that his occupation was *"un aspirateur"*: Lawrence Steefel explains that this pun combines the sense of "free breather" (which implies personal autonomy) with the sense of a vacuum cleaner. Added to this is the idea that the inhaling of breath is "inspiration," and inspiration is an obvious necessity for any artist (Sanouillet 1989, 71–72).

Duchamp used several pseudonyms, each for a different reason. His best known *nom de crayon*, Rrose Sélavy, is an obvious pun on the resignation of the French "c'est la vie" ("that's life," with a shrug) and *"la vie en rose"* (a rosy or optimistic view of life). Duchamp explained in an interview with Cabanne that he wanted to change his identity. Born a Catholic, he first thought of taking a Jewish name, since to change from one religion to another simultaneously with a change of name would, he thought, certainly effect an abrupt change of identity. When he couldn't find a Jewish name that fit his requirements, he thought of changing his gender, and Rose Sélavy popped into mind. Rose, considered a terrible name in 1920, demonstrated his rejec-

tion of good taste as an element in art (1987, 65). Changing his identity to female also fit with his interest in alchemy. The ancient alchemical androgyne (or hermaphrodite) preoccupied the poets and painters around him, especially the symbolists and the surrealists.

He picked up the second "r" in Rrose after writing a pun to Picabia: "*Pi Ou'habilla Rrose Sélavy.*" Phonetically, this sounds like "*Picabia arrose c'est la vie*" (Cabanne 1987, 65)—which makes the same sound as Picabia's name followed by Duchamp's *nom de crayon*. When the "a" in "Picabia" is run together with "Rose," it creates "*arrose*," which suggests "water"; and the added "r" emphasizes the water connection.[2] This could imply "Picabia makes water; such is life." Duchamp claimed he particularly liked this reference to water, so he added the second "r" in Rrose permanently. The "*Pi*" in Duchamp's pun is pronounced like "pis," with the "s" dropped phonetically, and means "the worst"; but if the "s" sound is retained, it means "piss," as in the verb *pisser*, which would be consistent with the image of urine that Duchamp used often. (Alchemists also used urine in many of their illustrations and processes, partly because of the significance of the color yellow.) Or if the "Pi" is combined with the following "Q," it renders the sound, "pic," meaning high fashion. The sound derived from the "Q" could mean "what." Hence "*habilla*" can refer to either "dwelling" (where one lives) or "clothes."

Putting all this together offers a host of possibilities and implications: the worst (or the best) taste in dress (dress perhaps referring to Rrose's transvestism); the manner of, or location of, living or life (perhaps on water—divinity?) or pissing on life; the paradox of both the tone of resignation implied by "that's life" and the tone of optimism implied by a rosy outlook on life. Taken in its totality, this pun offers an elegant interrelated complexity.

Furthermore, Duchamp's feminine alter ego echoes the sixteenth-century French tradition of the *Mère-Folle*. This is another of several connections between Duchamp and the carnival grotesque of the sixteenth century. Enid Welsford explains that the *Mère-Folle* (mother fool, or mad mother) was a man dressed as a woman (which intentionally implied the androgyne of alchemy). The *Mère-Folle* was the leader of the satirical society of the Kingdom of Fools, which stemmed from the more ancient European Feast of Fools.[3] This fools' society consisted of hundreds of commoners, but it also included some nobles. Members used literary skits and satire to punish people

[2]I appreciate the help of my colleagues in the French Department, Dr. Kelton Knight and Dominique Isner-Ball, who aided me here with the French translations and puns.

[3]This society was known as either the *Mère-Folle of Dijon* or the *Infanterie Dijonnaise* (Welsford 1961, 206).

who offended their sense of ethics (1961, 206).[4] This establishes another connection with aesth*ethics* and echoes the carnival grotesque.

Given Duchamp's erudition, intelligence, satirical literary nature, and penchant for cramming the most complex meaning into the fewest possible words, his interest in such a connection could have been predicted. Furthermore, he would have enjoyed and claimed such a connection whether or not he had intended it. When asked what he thought of the many different ways his work had been interpreted, he said he liked them all because each offered an interesting contribution that was neither true nor false. Certainly this attitude is consistent with the postmodern belief that meaning is not limited to the intention of the artist. Duchamp said the same thing concerning what had been written about impressionism: "You believe one or you believe another, according to the one you feel closest to" (to Cabanne 1987, 42). Pick the one you like.

Duchamp drew a moustache and a beard on a reproduction of Leonardo's *Mona Lisa*. Under the picture he carefully printed "L.H.O.O.Q." Pronouncing the letters phonetically in French renders "She has a hot haughty ass," in the same manner that "I.C.A.C.N.10.S.E." pronounced in English sounds phonetically like "I see a sea in Tennessee."

In French: "L" sounds like *elle* (she); "H" is pronounced "ah shay"; "O" is "Oh" (spelled "haut"); "Q" is similar to either "*queue*" (tail) or "*cul*" (ass). The combination of "L," "H," and "O" pronounced in French sounds roughly like "el ah show" (*Elle a chaud* or She is hot). The second "O" must refer to the French word "*haut*" (pronounced "oh"), meaning high, pretentious, or haughty, as in *haute couture*. Put together: "She has a hot haughty ass"—a joke.

Arnheim comments that artists, particularly the French, often joke and play, and he insists that the persistent failure to recognize this has handicapped American art criticism (1989, 274). Mikhail Bakhtin corroborates Arnheim's observation when he tells us the main reason contemporary critics fail to understand Rabelais is that they insist on fitting images of the carnival grotesque into "the framework of official culture" (1968, 473). A major theme running throughout Mikhail Bakhtin's *Rabelais and His World* is the importance, and positive quality, coarse scatological and sexual humor had in the work of sixteenth-century artists. This humor is also important in the work of Duchamp.

When invited to participate in the Dada Salon of 1920, Duchamp sent another pun, a two-word telegram: "*Pode bal.*" This pun, which sounds like

[4]They punished, for example, men who married widows, men who were beaten by their wives, and men who beat their wives in the month of May—which was considered an inappropriate time for wife beating (Welsford 1961, 207).

"*Peau de balle,*" was greatly admired by French artists and writers in the dada and symbolist group. *Peau* (literally "skin") combined with *de balle* (of bullet) means "skin of bullet," which can imply the following idiomatic expressions: "tough" (bullet-proof skin); "skin ball" or testicle; "ejaculation" (skin bullet); skin of the ass (*trou de balle* means asshole); or a rare idiomatic expression, "nothing doing." Thus the pun renders a combination of: I'm tough; I've got balls; I'm bullet proof, impervious to your entreaties.

Also, since *peux* (as in *je peux*) means "I can," Duchamp's telegram possibly means: "I can ejaculate (fire a skin bullet)," "I can resist your entreaties," or even "I can resist; you can't make me ejaculate." These two words reek of multiple meanings—some that are obvious, some that can be figured out, and some that are sensed lurking on the staircase. (The French use "staircase wit" to mean those clever things you think of saying as you exit down the staircase—when it is too late.) The two words even suggest a double entendre in English: "You can't make me come" (to the salon to which he had been invited, or ejaculate).

Anne D'Harnoncourt reasons that Duchamp's fascination with puns was consistent with his theory of "*infra-mince*" (roughly translated as "infra-thin"), which referred to his rapt attention to minutiae. Based upon minute shifts in sound or spelling, the best puns create several separate but related meanings with the fewest possible words (1989, 37). Thus puns demonstrate an elegant economy of language by lavishing attention on the most minute details, while simultaneously maintaining an awareness of each change and its exaggerated effect on the whole. Suddenly Duchamp seems to have a lot in common with Jan van Eyck: a careful attention to both the micro- and the macrocosmic, which is also a fundamental concern of Saussurean linguistics.

Add to Duchamp's elaborate verbal puns a series of equally elaborate rebuslike[5] visual puns; plot a multitude of sexual puns into one large piece; spend twenty years working in secret on that one piece; then incorporate into this *bouillabaisse* the potential for a host of elaborate and related connections with agricultural and alchemical allegory: and the result is Duchamp's major work, *The Bride Stripped Bare by her Bachelors, Even* (Figure 9.1—also known as the *Large Glass*.[6]

As an opening ante: if the word "*m'aime*" is exchanged for its sound-alike "*même*" in the French version of the title, it translates as *The Bride*

[5]The rebus and hieroglyphics have always offered the strongest fusion of words with visual images. Both are a preliminary stage in the development of a phonetic approach to writing.

[6]The French title is *La Mariée mise á nu par ses célibataires, même*, 1915–1923 (*le Grande Verre*). Soon after spending twenty years working on the *Large Glass*, Duchamp began another twenty-year odyssey on *Étant Donnés: I° la Chute d'Eau, 2° le Gaz d'Éclairage*, 1946–1966 (*Étant donnés*). This work was done in deep secret, and it is at least as complex as, and even more esoteric than, the *Large Glass*.

FIGURE 9.1 Duchamp, Marcel. *The Bride Stripped Bare by Her Bachelors Even* (*The Large Glass*)—Front view (c. 1915–23). Oil and lead wire on glass (109 1/4″ × 69 1/8″) The Philadelphia Museum of Art: Bequest of Katherine S. Dreier—Photo by: Graydon Wood, 1992.

Stripped Bare by Her Bachelors Is in Love with Me. Consequently, the oral pronunciation of the title opens the gambit with two quick and easy meanings. Furthermore, Jack Burnham says that the French title suggests a brutal public stripping, not amorous foreplay, so Duchamp is implying that even though other artists may "in time strip art of her signifying power, Duchamp has done it already—leaving a Bride who is not virgin" (1973, 160).

As far as I know, this work has generated more complex translations than any other artwork in history. Several entire books are devoted to explaining its significance. Arturo Schwarz reasons that all Duchamp's important early pieces converge toward this major work—many of them are even included in it—and all his important later pieces diverge from it. Predictably, then, this major piece should offer the greatest number of alchemical references. And it does (1989, 89). Schwarz points out numerous correspondences between the *Large Glass* and alchemical icons. It would not be reasonable to attempt a complete rendition in a single chapter, but a brief sample of the underlying theme, and a partial translation of just one isolated image, may help to demonstrate the complexity of the overall piece.

Burnham insists that the element of unrequited sexuality and mechanical sexuality that so many find in the *Glass* is one of the many "covering ruses" proper to a hermetic alchemist (1974, 89). The division of the glass into two halves reflects the single most important element of occultism. Burnham quotes the *Emerald Tables of Hermes* (the source of the word "hermetic") *Trismegistus:* "What is below is similar (NOT EQUAL) to what is above, and what is above is similar to what is below in order to insure the perpetuation of the miracle of the Unique Thing" (89).

A subtitle of the *Glass* labels it an "agricultural machine," and Mikhail Bakhtin tells us that growth and renewal are the leading themes of the carnival grotesque (1968, 450). Schwarz explains that the label "agricultural machine" refers to the alchemical wedding of earth and sky, and it associates plowing with insemination, thus sex.

Duchamp spoke of the *Glass* as "a world in yellow." As stated before, yellow represents gold and the sun in alchemy, and thus revelation, because light reveals. Both yellow and gold signify in initiate in alchemy, as well as in several other sacred pursuits, such as some branches of Buddhism and Taoism (Schwarz 1989, 90). Consistent with his intent to celebrate the verbal over the retinal, Duchamp supplied an oral image of yellow rather than the actual color yellow.

Beginning with the pun in the title, the extensive subtleties in the implied elements are a hint that Duchamp intends to exploit myth. In the mythic tradition the *Glass* employs visual allegory, puns, and metaphors to disguise its real content from all but the initiated. In other words, it exploits the visible as a disguise for the invisible.

Jung has observed that whether we recognize mythical references or not, they project a spiritual presence that directly affects our unconscious (1953, 293). Duchamp and his major piece the *Large Glass* are themselves examples of contemporary myth, for few people in the history of the visual arts have been ascribed a more mythic reputation than Duchamp, and no other work of art has ever spawned the myth, or endless array of articles, books, and valid translations, that the *Large Glass* has—unless it should be Duchamp's last major piece, *Étant Donnés* (for short), which was kept secret

and intentionally unveiled only after his death. What better way to mythologize an event?

Duchamp's Readymades establish yet another connection to alchemy and another example of his interest in myth. He titled and exhibited manufactured objects he often chose arbitrarily—a urinal, a bicycle wheel, a chocolate grinder, and so forth—insisting that anything he selected and chose to call art was art. This act was intended to demonstrate that artistic elegance exists everywhere under everyone's nose, but goes unrecognized: it is an allusion to the discovery of the Philosopher's Stone. Schwarz offers a relevant quote about the Philosopher's Stone from a seventeenth-century document by Barclus: the Stone "is familiar to all men, both young and old, is found in the country, in the village, in the town in all things created by God; yet it is despised by all. Rich and poor handle it every day. It is cast into the street by servant maids. Children play with it. Yet no one prizes it" (1989, 89).

Once pointed out, the connection with Duchamp's work is obvious. Schwarz reasons that Duchamp is demonstrating that, like the Philosopher's Stone, art exists in commonly overlooked objects everywhere. Duchamp himself said the "choice of these Readymades was never dictated by aesthetic delectation. The choice was based on a reaction of *visual indifference* with a total absence of good or bad taste" (from Schwarz 1989, 89). The nineteenth-century naturalists had insisted that any object whatsoever is a worthy vehicle for art; hence they painted mundane everyday objects. Duchamp took this practice one step further by exhibiting the objects themselves. If the first is true, he seemed to reason, why would the second be false?

Duchamp did once deny that he was an alchemist, and some have taken this to mean that alchemical interpretations of his work are invalid. But this situation is a little like the elementary logic riddle of the Liars and the Truth Tellers. Any serious alchemist would deny being an alchemist for at least two reasons: alchemy is a secret activity; and it is so complex that anyone who understands it knows it cannot be understood, and therefore would not be so arrogant as to claim the title. If asked, all honest people must deny being alchemists whether they are or not. Consequently, Duchamp's denial has no meaning.

Furthermore, though he denied *being* an alchemist, he did not deny being interested in and studying the science. It would be foolish, indeed, to contend that Duchamp had no interest in the elaborate sign system of alchemy. As John Golding points out, alchemy's mixture of science and the irrational, its direct connection between mind and matter, was exactly the approach that would appeal to Duchamp (1973, 86). Certainly he would have come into contact with alchemy through symbolism and the *Rose-Croix*—both of which were thriving in France when he created *Large Glass*, especially among artists and writers. Incidentally, the *Rose-Croix* is probably another source for the "Rose" in the name Rrose Sélavy.

Just after he exhibited his famous urinal in the Armory Show of 1913, Duchamp painted two versions of a chocolate grinder that had fascinated him since first he saw it in a shop window in Rouen. These were some of his last (somewhat) retinal paintings. In the second painting, *Chocolate Grinder No. 2* (Figure 9.2)—which he later used as an image in the *Large Glass*—he attacked several current artistic practices: like Degas before him, he shoved the horizon above the top of the painting in a variation of rising perspective, which transformed the entire painting into one large ground plane; and he returned to linear perspective, which modern artists had begun to avoid sometime after 1870.

The flat ground plane, an effect of the unusually high horizon, is a prototype of the formula Duchamp would later exploit in images like the *Large Glass*. Though the perspective in the depicted objects suggests they are situated solidly on a flat surface, Duchamp makes no other concession to the ground plane as background: he allows no cast shadows or modulation of

FIGURE 9.2 Duchamp, Marcel. *Chocolate Grinder, No. 2* (1914). Oil, thread, and pencil on canvas (26″ × 21″). Philadelphia Museum of Art: Louise and Walter Arensberg Collection.

tone to suggest a real surface. In short, he begins to move toward leaving the background entirely blank. In the *Large Glass* he went so far as to use glass as a support so the ground would be entirely blank, even transparent. Like most signing painters, Duchamp had always been more interested in the image of the depicted object than in filling in background spaces. He said: "The question of painting in a background is degrading for a painter. The thing you want to express is not in the background" (from Golding 1973, 68).

In the first version, the chocolate grinder was depicted as a flat shape: it mocked the multiple viewpoints of classic cubism. In the second, Duchamp rendered the chocolate grinder, and the ridges along the cylindrical surfaces, in precise traditional linear perspective; and this perspective is accentuated by threading string through the surface of the canvas to accent the ridges. His mechanically precise rendering negates the personal qualities that are so obvious when paint is applied by hand—in contrast to the modernists, who were fascinated by the practice and result of applying paint by hand.[7] The machinelike precision Duchamp used to paint apparatus that are intended to suggest sexual functions signifies that he was fascinated, like the alchemists who preceded him, by the idea of using machines to signify the function of human organs. As Ihab Hassan says, postmodernism implies a rejection of the human as a measure and as identity: he illustrates this with Warhol's well-known line, "I want to be a machine" (1987, 5).

Alchemists used sexual allegory to disguise their process, and they used machines and apparatus to represent human organs in their sexual allegories. In his notes for the *Green Box* Duchamp indicated that the chocolate grinder is a sign for the male genitals: in the *Large Glass* it represents the bachelors' genitals and complements the bridal sex cylinder. The *Green Box* is a key to the meaning of the entire *Large Glass*. Gloria Moure contends that because the grinder operates by itself, it is a sign for onanism: "the bachelor grinds his chocolate himself" (1988, 20).[8] Jack Burnham, however, insists that "grinding chocolate relates to the grinding of paint pigments" (1973, 168). Duchamp's signs consistently invite a multitude of interpretations.

Even the decision to paint this major work on a sheet of glass might well suggest alchemy, for alchemists believe the alchemic process of purifying the Philosopher's Stone causes it to surrender, one by one, the colors it has accumulated until it finally becomes transparent. Golding suggests that trans-

[7]Ecke Bonk notes that after 1912 Duchamp rejected what he considered superficial sensibilities of overwrought emotional expression and began to practice a very precise mechanical drawing—precision painting—carefully rendering razor-sharp edges and crisp line (1989, 9). But in a typically French response, he spoke of precision and promoted chance—his own version, in which chance was allowed only within certain parameters.

[8]Duchamp himself was a bachelor most of his life. He didn't marry until he was sixty-seven, and then he said he purposely married a woman who did not want children (from Cabanne 1987, 76).

parency represents revelation and true knowledge, and the process of trans-mutation into this state is often allegorized as the "stripping of the virgin" or "bride" (1973, 87). Thus *The Bride Stripped Bare . . .* Duchamp may also have painted his images on glass because it allowed viewers to see their environment through the glass, as well as themselves reflected in the glass (1973, 69). The artwork, the viewer, and the immediate environment are brought together into one simultaneous image.

Duchamp said there was a "gap" between the artist's conception of a work and the actual physical realization of the piece. This idea of Duchamp's has received little attention, but it seems to be a significant link to (or discussion of) two other important ideas that drive postmodernism: first, Saussure's famous "gap" between *langue* (an entire language system) and *parole* (the individual instances or utterances of speech); and second, the insistence—argued well in 1938 by Collingwood—that it is the original idea as it exists in the mind of the artist that is the real work of art, and not the product of that idea, which merely *represents* real art.

First (and briefly), Saussure explained that *la langue* represents the entire system of a culture's language. This system supposedly has nearly unlimited potential, which can never be realized in any individual act of speech (*parole*). Consequently, there is always a gap between *langue* and *parole*—between the potential of the language system as it exists in the mind and the individual's ability to fully realize that potential (1959, 19–24). Put simply, we are always disappointed with what we are able to communicate: "That didn't come out right; that's not what I meant," we are wont to say. We are all aware of this gap. William Faulkner demonstrated a similar concern in 1930 when he put the following words into the mouth of Addie Burden, an illiterate mother, in *As I Lay Dying:* "That was when I learned that words are no good; that words dont ever fit even what they are trying to say at" ([1930], 1955, 162–63).

The linguist's primary concern, Saussure argued, is with the overall system of language. When analyzing a language, the primary concern is "to determine the units and rules of combination which make up the linguistic system," not to describe individual examples of speech. Saussure "wrote": "we are separating what is social from what is individual and what is essential from what is ancillary or accidental" (1959, 19).[9] As an artist concerned with the elements of language, Duchamp was more interested in the process of probing the *system* of language than in the value of an individual utterance. As a result, he was always disappointed in the outcome of any single work—the gap between the language of art (*langue*) and product (*parole*). No

[9]Actually, Saussure did not write the *Course in General Linguistics* himself. In the tradition of Socrates and Wittgenstein, his book was writtten by several of his students from notes taken in his classes.

work ever matched his vision of the hidden potential in the combination of the visual and the verbal.

Second, Collingwood's thesis about musical composition fits the visual arts snugly with little translation. He argued that the business of the artist proper is to make a work of art. But this work of art is already complete and perfect as it exists in the artist's mind. If an artist fabricates the material work in order to exhibit his imaginary work to an audience, it then comes into existence as a real work of art. "Which of these two," he asks, "is the work of art?" He answers: "The work of art, is not the collection of noises, it is the tune in the composer's head. The noises made by the performers, and heard by the audience, are not the music at all; they are only means by which the audience, if they listen intelligently (and in no other way), can reconstruct for themselves the imaginary tune that existed in the composer's head" (1961, 139). Thus, Collingwood contends, the real work of art exists only in the artist's head.[10] The physical execution of the work is simply a communication of that idea—a trick of craftsmanship. Collingwood's hint, supplemented by other sources, leads to conceptual art.

Duchamp himself believed the actual work of art as it was fabricated by artists was incomplete until it had been "refined" by spectators. In his words: "All in all the creative act is not performed by the artist alone; the spectator brings the work in contact with the external world by deciphering and interpreting its inner qualifications and thus adds his contribution to the creative act" (1973, 48).

To reiterate: Duchamp believed there was a gap between what he held in his mind and the actual piece he produced. When this is considered in context with his belief that the real work of art exists only in the artist's head, and his contention that it is spectators who complete the pictures, his ideas begin to reverberate with powerful echoes of Saussure and also to augur the advent of conceptual art—perhaps even some aspects of reader response theory.

Duchamp's interest in the collaboration between artist and audience underlay his interest in myth. Since he was interested in contemporary as well as ancient myth, he was fascinated by the "discovery" of the fourth dimension.

Jim Holt notes that it was the Cambridge Platonists in the seventeenth century who introduced the idea of the fourth dimension. In 1671 one of them, Henry Moore, suggested that perhaps spirits were beings from the fourth dimension. Then Descartes added to his geometry an extra algebraic variable and described four-dimensional figures, which he called *suroslides*. Then Kant argued that we see in three dimensions only because our percep-

[10]I note that Richard Wollheim argues (not too convincingly) that this proposition, from Book I of *The Principles of Art,* is inconsistent with Collingwood's denial in Book III that "the relation of the audience to the work of art is non-existent or inessential" (1973, 250).

tion has been structured that way—so dimension became phenomenological rather than a reality. Finally, during the nineteenth century, several geometrists discovered an *n*-dimensional non-Euclidean geometry (1993, 22–23). Suddenly entirely unsuspected realities became imaginable, and thus available to artists, through the fourth dimension, which was supposedly hidden somewhere in the intricate curved space of non-Euclidean geometry.[11]

Tom Gibbons notes that the idea of the fourth dimension captivated European and American society so quickly that when M. Y. Sommerville published his *Bibliography of Non-Euclidean Geometry* in 1911, he was able to list about four thousand references to books, reviews, and articles about non-Euclidean geometry, hyperspace, and the fourth dimension (1981, 130).[12] The fourth dimension also had a powerful effect on many verbal and visual artists during the late nineteenth and early twentieth centuries.[13] The repercussions of non-Euclidean geometry were still being applauded as late as the 1960s, when Barnett Newman titled a painting *The Death of Euclid*.[14]

Duchamp and his contemporaries were fascinated by Einstein's new explanation of the fourth dimension as the relationship between space and time. Duchamp said: "What we were interested in at the time was the fourth dimension. In the 'Green Box' there are heaps of notes on the fourth dimension" (to Cabanne 1987, 39).

Actually, Duchamp and the others had little interest in the technical or mathematical aspects of the fourth dimension. They were interested in this

[11]Suzi Gablik notes that Lobatschewsky and Gauss demonstrated that the Euclidean construct of a single kind of fixed space was only one in an unending succession of viable constructs. Gauss insisted that a three-dimensional space was a peculiarity of human perception, not an inherent quality of space. "With the creation of non-Euclidean geometries, it became clear that mathematicians were not recording nature so much as interpreting it, and that there were no *a priori* means of deciding from the logical and mathematical side which type of geometry does in fact represent the spatial relations among physical bodies" (Gablik 1977, 70).

[12]Howard Hinton, in numerous books, articles, and pamphlets in the nineteenth century, was the most effective popularizer of the idea (Gibbons 1981, 134, 136).

[13]In her book *The Fourth Dimension and Non-Euclidean Geometry in Modern Art*, Linda Dalrymple Henderson documents that the fourth dimension influenced many authors at this time, including: Dostoevsky, P. G. Wodehouse, H. G. Wells, Oscar Wilde, Joseph Conrad, Ford Madox Ford, Marcel Proust, and Gertrude Stein (1983, xix).

[14]Holt notes that anecdotes about people disappearing into the fourth dimension were popular. For instance, the Los Angeles architect Quintus Teal designed a house in the form of a four-dimensional hypercube, or "tesseract." Because he did not exist in the fourth dimension, he unfolded the eight cubes that made up the four-dimensional house into a three-dimensional form—just as a three-dimensional box can be unfolded into a two-dimensional crucifix shape composed of six square planes. The cross in Dali's *The Crucifixion: Corpus Hypercubicus* is an illustration of such a four-dimensional hypercube unfolded into its three-dimensional form (1993, 23).

new, and hardly understood, concept because it was (and is) a twentieth-century myth—a modern cosmogony. What little they did know, they gathered from a man named Princet, a high school math teacher who, Duchamp said, "pretended" to be an expert on the fourth dimension. "The fourth dimension," he said, "became a thing you talked about, without knowing what it meant. In fact, it's still done" (to Cabanne 1987, 23–24).

Duchamp had demonstrated an interest in the fourth dimension as early as his painting of *Nude Descending a Staircase*. Like many painters at that time, he reasoned that if reality existed in four dimensions, it could not be captured in three. Therefore the artist was obligated to acknowledge this. Music and poetry take place in time. The painter's dilemma was: How can "time" be acknowledged in an art form like painting that has always existed in space? Several artists solved this problem by suggesting movement in their paintings. Because it takes time for any movement to take place, there is no movement without time. Hence time is signified by signified movement.

Nude Descending a Staircase is an excellent example of these attempts to signify movement and thus time. The image suggests a multiple-exposure photograph of a figure at different points in time as it descends a staircase. In fact, the painting was inspired by just such photographs. Duchamp stated that he was influenced by chronophotography, which captured the impression of objects in motion. He told Cabanne that he "wanted to create a static image of movement" (Cabanne 1987, 30).[15]

Duchamp further explained that he thought about a three-dimensional object casting a two-dimensional shadow and concluded by intellectual analogy that the fourth dimension should project a three-dimensional shadow. "It was a bit of sophism," he admitted, "but still it was possible. 'The Bride' in the 'Large Glass' was based on this, as if it were the projection of a four-dimensional object" (to Cabanne 1987, 40). What alchemist would not have been interested in the transmutational concept of the fourth dimension?

The idea that our perceptions are only a shadow of some more elaborate reality has intrigued philosophers and painters since Plato. In his *Republic* Plato used the analogy of prisoners chained in a cave so that they were prevented from ever seeing themselves or the other prisoners. All they ever saw was a "puppet show" of shadows cast by passing "implements" fashioned in the shape of humans and animals. The bearers who carried these implements sometimes spoke, but the prisoners heard the sound only as it

[15]Duchamp added: "I was explaining that, when you wanted to show an airplane in flight, you didn't paint a still life. The movement of form in time inevitably ushered us into geometry and mathematics. It's the same as when you build a machine" (from Cabanne 1987, 31).

echoed off the wall upon which the shadows were cast. "Then in every way," Plato concludes, "such prisoners would deem reality to be nothing else than the shadows of the artificial objects" (1961, 747–48: Sec. 514–15).

Painters have always been intrigued by the idea that paintings are elaborate two-dimensional "shadows" of a more complex three- and (later) four-dimensional reality. It is generally acknowledged that Saussure has had a powerful influence on painters who investigate the nature of this idea. If any other "writer" has had as strong an influence on twentieth-century painters who sign, it has to be Ludwig Wittgenstein, with his elaborate investigations of the limitations of language.

Painters have been fascinated by Wittgenstein's elegant transmutation of Plato's analogy: "what we expect is not the fact, but a shadow of the fact; as it were, the next thing to the fact" (1969, 36). Wittgenstein posits two kinds of painting: one kind of copy imitates what the painter sees and can be understood immediately without interpretation; but another kind of copy demands translation, "that is, [we] translate them into a different kind of picture, in order to understand them" (36).

If you receive a telegram written in code, you would not say you understood it until you had translated it into ordinary language. Though you had simply replaced one kind of symbol with another, you could now read the telegram with no further interpretation. You might also translate this telegram into a picture, but as in the first example, "you have only replaced one set of symbols by another" (Wittgenstein 1969, 36). Both the translation and the picture are the second kind of copy.

Speaking, hearing, or reading often generates visual images that correspond to a particular sentence. Therefore, as translations of that sentence, they are correct only when they appear to be similar to that which they represent. In Wittgenstein's words: "Copies are good pictures when they can easily be mistaken for what they represent" (1969, 36). But a flat representation of one hemisphere of a round globe of the world, for instance, is not a "copy" of the globe (36).

Wittgenstein's next idea might be fairly represented by the following example: a photograph or a painting of a face as it is reflected in a wrinkled piece of mirrored Mylar plastic is a "correct" projection of the reflection of that face; but it is not a " 'good portrait of so-and-so' because it would not look a bit like him" [or her] (1969, 37). The photograph of the image in the wrinkled mirror is not either kind of Wittgensteinian "copy" of the face. Still, such a "correct" picture, though it does not look a bit like the person, serves as a shadow of that person.

Wittgenstein also speaks of family resemblances. He reasons that we often use the same word, "language," for many varied examples of entirely different methods of expression that seem to be somehow related. This is not because there is one single thing that these many different methods have in common; rather, it is because they are related to each other in many different

and overlapping ways. "And it is because of this relationship, or these relationships, that we call them all "language" (1969, 31).

When we see a large family assembled—daughters, sons, parents, and grandparents—they generally resemble one another. Perhaps they do not all have the same nose, nor the same eyes, nor the same way of walking; but a myriad of similarities overlap, and this is what Wittgenstein refers to as "family resemblances" (1969, 31). This theory explains our ability to consider such disparate things as chess and football as being in the same "family" and to describe them all as "games." Wittgenstein's concept of "family resemblances" has had a strong influence on the arts.

Wittgenstein concludes that it is too simple to believe that all the ideas in a family of ideas contain a single ingredient in the same manner that all alcoholic beverages, such as beer, wine, brandy, whiskey, and bourbon, contain alcohol. It is also far too simple to think that beauty must be an ingredient of all beautiful things, that "we therefore could have pure beauty, unadulterated by anything that is beautiful" (1969, 17). This is consistent with the distinction between "beauty" and "elegance." "A *picture* held us captive," he said. "And we could not get outside it, for it lay in our language and language seemed to repeat it to us inexorably" (1958, 48).

These ideas—or similar ideas beginning to supersaturate the society around Duchamp: languages games, beauty without the ingredient of beauty, communication as a shadow of the real, and family resemblances—had a powerful influence on him. Certainly, Saussure, Duchamp, and Wittgenstein all probe and examine similar linguistic ideas: the shadow of the real, the gap between the potential of a language and what is expressed, and the game aspects of art and language. (Saussure also used chess as an analogy to explain many linguistic concepts).

Not only did Bosch and Duchamp manage complexity beyond the measure of words when they demonstrated a family resemblance between visual illusions, puns, anagrams, and myth, they both also managed a fusion of science and technology with art. Like Gauguin, Duchamp was well acquainted with the symbolists, and both artists were as interested in allegory as any medieval artist. Duchamp, too, echoed the well-known phrase from the Middle Ages when he claimed that he searched for the invisible in the visible.

Duchamp rejected retinal painting and invented a method of expression focused more on language. Writing and the visual became so interwoven in his work that it is not clear whether the words explain the visual or the visual explains the words. His work is elegant and playful in the manner of intricate games. He mixes words and images as if he intends to invent new games; and Wittgenstein insists that inventing a language is analogous to inventing a game (1958, 137). Still, if we accept Saussure's ideas (and Claude Lévi-Strauss certainly agrees), an individual can play language games, but no individual can single-handedly invent a language. Moreover, Duchamp demonstrated that he too accepted this premise.

Thierry de Duve reasons that when Duchamp said, "This language is it speakable? No," he was mocking the naiveté of painters like Kandinsky and the functionalists who believed they had invented a language, yet still expected their work to speak to viewers directly (1991, 128). In agreement with Saussure and Lévi-Strauss, de Duve advises us that no individual can invent a language, "even a pictorial one. It is language that founds the" individual, even the painter. De Duve insists that while Duchamp and the other major artists of his generation all wanted to find a foundational language, only Duchamp understood that no individual can invent a language alone (128–29). De Duve's comment is representative of poststructuralist thinking, but the limitations inherent in his idea demand some comment.

Is it really impossible for an individual to invent a language? Newton's invention of calculus in the seventeenth century in order to be better able to write about his new concept of gravity and L. L. Samenhof's invention of Esperanto in 1887 (once used by many as a universal language) might both be classified as inventions of new languages.[16] In the *Trilogy of the Rings* J. R. Tolkein invented a language spoken by the Ents, trees that walked and talked (though slowly, slowly), and people all over America still correspond in this language. A professional linguist, Marc Okrand, invented an entire sophisticated Klingon language to be used on the television show *Star Trek*. Klingon became so popular that Okrand published the rules and vocabulary in *The Klingon Dictionary*, and there are now 250,000 copies in print (the same as the number of hardcover sales of Gabriel García Màrquez's *Love in the Time of Cholera*). Then he marketed 50,000 copies of *Conversational Klingon* on audiotapes: "*Bljeghbe chugh vaj blHegh*" ("Surrender or die!"). Okrand says he is constantly surprised by people who approach him in public and speak fluent Klingon. (He does not.) And how about the previously mentioned shorthand languages for signifying each movement in a dance, Laban and Benesch? Are these languages or merely codes? Certainly none of these is the "natural language" sought by Bacon and Pound. There is no immediate audience for these new languages: no one immediately and spontaneously understood either calculus or Esperanto. They first had to learn the language. But that is true of every language.

The poet and critic André Breton delivered a lecture in Barcelona in 1922 in which he named the most advanced artists of the time: Duchamp,

[16]We must consider calculus a language if we accept Derrida's assertion that algebra is a language.

Esperanto was modeled after a universal language invented by the Chinook tribe that once occupied the area around what is now Portland, Oregon. It was said that any Native American west of the Rockies from Alaska to Baja California could understand *Chinook Wa Wa* (Chinook speak speak), and many Anglos who claimed to speak "Indian" spoke only this simplified universal argot. But we do not know if this language was invented by an individual or a collective.

Picasso, Picabia, de Chirico, Max Ernst, and Man Ray. Kynaston McShine notes that at that time, Breton had seen no major visual works by Duchamp because most of them were in America (1989, 138). So he must have based his decision on Duchamp's puns and the words accompanying his works. The surrealists were also heavily affected by six of Duchamp's puns when they were published in a contemporary journal. Breton wrote: "They were, to my mind, the most remarkable thing produced in poetry for a long time" (from McShine 1989, 138). Duchamp's reputation with these people depended mostly on his words.

Perhaps the most appropriate current successor to Duchamp is Shusaku Arakawa. Howard Smagula—in as clear and concise an interpretation of Arakawa's work as I have seen—explains that after Arakawa's early studies in medicine and mathematics, he realized that the claims science made to objectivity and logic were "based on self-referential systems and arbitrary signs" (1983, 66). (Note that this arbitrary quality of the sign has been a focus of concern for centuries.) Smagula continues that Arakawa's world view, balanced somewhere between Eastern meditative awareness and Western positivistic methods, perhaps predisposed him to believe there was just as much potential in some modes of nonlogical thought as there was in logic and reason. Like Wittgenstein, Arakawa understood that a full examination of language was necessary in order to fully understand meaning (66–67). On a blank white four-by-six-foot canvas, Arakawa carefully stenciled the three-line paradox: "I HAVE DECIDED TO LEAVE THIS CANVAS COMPLETELY BLANK." (The description suffices, this verbal work hardly needs to be seen.)

With this and many far more elaborate linguistic traps, Arakawa deliberately confused viewers with painted signs and linguistic paradox to reveal that our construct of the world is "dependent on thought, and that thought is significantly modified by language" (Smagula 1983, 72). Arakawa displays an absolutely medieval propensity to embrace both poles of a paradox. He seems quite comfortable with the fact that he has written on a canvas that he claims he has decided to leave completely blank. That seems a little like a doctor offering a lifetime guarantee for eternal life.

In *Gödel, Escher, Bach: An Eternal Golden Braid*—a Pulitzer Prize–winning comparison of language games in mathematics, art, and music—Douglas Hofstadter explains a looping paradox that he calls a "Strange Loop." Arakawa's canvas and stenciled statement in combination is an example of Hofstadter's "Strange Loop": one element cancels the other. But as separate elements, either the blank canvas or the statement stenciled on it is harmless (true?), perhaps even useful. Mathematicians and those interested in the structure of other languages have for millennia been puzzled by the paradox and Strange Loops inherent within the structure of all languages.

One of the most famous paradoxes in history was created in the seventh century B.C. by the prophet and poet Epimenides, a Cretan who said: "All

Cretans are liars." If the statement is true, the speaker obviously cannot be be-lieved; hence the statement cannot be true. Hofstadter twisted Epimenides' simple paradox into a "Strange Loop" when he wrote: "The following sen-tence is false. The preceding sentence is true" (1979, 21). As in Arakawa's un-blank canvas, each separate sentence is harmless, but taken together, they make a loop and create the same effect as Epimenides' statement—similar, Hofstadter says, to the effect created by M. C. Escher's drawing of two hands, each drawing the other.

Both Duchamp and Arakawa refuse to acknowledge the verbal and the visual arts as separate languages. Their works are difficult to classify in any category: they are neither painting nor sculpture, verbal nor visual. Or are they both? Or all? This tendency to explore that "aporetic" area between po-lar elements challenges traditional boundaries (as postmodernists are so prone to do), accentuates the mythic quality of their work, and echoes the concerns of deconstructionists to come.

Jacques Derrida used the word "aporia" as an analogy for decon-struction when he spoke of "that singular aporia called 'deconstruction'" (1986, 137). And even Timothy J. Clark—who harbors severe reservations about the strategy of deconstruction—insists that aporia, those doubts con-cerning the boundaries of art, vision, representation, and "everything in-volved in the act of painting," is a value and an aesthetic in its own right (1985, 12).

Extending the idea further, Derrida wrote that it is necessary to think of all history in terms of an aporia; and furthermore, that aporia stimulates work, "provokes thought, and confuses the limits between the realms of the text" (1986, 136). When Duchamp said, "I have forced myself to contradict myself in order to avoid conforming to my own taste" (from d'Harnoncourt 1989, 35), he created further ambiguities and doubts about such limits. He also echoed two often quoted nineteenth-century American statements, the first by Walt Whitman and the second by Ralph Waldo Emerson: "Do I contradict myself? Very well then I contradict myself!" and "A foolish consistency is the hobgoblin of little minds." Perhaps this is one of the reasons Duchamp moved to America and became a citizen—in Derrida's words: "America *is* deconstruction (*l'Amérique, mais c'est la déconstruction*)" (1986, 18).

This word "aporia" is a natural for use in deconstructive discussions. It implies doubt, particularly doubt concerning language, boundaries, or be-ginnings; thus it suggests a sense of reversal in the primacy of cause and ef-fect or origins. And Edmund Leach tells us that this area of aporia, "the boundary, the interface layer which separates categories of time and space, is the zone of the sacred," and thus is linked to magic, taboo, and religion (1985, 19–20).

Duchamp moves beyond Saussure's structuralist concepts into those areas that were later plumbed by linguistic investigators such as Noam

Chomsky, Wittgenstein, and Arakawa. Saussure believed the structure of language was defined by his theory of signifier and signified, combined with ideas such as syntagm versus system. Burnham notes that when Saussure recognized the inability of his system to note or explain the phenomenon of ambiguous multiple propositions in a sentence, he preferred to consider this a "relatively insignificant aspect of speech, thus a phenomenon which occurs outside of language proper" (1973, 28).[17] Noam Chomsky praises Saussure as a pioneer in the field, but he regards structuralism as a mere investigation of "surface structure," while "deep structure" can be found only through investigations of the linguistic structure of the mind (28).

Structuralists had labored to classify the elements in a few arbitrarily chosen sentences. They had little concern for meaning or the way a sentence was used. They felt that human beings learned meaning through stimulus and response, as the behaviorists insisted. Chomsky, on the other hand, focused on the underlying structure of the brain that endows human beings at birth with the innate ability to generate and understand an infinite variety of sentences—*even with little or no formal instruction*. Chomsky and his early followers attempted to define the grammatical rules that form the foundation of sentence construction. According to John Searle, they believed that the structure of the brain determined the structure of syntax, and hence that syntax was the most important key to the study of the human mind (1972, 19). But Chomsky's "generative grammar" was founded on the premise that form (or syntax) should be studied independent of meaning (or semantics), and this was soon perceived as a severe limitation. Later linguists attempted to find the structure that allows form and meaning to interact (thus the pervasiveness of the term *hermeneutics* in linguistics).[18] According to Searle, there are now two radically different concepts of language: the first is Chomsky's model of language as a self-contained formal system that is incidentally used to communicate; the second perceives language primarily as a system for communication (23).

Mark Poster tells us modernists had once assumed that theoretical discourse expresses a truth that exists in the theorist's mind and thus represents historical reality. In challenging this assumption, poststructuralist writers such as Foucault, Derrida, Baudrillard, and Lyotard apply the new perceptions concerning the nature of language. From this new perspective, they reevaluate the nature of theory, as well as the subject or the theorist that gen-

[17]Mathematicians also dismissed, as accidental or irrelevant, tiny variations in predicted results (7000.001 instead of 7000). Not until the advent of the complex sciences, such as chaos theory and fractal geometry, did they learn that these variations were significant and that they could utilize them.

[18]Searle insists that Chomsky's achievement is comparable to Freud's, that he has created more than just a revolution in linguistics, he has invented a new discipline of generative grammar that is revolutionizing both philosophy and psychology (1972, 24).

erates it.[19] These writers point out the language habits (which had previously gone unnoticed) that inescapably dominate and influence the discourse of theorists (1989, 3). Burnham deduces from his analysis of the *Large Glass,* and Duchamp's notes accompanying it, that Duchamp was investigating such poststructuralist semiology in art as early as 1912. He says this fact "explains the artist's subsequent secrecy and semiretirement from art. Duchamp's obvious aim after 1912 was to establish the most distant limits of art: anything accomplished after that he understood as so much repetition and elaboration" (1973, 170).

Duchamp fashioned a combination of signs proper and iconic signs that illustrated the polysemous and ambiguous nature of language. Like Chomsky and Wittgenstein, he demonstrated inadequacies in early structuralist theories—and yanked art into direct contact with poststructuralist concerns. When Wittgenstein, Duchamp, Derrida, and Arakawa point out flaws in language, however, they are not just demonstrating the inadequacies of our language system. Their probings also show the superiority of the complex, genetically based linguistic abilities that enable us to instantaneously consider the syntax of a word in relation to the words that accompany it. It is syntax that allows us to make apparent sense of sentences that offer endless combinations and possibilities of meanings.

Consider this short sentence: "I am going to town." My abridged computer dictionary lists twenty-eight separate meanings under "I"; I find twelve under "going," and eleven under "town." But our elaborate computerlike mind immediately selects the relevant meanings of these words in the context of this sentence, so that twenty different listeners will more or less agree on the basic meaning of the sentence. Someone unfamiliar with our language system, who looked up each word in a dictionary and tried to assign it the correct meaning for this sentence, would quickly discover the complexity of the system. If one meaning was selected for "town," that would limit the meanings that could be selected for "going." Any change in the meaning of one word would require changes in the meanings of the others. The task is so complex, in fact, that it seems just short of impossible. It should come as no surprise, then, that our elaborate language systems make it quite possible for a thoughtful person to create ambiguities and paradox. (The great surprise is that rigorous examination turns up so few.)

Duchamp worked on the *Large Glass* from 1915 to 1923—exactly the period when the death of the old rational order and the birth of the irrational new one could first be perceived.

[19]According to Poster, the word "poststructuralist" originated in the United States as a way to relate to the work of the French theorists named above. Many of these theorists would reject such a label (1989, 4).

William Klingaman begins his book *1919: The Year Our World Began* with this sentence:

"The world broke in two in 1919."

He maintains that was the year when alert members in our society first understood that the "last remaining vestiges of the old order had been swept away, and that mankind had entered a new age that was considerably less rational" (1987, vii). Dada and Marcel Duchamp introduced the art of this new age—postmodernism, the absurd, the art of the irrational.

10

Fools, Dream Painters, and the Mad Muse

Schizophrenia is the foundation of postmodernism. Furthermore, it is evident from the earliest historical records through the postmodern period that many societies throughout the world have a tradition of feigning both the sound and the image of schizophrenia.

Images created by mad artists are of serious interest in the postmodern art world. One manifestation of this interest is "Parallel Visions," a major exhibition of the work of such "outsider" artists that originated at the Los Angeles County Museum of Art in 1993 and has traveled to other cities since then. Writing about this exhibition, Ken Johnson notes that not only have many recent "insider," or mainstream, artists been influenced by such "outsider" art, but also that "the look of idiosyncrasy-bordering-on-psychosis" saturates the contemporary image in art (1993, 85). Johnson lists the following twentieth-century schools and artists as influenced by the art of the mad: surrealism, Chicago imagism, West Coast funk, "bad painting," new image painting, neo-expressionism, East Village wild style, Klee, Dubuffet, Breton, Ossorio, and Jim Nutt. He lists as more tangentially influenced: Baselitz, Boltanski, Red Grooms, Joseph Cornell, Philip Guston (his late work), Lucas Samaras, Peter Saul, Elizabeth Murray, and Jean-Michel Basquiat (1993, 85, 91). The list could easily be extended. Important postmodern writers have also been heavily influenced by the sound of schizophrenia: Joyce, Beckett, and Derrida are prime examples.

Gilles Deleuze, a philosophy professor, and Félix Guattari, a practicing Lacanian psychoanalyst, are two of the most influential poststructuralists and radical advocates for utilizing the schizophrenic process throughout society. In *Anti-Oedipus* they go so far as to promote what they call "schizoanalysis," the encouragement of a schizophrenic "process" (not

schizophrenia itself) as an alternative to what they perceive as the fascist, paranoic, autonomous individualism generated by modern capitalism and governments. They insist that the "schizophrenic process" is "not an illness, not a 'breakdown' but a 'breakthrough,' however distressing and adventurous" (1977, 362). Though Foucault's ideas differ in some aspects from Deleuze and Guattari's, he is a fervent admirer of their writing and theory, and the feeling is mutual.

I do not mean to imply in the remotest sense the naive idea that important writers and painters of any period are themselves mad. Shoshana Felman notes that only a few well-known writers—Nietzsche, the Marquis de Sade, Antonin Artaud, Baudelaire, Gérard de Nerval, and Hölderlin— were actually considered insane (1985, 48). Most successful artists, even those fascinated by images generated by the mad, are not themselves mad.[1]

In *The Fool* Enid Welsford tells us that prior to the seventeenth century many societies perceived little distinction between the foolish and the mad; both were often called "fools," and both were hired as professional entertainers. Fools entertained and were respected by society in Eastern as well as Western societies. In the East before Islam, the magic powers believed to accompany mad poets assured them influential positions in their tribe; they were also regarded as indispensable in battle (1961, 80).

Lillian Feder notes that ancient Greek philosophy and drama depicted madness as simultaneously a sickness and a gift. Madness was perceived as a source of insight because the mad were believed to be touched by the divine. This paradox (sickness versus divine gift of insight) has troubled our thinking about madness from earliest recorded history to the present (1980, 6).

The tradition of feigning madness was well established by the time of the Middle Ages, when court fools, who were often schizophrenics, were hired by kings and noblemen, as well as corporations and guilds, to entertain. Court jesters lived in luxury so long as they pleased their patrons (Welsford 1961, 156). Quality fools were in such demand that some noblemen were paid during their travels to act as talent scouts of mad entertainers (Billington 1984, 32). Professional fools were found everywhere—by the fifteenth century, they were obtaining work even in taverns and brothels (Welsford 1961, 121), and these positions were so lucrative that many people of sound mind sought employment by feigning simple-mindedness or madness. In *Piers Plowman* (ca. 1380) William Langland instructed his readers on how to avoid hiring those who deceive by pretending witlessness. Eventually a law was passed sanctioning investigations for the express pur-

[1]The old idea that genius and insanity are two sides of the same coin, which culminated in 1910 in the theory by Cesare Lombroso, has long been considered wrong.

pose of exposing counterfeit fools: *"de idiota inguirendo* allowed for examining the witlessness of" prospective employees (Billington 1984, 17, 33).

Many professional fools were women. One of them, Mathurine, was a notorious madwoman who flourished at the French court from the reign of Henry III through that of Louis XIII. Several seventeenth-century writers believed her madness was a mask contrived to disguise her politically astute observations. Her notoriety became a common refuge for satire: many writers used her name as a pseudonym for a kind of satire that came to be called "Mathurinade" (Welsford 1961, 154).

The practice of employing fools at court probably stemmed from the ancient traditional carnivals that were held on holy days. The famous Saturnalians—feasts of unrestrained drinking and merrymaking—that the Romans had habitually celebrated during the month of December eventually evolved under Christianity into clerical Saturnalians "in which mighty persons were humbled, sacred things profaned, laws relaxed and ethical ideals reversed" (Welsford 1961, 201).[2] These carnivals were led by a simulated Patriarch, Pope, or Bishop who was known as the "Prince of Fools." Participants performed satirical verse, plays, and sermons (201). These celebrations came to be known as the Festival of Fools. Bosch and Bruegel, among others, depicted such festivals in their paintings.

Though the Church harbored conflicting feelings about fools themselves, it often tolerated Fool celebrations because St. Paul had associated himself and his fellow apostles with the social fool: In I Corinthians 4:10 Paul had said, "We are fools for Christ's sake." Furthermore, Welsford maintains that such revelries were perceived as a vent for social pressures. Professional and amateur fools offered a remedy for the "pretentious vanity of officialdom, a safety-valve for unruliness," and a release for a secret spiritual independence that would otherwise be dangerous to display (1961, 321). A doctor during that period offered the analogy that wine barrels burst if their bung-holes are not periodically opened to relieve the pressure; and the clergy, being "'nothing but old wine-casks badly put together would certainly burst if the wine of wisdom were allowed to boil by continued devotion to the Divine Service'" (from Welsford 1961, 205).

Welsford reasons that these temporary periods of tolerated folly and inverted priorities must have generated the medieval concept that Fools were sanctioned critics of society (1961, 76). T. G. Nelson notes that many societies allow fools to make jokes that others are not allowed to make

[2]Some Native American tribes had a similar practice. A few members of the tribe might choose to be permanent "Contraries" who would satirize ceremonies, religious rituals, and even warfare (they sometimes rode into battle backwards) during the actual event. They walked and talked backwards and reversed common social customs.

(1990, 114). In the medieval Feast of Fools these sham fools even caricatured and mocked official clerics, which is why the fool's cap resembles the monk's cowl (115). The fool's position of privilege originated in the notion that the mad have been granted access to special knowledge—particularly knowledge of the future—by divine powers. This belief applied to seers and augurers as widely separated as Hebrew prophets, Greek oracles, and shamans. Muslims still maintain a strong connection between insanity, clairvoyance, and sainthood (Welsford 1961, 78). Westerners, too, still harbor such beliefs: Ken Johnson wrote in 1993 that those touched by madness "tap directly into deep psychic wells of creative vision, sources of inspiration to which most of us are denied access" (85).

In certain locations and during some periods, the medieval Festival of Fools was outlawed in Church activities, but the Prince of Fools was still quite welcome in the villages, universities, and even courts of law. Finally, the ecclesiastic version of the Feast of Fools evolved into secular Fools Societies (Johnson 1993, 205).

In *Madness and Civilization* Foucault tells us that a new image of madness appeared suddenly during the early Renaissance: "the Ship of fools—a strange 'drunken boat' that glides along the calm rivers of the Rhineland and the Flemish canals" (1965, 7). When villagers did not drive their mad out of town to wander naked in the countryside, they handed them over to mercenary boatmen, and these boatloads of insanity moved their unwelcome cargoes up and down the rivers from one town to another (8). Foucault sees these boats as a pilgrimage allegory, "cargoes of madmen in search of their reason" (9). A great disquiet descended on European culture at the end of the Middle Ages, and people took a sudden interest in these mocking and terrifying mad creatures because they signified the madness of the world around them (not unlike today). An entire new literature sprang forth in which fools no longer served as mocking echoes of the ridiculous but were regarded as guardians of truth: the mad—it was supposed—deceived deception itself. They spoke "love to lovers, the truth of life to the young, the middling reality of things to the proud, to the insolent, and to liars" (13–14).

A long tradition of images depicting, or inspired by, the mad was generated: Hieronymus Bosch painted *The Battle Between Lent and Carnival, The Cure of Madness*, and *The Ship of Fools;* Bruegel painted *Dulle Griet* (*Mad Meg*); Erasmus wrote *Praise of Folly;* and Cervantes wrote *Don Quixote.* Northern art and literature, in particular, exploited images of the Feast of Fools, and the face of madness has kindled the imagination of Western artists ever since the fifteenth century (Foucault 1965, 15). The divine knowledge and wisdom that were so ephemeral and attainable only in fragments to the reason-bound seemed to come intact to the fool in an "unbroken sphere" signifying invisible knowledge (22). Foucault reasons it is this unbroken sphere, disguised as a traveler's bundle, that is thrown over the

shoulder of Bruegel's *Mad Meg*, and the sick man's attempts to penetrate this crystal sphere are mocked. He further conjectures—though he offers no supporting evidence or rationale—that this is the sphere on the exterior of Bosch's *Garden of Delights* (Figure 4.3) when the panels of the triptych are closed (22).

Fred Gettings explains, perhaps more persuasively, that the traveler's bundle, tied at the end of a stick and carried over the shoulder of a fool or a lunatic, was an alchemical allegory for the Philosopher's Stone, the most precious thing of all and constantly overlooked (remember Duchamp's Readymades). The fools of the world never bother to look inside their sack to discover what it is that is weighing them down and holding them back. This was intended as a parable of life: few look into their inner life, and hence few discover the hidden riches of the golden soul (1987, 141).

The fascination with the image of madness is inseparable from the image of the carnival grotesque; and both began to wane rapidly at the end of the sixteenth century. Hence, Foucault tells us, during the seventeenth century—less than a hundred years after the saga of the Ships of Fools—the Madhouse was born (1965, 35). The principal strategy for coping with madness during the entire Age of Enlightenment was to confine the mad, to remove them from sight. Numerous prisons and madhouses were established—often in former leprosariums, which had been vacated after the fourteenth century. More than one out of every hundred citizens in Paris came to be confined in these enormous madhouses. Some were merely mendicants—idleness was considered the source of all disorders (38, 47).

The Age of Reason banished to the madhouses "the debauched, spendthrift fathers, prodigal sons, blasphemers, men who 'seek to undo themselves,' [and] libertines" (Foucault 1965, 65). There was little sympathy for the insane in the eighteenth century, particularly after 1758, when Tissot's *Onanism or the Illnesses Produced by Masturbation* was published. From then on, laypeople as well as the medical community believed that the insane created their own afflictions (Gilman 1982, 156). But fools still entertained the public. Since the Middle Ages, people had customarily visited madhouses for entertainment and "education." And they continued to do so. Keepers displayed their mad creatures to spectators as if they were monkeys performing tricks (Foucault 1965, 68).

Social behavior during the Englightenment was increasingly dominated by a worldly concern for the "dignity of man" rather than a concern for "cosmic law." Actions in public were designed to demonstrate dignity and give the appearance of respectability. Tolerance for fools declined (Billington 1984, 81). Light had signified divine revelation and divinity during the Middle Ages, but after the Renaissance it came to signify truth revealed and objective knowledge and logic, for people had begun to examine all ideas in the "light of reason." Hence the new period was called "the Enlightenment" and the Middle Ages referred to as the "Dark Ages," signi-

fying an absence of the light of reason, a thousand-year drought between two periods of green.

At the beginning of the nineteenth century, no historian or psychiatrist perceived any viable alternative to confining the mad. There were few prisons where the mad were not chained in the dark beside criminals: "The calm madmen [were] treated worse than malefactors" (Foucault 1965, 221). Little attempt was made to free the insane until the hegemony of postmodernism during the last quarter of the twentieth century.

In his history of insanity Foucault—the exemplary poststructuralist who, until just before he died, defined himself as against the Enlightenment, reason, and the autonomous Cartesian "self"—concludes that those disciplines that study the workings of the human mind, consciousness, and culture have been biased against madness because they have refused to try to understand its unique language. Based on this romantic image of insanity, Foucault blames Descartes for the Enlightenment's focus on rational thought to the exclusion of all other. He insists that this focus negated any contributions the mad had to offer to society.

Derrida explains that Foucault's is a history of madness that speaks from the foundation of its own experience, rather than "a history of madness described from within the language of reason" (1978, 34). Foucault tries to avoid the trap of an objective history "caught and paralyzed in the nets of classical reason, from within the very language of classical reason itself" (34). Foucault's dilemma is that within our logic-driven society it is difficult to maintain a persuasive argument that is opposed to reason without using the language of reason itself. Derrida points out that "one can protest it [reason] only from within it"; consequently, "one cannot speak out against it except by being for it" (36). Derrida, too, regrets the lack of a language of madness.

Postmodernists maintain a suspicion of the three integrated classical paradigms: reason, objectivity, and history (for history has always been a rational concept). They search for alternative strategies to reason as painters once searched for alternatives to rational Renaissance perspective, which had also seemed so objective and self-evidently true. Many twentieth-century thinkers have based their alternative perspectives on the "language" of insanity.[3] Postmodernists in general are fascinated by languages and their ability to simultaneously amplify and limit our understanding. Émile Benveniste, for instance, maintains that linguistic form is the "first of

[3]Feder reasons that when Antonin Artaud declared, after one of his bouts with insanity, that delirium was "as legitimate, as logical, as any other succession of human ideas or acts," he was protesting the clinical definition of madness and demanding recognition for an alternate mode of communication (Feder 1980, 7).

all the conditions for the realization of thought. We do not grasp thought unless it has already been adapted to the framework of language" (1971, 56). This is not to limit thought to verbal languages. Mathematics, music, and the visual arts, for example, also adapt thought to the framework of language. But just as the framework of language allows us to grasp thought, it also imposes strict boundaries on the thought it structures.

If language is compared to the trunk, limbs, and twigs of a tree, thoughts might be represented as the leaves. Without the trunk and limbs of language, the leaves of thought would lay in a sodden, muddy heap on the ground. They could not extend far and still maintain their relationship to one another. Linguists like Benveniste have argued that there is thought without language, but it remains exceedingly simple. The "linguistic" system of the trunk and limbs organizes and relates the leaves and extends their realm into areas they would never have reached without this nourishing system. But the system is limiting: the leaves cannot reach in any organized manner beyond the finite limits of the trunk and limbs: thought isolated from language withers and dies.

In other words, languages structure and extend our thoughts into otherwise unreachable heights and relationships, but they also limit our thoughts to those areas encompassed by the specific language we are using. For instance, ideas can be expressed and proved in one language, such as algebra, that can barely be approximated in another, such as English. The same structures and limitations apply to Western culture's logic and reason. Reason is a convention that allows us to think precisely about specific concepts, but it blinds us to other ideas.

Language is not only the medium within which thought exists; it is also a medium that blinds its user to its limitations.

Derrida applies the following analogy to both language and reason: the blind cannot see an implement that supplements their sense of sight and thus allows them to see: "*Blindness to the supplement* is the law," he insists (1992, 89). Consider the sound generated when any two objects collide. Many of us come to assume that sound will be generated any time two hard objects collide after traveling toward each other at a considerable speed. We then tend to believe this sound is created solely by the collision and rarely think of the critical role played by the medium upon which sound travels. A collision in a vacuum would generate no sound whatsoever because the medium, air, is as crucial to sound as the collision is. Yet we tend to forget the role it plays. Air is so pervasive it is invisible.

Sigmund Freud (1856–1939) examined madness and dreams to discover the medium within which they existed, and found the previously invisible unconscious. Foucault explains that in the late nineteenth century Freud initiated an investigation into madness (and dreams) as a unique language, and he inspired in "medical thought, the possibility of a dialogue with unreason"—the irrational unconscious (1965, 198). In one of the most

influential and persuasive acts of recent history, Freud convinced an entire century that *"Language is the first and last structure of madness"* (100).

It was Freud's concept that madness and dreams are structured like languages that fascinated the surrealists (and later the postmodernists). They hoped that by reaching an understanding of the structure of Freud's newly discovered languages they might come to understand or extend the structure of their own painted and written languages. Perhaps, even, Freud had provided the key to unlock the impenetrable human mind—particularly the unconscious, which has always been important to artists.

The initial impetus for this interest in language that drove Freud and his followers and the surrealists was generated by the nineteenth-century American philosopher Charles Sanders Peirce (1839–1914). Peirce was just seventeen years older than Freud. Colin McGinn maintains not only that Peirce is the greatest American philosopher, but also that he anticipated most "of the course of twentieth-century philosophy, especially in epistemology and the philosophy of science" (1993, 28). Furthermore, there seems to be a steadily increasing recognition of his influence. McGinn offers a simpler and more succinct snapshot of the core of Peirce's complex ideas and overall contribution than I would have believed probable. He notes that Peirce gave us several key postmodern innovations. The following four fundamental principles of Peirce's thought as explicated by McGinn are important to ideas developed through the remainder of this book:

1. Peirce argued convincingly that "truth" is whatever a community of competent inquirers agrees on: "It follows that when doubt and disagreement cease, truth will be the inevitable result" (McGinn 1993, 27). Because truth to Peirce is little more than a communally accepted belief, it is, therefore, never stable; and it never quite matches the way things actually are (27). Some poststructuralists, I note, are uncomfortable with Peirce's idea of truth, which they call "consensual truth." Derrida, for instance, applauds "the undecidable."

2. Peirce gave us an important strategy that he called "abduction"— now called "inference to the best explanation" (McGinn 1993, 27). An inquirer who employs this strategy attempts to explain relevant data or pieces of information by making radical guesses or imaginative hypotheses that may extend well beyond the available data—but that can still be tested in light of those data. Peirce maintains that we constantly employ such hypotheses, not only in science, but also in our basic perceptual judgments (27). Children learn to do this early. When a child sees an oil spill that prisms light into a variety of colors and tells a parent to "come see the dead rainbow," this is an early attempt at "inference to the best explanation."

These hypotheses are "creative efforts to represent how the world has to be in order for the data to be rendered explicable"; without this method of reasoning, "human thought would be crippled" (McGinn 1993, 27).

Peirce maintains that science is rational only when truth matches that upon which human inquiry converges (27)—hence he gives us the communal or collective truth of postmodernism. This method might be perceived as an extension of the freedom to assume other realities that was loosed by the nineteenth-century discovery of non-Euclidean geometry. Certainly the concept of the collective and collaborative generation of new ideas espoused by Collingwood and the postmodernists is related to Peirce's concept of communal truth.

3. McGinn tells us that Peirce understood more precisely than any prior thinker that a workable logic must account for its representations through semiotics. Reasoning, Peirce explained, is accomplished through signs (either inner signs or exterior signs), and these signs must have meaning if the beliefs they generate are to have any substance. Hence the linguistic strategy woven through all postmodern thinking stems from Peirce's basic construct that meaning is the fundamental principle of the theory of inquiry, or epistemology; and "epistemology is the ultimate subject of metaphysics" (1993, 28).

4. The signs that a community of inquiry employs generate a linguistic community. Such a community may consist of any group of people who cooperate in any inquiry, including: the medical, psychological, or scientific community; the art world; that linguistic community composed of Bosch and his audience. Hence the idea of a community of signing inquirers (as first mentioned in the chapter on van Eyck) is basic to an understanding of postmodernism (McGinn 1993, 28).

These four principles offer a glimpse of the basic strategy that drove the postmodern interest in linguistics, hastened the waning of the solipsistic, indivisible, unique self, and thus sounded the death knell of the cult of individual genius. Every individual inquirer was henceforth understood to be governed by the "communal standard supplied by logic, and expressed in a system of public signs, so that in the long run convergence of opinion is accomplished" (McGinn 1993, 28).

Just forty years younger than Freud, André Breton (1896–1966) was the driving force of surrealism and the point of the lance in the postmodern penetration of the arts. He had worked with shell-shocked troops during the First World War, and he was fascinated by Freud's idea that both insanity and dreams are structured like languages.[4]

[4]Surrealism grew out of linguistic concerns stemming from dada. J. H. Matthews insists the dada group advocated a complete break with the past, and they were strenuously opposed to language as it had been traditionally used in the arts. They sought to undermine the foundation of language by denying logic. An early issue of Dada asserts: "Logic no longer guides us" (from Matthews 1965, 21).

Breton and the enfeebled irrationalist forces in the arts suddenly found Freud's discovery, supported by Peirce's philosophy, a weapon to aid their struggle against what some had long felt was the tyranny of reason: "We are still living under the reign of logic," Breton wrote in his first "Manifesto of Surrealism," fifteen years before Freud's death. "But in this day and age logical methods are applicable only to solving problems of secondary interest. The absolute rationalism that is still in vogue allows us to consider only the facts relating directly to our experience" (1924, 9).

Breton insisted that in the name of civilization and progress the proponents of reason had banished superstition and fantasy; but Freud, he felt, had reasserted the rights of the imagination. Breton searched for "strange forces" in the depths of our minds, forces that could augment, not replace, conscious reason. Once discovered, he asserted, these forces would be submitted to the control of reason (1924, 10).

If we were limited to either method of thinking alone, our understanding of the world would be incomplete. Both the rational and the irrational methods have their weaknesses, but when each supplements the other, they gain added strength. Breton envisioned a rationality rendered virile and vital by its access to the autonomy and inventiveness of the irrational. He wanted to harness the irrational to the service of reason, like a wild and untrained horse harnessed and forced to pull alongside a well-trained one. As a matter of fact, Breton was obliged to compel reason to argue its own abdication: reason, simply because it was reasonable, advocated the hegemony of its competitor, the irrational.

Breton was interested in Freud's exploratory excursions into the meaning of the dream world as an escape from the everyday world in which people were merely the "playthings" of their own memories. Breton insisted the dream had its own reality and continuity, but people ignored their dreams in order to quickly resume their life in the daytime world, which they had left only a few hours before. That daytime world was all they considered worthwhile (1924, 11). Breton explained the surrealists' interest in dreams in four points:

1. There is evidence that dreams are as organized and continuous as daytime experience. They only appear disorganized and fractured because arrogant memory usurps the right to remove important transitions from what Breton calls the "sign of the dream" (which parallels current linguistic postures). Without these important transitions, we have only fragments of what was in actuality an entire dream, and we falsely interpret each fragment as one complete dream. Breton wonders if dreams might be used to solve fundamental questions of life. He assures us the questions are the same in both the waking and the sleeping worlds; then he asks: "Is the dream any less restrictive or punitive than" daytime reality? (1924, 11–12).

2. Breton considers the waking state an interference. It is the waking mind that has lost its bearings and makes (what we now call Freudian) slips

and mistakes. The normal mind responds to little else than "the suggestions which come to it from the depths of that dark night to which I commend it" (1924, 12–13).

3. During the dream, dreamers are fully satisfied with the reality of the dream. They no longer need to be concerned with what is possible: they fly, love to their heart's content, or kill (1924, 13).

4. Breton advocated the future union of dream and reality, "which are seemingly so contradictory, into a kind of absolute reality, a *surreality*" (1924, 14).

Hence surrealism is intended to be a combination of the real and the dream, the rational and the irrational. Later, in his "Second Manifesto of Surrealism," Breton explained that the art object "lies between the [sensuous] and the rational. It is something spiritual that seems to be substance. Insofar as they address themselves to our senses, or to our imagination, art and poetry deliberately create a world of shadows, of phantoms, of fictitious likenesses" (1935b, 255–56).

Breton insisted that surrealism was based on a disinterested play of thought used to create associations that were previously unavailable or ignored. He is here referring to "automatism," the disciplined ability to ignore conscious thought and gain direct access to the unconscious.[5] He calls automatism a strategy "dictated by thought, in the absence of any control exercised by reason, *exempt from any aesthetic or moral concern*" [emphasis mine] (1924, 26). This simple statement makes it easy to see why Breton exerted such a powerful influence on Duchamp. Breton advised writers to write the first thing that came to mind, so rapidly that the conscious mind could not control the flight of thought. Painters were to hold a marking tool and move their hand about so rapidly they would lose conscious control of it: they would not have time to plan rationally. Thus they would establish a direct connection from the hand to the unconscious. Breton declared this the region "where myths take wing" (1953, 299).

Furthermore, he advised writers and artists to *simulate mental disorders* in order to exceed the boundaries of conventional thought. This perhaps echoes the often quoted words of the late-nineteenth-century poet Arthur Rimbaud, who said: "The poet makes himself a visionary through a long, prodigious, and *rational* disordering of all the senses" [emphasis mine]. In 1930, in collaboration with the poet Paul Eluard (who was a close friend of Picasso's), Breton wrote "The Immaculate Conception," which had a section titled "Simulation of Mental Debility" (1930a, 51) and another section titled

[5]He wrote: "I shall never tire of repeating that *automatism* alone is the dispenser of the elements on which the secondary work of emotional amalgamation and passage from the unconscious to the preconscious can operate effectively" (1935a, 230).

"Simulation of Delirium of Interpretation" (1930a, 54). Each section demon-
strated how to simulate the state mentioned in the title.[6] The young Jacques
Lacan, who would later assume the leadership of the structuralist version of
psychoanalysis, reported on these articles approvingly.

Art would never again be the same.

Few artists of any period have denied that the best art issues from the
unconscious, but automatism, a method of tapping the unconscious where
art is known to abide, became the *technique* of choice in modern and post-
modern art. It evolved into the three principal directions of twentieth-
century art. The first pursued the dream imagery dredged up from the
unconscious for which surrealists were so well known: this might be per-
ceived as a new approach to the carnival grotesque, but without the humor.
The second direction focused on the linguistic aspects of painting and led to
a host of signing painters. The third direction developed into what the ab-
stract expressionists called the "autonomy of the hand," an unconscious
manipulation of art media that was later disciplined by ideas taken from
Taoism and Zen Buddhism.[7]

Their interest in Freud's dream language led Breton and the surreal-
ists to initiate what would later evolve into a consuming interest in linguis-
tics. Breton wrote that to speak of expression is to speak of language; thus it
should surprise no one that surrealism (he could have said "art") is "almost
exclusively concerned with language" and will constantly return to the
question of language after exploring other areas (1930b, 151–52).

The surrealists' interest in language and dreams led to a renewed in-
terest in myth. Susanne Langer explains that language reflects the human
ability to make myths more than it reflects the ability to reason. Though
language is related to both the logical and the imaginative (the mythic), the
older of the two is the mythic (1946, vii–ix).

The surrealist interest in language and myth, in turn, sparked a new
interest in alchemy.[8] Breton declared there was a remarkable analogy be-
tween the goals of the surrealists and those of the alchemists. He reasoned
that the principal purpose of the Philosopher's Stone was to liberate the
imagination through the "long, immense, *reasoned* derangement of the
senses" [emphasis mine] (1930b, 175). The surrealist discussions and
Breton's writing were so full of references to alchemy that he was prompted

[6]When this article appeared in the *Éditions Surréalistes*, it was preceded by an an-
nouncement explaining that the work included attempts to simulate various mental disorders
to demonstrate "the capacity of the mind to exceed, by poetic means, the conventional bound-
aries of 'normal' thought" (F. Rosemont, from Breton 1930a, 49).

[7]See Dunning 1991a, 174–77.

[8]Breton was taken with André Malraux's comment that "the work of the Western artist
consists of creating a personal myth through a series of symbols" (from Breton 1935a, 231).

to comment: "Alchemy of the word: this expression which we go around repeating more or less at random today demands to be taken literally" (1930b, 173).

Breton believed the whole point of surrealism was to gain access to the "'prime matter' (in the alchemical sense) of language" (1953, 299). Finally, he connected all this with "a certain return to the study of the philosophy of the Middle Ages" (1942, 288). Breton recognized surrealism as a new approach to an ancient artistic tradition that intended to tear through the drumhead of reason and look through the rip to worlds beyond (1953, 300).

Whitney Chadwick reports that Breton and the other men in the surrealist group were obsessed with both the power of myth and the alchemical significance of women. They believed women were endowed with two important abilities that were denied to men: the "inspiration of lucid frenzy; and the divine power of unaided conception—parthenogenesis, the immaculate conception." These characteristics were considered essential to the creative act in surrealism (1985, 182). Though from our perspective as we approach the beginning of the twenty-first century, the surrealists were patronizing to women even in their admiration, they were quite advanced in terms of the available light at the beginning of the twentieth century.

Perhaps because many early alchemical texts were written by women, alchemy had always held that the purified transformed person was half male and half female—an androgyne combining the best elements of both genders. Representations of androgenous figures were common in both alchemy and surrealism. Male surrealists aspired to female qualities in their own work, to signify spiritual fertility and procreation, and they linked alchemy with erotic implications in order to fuse opposite genders. The sexual act exemplified to them a combining of the two genders.

Women artists had long felt closeted off by their traditional roles and held impotent, unconnected, like robust bees imprisoned in separate bottles. Thus, Chadwick tells us, they readily accepted alchemy's support of the creative powers of women, which had so often been ignored, condemned, or forbidden by society (1985, 190).

Meret Oppenheim (1913–1985) studied under Rudolf Steiner, who was mentioned earlier as the founder of an alchemy-based group that featured theosophical ideas and the teachings of Madame Helena Blavatsky (Liebmann 1989, 127). In her speeches and interviews Oppenheim often spoke of androgyny: she maintained that true creativity demanded that the two opposite genders be consolidated in each individual (Liebmann 1989, 128). Oppenheim said: "A great work of literature, art, music, philosophy is always the product of a whole person. And every person is both male and female" (1975, 130). Though she faulted neither gender, she argued that Western society ignored such aspects of human beings as feelings, intuition, and wisdom in order to force the bloom of reason—at the expense of dis-

torting the concept of self in both men and women (131). Later, when the women's movement gained momentum, Oppenheim championed their cause but absolutely opposed the idea of "women's art." "The mind," she would snap, "is androgynous!" (from Curiger 1989, 82).

Oppenheim's *Breakfast in Fur* (Figure 10.1) has been cited and reproduced as often as any object in the history of surrealism. Slatkin considers this piece a striking model of the surrealist ambition to create disturbing objects (1990, 140). Her piece disturbs the viewer in the tradition of Duchamp's urinal, but it offers additional layers of meaning. This piece exemplifies unpredictable associations, an idea the surrealists had gleaned from Freud's concept of the linguistic structure of dreams and insanity. Oppenheim transformed an everyday household object into a nonutilitarian artwork. Thus she transmuted a familiar object into a suddenly exotic and alien image.

The gazelle fur that covers the cup is soft and sensual; it invites stroking and touching. The cup invites the viewer to envision drinking from it, but imagining the cup full of liquid creates a mental image of wet matted fur; and few things arouse a more overpowering tactile sense than the image of a mouthful of wet fur. Robert Hughes perceives the fur-lined

FIGURE 10.1 Oppenheim, Meret. *Object* [*Le Déjeuner en fourrure*] (*Breakfast in Fur*) (1936). Fur-covered cup, saucer, and spoon; cup 4 3/8" diameter; saucer, 9 3/8" diameter; spoon 8" long; over-all height 2 7/8". The Museum of Modern Art. New York. Purchase.

teacup as an icon of oral sex (1992, 69). Curiger reports that when an Italian art dealer asked Oppenheim to reproduce the fur-covered cup in a series of multiples, she "took revenge" by covering an oval with fake jewels, placing it under raised glass, and titling it *Souvenir of Breakfast in Fur* (1989, 82).

Like other surrealists, Oppenheim believed she should combat the tyranny of logic and reason, which had come to exclude all other strategies of thought. She argued that the rise of surrealism was "an indication that feelings, which have been suppressed for so long, are coming to the surface again to take their rightful place in our hearts—on equal footing with reason!" (1975, 131).

Feder argues that throughout the Age of Reason the antirational elements of madness and myth remained an important part of literature (and painting, I would add). Reason in Western civilization has always been locked in combat with its opposite, and starting in the nineteenth century, an antirationalist aesthetic took form. This new aesthetic attacked the Cartesian concept of the individual and the "self" (1980, 203). Subsequently, postmodernists in all fields have investigated insanity through the lens of linguistics. Feder explains that Freud's investigations into the unconscious mechanisms of dreams and imaginative writing "developed into various structuralist approaches to symbolism" (12). Psychoanalytic explorations of linguistic theory as a structure for interpreting dreams and symbols have, in turn, become a strategy for literary analysis.

Jacques Lacan combined Freud's ideas with rhetorical theory and Saussure's linguistic metaphor (Feder 1980, 12). Freud had reasoned that dreams and insanity were structured like languages. Both dreams and insanity, as we know, issue from the unconscious. Therefore—Lacan must have reasoned—the unconscious itself must be structured like a langauge. He wrote: "a material operates in [the unconscious] according to certain laws, which are the same laws as those discovered in the study of actual languages" (1977, 234). Thus Lacan expanded Saussure's linguistic metaphor to create a renascence in the investigation of madness, particularly schizophrenia, with his once-controversial insistence that "the unconscious is structured like a language" (1957, 103; 1977, 234).

Lacan asserted that unconscious dream-thoughts relate to each other in the same manner that signifiers in normal language do, and the tendency for dreams to condense ideas and place them in apparently unrelated contexts are "equivalents of metaphor and metonymy" (from Leavy 1978, 274). Lacan insists the human essence cannot be understood outside the context of madness (215). And interestingly, like Duchamp, he is addicted to complex and subtle puns (272). Postmodern literature is filled with references to Lacan's theory of the language of schizophrenia.

Frederic Jameson uses the linguistic metaphors invented by Saussure and Roman Jakobson as a lens through which to view the current state of society. He explains why Lacan's paradigm has been so useful to him, and

perhaps to other postmodern writers as well: Lacan's metaphor of schizophrenia, whether or not it is clinically accurate, suggests an "aesthetic model" (1984, 71).[9] Jameson ignores the traditional psychoanalytic background of Oedipal rivalries and so forth to focus on Lacan's description of schizophrenia as a breakdown in the chain of signifiers (72).

Jameson explains that Lacan accepts Saussure's two-pronged foundational concept that meaning is not derived from a "one-to-one relationship between signifier and signified"—the union of the word and the object or concept it signifies (72). This leaves us with the proposition that meaning is generated by the action that takes place between words—that is, the relationships between the links in the chain of signifiers.[10] When the relationships between the links in that chain break down, the chain snaps; and the result is a rubble of separate signifiers that do not relate to each other—in other words, schizophrenia (72).

This application of Saussure's metaphor generates two important ideas: (1) personal identity depends upon understanding and unifying relationships between past, present, and future;[11] and (2) the unification of time is a function of language. When schizophrenics develop the impaired understanding of time typical of their condition, they find it impossible to unite the links in the signifying chain from one moment to the next in order to decipher the meaning within and between sentences. When their signifying chains break, they are reduced to experiencing each signifier separately, "a series of pure and unrelated presents" (72) that deny both the future and the past.[12] Roman Jakobson and Grete Lübbe-Grothues have observed that Hölderin, "the greatest of the schizophrenics," wrote excellent poems after

[9]Jameson writes: "(I am obviously very far from thinking that any of the most significant postmodernist artists—Cage, Ashbery, Sollers, Robert Wilson, Ishmael Reed, Michael Snow, Warhol or even Beckett himself—are schizophrenics in any clinical sense.) Nor is the point some culture-and-personality diagnosis of our society and its art, as in culture critiques of the type of Christopher Lasch's influential *The Culture of Narcissism*, from which I am concerned radically to distance the spirit and the methodology of" my remarks (1984, 71).

[10]Leavy shows that Lacan's theory is also derived from Lévi-Strauss's concept of "symbolic order." Lévi-Strauss contends that the entire system of signifiers has been created and organized before any specific individual appears on the scene. Individuals are introduced to the system when they acquire language, just as they are introduced to all the other social forms. These social forms—dress, ritual, religion, courtesies, morals, etc.—are also structured like a language (1978, 280).

[11]In the next chapter I will explain that it is the Cartesian "self" or identity that depends on such an understanding. The post-Cartesian identity does not.

[12]Jameson notes that "some of Beckett's narratives are also of this order, most notably *Watt*, where a primacy of the present sentence in time ruthlessly disintegrates the narrative fabric that attempts to reform around it." And he notes that a group of poets in San Francisco (Language Poetry, or the New Sentence) seems to have adopted schizophrenic fragmentation as a fundamental aesthetic (1984, 73).

his psychotic break into schizophrenia, when he was totally incapable of maintaining any semblance of dialogue. But he wrote in nothing but the "unmarked" present tense: "The 'absolute rule of the present' . . . abolishes the sequence of tenses and reveals 'the whole of the cycle of time throughout each season' " (1985, 139).

In writing about the material from which dreams are made—rebus elements, puns, and picture stories—Leavy explains that like these dream images, the schizophrenic's signifiers "float"; "they do not exist in a one-to-one relation with any [other] particular signified element" (1978, 276). A schizophrenic patient was asked, What is insanity? "A strictly poetic term," he replied. "I say that because of its rhythm and the combination of vowel and n sounds" (from Richmond 1968, 50).

This points to the connection between insanity and art that current painters and art critics find so fascinating. There are two important analogies that apply equally to the three categories of schizophrenia, dreams, and signing paintings: (1) images "float" in an unending present; and (2) there is no established "grammar" that organizes the relationships between one image and another.[13] Hence, if the structure of the schizophrenic language could be deciphered, it might well translate into a parallel structure that painters could exploit to extend the potential of their own language.

In terms of the first analogy (floating), the images in Bosch's or Gauguin's paintings—or in other signing paintings that utilize rising perspective—float above and below each other, scattered across the surface of the canvas, unrelated to each other in viewpoint. Often they are not quite attached to the ground plane upon which they apparently rest. Though they may at first appear to rest on a ground plane (as in Bosch's paintings), they are often depicted as almost flat (with no apparent weight or volume), and they usually fail to match the perspective suggested by the ground plane or the high horizon line. Thus they are usually not firmly related by weight, perspective, or perception, and do not even cast shadows to either the ground plane or to each other.

Retinal paintings like Leonardo's *Last Supper,* on the other hand, use full dark-light shading to create mass and volume in the figures; the perspective and viewpoint of the figures matches that of the rest of the scene; and images within the painting are all related to one another because they exist in the same unified pictorial space owing to the fact that they are all seen from the same viewpoint. Furthermore, the figures often form a single monolithic group. Since these images are related to one another in many different theoretical and empirical ways, they do not "float."

[13] I use the word "grammar" here in the Wittgensteinian sense. He says grammar describes the use of signs; it does not explain it (1958, 137).

In regard to the second analogy (no established "grammar" organizing the relationships between one image and another): Leonardo's *Last Supper* is visually structured by the formal grammar of perception, as explained above. But it needs little grammar in a linguistic sense. It "says" only: Jesus, calm; Peter, questioning; Judas, dark and guilty—in a group in which the other ten disciples demonstrate facial and gestural expressions that are only slightly varied. A contemporary audience at that time (Peirce's linguistic community) might find some allegorical meaning: for instance, each apostle handles his own denial of faith differently. Still, such meanings are usually more inferred than implied or structured by a grammar. Bosch's paintings, on the other hand, *imply* many layers of complex allegory, and van Eyck's paintings signify complex scholarly arguments.

Can the schizophrenic language be translated into a parallel structure for painters? Though schizophrenic speech and drawings often seem indecipherable, there is a strong current interest in finding such hidden grammars (finding the invisible). Foucault insists that our lack of ability to communicate with the mad is *society's* language deficiency. He maintains that when we confine madness, we stifle a valid language: "in the patient's insane words there is a voice that speaks; it obeys its own grammar, it articulates a meaning" (1965, 188). Schizophrenic drawings, for instance, are often loaded with mythic references and allegory, and the artists often propose elaborate verbal translations of their work. Full of typical repetitions, mythic allegories, and fragmented ideas, the following paragraph from Prinzhorn's *Artistry of the Mentally Ill* is about one-third of the explanation this schizophrenic artist offered for one of his drawings:

> "Christ comes, the dead arise," is inscribed at the scene of a crime which begins with a judicial murder marked by a habeas corpus writ, and incited by insane physicians in the service of American railroad subsidy swindlers in Mexico, was hidden for 15 years behind insolent conscious falsification of documents by methodically secret poison murderers and killers in Germany, and ends with a miracle by the Holy Ghost, as represented in the attached drawing, a miracle in the insole of the victim ruthlessly sacrificed, disinherited, declared dead, by the secret violent poisoning and brain crushing of assassins possessed by Satan and mentally disturbed. A four-sided picture in an insole. . . . (1972, 87)

Algimantas Shimkunas tells us that recent studies indicate a loss of function in the left half of schizophrenics' brains. He explains that they cannot control what their attention is focused on, so their consciousness is taken prisoner by fragments of peripheral and irrelevant information. They cannot choose to pay attention to what is being said to them; instead, they may, for instance, arbitrarily focus on a color they perceive surrounding a light source. Since the left side of the brain is "immobilized," they do not respond well to verbal instructions or constraints (1978, 216). Notice that in

the extract above the speaker is unable to maintain a single topic even for the length of a sentence.

The left brain is responsible for our sense of continuity in time and endows us with the ability to respond to information from the recent and distant past; but the right hemisphere processes information simultaneously and immediately. As the right side of their brain grows more active to compensate for the passive left, schizophrenics tend to concentrate on the immediate present. Thus their verbal behavior, as well as their perception of the relationship between physical stimulus and sensation, is influenced by their most recent experience (Shimkunas 1978, 216).

Classic schizophrenics perceive little difference between objects—they may even fail to discriminate well between objects and people or objects and words. They have little ability to establish meaningful exclusionary categories (this is called "overinclusion"), so they have little ability to select adequate synonyms (Shimkunas 1978, 217). This tendency to broaden categories to include so many dissimilar things demands an increased ability to generalize in order to create more flexibility in abstraction. For example, schizophrenics may put cows and robins in the same category; then they must establish a new and meaningful category that includes the two by abstraction, and this demands a gross generalization that "may take some bizarre form, such as a 'milk giving creature which can jump over the moon,' [which] may cause the 'milkman to lose his job because she can deliver the milk herself, airmail'" (222). Such apparently incomprehensible statements by schizophrenics may "become understandable as attempts to combine different levels of abstraction" in an attempt to make some sense of an otherwise overly complex and undiscriminated reality (222). Schizophrenic thinking is currently perceived as shifting back and forth between oppositional elements; it is polar in nature (222). (This tendency to focus on oppositional elements is also a postmodern strategy.)

Finally, because schizophrenic thought is organized primarily in the right hemisphere (called "preattentive structuring"), the mind tends to sift unclear *verbal* thoughts through the right hemisphere and restructure them into *visual* schematics and pictorial representations (Shimkunas 1978, 223). It is easy to see how this construct would be of interest to signing painters, who wish to express verbal thoughts through visual imagery. Furthermore, as Otto Billig and B. G. Burton-Bradley note, schizophrenics characteristically show little or no organization of pictorial space: they seem to simply ignore it. Again, this is due to their lack of discrimination (overinclusion). They often cannot differentiate even between themselves and their environment (1978, 7).

At birth, babies are also incapable of differentiating between themselves and their environment, and until they learn to do so, they cannot establish relationships with others. Because babies recognize no limits in their personal world, they feel omnipotent. But as they explore their world,

they begin to understand their own position relative to their environment (Billig and Burton-Bradley 1978, 7). They begin to structure the space around them, and this structuralization "reflects not only the integration of the personality, but also the individual's conception and adaptation to reality" (8).

It is this integrated personality, spatially related to its environment, that schizophrenics fail to demonstrate in their actions, drawings, and paintings. And this same lack of spatial organization is evident in the work of signing painters to a greater or lesser degree—in fact, it is one of the family resemblances among various paintings that can be classified as postmodern. In contrast to formalists and retinal painters, signing painters tend to perceive a purposeful lack of spatial differentiation as an asset because the lack of discrimination between the object and its environment leads to an integration of figure and ground. This is yet another characteristic shared by schizophrenics and painters who sign: they tend to execute both figure and ground in a similar, often microcosmic technique, and both favor the verbal or allegorical meaning of images over illusion or the organization of pictorial depth.

In short, many schizophrenics exhibit the following tendencies: they express themselves in terms of myth and allegory; they live in the immediate present; they appear to use linguistic structures that accommodate a multitude of simultaneous and immediate images; and they do not discriminate between past, present, and future. These are similar to the family resemblances in the work of many postmodern painters—as well as writers (for instance, Toni Morrison and Gabriel García Màrquez, who will be discussed in Chapter 11).[14]

The interest in schizophrenia demonstrated by current artists and critics is even easier to understand when the previously listed similarities are combined with the following elements: schizophrenics' propensity to express ideas in schematics and pictures; their tendency to use floating images (verbally and pictorially); and their compulsion to treat the image as sign at the expense of pictorial space.

Five major items in the postmodern agenda are: (1) to discover new linguistic areas; (2) to include and find value in diverse groups (for example, minorities and women) that have traditionally been denied voice, power, and privilege; (3) to explore the significance of oppositionary or "fringe" elements or ideas; (4) to fragment images and information; and (5) to break down traditional hierarchies (read: prejudices). Moral princi-

[14]For instance, George McMurray insists that García Màrquez creates a sense of cyclical time, which emphasizes the fact that times does not pass but repeats itself in a circle, and thus may construct or imply "an illusion of a perpetual present" (1977, 77–78).

ples nowadays are often perceived as little more than whitewashed prejudices. Important elements of many of these postmodern strategies are embodied in the thinking, writing, and images of schizophrenics, and there are ancient precedents for valuing insanity as another source of insight. In *Anti-Oedipus* Gilles Deleuze and Félix Guattari insist that we should liberate the schizoid impulses of the libido.

Madness is our muse.

Mildred Glimcher explains that because World War II so devastated the world psychologically, culturally, and materially, the following decade saw a repudiation of traditional values. This led to a search for national as well as primal origins. The mad events in the world about artists intensified their stronger interest in madness and mental illness (1987, 4–5). Further spurring this powerful new interest in the art of the insane was the reaction against the Nazis, who had derogated art by the insane in their famous Degenerate Art exhibition of 1937.

Jean Dubuffet (1901–1985) was one of the first artists to actively champion the work of what has come to be called the "other."[15] Dubuffet is known to have acquired a copy of the *Art of the Mentally Ill* in 1923, written by Hans Prinzhorn, who was both a psychiatrist and an art historian, and this book had a profound influence on his direction.

In 1945 Dubuffet began to collect what he labeled *"Art Brut"*—art done by prisoners, mediums, provincials, clairvoyants, and women (his connections may now seem inappropriate).[16] He was heavily interested in

[15]I use the term *other* here in its most simplistic sense, as it is often used in current art literature, to mean "those who lack access to power and privilege" (women, minorities, the mentally ill, the homeless, etc.). Hazel Barnes, in the introduction to *Being and Nothingness* by Jean-Paul Sartre (who was Simone de Beauvoir's long-time companion), notes that the idea of the Other has a long history. It started with Plato in the *Sophist*, though certainly not in its modern form. Sartre expanded the complexity of the concept, though Barnes says he recognized that his use of the word was still not too far removed from Plato's (n.d., xxiii). The philosophical use of the term referred to that which constitutes the other part of being. It is the counterpart or double of the former: the *non-ego* is the "other" of the *ego*.

Simone de Beauvoir used the term "Woman-as-Other" to refer to those who lack access to power, and this seems to be the meaning it has assumed in the usage of many current writers. The complex philosophical modern sense of the term actually started in the work of Hegel, and then Heidegger; and it was utilized in an even more fragmented complexity by Lacan. These three writers intend a far more complex meaning than I use it here: they intend the term as a counterpart to "Being"—particularly when the word is capitalized as "Other."

[16]Tom Gibbons explains that the invention of X-ray photographs by Röntgen in 1896 was immediately hailed as scientific proof of clairvoyance and the fourth dimension, particularly by theosophists such as C. W. Leadbeater (Leadbeater, alchemy, get it?). Clairvoyants had long been thought to see solid objects as transparent, supposedly because they had the ability to see a four-dimensional world (1981, 139). This, too, is similar to the perception many schizophrenics have of bodies and objects.

the work of the mentally ill—particularly schizophrenics, it appears, because their special linguistic bent often creates fascinating and imaginative juxtapositions of images. Dubuffet insisted there was no such thing as "art by the insane" any more than there was art by dyspeptics or people with bad knees (from Glimcher 1987, 6).[17] It was all just art to him. Dubuffet wrote:

> Among the most interesting works we have seen, certain were done by people considered to be mentally ill and interned in psychiatric asylums. . . . The clear-cut idea that we have of sanity and of insanity often seems to be based on very arbitrary distinctions. The reasons for which a man is judged unfit for life in society are irrelevant to us. Consequently, we mean to consider in the same light the works of all people, whether they are judged to be healthy or sick, and without making special categories. (1986, 97).

The influence of the art of the mentally ill on Dubuffet's work is apparent. His "Hourloupe" series, for instance, was obviously influenced by the work of Gaston Chaissac, one of the artists in Dubuffet's collection. Like the majority of Dubuffet's work, the figure in *Joë Bousquet in Bed* (Figure 10.2)—though executed with the competence and consistency of a talented professional—shows remarkable resemblances to drawings and paintings done by many schizophrenics:[18] the extreme distortion in the proportion of detail to whole; the refusal to indicate that one part is more or less important than another; the *horror vacuii* (tendency to cover the entire painted area with marks and detail); the concentration on multiplicity rather than unity; the childlike technique; and the fact that the figure is undifferentiated from its environment—figure and ground are well integrated. (This is not to be interpreted to mean that figure-ground integration, minus other elements, is a sign of schizophrenic influence.)

I have often noticed that a guitar-shaped human head (which suggests the shape of the skull), like the one depicted in *Joë Bousquet in Bed*, is a characteristic in the work of many schizophrenic artists. And Deleuze and

[17]Dubuffet was a revolutionary. He hated formal education, authority figures, and society in general. His book *Asphyxiating Culture* is a jeremiad against society. He suggested bringing the current society to an end by facilitating and accentuating its problems, "making it as bad as possible, implementing its most worn out, devalued clichés, and *heating* them, so to speak, as alchemists used to *heat* things, to the point at which they explode" (1986, 97).

[18]Incidentally, when looking through a book like Prinzhorn's *Art of the Mentally Ill*, I find that many of these works bear a striking resemblance to either medieval or postmodern work. It is extremely difficult to find any resemblances between these examples and other styles or periods. None of them would pass for a work done during the Italian Renaissance or for an example of retinal painting in modern art. But the elaborate verbal and allegorical meanings these artists are so easily coaxed to assign to their work bear a close resemblance to the intent of signing painters.

FIGURE 10.2 Dubuffet, Jean. *Joë Bousquet in bed* from the *More Beautiful Than They Think: Portraits* series. (1947). Oil emulsion on canvas (57 5/8" x 44 7/8"). The Museum of Modern Art, New York. Mrs. Simon Guggenheim Fund.

Guattari note that schizophrenics perceive the body as simultaneously "a random jumble of fragmented parts, and as a solidified, unindividuated, mass"; Antonin Artaud, after his psychotic break, referred to this perception as the "body without organs" (Best and Kellner 1991, 84). Dubuffet in *Joë Bousquet* captures well the image that schizophrenics use to express this perception.

Dubuffet advocated the art of the mentally ill and appropriated many of its characteristics for several reasons. He was interested in painting as a language, and the language of insanity was a powerful weapon in his war against the tyranny of reason. Clues he gleaned from madness helped him access the idea (known to Hogarth, Émile Bernard, and Burchfield) that memory retains the important essentials of things. The lack of discrimination in madness offered alternatives to society's canon of beauty (to which

he strenuously objected). Madness generated unpredictability (which he sought). Dubuffet was a pluralist who had an interest in the work of the "other." Finally, there is an unmistakable connection to the Philosopher's Stone.

Like many other signing painters, Dubuffet often spoke of alchemy: in fact, he did a series called "Philosopher's Stones" and mounted an exhibition titled "Landscaped Tables, Landscapes of the Mind, Stones of Philosophy." Dubuffet's interest in finding value in society's disenfranchised echoes the alchemist's belief in the Philosopher's Stone: the most precious of all things is constantly overlooked by all.

Furthermore, Ken Johnson reasons that the twentieth-century commitment to accept influences from outsider art is a moral choice. It demonstrates a decision to place less importance on "art history, tradition, contemporary theoretical discourse and social conventions," and an intentional move toward more "irrational impulses" (1993, 90).

Dubuffet conducted a constant assault against the dominance and shortsightedness of Western reason. He abhorred the arrogance of Europeans who believed their rational minds were capable of perfectly understanding the world and labored under the misapprehension that the rest of the world agreed with them. (This is another harbinger of the postmodern suspicion of Eurocentric history, cultural dominance, and solipsism—the refusal to concede validity to any experience or belief other than one's own.) He was convinced that tribal cultures considered reason and logic to be inferior tools for gaining knowledge, and argued that this was why they so admired delirium; and he believed art was closely related to delirium (1952, 127–28). This insight into tribal languages is borne out by Benjamin Whorf's studies of Native American languages such as Hopi in the 1930s: Whorf demonstrated that what we call "reason" is generated by the structure of European languages, and that many non-European languages are not structured so as to support the same logic (1941, 233–44).

Dubuffet is an excellent example of a proto-postmodernist. Like Hogarth and Bernard, he believed memory retained the important essentials of any subject. He believed it was unnatural to scrutinize living models, then paint an accurate inventory of the visible details: "Such a position in our relation to them seems to me to distort completely (if not to empty of all content) the mechanisms of communication that exist between" human beings and the objects around them (1954, 96). He argued that when art students carefully scrutinize and draw a motionless person, it violates the normal conditions under which unclothed bodies are seen. The idea that anyone could reconstruct under these abnormal conditions anything resembling the image of a naked person as it exists in a normal person's memory seemed the true insanity to him (96).

Because schizophrenics do not discriminate differences, they tend to lump apparently dissimilar things together. If there is no discrimination,

Dubuffet reasoned, there could be no standard canon for beauty; and he strenuously objected to the Western notion of beauty. Yet, with typical inconsistency, he took as his second wife Lili Carlu, a model during the 1930s who was celebrated for her (purely Western) beauty. Still, Dubuffet believed that tribal cultures accepted no such distinctions of beauty. Because they do not understand what Westerners mean when they say "beauty," we call them savages: "A name reserved for anyone who fails to understand that there are beautiful things and ugly things and doesn't really worry about it either" (1952, 129). In 1950 he painted a series called *Corps de Dames* (Bodies of Ladies) that many misunderstood as an extremely ugly attack on women. Helen Dudar tells us, however, that his intent was to paint women whom no one would covet, and thus remove them as objects of "lust and carnal possession" so they could become *"places* of celebration" (1993, 83). This is an idea ahead of its time, for many feminists today object to the constant representation of women as erotic images in art and the media. More importantly, *Corps de Dames*, like most of Dubuffet's paintings, are funny. These images, like those of Bosch, Rabelais, and Duchamp, can be interpreted as insulting, vicious, and threatening, however, if viewers do not perceive humor in the spirit of the carnival grotesque.

If the idea of these paintings as "places of celebration" is expanded, the subtle relationship between Dubuffet's paintings and maps becomes evident. Dudar notes that people resemble "places" even in Dubuffet's earliest paintings. The surfaces and textures of his paintings with dark and light lumps use the figure as a metaphor for landscape (1993, 83). These landscapes may be read as either micro- or macrocosmic representations, and often resemble relief maps of an entire country or continent. Once again, the relationship between painting and maps, so often evident in the work of signing painters, is demonstrated. This synthesized image also reflects the influence of the schizophrenic's inability to distinguish among people, places, and things. A noun is a noun is a noun.

Like the surrealists, Dubuffet believed the element of unpredictability was a major part of creativity: "A painting does not work for me if it is not completely unexpected" (1961, 165). Because schizophrenics overinclude, they tend to perceive unexpected relationships that escape normal people, and thus to create entirely unpredictable juxtapositions of objects and situations. Dubuffet, echoing the ancient belief that the mad could see the future, believed madness stimulated clairvoyance and unburdened the imagination, thus giving such artists wings (1949, 104).

Feder contends that the primary distinction between late-twentieth-century "non-rational" approaches to investigating the human mind and previous approaches is the growing belief, beginning with Nietzsche, that because God is dead, each individual consciousness is its own primary authority. The postmodern assumption is that this consciousness has been obstructed by rational masks and lies, and it can only be rendered visible by

returning to its eternal roots. These roots may be discovered in primordial processes that may be revealed only through madness (1980, 280).

Few painters have ever worked in as wide a variety of styles, materials, and subject matter as Dubuffet did. Yet, as Peter Selz notes, all these apparently disparate contrasts exhibit strong underlying consistencies: abstract landscapes easily transpose into tables or stones, and they resemble in surface and method his depictions of women (1962, 163). Dubuffet purposely blurred divisions between subject, material, and resemblance, and this vagary of boundaries again echoes the schizophrenic tendency to overinclude, as well as the previously mentioned postmodern interest in aporetic relationships—the dissolution of boundaries.

Dubuffet respected the work of schizophrenics as work created by the other. In direct opposition to solipsism, he strived to demonstrate that there is more than one valid reality. There are countless other equally justified readings of reality, all of which may be as valuable as the reading our culture imposes. Only habit leads us to confuse cultural convention and tradition with fact. In advocating this stance, Dubuffet demonstrated his appreciation for a pluralist point of view, a decidedly postmodern attitude.

Gilles Deleuze and Félix Guattari are currently the most influential and radical champions of the schizophrenic bias. They hope to teach nonschizophrenic subjects to emulate or utilize schizophrenic insight as a revolutionary strategy. They insist that traditional psychoanalysis supports modernism, that it neuroticizes and produces autonomous Cartesian identities, who passively accept authority and comply with repressive laws. They equate modernism with capitalism and insist it generates paranoia. The alternative strategy they advocate—which they call "schizoanalysis"—is the antithesis of psychoanalysis and modernism. It is meant to disassemble the modern Cartesian ego and "schizophrenicize" subjects to follow their own "desires" rather than society's imposed hierarchies and structures (1977, 362). But they caution innumerable times that they are not celebrating actual schizophrenia or intending to produce real schizophrenics.

Neither is schizoanalysis intended to produce a political party or organized revolutionary group; that would be considered fascist or totalitarian. Instead, Deleuze and Guattari hope to enable subjects who will not passively accept the authority of the state (1977, 380). They insist that art and science have a revolutionary potential if all concern for meaning—which to them is a proper concern only for specialists in the field—is ignored or dismissed. Art and science, they contend, should be exploited to decode and "deterritorialize flows" that are perceptible to eveyone. In short, Deleuze and Guattari believe artists and scientists should push to expose the most misguided goals and agendas of society, then encourage and enable those goals and agendas in order to thoroughly saturate and complicate the process until it becomes so explosive that artists and scientists will have no alternative but to react against the "authoritarian designs of a State that is incompetent and above all castrating by nature" (379).

Foucault explains in the Preface to Deleuze and Guattari's book that they are resisting the major enemy of society and justice: fascism. Not just the historical fascism of Hitler and Mussolini, "but also the fascism in us all, in our heads and in our everyday behavior, the fascism that causes us to love power, to desire the very thing [capitalism and its commodities] that dominates and exploits us" (1977, xii). Somehow, Deleuze and Guattari believe, their strategy of schizoanalysis will have an ultimate healing effect and create a new earth. "In truth," they assure us, "the earth will one day become a place of healing" (1977, 382).

11

The Post-Cartesian Concept of "Self"[1]

Individual members of any society share a common concept of "self." Like language, this concept of self simultaneously structures and limits their perceptions of the similarities and the differences between themselves and others. In *The Language of the Self* Anthony Wilden points out that most current sociologists and anthropologists consider the idea of self to be a construct specific to the society in which an individual exists. He reminds us that Claude Lévi-Strauss argues that the individual tends to disappear entirely within the social structure (1968, 178–79).

In order to understand the relationship between postmodern painting and previous styles, it is first necessary to understand the changing concept of personal identity and "self" and its effect on the painted image. As a society's concept of self changes, its art must reflect this change; otherwise it is relevant to neither artist nor thoughtful viewer. Understanding the difference between the modern and the postmodern concept of self, then, provides a foundation for perceiving many of the important differences between modern and postmodern painting.

Human beings have always speculated on the nature of the "individual," and for the last four hundred years we have struggled to comprehend

[1]Separate parts of this chapter were previously published under the following two titles: "Demonstrating Postmodern Structure to Painting Students Through Literature," in *Art and Academe* 4 (Spring 1992): 10–17; and "The Concept of Self and Postmodern Painting: Constructing a Postmodern Viewer," in *The Journal of Aesthetics and Art Criticism* 49 (Fall 1991): 331–36.

the reality of what we call "self." Walter Ong contends that the first *glimmerings* of a personalized self—an introspective, analytical, conscious awareness of the individual will—appeared sometime after 1500 B.C., about the time the Summerians invented the alphabet. He believes this gradual change in identity was generated by society's slow conversion from an oral to a literate tradition (1982, 29–30).

In his investigation of the human urge for fame, Leo Braudy points out that the original humanists of ancient Rome defined individual achievement in terms of public behavior: thus the entire society was driven to struggle for personal fame. But medieval Christians inverted Roman priorities. They emphasized private and spiritual values, rather than public behavior, as the primary avenue to self-fulfillment. The Church considered earthly life as nothing more than a brief preparation for the eternal glory to come, so medieval society had little interest in the individual (1986, 17, 213). Therefore, no medieval texts (other than the *Confessions* of St. Augustine, ca. A.D. 399) are autobiographical, and most medieval artists remain anonymous.

When Renaissance society discovered a new approach to classical humanism, public behavior was once again perceived as more important than private spiritual life. The status of the individual was revitalized. Renaissance artists invented new ways to advertise themselves, and this new public self was an external construct ("I am perceived by others"). The Reformation once again changed the relationship of spiritual to secular life in the sixteenth century, and a new interior awareness of the self emerged ("I perceive myself") (Braudy 1986, 343). The *Vita di Benvenuto Cellini* in 1562 launched a new tradition of self-perception in the form of autobiographical writing (although the term *autobiography* was not coined until the end of the eighteenth century).

Charles Sanders Peirce—the primary source of Saussure's theory—tells us that the seventeenth-century philosopher René Descartes, conditioned by this new interior and intuitive awareness of self, offered Western civilization the first rational notion of the individual soul (1986a, 491). In his new philosophy, Descartes offered convincing proof of the existence of self and body. He convinced European thinkers that the reality of self was proved by consciousness (*Cogito ergo sum*) and that of the physical world by the extension of the body in space. He developed a rigorous logical proposal: that the concept of self describes an inalienable nature that involves consciousness (awareness, feeling, and volition), while physical existence involves extension (three-dimensional extension and potential mobility in space) (Burtt 1954, 105–106). It was this idea that first established the basic Western dualism—the separation of mind and body. As T. S. Eliot tells us, in the seventeenth century a "dissociation of sensibility set in, from which we have never recovered" (1962, 2305).

The massive social, religious, economic, and political changes that took place during the seventeenth century could not have happened without a

major and corresponding shift in self-concept: "The overthrow of kings requires not just an explicit political theory or a set of grievances but also a deep-seated conviction that kings *can* be overthrown" (Braudy 1986, 342). Descartes's clearly and succinctly expressed version of the seventeenth-century concept of self would dominate the point of view of South Europe and most of its important artists until after the middle of the twentieth century. Italian and French painters during this entire period felt compelled to depict the external world in a manner that accommodated the Cartesian paradigm, and theirs was the dominant style. These "self"-centered paintings were geometrically oriented to, and centered upon, that specific site outside the painting where the painter is geometrically implied to have stood in order to view the depicted scene. This implied site is also the specific location where the viewer is assumed to stand. From the point of view of the exemplary modern perceptionist Rudolf Arnheim, "the location of an appropriately placed viewer is a prerequisite of the picture's existence" (1982, 49).

From the Italian Renaissance through the modern period, paintings were unified by various permutations of the structural elements of the Renaissance system of illusion. A unified light source, the separation of planes, linear perspective, atmospheric perspective, and color perspective all worked in unison to relate every figure and object to every other figure and object in the painting by depicting them all from a single specific viewpoint. Consequently, all the objects in such a painting exist in the same unified pictorial space. Arnheim contends that the Renaissance system of perspective was not invented to create likenesses, but to unify, "to provide a continuum of space in depth" (1982, 185). These paintings were unified in point of view (attitude), as well as viewpoint (location), because they were inspired by nature; thus they usually asserted a vertical head-to-foot image.

I maintain that such a painted text presupposes, perhaps even "constructs," a specific kind of viewer in the same manner that semiologists such as Umberto Eco insist that written texts imply or construct a specific kind of reader. That is, the writer of any text presumes his or her readers have a specific awareness, knowledge, or orientation. Authors may even attempt to modify the reader's consciousness. Recall how Eco used the first hundred pages of his novel *The Name of the Rose* "for the purpose of constructing a reader suitable for what comes afterward" (1984, 48).

Organized as they are around unified viewpoints and pictorial space, the self-centered paintings of southern Europe imply or construct a Cartesian viewer. They do not construct an empirical or a multiple viewer, as medieval and northern European paintings do. The very structure of South European painting implies a single viewer who stands in one specific location and visually extends a "sense of self" through a windowlike transparent picture plane into the illusionistic pictorial space depicted in the painting—as if both body and consciousness might travel into and move through the painting's pictorial space.

Toward the end of the nineteenth century, Walter Michaels points out, Charles Peirce expressed major disagreement with four principal aspects of the Cartesian method and spirit (1980, 188–89). Peirce was not the first to probe these flaws in the Cartesian method; some of these concerns were expressed by Descartes's earliest critics (including Christian Huygens) during his own time (190). Peirce, however, offered a systematic alternative approach to philosophy and the philosophical self (192).

Peirce argued three points that are important for the understanding, and perhaps the development, of the world view that created postmodern painting: "1. We have no power of Introspection, but all knowledge of the internal world is derived by hypothetical reasoning from our knowledge of external facts. 2. We have no power of Intuition, but every cognition is determined logically by previous cognitions. 3. We have no power of thinking without signs" (1986b, 2:213). In short, Peirce contends, we do not intuit an internal notion of self, as Descartes insisted, but instead, arrive at such knowledge externally, by inference and hypothesis. We construct a concept of self by trial and error (*empirically*). Furthermore, we know reality *only through signs*.

Michaels explains that Peirce argued persuasively that the self does not interpret; the self *is itself* an interpretation (1980, 199). Peirce argues elaborately and convincingly that we understand this personal self externally, *as a linguistic sign* (194).[2] Later Jacques Lacan corroborated Peirce's construct when he insisted: "I identify myself in Language" (1968, 63).[3]

When earlier art theorists—especially the formalists—based their theories on "form," they assumed that human thoughts and accomplishments were generated by, and thus must ultimately be related to, nature, which is in one sense or another created by some divinity; but the more current term *structure* implies that human ideas are generated through language, a human creation. Hence the term *structure* has come to be linked with human technology.

Linguists such as Saussure and Benveniste, for instance, argue that humans understand nature only through thought; language precedes all thought; hence thought, and thus our reality, is generated by language.

[2]Husserl had insisted that because the signifier "I" refers to a different person each time it is used, it constantly takes on a new signified (Jakobson calls these signifieds *shifters*). Heidegger's concept is "very close to Peirce's concept of the 'I' as one type of indexical symbol, substituting the concept of designation for that of signification" (Wilden 1968, 179–80).

[3]Walter Michaels explains that the earlier Cartesian self was primary and autonomous; it existed independently. But the twentieth-century construct, as developed by Peirce and Lacan, holds that we understand self as a linguistic sign, and like all signs, the self must distinguish itself in relation to some other, for that is the very nature of a sign (1980, 194).

The cultural shift from the term *form* to the term *structure* has come to indicate a shift of focus from material nature and the products of an industrial society to the postindustrial immateriality of a high tech service and information society. Rather than investigating the "real world," we now investigate social reality, and we base our understanding of this social reality on a human creation: language. Hence we now have a tendency to understand reality as a function of language.

In kindling the first embers of linguistic concern, Peirce sounds more like Huygens and the Dutch thinkers than like Descartes. Descartes, remember, was the spokesman for artists in the South, while Huygens spoke for painters in the North. Alpers explains that northern painting was created under the influence of concepts that were developed through Huygens's empiricism and Kepler's understanding of vision, and thus it corresponds to "the nominative and representative impulses attributed to language," particularly in North Europe, during and after the Renaissance (1983, 98).

Kindled by Peirce and fanned by Ferdinand de Saussure, the spark of aporia concerning the relationship of the external to the internal quality of self has blossomed into reams of poststructuralist discourse about "inside" and "outside": the *hors d'oeuvre* (the question as to what is inside and what is outside the work). Jacques Derrida writes of what he calls the *parergon* (literally "beside the work"). He discusses at length what aspects might be considered elements of the actual work and what might be conceived as beside the work (1978, 112; 1987, 15–120 *passim*).

Today we find Peirce and his concept of the self particularly interesting because it was he who invented the science of semiotics, and semiotics was a powerful influence on Saussure, whose linguistic metaphor—Frederic Jameson tells us—has become the foundation of twentieth-century criticism, including formalism, structuralism, poststructuralism, and deconstruction (1972, 101). Furthermore, Margaret Iversen shows that Peirce's system is richer than Saussure's for the purpose of formulating a semiotics of visual art. Peirce (and later Roman Jakobson) focuses more on the motivated visual signs—the icon and the index—than does Saussure, who concentrates on the arbitrary qualities of the unmotivated sign proper (1988, 84–85).

Taking a cue from David Carrier in "The Deconstruction of Perspective," I contend that perspective in South Europe has traditionally satisfied a Cartesian viewer who relates to the exernal world in a series of separate views, or pictures, each of which is located at a single point in space. The external world is typically the world of nature, in which at any one moment all objects are viewed from a single location. Carrier maintains that such a Cartesian viewer presumes the external world can be represented in a unified picturelike construct (1985, 28).

The unified monolithic system of Renaissance perspective implies or constructs Cartesian viewers who are inclined to extend themselves visually into the pictorial space of a visually unified painting (which was inspired by

nature). But this Cartesian concept of self may have little relevance in today's pluralist society, which we perceive to be influenced more by culture than by nature.

In our "postnatural" culture the abiding awareness of pluralist realities—multiple points of view—makes us question the completeness, if not the veracity, of any world that can be fully depicted from a single point of view. The isolated Cartesian self seems anachronistic as we close the twentieth century. When Ihab Hassan made his well-known list of eleven characteristics (or family resemblances) of postmodern art, he listed *Self-less-ness* as number four: "Postmodernism vacates the traditional self" (1987, 169). Consciously or unconsciously, our painters and critics insist on a new construct of self, a self that reflects our current beliefs and understandings.

Postmodern painters reject the single viewpoint and unified system of perspective that was used during and after the Renaissance because the principal purpose of such visual constructs is to unify the pictured world around a single center: the Cartesian viewer. In 1972 Leo Steinberg introduced a new term: "flatbed picture plane" (referring to the flatbed printing press, a horizontal bed that supports a printing surface). He maintains that this term describes the state of the picture plane after the 1950s. Steinberg's idea has been adopted by several current writers to refer to: (1) a picture plane that implies a horizontal surface; and (2) a fragmented multiple orientation to pictorial space, which is a characteristic of many postmodern painters (1972, 82).

In the first part of his argument—the implication of a horizontal surface—Steinberg insists that traditional paintings are inspired by nature and evoke responses that are normally experienced in an erect vertical posture, with the viewer parallel to the picture plane. Therefore the traditional picture plane in paintings inspired by the observation of nature "affirms verticality as its essential condition" (1972, 84). Steinberg maintains that even modern painters such as de Kooning, Kline, Pollock, and Newman—though they attempted to break away from Renaissance perspective—were oriented to a vertical plane. Their work addressed us head-to-foot because that is the form mandated by the construct of the vertical viewer. It is in this sense, Steinberg contends, that the abstract expressionists were often referred to as "nature painters."

When postmodern painters changed their reference from the vertical to the horizontal flatbed picture plane, their paintings began to signify the culture in which they lived rather than the slowly perishing world of nature. The postnatural world is now tyrannized by the pervasive artifacts and effects of human culture; and in such a postnatural world the work of artists, like the concept of self, must be shaped by the environment. Therefore art began to be inspired by the artifacts surrounding it, rather than by a rapidly dying nature. Steinberg contends that in painting, it was the work of Dubuffet, Johns, and Rauschenberg that began to indicate this substantial change in our concept of self.

Though we still exhibit postmodern paintings vertically—in the same manner that we tack *maps* (maps again), plans, or horseshoes to the wall—Steinberg claims these paintings no more insist or depend upon a vertical posture than does a tabletop, a chart or map, a studio floor, or any "receptor surface on which objects are scattered, on which data is entered, on which information may be received, printed, impressed—whether coherently or in confusion" (1972, 84). In an example of "inference to the best explanation," Steinberg reasons that when Robert Rauschenberg (1925–) "seized his own bed, smeared paint on its pillow and quilt coverlet, and uprighted it against the wall," it constituted his most profound symbolic gesture (84).

I am not entirely comfortable with this *first* portion of Steinberg's argument—the horizontal orientation of the picture plane. I do not see the evidence in current paintings; and though I am in sympathy with the idea, I do not feel this portion of his argument is well developed or convincingly argued. For instance, the pattern of paint (strokes, runs, and drips) on Rauschenberg's *Bed* (1955) clearly indicates the bed was first placed upright, *then* painted in that vertical position. The bed was not painted and then placed upright, as Steinberg insists.[4] I would like to accept this horizontal portion of his theory, however, because it would strengthen my own argument—particularly about the connection between Dutch painters and postmodernism. For it was the Dutch who first established the strong connection between maps and paintings when they painted charts and maps of all kinds to exhibit as wall hangings (Alpers 1983, 120).

In spite of my reservations about this first section of Steinberg's thesis, I believe the second portion (the fragmented multiple viewpoint) stresses an important departure from traditional perspectives and merits more attention and development. The second portion of this theory suggests a new post-Cartesian approach to pictorial space and an important new paradigm for the picture plane.

Even the cubists and the abstract expressionists—claims Steinberg—assumed that painting represented a Cartesian "worldspace." But postmodern painters use multiple viewpoints to create what he called a "flatbed picture plane"—a fragmented horizontal picture plane with a profusion of perspectives that refuse to locate the viewer in any specific position or identity (1972, 82). David Carrier reasons that the variety of visual choices allows viewers to play with the instructions they receive from the multiple perspectives that are constructed on such a flatbed surface—which create multiple viewer locations outside the picture plane. The flatbed picture plane generates a more complex relationship between viewer and painting because "no single point is defined as the right viewing point" (1985, 28).

[4]For a more complete argument concerning the first part of Steinberg's concept of the Flatbed Picture Plane, see Dunning 1991b, 334.

Rauschenberg laid his paintings flat, Steinberg insists, in order to impress several separate photographic transfers onto their surfaces. In works such as *Estate* (Figure 11.1) each of the multiple photographic images suggests a different viewpoint. Some of the images are upside down; some are seen from below in worm's-eye view; others are seen from above in bird's-eye view. The different viewpoints break the picture plane into separate fragments and imply multiple viewers.

FIGURE 11.1 Rauschenberg, Robert. *Estate* (1963). Oil and printer's ink (96" x 70"). Philadelphia Museum of Art: Given by the Friends of the Philadelphia Museum of Art.

Svetlana Alpers concurs that the fragmentation of the image so characteristic of seventeenth-century Dutch painting is also a characteristic of photographs. Seventeenth-century Dutch painters were heavily influenced by the camera obscura; and late-twentieth-century painters, along with their cultures, are even more influenced by photography (1983, 45).

Alpers notes whereas the Albertian painting was perceived as a plane section through the cone of sight, "an object in the world, a framed window to which we bring our eyes," the northern model of painting was congruent with the focal plane of a camera. Northern painting was perceived as taking the place of the eye itself (1983, 45). Consequently, the picture plane, the frame, and the viewer's location are left undefined: "If the picture takes the place of the eye, then the viewer is nowhere" (47). Neither northern art nor photography constructs a single-viewer location in the manner that Italian painting does.

Northern descriptive painting shares many characteristics with photographs: both create fragmented views; both use an arbitrarily chosen view; both can at times mimic the Albertian model; and both tend to displace time (Alpers 1983, 430). Alpers reasons that in a world artificially stilled and apparently submitted to the endless scrutiny of minute detail, as the world in Dutch paintings is, time is displaced since each observation appears to take place in a separate instant from the others (109).

The southern European, Albertian model, then, logically constructs a Cartesian viewer, but, I contend, the northern model does not. For the northern model of the picture plane is identified with the retina, and viewers cannot logically extend themselves into the pictorial space of their own retina the way Cartesian viewers extend themselves through Alberti's window into linear time or a unified pictorial space.

Rauschenberg, too, fragments the picture plane, in at least two ways: through the use of multiple images seen from different viewpoints; and through the pervasive use of photography, which creates a "focal plane" image rather than a transparent window. Each photograph in Rauschenberg's paintings was itself a separate illusion, and each of these "focal plane" illusions was oriented by its own perspective to a separate viewer location.

Steinberg reasons that in order to maintain relationships between these fragmented images, Rauschenberg was obliged to conceive of his picture plane as a surface to which anything "reachable-thinkable" could be attached. In other words, his painting had to become whatever a billboard or a bulletin board is. It is the single flat surface to which all the illusions are attached that unifies Rauschenberg's paintings. If one of the photographs or collage elements created an unwanted illusion of depth, he casually stained it or smeared it with paint as a gentle reminder that the surface was flat. Any kind of photograph or object could now be attached to the surface of a painting because such objects no longer represented an individual's view of the world, but rather a scrap of printed material (1972, 88).

These fragmented collage images seem impeccably tailored to the fragmented perception of viewers conditioned by rapidly escalating demands on their attention from a multiplicity of ever-more-fragmented media images with their glut of public personalities. Braudy insists that today's viewers are themselves "collage personalities made up of fragments of public people [role models] who are, in turn, made up of fragments" (1986, 5).

Like Rauschenberg, many current painters tend, through one pictorial device or another, to actually prevent the viewer from extending visually into the pictorial space of the painting. These painters often render their images in multiple perspectives, a series of fragmented Derridean apostrophes and digressions—footnotes rather than a cohesive central text—that each turns away from the main body or text. Each apostrophe, each digression, each footnote, constructs a different viewing location, or even a separate spectator, and thus implies a multiple rather than a single viewer.

Current novelists, such as Gabriel García Màrquez and Toni Morrison, display many of the tendencies, perspectives, and attitudes of postmodernism in as obvious a manner as current painters. Specifically, both García Màrquez and Morrison reject the single voice, or point of view, in favor of multiple points of view, and this creates a cyclic concept of time and a mythic reality. Using multiple points of view—which can easily be perceived as analogous to the painter's use of multiple viewpoint—constructs a post-Cartesian reader.

At least two major postmodern structural systems are as obvious and demonstrable in novels as they are in painting: (1) the use of equivocal fragmented "points of view," rather than the univocal monolithic practice of the moderns; and (2) the use of a cyclic time (created by the fragmented point of view) that refuses to separate past, present, and future, and is consistent with mythic realities. Postmodernists are more interested in the depiction of cyclic time than in a Cartesian, Newtonian, or modern concept of linear time because it implies relativistic glimpses of both consecutive and adjacent moments, as first demonstrated in the work of such writers and painters as Gertrude Stein, Apollinaire, and Picasso.

George McMurray explains that Gabriel García Màrquez, perhaps the most important postmodern novelist, often changes his perspective, or point of view, from third-person-singular to first-person-plural; and that he introduces numerous plot participants or observers, "some identified and some not" (1977, 132). This change in point of view can be seen as similar to the tendency among postmodern painters, beginning with Rauschenberg, to depict frequent changes in perspective due to changes in viewpoint. García Màrquez's fragmented point of view is supplemented by characters who show up again and again in different circumstances in subsequent works. This device creates the sensation that each story, each novel, is a mere fragment "of a more complete fictional universe" (158–59). It also suggests that his entire body of work may be perceived as cyclical.

Toni Morrison also changes point of view drastically and frequently in her work. In *Beloved* she alternates the third-person point of view between the characters of Sethe, Denver, and Paul D thirteen times in the first fifty pages. Then, toward the end of the book, Morrison devotes entire chapters to the first-person point of view of Denver, Sethe, and Beloved. In one chapter, toward the end of section three, an aporetic first-person point of view is shared by Sethe and Beloved—the reader is never certain which, so the mother and the child she killed become as one (again).

The fragmentation created by these multiple viewpoints in postmodern writing and painting often configures time in cycles. This cyclic configuration is also demonstrated by Morrison's and García Màrquez's relentless jumps into both past and future through great spans of time and space. Both writers refuse to separate present from past or future. McMurray insists that García Màrquez's emphasis on the fact "that time is not passing but turning in a circle" constructs "an illusion of a perpetual present" (1977, 77–78). The spiral structure of the novel, McMurray reasons, also creates a mythical time, a sense of endless renewal that tends to negate any movement through time, and "thus escape[s] from the terrors of history, into a realm of absolute stability. Aesthetically, the end result is a kind of static, timeless continuum in which present and past are joined spatially through the principle of juxtaposition" (135).

I contend that the fragmentation of the picture plane and the complexity of images in postmodern painting displace time in a manner similar to that described by Alpers in her analysis of seventeenth-century Dutch painters. I further contend that this penchant to displace time, along with a cyclic construct that refuses to separate past, present, and future, is a tendency in many postmodern works in both the visual and the literary arts.

Compare the compression of past, present, and future in just the first paragraph of each of two books: *Chronicle of a Death Foretold* by García Màrquez, and *Beloved* by Toni Morrison.

Here is Gabriel García Màrquez:

> On the day they were going to kill him, Santiago Nasar got up at five-thirty in the morning to wait for the boat the bishop was coming on. He'd dreamed he was going through a grove of timber trees where a gentle drizzle was falling, and for an instant he was happy in his dream, but when he awoke he felt completely spattered with bird shit. "He was always dreaming about trees," Placida Linero, his mother, told me twenty-seven years later, recalling the details of that distressing Monday. "The week before, he'd dreamed that he was alone in a tinfoil airplane and flying through the almond trees without bumping into anything," she said to me. She had a well-earned reputation as an accurate interpreter of other people's dreams, provided (1982, 1)

In this one paragraph the author speaks of Santiago Nasar's (future) execution, the (future) arrival of the bishop's boat, the (present) morning before this execution, the dream he had the night before (the past), and the separate

timeless reality of this dream. This same paragraph then jumps twenty-seven years into the future, where Nasar's mother still speaks of his dreams, and from this distant future refers back to that "distressing Monday," which is either the present—from our perspective—or the distant past from the mother's present position in time. When the author places the mother in the temporal position of "twenty-seven years later," he makes future of the past. From this position in the future, she jumps into *our* past when she tells us of Santiago's dreams the week before the execution. Then the author himself jumps into the mother's past, her life prior to that "distressing Monday," when he tells us of her "well-earned reputation." There are three more temporal shifts before the end of the paragraph. I count a dozen temporal shifts that compress past, present, and future in just this one paragraph; other readings of ambiguous situations could easily document more.

Toni Morrison, in her first paragraph, tells us the history of 124, the house in which most of the story takes place. Morrison tells us the following: Sethe and her daughter live in the house now; the grandmother is dead; Sethe's two sons each left under mysterious circumstances. And she relates several antics committed at different times by the resident ghost of Sethe's murdered baby.

All of this is told as if it had happened over a period of years, when in fact a close reading reveals that everything is overlapped and happening in close temporal proximity. Like García Màrquez, Morrison creates a deconstructionist's paradise when she refuses to distinguish among past, present, and future. This is the first paragraph in Toni Morrison's *Beloved*:

> 124 was spiteful. Full of a baby's venom. The women in the house knew it and so did the children. For years each put up with the spite in his own way, but by 1873 Sethe and her daughter Denver were its only victims. The grandmother, Baby Suggs, was dead, and the sons, Howard and Buglar, had run away by the time they were thirteen years old—as soon as merely looking in a mirror shattered it (that was the signal for Buglar); as soon as two tiny hand prints appeared in the cake (that was it for Howard). Neither boy waited to see more. . . . No. Each one fled at once—the moment the house committed what was for him the one insult not to be borne or witnessed a second time. Within two months, in the dead of winter, leaving their grandmother, Baby Suggs; Sethe, their mother; and their little sister, Denver, all by themselves in the gray and white house on Bluestone road. It didn't have a number then, because Cincinnati didn't stretch that far. In fact, Ohio had been calling itself a state only seventy years when first one brother and then the next stuffed quilt packing into his hat, snatched up his shoes, and crept away from the lively spite the house felt for them. (1987, 1)

Morrison tells us that Sethe's two sons left "within two months, in the dead of winter"; and then she tells us the house "didn't have a number then, because Cincinnati didn't stretch that far." "In fact," she continues, "Ohio had been calling itself a state only seventy years." This sounds as if the two boys

had left years earlier, before the house had a number, but when we go to the encyclopedia to investigate these two sentences, we find both refer to the same year, 1873, in which she has told us—earlier in the same paragraph—the story unfolds. From this information we can deduce that the house number 124 does not exist at the time the story takes place; Morrison has snatched the house number from the future. And in spite of the fact that this takes place in 1873, it is told as if it were happening in the present.

Morrison says: "Ohio had been *calling* itself a state only seventy years." She uses the phrase "calling itself a state" pointedly, because historically the date of Ohio's statehood is ambiguous. Congress passed an enabling act for statehood in 1802, and the Ohio state legislature convened on March 1, 1803, which is the year that is usually regarded as the one in which statehood was granted. But Ohio was not officially designated a state until 1953, when the U.S. Congress officially declared March 1, 1803, to be the date of Ohio's admission to the United States.

Both *Chronicle of a Death Foretold* and *Beloved* stress postmodern attitudes and structures in literature that are demonstrably analogous to attitudes and structures in painting. Both books liberate literature from the predictability of traditional linear time, just as Steinberg contends the flatbed picture plane has liberated postmodern painting to pursue a more unpredictable course (1972, 88). Modern artists were obligated to constantly assert, by rigorous control of illusionist elements, the integrity of the flat picture plane. But the flat picture plane is now an accepted given, and flatness is no longer a pressing problem that requires repeated proof.

As the postmodern novel is no longer obliged to maintain a single voice or point of view, neither is postmodern painting obliged to maintain a single viewpoint. Painters no longer feel bound, as de Kooning did, to adjust each area, stroke by stroke, until it is carefully resolved into homogeneous conformity with the overall illusionistic single "voice" of the painting.

This multiplicity of voice, viewpoint, and point of view must imply pluralism. For instance, Elizabeth Dobie describes current works, such as *Hera Totem* (1985) by Nancy Spero, as separate images—words and icons—on horizontal pieces of paper, two hundred feet long, strung like unwound scrolls around the room or hung in vertical strips from the ceiling. Each image is frontal, seen from a location directly in front of the image; thus each image is delineated from a separate viewing location (1990, 382). Dobie explains that because feminist work refuses to strive for a single voice, it "bears an intrinsic affinity to pluralism" (381). Consequently, these postmodern works, which alter "the position of women within discourse and their relation to it" (384), are pluralist in both viewpoint and point of view and thus might be said to reflect a new and more complex concept of self.

In *Recent Philosophers* John Passmore tells us that the traditional view of self equated personal identity with the continuity of memory: our identity was marked by our ability to think of ourselves as being "ourselves" (the

same self) at different times and places. Yet, paradoxically, we insisted upon a continuity of *body* rather than memory when we considered an amnesiac to be the same person as before the memory loss (1985, 18). Saussure's linguistic metaphor led Derrida to propose a new concept of personal identity, one with which the ancient philosopher Heraclitus might have agreed. Derrida displaces the idea of *identity* as defined by difference—in both the sign and the self—with the term *différance*, which implies both differing and deferring. Our identity, he contends, is now defined by the manner in which we are different from others within our own particular system, and this identity is never fixed or determined. Thus "Our 'nature' is always 'deferred' " (from Passmore 1985, 31).

Frederic Jameson tells us modernism was founded on the principle that the artist was obliged to invent a personal style as unmistakable as a fingerprint, and this principle links modern art to the concept of a unique self—an individual expected to generate a unique style and vision of the world. But today's scholars—who study fields as disparate as social theory, psychoanalysis, linguistics, and cultural and formal change—believe that kind of individualism and personal identity are anachronisms (1983, 115).

There are two variations on this theory. In the first, moderate postmodernists hold there once was such a thing as a unique individual, but it no longer exists in our age of corporate capitalism. In the second, more radical postmodernists maintain that the unique individual was never anything more than a myth. They contend it never existed, that the construct of the individual self was "merely a philosophical and cultural mystification" intended to persuade people that they were unique individuals (Jameson 1983, 115).

In either case, postmodernists contend that ideas and language belong to no one: the very concept of ownership depends upon either an obsolete or a mythical concept of the self. Derrida—speaking for many others—insists that poststructuralism heralds the end of private property. John Passmore tells us that the real meaning of this statement is: Poststructuralism portends the end of the private self (Jameson 1985, 33).

12

Science, Self, and the Sacred[1]

The end of the private self!

I have returned again and again to Passmore's disturbing interpretation of the poststructuralist agenda, and after considering the implications, I conclude that he has offered only a partial and inchoate interpretation. The poststructuralist agenda might be better explained as: The death of the *indivisible* self.

In this age of pluralism and fragmentation, it is the *indivisible* self that rings anachronistic. Consequently, the concept of a divisible self supplies the necessary mortar with which to fashion a rigorous and consistent edifice from the many concerns shared by postmodern thinkers—concerns such as our relationship with a collective identity; a cyclical rather than a linear sense of time; and myth as an alternative to narrative and history.

Since the sixteenth century, one of the principal differences between Western European–based consciousness and the consciousness of various tribal societies has been that the European-based societies have perceived individual identity as a single indivisible self communicating with indivisible others, while most tribal societies—both those that predate the sixteenth century and those that coexisted with or came after it—have associated each individual with something outside the boundaries of his or her own body and mind: an ancestor, an animal, a mountain, or a plant. Thus each individual tribal identity is divided.

[1]Parts of this chapter were previously published under the title "Postmodernism and the Construct of the Divisible Self," in *The British Journal of Aesthetics* 33 (April 1993).

Perhaps the difference between the tribal concept of a divided self and the European concept of an indivisible self is best illustrated by the sixteenth-century confrontation between the Aztecs and their conqueror, Hernando Cortés. In *Augury* Philip Garrison offers a lucid explanation of a principal difference between the Aztec and the typical sixteenth-century Spaniard:

> The essence of the Spaniard is a soul, a sliver of existence both immortal and immaterial. The soul is also simple, seamlessly unified, indivisible into further components. But the nature of the Aztec is double: each is not just himself or herself, but is also a *nahualli*. At the moment of birth, each Aztec gets associated with a specific bit of plant or animal life, or maybe with a few inches of dirt, or a glimpse of sky. Each of the gods, even, is bound to this kind of other: to an owl or to an eagle, say, to a coyote or a coati. (1991, 116–17)

It is easy to extend this image of a divided sense of self. Those Aztecs who are associated with a particular bit of nature—say, a certain animal—must also associate themselves with all the other Aztecs who are associated with that animal. They must identify, too, with any divine entity who is associated with that same animal. All these associations divide their identities into still more complex parts and fragments. Hence each Aztec is part of a subcommunity composed of gods and other Aztecs who are connected to one another by their shared *nahualli*. Lévi-Strauss tells us most tribal cultures perceive an analogy between totem animals and gods or dead ancestors (1987, 29–30).

Preliterate tribal communities gradually translate each important recent event into myth through a process of telling and retelling stories. Myth compresses past, present, and future into one inseparable, timeless body. Richard Slotkin has observed that what is lost when history becomes myth is the fundamental prerequisite for history—the distinction between past and present. Myth, being timeless, transcends historical possibilities. The present emerges as a repetition of "persistently recurring structures identified with the past" (1985, 24), and Derrida maintains that to know the present is to know infinity (1973, 54).

In his article "The Enigma of Time," John Boslough writes that many scholars believe all people once perceived themselves as living in a state of "timeless present"; they did not discriminate between past and future. They pictured time as circular, turning back upon itself, so that all things were possible at all times (1990, 129). Buddhists and Taoists have retained this perception of circular time. They consider history to be a fiction because they understand that all things return to a former state. Because of differences in human perception, the struggle to assign numbers to the passage of time was one of humanity's most elusive and sustained quests, and the achievement of this goal is one sign of the modern world. Clocks were devised so individuals might understand what time belonged to their employers and what was their own (111–15).

Postmodern scientists like Stephen Hawking, the current holder of the Isaac Newton Chair at Cambridge University, are avoiding linear concepts of time. Hawking finds "imaginary time" a necessary construct in the unification of quantum mechanics with gravity. He explains that when measurements are determined in real time, "singularities" are established that demand a beginning and an end to the universe, and this creates boundaries that breed contradictions in the laws of science. In imaginary time there is no important difference between going forward and going backward; consequently, recent (postmodern) scientific laws also "do not distinguish between the past and the future" (1988, 139–44). Like any good postmodernist, Hawking maintains that "imaginary time is really the real time, and that what we call real time is just a figment of our imaginations" (139). The new scientific paradigm, then, is more supportive of the premodern and tribal constructs of cyclical time than of the traditional European construct of linear time. It also negates history.

Furthermore, postmodern cultures have come to see that history changes with each point of view, and therefore they reject history as "truth." Richard Stengel was moved to write in *Time* magazine: "History becomes a minstrel show glimpsed through a musty lens distorted by tradition, popular culture and wishful thinking" (1991, 78). And, bringing the future to the present (an impossibility in modernism), Christopher Meyer—a California music-synthesizer designer whom *Time* offers as an example of cyber-punk—insists that history "is a funny thing for cyber-punks. It's all data. It all takes up the same amount of space on [a computer] disk, and a lot of it is just plain noise" (from Jackson 1993, 65).

In *Fire on the Earth* John Gilmour explains that cultures that conceive of time as cyclical tend to establish "contemporaneous relationships with earlier generations" (1990, 163). For instance, Benjamin Whorf shows that in the Hopi language events may be labeled only as "earlier" or "later," so that what we perceive as length in time, they perceive "as a relation between two events in lateness." "Becoming later" is the essence of Hopi time (1939, 140). The Hopi do not count days as we do. For us, an assemblage of ten different days is like an assemblage of ten different men. The Hopi count the ten days as the reappearance of the same day, as we would count the reappearance of the same man (148).

Prior to the twentieth century, the Euro-American sense of identity clearly differed from that of tribal societies and other cultures in the following manner: the Euro-American perceived a single indivisible self existing within one physical body in linear time, while these other cultures constructed a fragmented self that existed in cyclical time, which offered endless repetitions of any event—or identity. In the late nineteenth century, however, Freud helped to hasten the end of the Enlightenment when his discovery of the unconscious led him to suggest that Euro-American identity might not be so monolithic and indivisible after all. Perhaps the alien un-

conscious, with its own separate language, was actually an entity separate from that consciousness with which we had associated our identity. If so, our identity would now have to be understood as composed of at least two entities. As Jacques Lacan has said, we notice an error in previous philosophies "as soon as Freud has produced the unconscious . . . and accords it the right to speak" (1990, 108).

Lacan expands Freud's concept of the split self into a more elaborate and divided concept: the I, the *moi*, the other, and the Other.[2] The self, as Lacan perceives it, is now divided among four aspects, permutations, and "doublings" (note Garrison used the word "double" to explain totemic identity) of the conscious and the unconscious. Each aspect is further compounded by the influence of two additional oppositionary categories: the "I am" of existence, which is separate from the "I am" of meaning (1990, 108); and the "Imaginary" and the "Symbolic" (Mellard 1989, 632–33).

Because Western culture can no longer be perceived as monolithic and indivisible, neither can Western identity, for the concept of self must agree with the culture that generates it. Certainly the perception of the self as an indivisible constant is not a "natural state." Freud and Lacan were well motivated to understand the fragmentation of identity, but hindsight renders it obvious that identity could not have remained indivisible in the new, fragmented society of the twentieth century. And if, as postmodernists insist, art echoes the perception of identity and signifies the ideology of a period, then the obvious reason for fragmentation in art is that the current Euro-American culture and world view (thus identity) are more fractured and fragmented than ever before. Euro-American cultures are fragmented in terms of race, ethnicity, and gender, and each separate group sees the world from a different point of view. The current view of the external world is also physically fragmented. Values, stories, and myths are volatile, changing, infinitely mutable, new every day.

Even time is savaged—constantly fractured into smaller and smaller fragments. The twentieth century has seen the old empires—the Spanish, the British, the French, and the Dutch—gelded and divided. More recently, the world has been astounded by the sudden shattering of the Eastern Bloc and the further shattering of the smaller countries that once composed it. We have watched the Soviet Union itself, and then its parts, swiftly and violently rent asunder. We begin to see signs of such a rift in Canada, and we wonder more and more about the fate of the United States.

[2]James Mellard explains that Lacan's concept of the "other" and the "Other" involves two forms: "The other is the figure of the double or antagonist in whom we project our best and worst selves. The origin of this other is the mother. . . . The second form is the [Other] of the unconscious. . . . In Lacan, this Other/*Autre* resides in the place of the father" (1989, 626–27).

Consider for a moment just the visual fragmentation most of us experience during the time spent driving each day. People in American cities drive more than twenty thousand miles every year, which translates into more than five hundred hours—about a fourth of the time we spend on the job. Speeding down the road, the driver's eyes and attention are focused on that narrow band of paving laid flat across the surface of the world. Drivers merely *glance* in other directions. They snatch quick glances out the right side windows, out the left side windows, and out the back window; then they glance hastily to the left rear-view mirror, the center rear-view mirror, and the right rear-view mirror—which has written across the bottom: "OBJECTS IN MIRROR ARE CLOSER THAN THEY APPEAR." Sometimes they think they catch a brief glimpse of nature as they speed past. Thus the ever-present automobile, perhaps our most collectively shared experience, offers a myriad of narrow disjointed and distorted views of the world around us.

Add to this the fact that computers now keep records of our activities: what we buy, where we have traveled, whom we owe, whom we phone, what library books we read, how much we are worth, intimate medical and legal details about us, and so on. Everything we do is stored somewhere in the memory bank of a computer. Thus computers construct for each of us another identity, location unknown, that is both separate from, and the same as, the familiar everyday version. Our identities are split into further divisions.

People in the twentieth century do not experience the world in one piece. Rather than hearing the same stories and myths again and again, as people did in the past, today's stories and myths are quickly told and quickly discarded in movies and on television—new ones every day. A movie runs a scant hour and a half, and most of us rarely choose to watch the same movie twice. Many of us are more outraged by being offered summer reruns on television than by rampant injustice and runaway pollution. The stories we see on television are often completed in a half hour, and even this short time is fragmented into several smaller increments sandwiched between endlessly repeated commercials—life in a nutshell. Our high-tech world seems to have little continuity. We are tired of hearing that the only constant we can take for granted is the accelerating constancy of change itself.

In such a fragmented world, is it any wonder that a writer as alert as Leo Braudy has observed that people now develop their identities by emulating well-known personalities? Braudy concludes that late-twentieth-century identities are a collage of multiple personalities (1986, 5): a smidgen of John Wayne here, some Diana Ross there, now a little Tom Cruise, then a pinch of Madonna.

We are a community of collective personalities.

Once we get over the shock of this awareness, we realize that such a fragmentation of identity restores us in some respect to the ancient sense of

a divided identity—not the same as, but similar in many ways to, the sense of identity in many tribal societies. Thus is the past recycled to meet the present.

Jacques Lacan, too, was a product of this fragmented postmodern culture when he proliferated Freud's split self into a kaleidoscopic collection of identity fragments. And many postmodern paintings reflect this post-Cartesian sense of self. Gilmour demonstrates that Anselm Kiefer, like many other postmodern painters, links human identity to text and tradition rather than to the artist's genius and creativity. Kiefer appropriates historical material (visual quotes?), takes them out of their historical context, transmutes them to create conflict, and uses them to ask questions about his time (1990, 140). Like James Joyce, Kiefer is interested in mythic images; neither artist could be satisfied with the construct of the unique self. Kiefer is not so certain of his single viewpoint and unique identity as were modern artists.

Kiefer uses his medium to explore his own deeper points of view and sentiments and their relationship to the collective sentiments of his society (Gilmour 1990, 140). In an interview he stated: "In those early pictures, I wanted to evoke the question for myself, Am I a fascist? . . . To say I'm one thing or another is too simple. I wanted to paint the experience and then answer" (from Madoff 1987, 129). In other words, Kiefer searches for the interior, or hidden, fascism that lurks in each of us, causing us to "love power" (recall Foucault's reference to the concerns of Deleuze and Guattari). Kiefer attempts to tap the resources of a collective rather than an individual consciousness: he says that his intent is "to perceive as precisely as possible that which goes through me as an example for that which goes through others" (from Gilmour 1990, 157). Thus Kiefer's approach demonstrates an awareness of himself as a collective identity rather than a continuous, indivisible individual identity.

From the time of the Renaissance through the era of modern art (and especially since late-eighteenth-century romanticism), Euro-American society believed art issued from the fount of individual genius. Postmodern artists like Anselm Kiefer, on the other hand, place their faith in the deeper collective awareness of the society that creates their identities. Kiefer appropriates ancient materials and historical ideas, then transforms them into questions for our times. Perhaps this process marks an awareness of a new and more linguistic relationship between the contemporary self and its culture—a self defined by its relationship to the parts within the whole in the same way that Kiefer's more collective sense of self seems defined by its context and its relationship to others within the culture.

Furthermore, Kiefer combines his more linguistic approach to painting with a "tendency to portray a cyclical view of existence rather than one organized according to the causal and linear time structures" (Gilmour 1990, 55). This cyclic view allows him—in some sense like a tribal artist—to

use his historical and mythic images to imply "contemporaneous relationships with earlier generations."

Hinduism and Buddhism also perceived time as cyclical and both believed human beings were reincarnated through endless cycles (the ultimate recycling program). The only way for the individual to escape from this endless sequence of births and deaths was to become one with the All. Hinduism promised to dissolve the individual into an eternal and nameless Absolute. Buddhism proposed that life was full of suffering caused by our wants and desires, and sought enlightenment in order to become one with the Universe and escape the endless cycle of reincarnation.

Boorstin explains that Islam and Christianity, both rooted in Judaism, sought to escape the eternal reiteration of lives by finding meaning in present life experience. These three religions shifted the perception of time from one of endless cycles to one of linear history (1983, 566). The descendants of Judaism, Islam, and Christianity centered their thoughts and interests around themselves, their friends, and their enemies as individuals. They saw themselves and their acquaintances advance through history from birth to death in an irreversible linear direction. They pictured a beginning and an end. When people died, they were gone from the earth forever. Eventually not even a material piece of them was left. With this kind of philosophy/theology, Jews, Christians, and Muslims had little understanding of cyclical time.

But those who subordinated their interests to a larger extended family or tribal unit picture that unit as timeless and permanent. In Latin America, for example, Ignacio's grandson is named after him. Ignacio dies; but Ignacio lives on in his grandson. And there are still parts of the old Ignacio obvious in the new Ignacio (as well as in his siblings): his eyes, his totem, his namesake, his animal, his mountain abide forever. Birth balances death in a continuous cycle.

This emphasis on the importance of separate parts is consistent with the mythic principle of *pars pro toto* (part for whole). As Ernst Cassirer explains it, in tribal cultures a part has power over the whole. The function of the part is not important: a piece of hair, a fingernail clipping, or even a person's shadow is enough of a part of an individual's body to have power over that person's body. Cassirer insists that all mythic thinking, so characteristic of totemism, is "governed and permeated by this principle" (1946, 92). This may be seen as further evidence of the fragmentation of identity in mythic cultures, of why it is unusual for such cultures to understand time as anything other than cyclic—a loop of film repeating itself again and again.

Gilmour maintains that Kiefer's paintings demonstrate that the mode of representation a culture sanctions is directly related to the form of identity that culture constructs. Therefore Kiefer does not trust the modern insistence that reason and visual presence express the psyche of a unique

individual. Mythic images, which spring from a more collective conscious-
ness, imply a more complex relationship between artist and work of art.
Gilmour reasons that the perception or premonition of preternatural mythic
powers undermines a Cartesian sense of individual identity because a
Cartesian identity depends on or "presupposes the orderly background of a
rational world" (1990, 82, 168).

Kiefer's postmodern approach is less controlled by reason and science
than the approach of the moderns, who had rejected religion in favor of
perception, optics, and physics. Gilmour labels Kiefer's approach "prescien-
tific" (1990, 36).[3] Before he was likely to have encountered such recent sci-
entific concepts as chaos theory, imaginary time, or fractal geometry—for
which he might have more sympathy because they are more consistent with
postmodern attitudes—Kiefer said in a particularly revealing statement: "I
think a great deal about religion because science provides no answers"
(from Rosenthal 1987, 26). (A modernist might well have said the opposite.)

Postmodern perceptions are moving away from the Cartesian scien-
tific, rational, indivisible self toward a more ancient, prescientific, mythic,
fragmented identity. This pluralist identity is more readily affected by pow-
ers that are not entirely rational, and it pursues meaning through myth
rather than history, religion rather than science, and cyclical (rather than
linear) time.

The well-heralded fragmentation of society and renewed interests in a
collective identity, myth, religion, and cyclical time demand an idea more
complex than the "death of the private self." These combined ideas demand
an awareness of the rebirth of a divisible self. Andy Warhol's well-known
one-liner "Someday everybody will be famous [or infamous?] for fifteen
minutes" was a harbinger of the era now upon us, when even celebrity is
collective and fragmented. Fame and infamy are today as divisible as iden-
tity.

Before modern art, paintings resembled things in the exterior world—
people, animals, landscapes, and still lifes. For this reason, premodern pic-
tures are primarily classified as iconic signs. When a painting is so accurate
in its depiction of objects and the space in which they exist that the scene
seems to actually exist in its own space on the other side of a window, that
painting is said to be *visually transparent*. Modern artists destroyed this
transparency: they created an opaque picture plane. At its most exem-
plary—for instance, in Willem de Kooning's *Excavation* (1950)—no mark on
the painting appears to recede behind the real surface of the painted can-
vas. The only illusion is the illusion of flatness.

[3]George Steiner tells us "a branch of inquiry passes from pre-science into science when
it can be mathematically organized" (1967, 15).

Neither does Kiefer create paintings that transparently resemble real objects, but he does transform visual images into opaque signs and symbols. For instance, he often uses the image of fire to signify the artist's power to transform (Gilmour 1990, 120). Like many postmodern painters, Kiefer uses the referential power of the painted icon, but not to open up the pictorial depth of visual transparency. Instead, his recognizable imagery functions as iconic and indexical signs, and these signs make statements. Gilmour says that Kiefer uses the discursive power of the sign system to ask questions about the nature of reality and the representational systems that represent this reality on the canvas. Again, Kiefer's return to representation leads toward prescientific and mythic forms of thought (36–37).

I contend this tendency to question reality and to move toward the prescientific is also signified by the predominant use of black and white. In many of his paintings Kiefer favors black and white over color. But—as every good postmodernist knows—the presence of one of any oppositionary pair implies the absence of the other. Black and white thus implies the absence of color, and the absence of color in Kiefer's paintings weakens a fundamental referent to reality in the external world. The world outside the painting is inescapably immersed in color—except at night.

We see no color at night because the scant natural light fails to activate the cones in the retina, leaving only the rods active. It is the cones that are responsible for our sense of color; when only the rods are activated, we see with what is called "scotopic" (low-light) vision because the rods can see only dark and light and movement. Thus the "color" of night is black and white.

No matter how nonrepresentational abstract painters made their shapes, no matter how scrupulously they tried to remove any suggestion of a world outside the painting, those who used color still implied the reality of an external world. In Derrida's words: "there always remains in a painting, however inventive and imaginative it may be, an irreducibly simple and real element—color" (1978, 49). But not *always*. Kiefer's implication of mythic and supernatural forces denies daytime reason and reality as we know them; thus his use of black and white functions to remove his scenes from daytime reality.

Kiefer's archetypal subject matter fits more naturally into "the depths of that dark night" into which André Breton commended us. Kiefer's paintings, when knowledgeably interpreted, are more akin to dream and to myth than to everyday waking reality. Furthermore, the absence of color connotes death: first, in the sense that black and white is easily perceived as lifeless; and second, in the sense that Alexander Pope suggested when he wrote: "Is not absence death to those who love?" Both elements—death and the absence of color—are consistent with the stage of putrefaction in alchemy, which is intentionally signified by Kiefer's scorched earth image.

When viewers see Kiefer's paintings, they may (consciously or unconsciously) ask: Where's the color? Where's the illusion of volume? Where's the careful rendering? Elements that are noticeably absent assume more importance than those that are present. Derrida has often argued—and many deconstructive strategies are based on this argument—that languages grant higher status to the concept of presence than to absence; but those ideas and structures that seem to be absent may be strongly implied by the presence of their opposing concept. Those elements that are present—available to our sight or consciousness—bring to mind those oppositionary elements that are absent. Thus the presence of black and white implies the absence of color.[4]

The elements absent from Kiefer's painting's, then, are as important to his discourse as those upon which he focuses. Derrida insists that the strategy of deconstruction does not point out flaws or weaknesses or stupidities in writers or painters; instead, it points out that what they *do* see is systematically related to what they do *not* see (1981, xv). Painters may pick one element (for example, black and white) because they wish to avoid the other (color). Such painters often find themselves trapped by what offends them. Their direction may come to be defined by those ideas they most rigorously avoid. Thus their work may document their resentments.

Paintings in black and white are also, on some level, more seducing, more believable, than paintings in color. Black and white implies the dispassionate dispensing of information in a documentary film or historical photographs, or the visual information presented in technical books. In short, it echoes the objective distance we expect in items of evidence.

Gilmour argues that Anselm Kiefer does not want his work to become just another example of commercial productivity. Because he favors transmutations, not products, he exploits the image and the effects of fire. Fire is Kiefer's badge. Fire emphasizes his transformative powers, and Kiefer's fire is intentionally reminiscent of the fire the ancient alchemists used to transform elements into gold (1990, 120). He alludes to mythological and alchemical events to notify his viewers that he is disappointed with the modern world view he and we have inherited (41). In many of his paintings he adds to the pervasive black and white only one color—red. Black, white, and red are the colors of alchemy.

Kiefer wants his work to serve as a catalyst for human change, just as alchemists sought to change both the nature of the elements they used in their experiments and the nature of human beings. As mentioned in Chapter 1, alchemists likened the psyche to gold covered with dirt, and

[4]In Robert Sokolowski's words: "The associating object is present, the associated is absent; if the latter were not absent, we would speak of a continued perception, not an association" (1978, 24).

sought to remove the dirt and expose the pure gold of the soul. Echoing Paracelsus's sixteenth-century directive that alchemy should thenceforth be used for the making of medicine, Kiefer—like his teacher and mentor Joseph Beuys—wants his work to function as a healing rite (healing in the sense that Deleuze and Guattari perceive). The burned and scorched material in Kiefer's paintings represents the scorched earth of alchemy and what he believes is the healing fire of revolution and societal change.[5]

Kiefer's use of fire to actually burn and scorch the material in the painting qualifies as an indexical sign for fire rather than an iconic sign or sign proper. Remember, the relationship between object and indexical sign is one of cause and effect—the sign is caused or created by (or offers evidence of) the object signed (Peirce 1960, 144). Because the index stresses a direct cause-and-effect relationship between an object and its sign, it often indicates the presence of the signed object more powerfully than the sign proper is likely to do. And Kiefer's purpose is to bring signs into play in order to establish a new discussion centered on the relationships between human nature, metaphysical purpose, and the characteristics and uses of representational systems. Gilmour's suggestion that the revitalization of representational painting leads to a rediscovery of prescientific ideas (1990, 37) highlights the strong relationship between Kiefer's use of signs and his interest in the sacred sciences, myth, cyclic time, and a more collective consciousness.

Jung tells us that early human beings discovered their gods and a complete projected theory of human character abiding in the unconscious. He insists that such archetypal experiences are re-created every time we explore a new darkness: we quickly fill that new darkness with anthropomorphic form (1953, 234). He also tells us that the beginnings of science are to be found in humanity's early interest in the sacred sciences of astrology and alchemy.

Kiefer's frequent use of lead is an obvious reference to the base metals alchemists labored to transmute into gold. Gilmour reads into Kiefer's work a resentment of the fact that alchemy's transformations were exploited by modern scientific reasoning, and thus degenerated into a method of controlling, first the environment, then people. Modern scientists exploit the alchemist's sacred process and purification rituals in the cause of secular and material expediency, and Kiefer reacts to this situation as an "alchemist-artist, pushing the manipulation of molten lead to new heights" (1990, 131). Kiefer takes the process of alchemical transformation as a model for his art.

[5]Beuys, like many other artists, was a follower of the theosophist Rudolf Steiner (Beuys 1990, 68). He said he "realized the part the artist can play in indicating the traumas of a time and initiating a healing process. That relates to medicine, or what people call alchemy or shamanism" (from Smagula 1983, 228).

He is as much a process painter as de Kooning was. His rigorous process of destructuring and restructuring matter in a cyclic process to expose previously invisible ideas is a metaphor for the alchemical process that was once intended to transform base metals into gold (132) or base humanity into liberated souls. It is also an echo of the medieval agenda to render the invisible visible.

Gilmour notes that Kiefer uses the mythic past (Nordic myths, the myth of the ancient blacksmith, alchemy, and Jewish scriptures, all mixed with German history) to imply his respect for the mythic modes of thinking he finds missing in rational and abstract modern thinking (1990, 135). Stebbins and Ricci agree that Kiefer warns us against the modern tendency to emphasize rationality and progress and to favor intellectual rather than visceral understanding. Both Kiefer and Joseph Beuys believe our current crisis stems primarily from the avid materialism wrought by modern positivist and mechanistic thinking. Both artists are convinced that art can offer an alternative to this practice. Kiefer is particularly disturbed by the twentieth-century removal of human beings from their normal instincts; he believes this has created a gap between the conscious and the unconscious (1988, 20–21).

The earth is stable. We stand solidly upon it. It does not move. We clearly see the heavens revolve around it. In the seventeenth century we learned to reject this truth that was once so obvious. Modern science took its beginnings from Copernicus's heliocentric theory, which convinced all Europe that it was the earth and not the heavens that moved. Boorstin tells us this event introduced Europeans to the invisible world of modern science and convinced them to reject commonsense empirical knowledge. When the precise instruments and complex calculations of modern science furnished unimpeachable truths, we slowly learned to accept the notion that the world did not exist the way we saw it. Commonsense and myth no longer governed the world (1983, 294).

The new attitude led to a new form of experience—the experiment. Everyday experience is personal. It is easy to recount. It may even be told and retold until it becomes myth. But it may not be possible for others to repeat our personal experience with precision. Thus many of our everyday or unstructured experiences cannot be confirmed by others. Experiment, however, is a structured experience that can be precisely repeated by others. Executed within the rigorous form of structured experimentation, experience can be "coordinated, confirmed, and added piecemeal to the stock of knowledge" (Boorstin 1983, 395).

These scientific experiments initiated in the Renaissance worked well when applied to observations of phenomena in the physical world. But later, the behaviorial "sciences" tried to adopt the experimental model to investigations of the behavior of human beings, where it did not work well at all. Nonetheless they demanded of the general public the same credibility

for their conclusions—developed through a rather dubious application of mathematics and experimentation—that chemists and physicists commanded. Behavioral scientists convinced more than two generations of us to reject mythic and commonsense wisdom in our perception and treatment of others. We learned to assent to concepts and programs despite the fact that they did not appear to work.

Gilmour explains that Kiefer's Midgard paintings refer to the Edda Myths, Nordic legends that depict the gods' creation of the earth—the abode of men, called "Middle Ground" or "Midgard." The gods intentionally positioned earth between the underworld and heaven, between the darkness and the fire, Kiefer often represents earth as a stone flung on the beach, as if it has no apparent purpose (1990, 39).[6] Such representations might easily be perceived as mythic maps of heaven, earth, and the underworld—echoing the North European interest in maps.

Gilmour says the snake in *Midgard* (Figure 12.1) represents an archetypal fear of the unknown and the broken palette in the center of the painting represents modern art's shattered hopes that pure spirituality will triumph over cold reality. The snake slithers toward the cracks in the broken palette, signifying that even art is not immune from the dark fear of the unknown. Gilmour sees this as an allegory of Kiefer's fear that there is no support for human plans or values anywhere in the cosmos—which is an argument against the modern belief in the purity and the innocence of the creative process (1990, 60, 77). In short, Kiefer resents the fact that modern society has garroted the sacred attitude of alchemy from the modern scientific process. He attempts to reunite the two. He also offers the alternative of myth rather than history as a system for remembering the past.

Postmodernists are often fascinated with alchemy because it echoes their own interests in the following seven interrelated traits:

1. Alchemy is driven by myth rather than history. Poststructuralists favor myth over history because history tends to lay claim to an objective truth, which they do not believe exists.

2. Alchemy has generated a host of archetypal mythic images and ideas. Jung tells us that astrology and alchemy have always been driven by archetypal myth and mythic pictures from the collective unconscious, which is in direct opposition to the modern concept that real meaning issues from the rational mind of exceptional individuals (1953, 293).

[6]Gilmour reminds us that a wide range of ancient myths portray the origin of humans from stones. In such myths stones are "virtually alive, and those who extract them from the earth and transform them through fire play a role in religions from the Iron age on" (1990, 126).

FIGURE 12.1 Kiefer, Anselm. *Midgard* (1980–85). Oil and emulsion on canvas (142" x 237 3/4," 360 x 604 cm). Museum purchase: gift of Kaufmann's, the Women's Committee, and the Fellows of the Museum of Art. The Carnegie Museum, Pittsburgh.

3. Alchemy did not originate in Europe. Postmodernists feel that the traditional study of history has focused on European events and ignored ideas and contributions from the rest of the world. They perceive alchemy as a global paradigm. Its most important early centers were Egypt, India, and China; it spread to early Greece from Egypt. After the fall of Rome, alchemy almost disappeared from Western Europe, but it survived in North Africa, and during the eleventh and twelfth centuries a reawakening of interest in science led to the discovery of African accomplishments.

4. Nothing has had a more enduring impact on human ideas and world view than alchemy. Perhaps this is because alchemy and astrology (the other sacred science) have no chronological limits or geographical boundaries. They persist from before history to the present.

5. The nature of the alchemical process is to concentrate on both the micro- and the macrocosmic (Duchamp's concept of "inframince"). The alchemical emphasis on investigating reality from both the micro- and the macrocosmic point of view was in evidence in the Middle Ages, the Dutch culture of the fifteenth through seventeenth centuries and now postmodernism. This interest in the micro- and macrocosmic suggests a connection with linguistics: Saussure insists that meaning is generated by a word's relationship to other words, as well as by its relationship to the whole.

6. The Philosopher's Stone is a metaphor for finding value in the "other," the disenfranchised who are often ignored or discarded by a foolish society. Alchemists believed the Philosopher's Stone was "the most precious of all things, constantly overlooked by us all." When past societies favored one group, they often discarded others as worthless. When postmodern society finally began to perceive value in once-discarded groups, it echoed the metaphor of the Stone.

7. Many early treatises on alchemy were written by women and thus may offer a feminine point of view as a supplement to the usually dominant masculine point of view. This fact adds resonance to the metaphor of the Philosopher's Stone in postmodern eyes.

I noted earlier that from the fifteenth through the eighteenth centuries the best modern scientists and philosophers were also alchemists and/or astrologers and that, consequently, many invisible elements of the two sacred sciences permeated modern science. Also, astrology and alchemy were woven into the fabric of our religion and philosophy from the beginning of recorded history. Those who developed the world's sciences, philosophies, and religions were, in fact, so dominated by alchemy and astrology that it is impossible to conceive what form these disciplines might have taken had the influence of the sacred sciences never been felt.

Because Kiefer addresses elements of primordial myth and science in terms of today's world view, he initiates a conversation that condenses time by linking the distant past with the present to influence the future. Gilmour tells us Kiefer uses text and tradition to establish human identity (1990, 140): his painted texts are composed of iconic and indexical signs, as well as signs proper, and he mixes traditional and living myth with the primordial past. For instance, in an analogy to "the unknown solider," Kiefer dedicates pompous monumental ruins to the "unknown painter," which brings daimonic and German mythic elements into his painting (Harten 1988, 10). Thus Kiefer's work supplements the claim of Freud, Lévi-Strauss, and Lacan that we substantiate our sense of self through language.

When the eighteenth century revitalized the ancient Greek idea that the atom was the fundamental building block of reality, this "new" atomism displaced the earlier alchemical construct of four basic elements: fire, earth, water, and air. With this atomistic paradigm, secular scientists have succeeded in "transmuting" one material into another, as the alchemists had once hoped to do. They have accomplished the less important part of the alchemists' quest: they can make pure gold from base metals by manipulating the "prime" materials of electrons, protons, and neutrons. But they have not accomplished the more important part: they have not learned to purify the soul.

The postmodern suspicion of the "objective" sciences may not apply to the new complex sciences—chaos theory, fractal geometry, "fuzzy math," and even quantum physics—for unlike the classic Newtonian

sciences, these new sciences do not claim to furnish single objective answers to individual situations. They offer instead a host of alternatives and probabilities, a microcosmic approach to a macrocosmic image. (This approach is in tune with current linguistic concerns.) Recall from the first chapter that medieval alchemists had hoped to save the macrocosm of the world by healing the microcosm of the individual.

Kiefer's multiple and mythic viewpoints and his discursive questions and arguments, driven by his interest in cyclical time and the linguistics of visual art, appeal to a postmodern, post-Cartesian identity. Where modernists searched for immediate visual presences, Kiefer's paintings, like those of van Eyck and Bosch, lend themselves to prolonged close readings and verbal interpretations. His northern paintings are reminiscent of those earlier works that issued from North Europe: they are more closely related to the verbal than the perceptual; the discursive than the narrative; and myth than historical fact. And Kiefer often constructs a rising perspective in the tradition of van Eyck, Bosch, Bruegel, Gauguin, and numerous other signing painters. The large area of ground plane, a result of the high horizon line, furnishes an abundant flat space upon which Kiefer can locate his many iconic and indexical signs: snakes, broken palettes, and expanses of scorched earth (thus the ground plane itself becomes a sign).

Those painters who mix primarily verbal images with even inexact forms of perspective tend to need a larger ground plane to accommodate their signs. But those painters who practice the baseline method—which was used by many tribal artists and through much of the Middle Ages—recognize neither perspective nor the concept of a ground plane. Thus they are free to locate signing images anywhere they wish—along the baseline, floating above it, or pasted flat on the surface as if the painting were a bulletin board.

Remember Leo Steinberg's observation that at the beginning of the postmodern movement Rauschenberg was obliged to discard the horizon line and conceive of his picture plane as a surface to which anything "reachable-thinkable" could be attached: his painting had to become whatever a billboard or a bulletin board is (1972, 88). He, like Kiefer, favored black and white, and this choice also tends to flatten the picture plane. Where color creates a suggestion of pictorial depth through contrast in temperature (warm and cool color), black and white removes the possibility of color perspective.

From a flat but concrete picture plane with objects depicted across it to Kiefer's recognition that this concept simply represents a variation on rising perspective—with the horizon line located above the top and outside the painting—is an easy step. And this step echoes, in both motivation and result, the Dutch rising perspective, which, in turn, echoes the Dutch interest in map-making.

Some signing painters move the horizon down a bit into the painting, while others move more toward the medieval baseline concept. Some establish a baseline and locate objects along that line, while others ignore perspective altogether and position their signs as on a bulletin board—anywhere they wish without regard to baseline or horizon. Some, like the young New York painter Dan Rice, hang cutout paintings that assume the shape of isolated objects, with their surfaces squirming and crawling with other figures and objects.

13

The Dragons of Postmodern Art and Science

And there appeared another wonder in heaven; and behold a great red dragon, having seven heads and ten horns, and seven crowns upon his heads.—Revelation 12:3

Z^2+C—Algorithm for generating "the most complicated object in mathematics": the Mandelbrot set in fractal geometry. (Dewdney 1985, 20)

Postmodernists shun the objective truth and linear time implied by narrative, history, and the scientific rationalism of the Enlightenment and modern art. Instead, they favor myth, religion, and cyclical time. Anselm Kiefer has said that he looked to religion because he had little confidence in science. But the science he referred to was the rational, objective classical science that assures objective deterministic answers to every question.[1]

The rational ideas that spawned modern science were a strong influence on scientists and artists from the Renaissance through modern art, but scientists and artists at the end of the twentieth century share a different point of view. This new point of view has initiated not only a new art but also new, more complex sciences: chaos theory, fractal geometry, and nonlinear or "fuzzy math."

If there is to be a twentieth-century version of the ancient sacred sciences, these new complex sciences are the candidates. Through an elaborate process of perhaps infinite iterations they transmute mathematical formulas into facsimiles of complex patterns of turbulence in water and air; and they create near-perfect representations of mountains, coastlines, and entire hu-

[1]Deterministic answers are computed in linear math and adhere to a single point of view that recognizes that all facts and events exemplify natural laws and sufficient causes. Such answers are considered "true" or "correct" if the math is competently executed.

man circulatory systems—the very fire of life. Thus they "transmute" base numbers into water, air, earth, and fire.

Furthermore, these new sciences are founded on a synthesis of the micro- and the macrocosmic, as were alchemy and early Dutch science and painting, as well as Duchamp's infra-mince. Remember, this interest in the micro- and macrocosmic is compatible with linguistics. After an exhaustive investigation of the similarities between these new sciences and postmodern literature, Katherine Hayles concludes that chaos theory already demonstrates "a paradigm shift of remarkable scope and significance" (1991, 2).

Heir to these postmodern insights, Dan Rice achieves a commanding fusion of chaos theory with American myth, religion, and a cyclic image of time. He creates a complex geometry of structure that reinforces his mythic content and establishes a tense alliance between three ancient and mythic dragons.

1. His subject matter stems from the dragon in the biblical Book of Revelation, often known by its Greek name, the Apocalypse. Medieval painting also centered on the Apocalypse, and Ibin Hassan has said that one of the important characteristics of postmodernism is "the voice of the apocalypse."

2. Rice makes persistent visual references to cyclical time and eternity. The alchemical dragon Ouroboros twisting itself into a figure-eight position to feed on its own tail forever is the image from which we derive our symbol for infinity.[2] Ouroboros eating its own tail is also a symbol for cyclical time. Gettings notes that the dragon devours itself, and time seems to swallow itself and the world. Time itself disappears for human beings submerged in cyclical time (1987, 156).

3. Rice exploits an intricate structure of fractal scale invariance that echoes chaos theory; and chaos is often represented by the ancient Chaldaean dragon goddess of chaos, Tiamat. Chaos is also compared to the black stage of death and putrefaction in alchemy—the state substances assume when they have been decomposed through fire. This is the stage that Anselm Kiefer's use of lead signifies. Furthermore, many alchemical illustrations depicted the alchemical "king" being protected by beating and slaying a dangerous green dragon. (St. George and the Dragon is a Christian appropriation of this alchemical allegory.) This slaying of the dragon signifies the neutralization (represented by the battle) of an acid (the dragon) so it could not destroy the gold (the king) (Dixon 1981, 4). Chaos theory itself insists on cyclical rather than linear time: it demonstrates by math and graph that the daily fluctuations in any complex system (like prices in the cotton market, or life it-

[2]The alchemical dragon positioned to reach its own tail is sometimes pictured in the shape of a figure eight, and sometimes in the shape of a circle. Our infinity symbol was derived from the figure-eight position, while the Chinese symbol for infinity was derived from the circular position.

self) echo weekly fluctuations, and weekly fluctuations echo yearly fluctuations, cycle after cycle, to infinity.

Thus Rice combines apocalyptic imagery with fractal form and a cyclic image of eternity to unite religion, the new sciences, and myth. As we have seen, these three were once an inseparable system that became separate and independent systems only during the Enlightenment.

"Chaos" is a Greek word meaning "any vast gulf or chasm, the nether abyss, empty space, the first state of the universe." Hayles tells us that Western creation myths from Babylonia to Milton perceive chaos as the polar opposite of order, a disordered void that must be conquered before creation can occur (1991, 2). But scientists and artists in the last three decades of the twentieth century have come to perceive chaos as a complexity of information rather than disorder: "As a result, textuality is conceived in new ways within critical theory and literature, and new kinds of phenomena are coming to the fore within an emerging field known as the science of chaos" (1).

In *Chaos* James Gleick tells us that chaos theorists and fractal geometrists such as Benoit Mandelbrot believe they are responding to current cultural attitudes within their society. These scientists feel that society has moved beyond the simplistic order of the Bauhaus school. Simple ideas and simplified shapes, they contend, are "inhuman": they "fail to resonate with the way nature organizes itself" or with the way human beings perceive the world (1987, 116–17). Jack Burnham tells us that "one of the truisms of Structuralism is that myths mirror or recapitulate the social structure supporting them" (1973, 179). Thus scientists and artists now realize that this world is not made in the image of Euclidean geometry.

The geometric model these scientists exploit to explain the complex system they see at work in nature is a fractal order of repetition called "scale invariance" or "self-similarity." This fractal order is peculiarly parallel to the compositional structures that Rice devises.

In scale invariance, the most complex natural structures have an underlying geometric regularity. Viewed at different size levels, certain fundamental elements are echoed at different scales from the microscopic to the macrocosmic. Fractals enable the geometrist to describe the shape of a cloud, a coastline, or the human arterial system as precisely and simply as an architect might describe a house by means of traditional geometry (Jürgens, Peitgen, and Saupe 1990, 61, 67).

A fractal pattern may be created either mathematically or geometrically. An example of the first type is a computer program that generates a visual diagram of short nonlinear mathematical formulas like the one at the head of this chapter. An example of the second type of fractal pattern is the "Koch Snowflake," which is created by adding to each of the three sides of a simple equilateral triangle a smaller similar triangle that has a base one-half the length of the original, and then adding to each side of each of the smaller triangles another smaller equilateral triangle. If this additive process is re-

peated many times, a complex shape reminiscent of a snowflake will eventually develop. Snowflakes themselves grow additively in a fractal process.

Each time such a fractal growth is repeated, the line surrounding the shape grows more tortuous and complex—thus substantially longer—though the enclosed area will never grow larger than a circle drawn around the original triangle. If the process is repeated an infinite number of times, the length of the line bordering the shape will be of infinite length; hence a small finite area can be entirely enclosed by a single line of theoretically infinite length (Gleick 1987, 97).

Eternity in a nutshell.

The most famous fractal object is the Mandelbrot set. This series of patterns, easily generated on my home computer, demonstrates scale invariance through magnifications of more than a million to one. That is, if a pattern is generated through the application of the Mandelbrot set, then one small piece of that pattern is enlarged and expanded by mathematical iteration to generate a new image, and that new image will be almost indistinguishable from the first. If then a very small area of this new pattern is enlarged, it will also be composed of the same elements, and thus again bear a striking resemblance to the first two images. This process, which can then be repeated in either direction to infinity, demonstrates a similarity in structure at any scale level from the micro- to the macrocosmic. Interest in the Mandelbrot set is similar to the interests in alchemy, linguistics, and the medieval and early Dutch cultures that characterize postmodernism. An unending number of man-made and natural objects demonstrate scale invariance. Larry Short describes several, including *The Great Wave* by Hokusai, *The Deluge* by Leonardo, the Paris Opera House, and the Swiss Alps (1991, 351).

In a similar manner, Rice's large apocalyptic paintings whisper to us of eternity through their exploitation of the micro- and the macrocosmic. Derrida uses the term *en abyme* for an indefinitely multiplied self-referential image, mirrored over and over again in smaller versions within itself (1976, 163). As I mentioned in Chapter 6, this self-referential quality is normally associated with writing rather than painting. But a close reading of Rice's paintings reveals a rigorous architecture of scale invariance constructed by images repeated upon and within each other at various scales from the immense to the minute, in a recursive *en abyme . . . en abyme . . . en abyme.*

Katherine Hayles explains that chaos theory has changed our understanding of the relationship between cause and effect. Traditionally, a small event or cause was expected to generate only a small effect. If, for instance, the angle between two sides of a geometrically simple triangle is changed by one degree, the difference in the resulting triangle is hardly noticeable. But such a small change in the formula or the initial conditions of a more complex system often causes enormous changes in the final state; this is called the "butterfly effect." Because there are so many scale levels created by each reworking or repetition—called *iterations*—of the formula, the tiny initial

changes at the microscopic level exhibit more change with each iteration; hence they are quickly magnified and exaggerated to become major changes at the macroscopic level (1990, 211–12).[3]

Some of Rice's shaped paintings stretch forty feet or longer. His paintings are usually cutouts in the shape of nongeometric two-dimensional silhouettes of large objects: a human figure, a tree, a truck, a freeway system. Typically, as in the large figure cutout in *Maniac* (Figure 13.1), the surface writhes with slightly smaller images; these are covered with still smaller images (Figure 13.2), which are in turn composed of thick somatic swirls of wet-into-wet paint (Figure 13.3), which suggest, once again, still smaller figures and images. This recursive scale invariance between images at different scale levels creates a fractal barricade of figurative images composed of smaller figurative images, which are, in turn, composed of yet smaller figurative images, which are . . . *mise-en-abyme*.

The harmony between the micro- and the macrocosmic that Rice achieves is reminiscent of Panofsky's comparison of van Eyck's technique with infinitesimal calculus. The number of details approaches infinity and achieves a cohesive overall image in all visible forms, much as calculus achieves a cohesive numerical image: the small seems large in relation to the even smaller, and the large seems small in relation to the cosmic representation (1953, 181).

It is precisely this recursive element of scale invariance that creates the cyclical sense of time and complex rhythms that viewers perceive throughout Rice's work. Viewers focus on the small brush strokes and detail, and then discover, as they move back, layered and integrated rhythms pulsing

FIGURE 13.1 Rice, Dan. *Maniac* (1983). Oil on panel (108″ × 252″).

[3]*Iteration* is the term applied to a computing or problem-solving strategy in which a succession of computations or approximations is each structured to incorporate the preceding answer.

FIGURE 13.2 Rice, Dan. Detail (24″ × 36″ area) of *Maniac*.

throughout the paintings at every scale level. These self-similar rhythms re-verberate throughout the level of the smaller figures, the larger figures, the groups of figures, and the overall image of the painting—even in the relation of each separate painting to the body of work itself.

Scale invariance isolates both geometrist and painter from that tradi-tional reality wherein dimension may be defined by simple whole numbers (0, 1, 2, 3) and introduces them to a world of fractional dimensions—a plu-ralist reality in which dimension and "truth" are understood as dependant only upon point of view.

Benoit Mandelbrot used a ball of twine to illustrate this dimensional paradox. From a great distance, the ball of twine is perceived as nothing more than a point (zero-dimensional). As the viewer moves closer, the twine is seen as a sphere (three-dimensional). When the viewer zooms in still closer, the twine itself is perceived as a line (one-dimensional) organized in space (three-dimensional). Viewed through a microscope, the same twine turns into columns (three-dimensional) composed of fibers (one-dimensional), un-til finally the solid material dissolves once again into zero-dimensional points (Gleick 1987, 97).

FIGURE 13.3 Rice, Dan. Detail (9″ × 12″ area) of detail of *Maniac.*

Similarly, each viewing distance, each scale, of one of Rice's paintings may be read as a different dimension. From a distance, an entire painting, such as *Maniac* (Figure 13.1), insists upon being read as a large, flat, squirming figure (two-dimensional). As the viewer moves closer, the layered images gradually create an illusion of relatively more volume (pseudo-three-dimensional). Move closer still (detail, Figure 13.2), and the physical presence of the paint surface asserts once again the flatness of the images (two-dimensional). Still closer (Figure 13.3), and the encrusted paint becomes a virtual bas-relief—real volume (three-dimensional).

Rice uses complex cutout shapes to remove his images from the traditional simplified Cartesian grid composed of interiors and street scenes, which are normally depicted on rectangular canvases and structured by the three-dimensional Cartesian grid of linear perspective. Hayles tells us that fractal geometry also leaves the world of the Cartesian grid.

Hayles explains that because we grew up in an industrial society infinitely structured by such grids, we easily orient ourselves when strolling through the Cartesian grid of regularly spaced streets of a town or city, and we perceive these streets as predictable and well ordered. But we are often confused by the complex structure of natural forms like forests, mountains,

clouds, and galaxies. We have traditionally used devices such as the four compass points and the imaginary lines of latitude and longitude to impose a logical *fiction* of Cartesian grids on such complex natural phenomena. Fractal geometry, however, perceives complex phenomena in terms of simple self-similar shapes that appear complex only after numerous iterations (1990, 288–89).

Rice's street scenes are tumbling, jumbled spikes of buildings that cannot be structured within the Cartesian grid. In order to emphasize the paradox of fractional dimension, Rice restructures traditional systems of perspective and thrusts them into direct opposition with one another. He signifies pictorial space, but he never creates that pictorial space through illusion. That is, in most of his paintings, Rice overlaps one figure in front of the other to sign pictorial space; but, like Giotto, he never separates the figures in that pictorial space. This arrangement positions one figure in front of the other but never specifies how far in front; and this creates the effect of flat paper cutouts (echoing the cutout shape of the paintings) pasted one on top of the other.

Often, like van Eyck and Bosch, Rice positions the overlapping images spatially from lower to higher on the ground plane, thus signifying space as if these images were nearer and farther away from the viewer along a ground plane that is first asserted and then negated. Hence sign and illusion are held in unresolved conflict. This systematic negation creates a paradox, a spatial oxymoron, a tension that augments the overall image of frenzied self-destruction—which Rice implies is the warp and woof of our culture.

Only at the scale of the brush stroke does Rice allow the factor of focus and blur to breathe a hint of visual depth. His fluid strokes—which create sharp edges and blended edges, focused areas and blurred areas—suggest visual depth at precisely that scale where any hint of illusion is immediately negated by the physical bas-relief of the sculpted paint surface. Thus Rice uses scale invariance to generate a surface full of elusive fractal dimensions that signify a pluralist world which understands dimension and "truth" as dependent upon point of view. In this manner, art bestows new form and expressive potential to an idea that was previously the exclusive domain of science.

Rice's systematic scale invariance and determined synthesis of oppositional elements establishes a structural theme of paradox, cyclical recurrence, and inescapable eternal destinies. Eternity and paradox cycle throughout his image in both content and structural theme. And each depicted action forges a closed system allowing no escape.

Like the venomous dragon Tiamat, the malevolent truck in *Hell on Wheels* (Figure 13.4) scoops up its victims, grinds them under its wheels, and throws them back, only to scoop them up once again—implying an eternal cycle. The entire thirty-four feet of the painted truck blossom with evil little flowers of fire.

Many of Rice's paintings blaze with the healing and purifying fire of societal change—which, once again, echoes alchemy. His freeway paintings, too, form an endless circle, an eternal cycle suffering no entry, no exit. These freeway systems route the endless traffic again and again through the same cycle, and the reeling wheels of trucks and cars function as similar but smaller recursive systems, compressing past, present, and future as they repeat each cycle.

Rice's apocalyptic image reminds us that a fundamental involvement with questions related to religion and myth, and its accompanying sense of cyclical time, is inescapably woven into the infrastructure of postmodernism. Postmodern strategy assumes that complete truth is unattainable in any text because an author inevitably views each issue from a single specific point of view, and any point of view must be both biased and predetermined owing to the priorities, the assumptions, and the established hierarchies of both the author and the society that generated that author. Poststructuralists render these invisible biases and predetermined positions visible by exposing favored foundational concepts and their binary, or polar, opposites (like absence-presence, linear-painterly, unity-multiplicity, flat-volumetric, microcosmic-macrocosmic). This exposure indicates which pole of these concepts or ideas society tends to consider important.

This strategy of spotlighting a favored idea and its opposite forces attention on the aporetic border area that separates the two—the area that is both or neither, absent and/nor present, linear and/nor painterly, unified and/nor fragmented. This is the area once known as the "excluded middle" or "excluded third." A basic law in traditional Aristotelian logic states that "everything is either A or not A"; no third state is possible.

Edmund Leach tells us this aporetic area, "the boundary, the interface layer which separates categories of time and space, is the zone of the sacred," and thus linked to magic, taboo, and religion (1985, 19–20). Postmodern artists, as I have repeatedly demonstrated, tend to discard the deterministic truths of the modern scientific aesthetic in favor of myth and religion. But

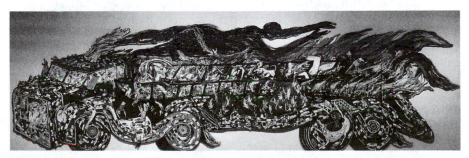

FIGURE 13.4 Rice, Dan. *Hell on Wheels* (1982). Oil on panel (120" × 408").

Rice explores an area that is shared by both religion and the new sciences, an area that tenders a stochastic and pluralist rather than a deterministic and objective point of view: Chaos theory and fractal geometry are thus germane to his mythic concerns. In contrast to traditional scientists, chaos theorists make no claims to objective truth. They do not believe it is possible to know—and thus control—everything and everybody, as traditional scientists once believed. Chaos theory proves that unpredictability is built into any complex system: air and water turbulence, the weather, the stock market, human nature.

In response to current collective attitudes in society—stemming from art, religion, science, math, and geometry—Rice has developed a complex visual system that seems remarkably similar to the "scale invariance" in fractal geometry. And because fractal geometry depends upon nonlinear or "fuzzy" math, it offers pluralist solutions rather than single truths. Fuzzy math is stochastic (conjectural) and recursive rather than deterministic and linear; it probes and explores, iteration after iteration, endlessly. Hayles notes that, like chaos theory, deconstructionists also emphasize what they call "iterative techniques and recursive looping" (Douglas Hofstadter's Strange Loop again) to destabilize systems, magnify minute changes, and force them to yield unexpected conclusions (1991, 11). Hence deconstruction, like chaos theory, replicates similarities, ruptures, and fragments (10–11).

Sheldon Teitelbaum insists this new fuzzy math is forcing the world's first scientific alliance between Eastern and Western beliefs.[4] He explains that for the first time, scientists have access to a mathematical method that can be used to calculate "that a thing and its opposite can at once both be and not be, or be partly and partly not"—simultaneously A and not A (1991, 12). Such reasoning, he says, has been more typically encountered in Eastern thought than in the Western system of logic. "Cultural biases accreted for 3,000 years stand to fall," says Teitelbaum. "Western beliefs, like Western economies, will be given a run for their money" (13). Because fuzzy math, like poststructuralism, tends to concentrate on "the zone of the sacred"—those aporetic boundary areas that exist between two theoretical opposites—this new math is easily integrated into postmodern myth and religion.

As fuzzy math and fractal geometry avoid the objective truths of math, science, and traditional Aristotelian logic, so does Rice avoid the objective truths of traditional narrative, history, and linear time. He explores cultural images, but he is no reporter. He is no historian either. He signifies the *myth*, not the *fact*, of the American city—a myth created by the biased assumptions and polarizations of supposedly more objective reporters. These reporters, these unintentional myth makers, have created an image of a city that warps

[4]Teitelbaum gives credit for the invention of fuzzy math to Lofti Zadeh, who was born in the Soviet Union and educated in Iran and the United States (1991, 12).

the perspective of readers and viewers, who are made hypervigilant by the endless ordeal of the evening news. In Lance Morrow's words: "Fantasies seep into facts. Entertainment and journalism drift back and forth across the borders" (1992, 50). If people in the city come to believe this myth about themselves, must they inevitably live up to it?

When reporters tell and retell stories, they translate the narrative of recent history into myth. And myth, with its accompanying sense of cyclical time, tends to compress past, present, and future into one inseparable body, as Morrison and García Màrquez do in their writing. Rice exploits the great American myth of New York to capture pluralist images of a culture in crisis. Many of Rice's paintings show recognizable bird's-eye views of areas that native New Yorkers will find familiar—once again echoing the ancient connection between painting and map-making.

Rice invokes the three alchemical dragons of chaos, eternity, and the Apocalypse, but he paints no traditional winged dragons. His dragons are the truck and the automobile, the clock and the freeway. These contemporary dragons serve as symbols of apocalyptic fragmentation and chaos. William Zimmer writes in *The New York Times* that "Rice likens the vehicle's wheels to the center of the earth, which is, of course, the same thing as hell" (1986). Also in the *Times*, Michael Brenson points out that Rice, like F. Scott Fitzgerald, uses the image of the automobile as a symbol of carelessness and irresponsible power (1985). Rice himself observes that "Bosch was one of the first to paint machines, inventions, and technological developments as symbols ultimately leading to the downfall and destruction of mankind. Bosch's Hell becomes Hell on earth; in Bosch's paintings man is destroying himself" (1987).

Rice uses his content and system toward one end.

He creates a powerful image.

Tom Lutes maintained after Rice's Quebec exhibit that "Those who can barely remember a painter's name or even a particular work after visiting a gallery will surely find that Rice's vivid, sometimes jolting pieces lodge firmly in the memory" (1988).

Every new art form, even as it destroys the old traditions, is itself generated by restructuring the boundaries of those traditions it hopes to replace. And Rice displays an uncommon familiarity with traditional art: Brenson notes that his paintings indicate, in both content and structure, an unusually broad art historical range (I note: of signing painters), which stretches "from medieval frescoes and manuscripts, to Abstract Expressionism and Jean Dubuffet, to Robert Longo and Sue Coe" (1985).

Nancy Gardener writes that Rice's work, like that of Hieronymus Bosch, "represents a hell teeming with activity—claustrophobic and suffocating" (1987, 53). Other reviewers, too, compare Rice's content to Bosch— and his structure and technique to Pollock. The similarity to the sixteenth-century painter Arcimboldo, a Rhetorician, is also obvious. But Rice's

paintings are yet more reminiscent of several non-European cultures—most appropriately, the *wag-wag* style from seventeenth-century India (a playful composite of small figures, animals, and people arranged to form a larger image, often an elephant). These influences—from the Middle Ages, the northern Renaissance, and non-European cultures—seem to permeate the postmodern image.

Rice manipulates iconic and indexical signs in his language with complexity. The images in his paintings are packed with action, but the reiterative eternal nature of this action signifies a negation or a cyclic sense of time rather than the narrative moment. Traditionally, paintings from the Italian Renaissance, impressionism, and modern art implied a linear temporal narrative, a precise moment in time, in which one area was sharply focused while details were progressively more blurred the farther they were from the center of focus. Focus and blur also functioned to create compositional climax.[5] This use of focus began as an attempt to mimic the interaction of foveal and peripheral vision, which signified a precise moment in time. In direct contrast to signifying a precise moment in time was the practice of seventeenth-century Dutch painters—what Svetlana Alpers calls a "displacement of time." These painters subjected an inert world to careful scrutiny and compiled focused, detailed descriptions of a manifold of objects seemingly without end (1983, 109). As in Dutch painting, or photography, every image in Rice's paintings is equally focused, equally important. Like Pollock, he negates compositional climax to create an all-over image in which no one area is more important than any other; and this image displaces narrative temporality to imply timelessness, the cycle of eternity.

As counterpoint to Rice's eternal cycles, mythical testaments, and apocalyptic warnings there are sudden and startling incidents of tenderness and play and wry humor: in the middle of frantic chaos a seemingly unconcerned figure sells flowers; another slides happily down a perilous cable; and yet another nonchalantly examines an unimportant detail with a magnifying glass while a mad world whirls around her. In fact, it is difficult to view Rice's work without noticing the close kinship with the ancient tradition of the carnival grotesque we have seen in Bosch, Rabelais, and Duchamp.

The best painters have always had a high tolerance for chaos; consequently, they have been willing to sacrifice control. Barnett Newman once wrote: "The subject matter of creation is chaos" (from Lyotard 1989, 243). Rice's juxtaposition of apocalyptic imagery and American myth with the new science of chaos theory highlights the continuing struggle between myth, religion, and science—and may thus suggest the high status that science has been granted in our society. Early-twentieth-century Euro-American society

[5]For a complete development of the compositional use of focus and climax, see Dunning 1991a, 86–88.

looked primarily to science for answers to its questions about the visible world, and the scientific answers it received were instrumental in the development of its concept of reality.

Where men and women prior to the Renaissance looked to religion and myth for answers to the mysteries of the universe, modernists looked to science. But in the late twentieth century many of us have grown disenchanted with the promises and easy answers offered by classic science. Materialistic science, it seems, does at least as much harm as good. With every step forward, there is a corresponding Newtonian step backward. Perhaps we are relieved when Hayles tells us that both poststructuralism and the new sciences recognize (as Newton did) that complex systems breed unpredictability because initial conditions can never be specified with enough accuracy to predict the results of the endless cycle of multiple iterations (1991, 30). Postmodernism shares these themes with science and current literature (or the arts)—Hayles continues—not so much because one influences the other, but because neither is above or apart from the culture; each is "embedded within it" (30). Furthermore, the parallels are "so extensive that the most likely source for them is no single site but the cultural matrix as a whole" (11). In other words, similarity of concerns does not come about so much because science influences art or vice versa, but rather because the different disciplines' concerns are shaped by similar contemporaneous experiences within the same society.

Dan Rice's complex content is woven with subtlety and rendered more dynamic by his cyclic and self-referential compositional system. He exploits art as a vehicle to bring religion and the new sciences to focus simultaneously on the same questions. This fusion of religion with postmodern science suggests there may now be less difference between these two presumably oppostional views than we once thought.

14

On the Shoulders of Giants

Modern artists were supreme zealots for personal creativity, originality, and the cult of the individual genius. They approached each task as if they were the first in history to attempt such a project. They aimed to write or fabricate each work in the most creative and unique manner possible. They operated under the assumption that each project might theoretically serve as a model for all future projects of its kind—as if responsibility for the direction of the future rested on their shoulders alone. Each artist struggled to be the first to originate a personal style or a valuable idea. Inquiring minds wanted to know: "Who did this first?" Those who were successful were labeled the "Avant-Garde" (the advance guard, those who point the way).

Though the concept of genius did not come into full bloom until the advent of romanticism in the late eighteenth century, it was certainly consistent with the earlier idea of the "Saturnine countenance" and *terribilità* associated with Michelangelo, whom Vasari called "genius" and "Divine." A typical statement about a creative giant was: "There was art before (fill in name), and there was art after (him or her), but the two were not the same."

In the middle of this discussion concerning the importance that modernists conceded to originality, I must interject a qualifier. During the 1950s and 1960s, when works were accepted by galleries or selected into juried shows, most were chosen because they "looked like"—or bore a "family resemblance" to—something the jury or the gallery owner had previously seen called "art." Those in a position to judge usually played it safe. Most jury selections, particularly prize winners, were obviously derivative of well-known styles. So despite all the lip service paid to unflinching originality and new ideas, the favored works of modernism displayed a family resemblance to past works. No one wanted to make a risky choice that

might prove "wrong" and be ridiculed. Entirely new directions or images were regarded with suspicion. The ideal work was different—but only slightly.

Postmodernists stand less in awe of unique individual insight. Their interest centers around "postsubjective" ideas. The term *subjective* in postmodern discourse refers to an individual or personal evaluation. It indicates excessive emphasis on the moods, attitudes, or opinions of an indivisible Cartesian individual. Pauline Rosenau explains that the postmodernist uses the term *subjectivity* to refer to the self-awareness of the individual subject. Postmodernists deny the importance of the subjective point of view or insight, no matter how bright or right a particular individual may appear to be (1992, 42).

The most extreme postmodernists contend that such superior individuals are fictions entirely constructed by society, merely public masks. These writers are critical of individuals who claim superior understanding or insist their ideas are more valid or more meaningful than the ideas of others. Such people—these postmodern writers insist—usurp power, which they then use to dominate and oppress. If such a unique individual identity ever existed, it was nothing but an illusion, and such illusions are no longer possible in a postmodern world. Furthermore, they argue, no lone individual single-handedly originates any meaning, theory, text, painting, or sculpture (Rosenau 1992, 42–43).

Meaningful images and ideas are now believed to be generated by the culture that created that individual. Though they may seem to issue from the mouths or hands of individuals, such individuals are merely giving voice to the collective ideas of their contemporaries. If Monet and Freud had not come along when they did—the theory goes—someone else would have been "forced" to take their place and create a similar body of work. Freud's ideas had been floating around society long before he organized them into a coherent whole. Dostoevsky, for example, filled his *Crime and Punishment* with Freudian imagery and ideas when Freud was only eleven years old. When such "collective" ideas reach the point of supersaturation, they may seem to organize (or crystallize) around one individual.

Rosenau notes that this awareness of the collective source of ideas was evidenced as early as the philosophical writings of Freud and Nietzsche. Freud's view that the individual was irrational and incapable of objective, reasoned argument was quickly adopted by the most extreme of the postmodern writers, even though Freud himself would never have completely repudiated the individual self, the Enlightenment, science, material reality, or the human capacity for rational reflection (1992, 44–45).

Those contemporary writers who assume a less extreme stance grudgingly accept a *new* concept of identity, though the self they would welcome would not be much like the one that was banished. This new self will not be a purposeful, fully conscious entity. Rather: "S/he will be a post-modern

subject with a new nonidentity, focused not on the 'Great Men' of history, but rather on daily life at the margins," and s/he "will reject total explanations and . . . a unified frame of reference" (Rosenau 1992, 57). The more radical writers, such as Deleuze, Guattari, and Foucault (though he reversed himself just before he died), go so far as to hope they can create such a postmodern decentered "self" who is liberated from "the terror of fixed and unified identities, and free to become dispersed and multiple" (Best and Kellner 1991, 79).

Because this postmodern identity lays no claim to objective truth, history, or the ownership of an idea, it is ethically bound to treat all images and ideas as the collective property of society. Consequently (in a direct attack on the copyright laws), it is felt that no individual should control the distribution of these images or ideas. We should all be free to "appropriate" ideas from any other "voice" issuing from cultures recent or cultures past.

A well-worn anecdote quotes Picasso as saying: "Good artists borrow ideas. Great artists steal them." Douglas Crimp tells us that assaults on the authority of authorship and originality have generated slogans like "If it works, use it" and "If it's not yours, steal it" (1990, 49). And Susan Suleiman contends that the most characteristic feature of postmodernism is the "appropriation, misappropriation, montage, collage, hybridization, and general mixing-up of visual and verbal texts and discourses, from all periods of the past as well as from the multiple social and linguistic fields of the present" (1993, 176).

Andy Warhol (1930?–1987), for example, appropriated commercial images in a focused and organized manner. He photographed reproductions of commercial images and made multiple reproductions of them— reproductions of reproductions. By 1981, Sherrie Levine was taking her photographic prints directly from Weston's photographs; she rephotographed his prints straight out of books. She hung as her own these copied prints in Metro Pictures gallery in New York (though her titles clearly indicated they were "after" Weston).

Gerald Marzorati notes that when lawyers for the Weston estate threatened suit, Levine quickly shifted to appropriating W.P.A. photographs, which are not copyrighted (1993, 97). Levine has rephotographed works by other artists, such as Walker Evans and Rodchenko. And she later copied meticulously by hand, from color plates in books, works by Egon Schiele, El Lissitzky, Miró, Malevich, and Mondrian. She gave these copies straight-forward titles also: *After Joan Miró,* and *After Kasimir Malevich.* She made no attempt to mislead viewers, but her copies were not intended as homage to the original artists. They were intended to advocate the act of piracy and thus to undermine the modern belief in originality and personal expression (91).

In short, Levine echoed and advocated the poststructuralist stand against private ownership—particularly ownership of images, texts, and

ideas. It is interesting to note that such acts of appropriation tend to imitate subjectivity and individuality while simultaneously denying that such things exist.

Levine also attempted to shift the balance in the relationship between the two oppositional issues of influence and originality. Marzorati says Levine felt that the difference between her method and Julian Schnabel's, for instance, was more in the reading their work received than in the substance of the work itself. The works of both Levine and Schnabel display some obvious influences from other works as well as some original elements; but in Schnabel's work, she reasoned, the "issue of influences got repressed. In my work, it was originality that got repressed, that did not get discussed" (from Marzorati 1993, 92). Quoting (appropriating?) himself from an earlier article, Crimp insists that "Levine's appropriation reflects on the strategy of appropriation itself" (1990, 47).

Like Levine, most late-twentieth-century art students, particularly those who attend universities that are located some distance from a metropolitan center, are accustomed to seeing art only (or mostly) in the form of reproductions. These students, as well as the art faculty who train them, have often been aesthetically "reared" on slides and photographs of artworks in books and magazines. Out of economic necessity, many smaller universities and colleges accumulate their slide collections by rephotographing reproduced photographs of artworks in books and magazines. Often these photographs of reproduced photographs *are* art in the experience of students who see nothing else. Few art students complete their education without at some time (surreptitiously and guiltily perhaps) copying a photograph or a reproduction of someone else's art, or tracing a photograph from a slide projected onto their paper or canvas. Photography has become the inspiration, the source, the tool, and the method of appropriation.

Certainly this willingness to trace images is not new in art. Renaissance artists had several devices for tracing an image accurately onto a pane of glass. And several artists—Vermeer is the prime example, though it has never been proved beyond the possibility of argument—are believed to have traced images they projected by means of a camera obscura. The proliferation of photography has simply made the process easier and more efficient, and therefore pervasive.

Joel Snyder reminds us that the construction of the camera did not evolve out of the desire to produce faithful images of nature. The original camera obscura was developed to aid sixteenth- and seventeenth-century artists in their attempts to produce easy and consistent images; these painters' expectations provided the standard for the kind of lens demanded (1980, 231). Since camera makers needed to know exactly what kind of image the artists wanted before they could design a lens to create that image, from its beginnings the "mechanism of the camera was thoroughly standardized to meet specific [preexisting] pictorial requirements" (233).

There were myriad possibilities for the form the standard camera lens might have taken: for example, pinhole, wide-angle, telephoto, or fish-eye lens (which, though it noticeably distorts objects nearer the camera, in some ways gives a more accurate, though less familiar, image than the standard lens). All produce a different image than the standard lens. In other words, beginning with Leonardo, the traditional camera lens evolved in a direction that was specifically designed to imitate the already familiar image of Renaissance painting.

Dan Cameron notes that since the 1970s appropriation has been used heavily by artists as a purposeful political strategy based on certain social and gender issues as well as on aesthetic concerns. But a younger second generation of artists now considers appropriation an accepted "method, not an issue" (1988, 93). This method might well have been welcomed by past thinkers such as Bacon, Comenius, and Pound as an easy way to collect nonarbitrary, motivated images (iconic signs) for discourse. After collecting all the images needed by photography, an artist need only arrange them in systematic order, in a linguistic syntax and grammar.

Postmodern artists flaunt past images and ideas in their work. Their intent is to place such images in entirely new contexts in order to make visible new ideas—once again, to make the invisible visible. To gain such a new perception they may take an image apart (destructure) and put it back together in a different sequence (restructure), thus rendering an entirely different image. Jacques Derrida tells us that "the part must be detached and examined separately. But in a pure philosophy, in a 'system of pure philosophy', everything must be sewn back together" (1987, 39).

Often this process of destructuring and restructuring an image is *reiterated* again and again through multiple cycles. Henry Staten maintains that the strategy of deconstruction is analogous to the act of weaving separate elements together in order to generate a particular fabric, then once again separating these elements, only to discover that the process of unraveling weaves them once more into a new fabric—or text: "By twisting fibers together we get a thread; by weaving threads together we get a text; by unraveling the text into its threads and the threads into their fibers we get deconstruction, which is at the same time itself a fabric woven according to the variable pattern of the unweaving of the deconstructed fabric" (1984, 107).

It is no great jump to substitute for fibers, threads, text, and fabric those elements that form the warp and the woof of any text, such as a painting. But deconstructive strategies require recursive cycles of such activity: the cycle must repeat itself again and again. A destructuring is not a deconstruction, just as half a turn of a bicycle wheel is not a bike ride: the wheel must complete a full cycle, many times. Derrida insists that deconstructive strategy makes sense in philosophy only when "treating the chain of philosophical works since Plato as 'one great discourse'" (from Staten 1984, 2). Thus the de-

constructive method makes sense in painting only when the chain of images from ancient cultures to now is treated as "one great discourse."

Many current articles on art mention the word "deconstruction" at least once, but the word is often used far too simplistically, as a synonym for "destruction," "destructuring," "negation," or "nihilism." That is not the intent of the word. Derrida himself has admitted he is not completely happy with the term *deconstruction* because it has a tendency to sound negative or nihilistic, like "destruction"; and the deconstructive strategy, Derrida insists, is constructive and affirmative, not destructive or negative.

Suzi Gablik evidences this confusion when she asserts that "there are two postmodernisms—a deconstructive and a reconstructive version" (1991, 21)—as if the deconstructive method tears down and the good method puts back together. She thus implies that "deconstruction" means the same as "destruction" or "destructuring." Actually, both the destructuring *and* the restructuring ("reconstructing") are requisite aspects of the deconstructive strategy. One demands the other.

Derrida tells us deconstruction is a "form of critique" and, like any critique, can be either positive or negative. The starting point for any theory or system—even those that seem natural or self-evident—is never natural or given. It is a construct that grows directly out of unique aspects of a specific language and culture, and it is "usually blind to itself" (1981, xv). A deconstructive critique of any such theory or system cannot be an audit of its flaws or a list of suggestions designed to improve it. The deconstructive critique, Derrida tells us, proceeds in reverse: it traces the history of the apparently natural, self-evident, or universal aspects of the system to find the reasons they are the way they are, and their influence on what follows (xv). It ferrets out the fundamental aspects to which we are blind. In this sense, poststructuralist "theory" may be understood as an attempt to gain new perceptions of ideas and images that society perceives as self-evidently true—perceptions of, for example, gender, race, history, and truth itself.

Copernicus, Derrida explains, wrote a critique of the Ptolemaic construct of the universe, not because his new idea that the earth orbits the sun was better than Ptolemy's geocentric construct, but because it was a shift in paradigm that "literally makes the ground move. It is a deconstruction of the validity of the commonsense perception of the obvious" (1981, xv). The new paradigms resulting from such critiques are not considered better than the old ones; they are simply intended to offer a valid and viable alternative.

The once-pervasive modern concept that art is hierarchical and progresses from lower and inferior planes to higher and superior planes—climbing from past to present as if it were ascending a ladder—has been dismissed in favor of the more current notion of lateral displacement. Any two styles merely stand alongside each other. New styles are no longer considered better than previous styles, just different, and perhaps more appropriate to the new age that generated them. Gablik tells us that progress in sci-

ence and art is not made by accumulating more knowledge: progress, she contends, "is made by leaps into new categories or systems" (1977, 159).

The strategy of complex "appropriation"—destructuring, restructuring, and building on the images or discourses of others—is a way of using past works as a foundation upon which to build new ideas and concepts.[1] Its roots go back to the Middle Ages. The pluralist tendency to simultaneously accept and act on both sides of two opposing points of view led medieval scholars to appropriate from the sacred sciences and pagan classical literature any ideas they considered good—ideas, for instance, that illustrated Christian dogma—and leave the rest behind.

In the twelfth century John of Salisbury described one of the distinctive characteristics of the Middle Ages: "Bernard of Chartres used to compare us to dwarfs perched on the shoulders of giants. He pointed out that we see more and farther than our predecessors, not because we have keener vision or greater height, but because we are lifted up and borne aloft on their gigantic stature" (1962, 167). This notion, that important ideas are built directly "on the shoulders" of previous ideas, stands in direct opposition to the modern model of the individual genius—the intellectual John Wayne or Sigourney Weaver—who single-handedly conceives magnificent images that are more in opposition to than in tune with the surrounding culture. Postmodern artists do not hesitate to "perch on the shoulders of giants." They often welcome the groundwork, counsel, and guidance of others, past and present, that allows them to give voice to collective insights. In the current culture one person's (collective) ideas are considered as valid as another's; therefore we tend to recognize no "Great Men."

We do, as a vestigial remnant of the old modern ways, still recognize the names of individual artists; but the current inclination is to value the works of so many artists that the individual becomes almost anonymous, lost among the multitude. This attitude simultaneously reflects medieval anonymity and Warhol's often quoted line: "Someday everybody will be famous for fifteen minutes." In modern art, it seems, there was nothing but Rolls-Royces and worthless junkers; now we have minions of Fords and Toyotas.

Timothy Burgard defines "appropriation" as "The creation of a new work through the copying or paraphrasing of an existing image" (1991, 479). Though Picasso believed in the modern Cartesian construct of unique identity and the notion of the artist's divinity, he was in many other ways a precursor to the postmodern. Like Gauguin, he was quick to appropriate and exploit the ideas of others. Burgard reports that Picasso said art was "a form of

[1]Note that a meaningful appropriation is not the same as a pastiche. A pastiche is a meaningless "hodgepodge" of borrowed ideas to no apparent point.

magic," and in his role as Creator, he formed a strong personal identification with God as well as an identification with his own construct of the first prehistoric human artist (whom he called "the little man"). He was convinced that by appropriating tribal images, he could acquire the magical powers of tribal shaman artists (479).

After seeing a show of tribal art in 1907, Picasso wrote: "At that moment I realized that this was what painting was all about. Painting isn't an aesthetic operation; it's a form of magic designed as a mediator between this strange, hostile world and us, a way of seizing the power by giving form to our terrors as well as our desires" (from Burgard 1991, 483). Though Picasso's understanding of this process was rooted in modern concept, he did share one major view with postmodern appropriators: he considered appropriation to be a form of "'intercourse' with rival artists of the past and present" (479).

Bette London corroborates that the foundation of modernism was the concept of authentic self-expression, the production of originals, and a separate individual aesthetic. This concept depends on the belief that each voice is unique and proclaims, as we have seen, a personal identity as "unmistakable as a fingerprint." This modern belief, of course, is a product of the Cartesian concept of coherent, indivisible identity (1990, 1–3). But appropriation—considered a postmodern characteristic—was an unacknowledged and invisible ingredient of modernism (160). In the best spirit of the Middle Ages, postmodernism insists on making the invisible visible: the practice of appropriation is now rendered obvious, undeniable, and inescapable.

Some topics are timeless. They appeal to what Jung has called the *archetypal unconscious*. When this happens, an image may come to be appropriated over and over again through the millennia. Each time such an image is selected, it is destructured, then restructured to yield a new fabric, image, or perception.

Fran Murphy drew from live models only a few times as a student. Since then, recognizing the importance of photography in our experience of reality, Murphy has drawn and painted exclusively from photographs. In 1990 this practice led to an appropriation of Jean-Léon Gérôme's nineteenth-century image of *Pygmalion and Galatea* (Figure 14.1). Through an elaborate process of photography and painting, Murphy repeatedly destructured and restructured Gérôme's nineteenth-century image, and finally re-created it in the form of *Anatomy of a Painting (Pygmalion and Galatea)* (Figure 14.4).

The recombinant process recently manifest in Murphy's version of *Pygmalion and Galatea* began in ancient Greece and can be traced forward through layer after layer, like the multiple texts of a medieval palimpsest. (Many current writers are fascinated by medieval terms like *palimpsest* and *hermeneutics*.) Palimpsests (from a Greek word meaning "scraped again") were generated by a process of writing and erasing as a seemingly endless train of medieval scribes scratched with goose-quill points their fleeting

FIGURE 14.1 Gérôme, Jean-Léon. *Pygmalion and Galatea* (1890). Oil on canvas (35" × 27"). Metropolitan Museum of Art, New York.

thoughts on parchment surfaces and the next scribe erased them. Parchment was the skin of a sheep or a goat, finely tanned and carefully split, thinned, and prepared as a writing surface. These thin sheets of fine leather were highly valuable—frequently more valuable than the texts recorded so laboriously upon them. Consequently, parchments were often erased, reused, reerased, and readied once again for yet another reuse. Some of these sheets were erased and reused five or six times. The rubbing process employed to obliterate the previous texts, however, was not very efficient. It left faint traces of previous texts. We in the twentieth century have developed processes that resurrect these long-erased texts. Thus these palimpsests,

these ancient parchments cluttered with layered texts, are aggregates of all the previous texts written upon them—even as the post-Cartesian self seems to be an aggregate of previous selves. The train of scribes that once seemed so endless has long since ended, but the thoughts once considered so fleeting now endure.

The elaborate palimpsest of Pygmalion and Galatea starts, so far as we know, with ancient Greek mythology, and it has been appropriated and re-created many times in several different ways through more than two and a half millennia. The original text came from the ancient Greek myth of Pygmalion and Galatea. This version portrayed Pygmalion as the king of Cyprus who fell in love with a statue of Aphrodite. Later, in Rome, Virgil wrote the *Aeneid* in which he used the name Pygmalion for the king of Tyre, the brother of Dido, who murdered his sister's husband to gain his wealth. Only a few years later, in *Metamorphosis* (possibly our richest source of ancient Greek myth), Ovid penned a more complex version of the original story. Ovid's Pygmalion was a sculptor who hated women and was thus incapable of loving any but his own creation. He gave material shape to his vision of the ideal woman in the form of a statue. When Pygmalion fell in love with his own creation, Venus took pity on him and brought the statue to life as Galatea.

William S. Gilbert appropriated Ovid's story in 1871 to write his version of *Pygmalion and Galatea*. It is this nineteenth-century version that seems to be the source of most modern retellings of the story. In 1912 George Bernard Shaw appropriated the story in his play *Pygmalion*, introducing the element of irony as an important aspect of the creative artist. The musical *My Fair Lady*, based on Shaw's play, was followed by the movie of the same name, which starred Rex Harrison and Audrey Hepburn in an allegorical restructuring of the Pygmalion and Galatea myth. Another adaptation of the myth was the movie *Born Yesterday*, starring Judy Holiday, which was followed by a remake of that same movie, starring Don Johnson as an analogue of Pygmalion and Melanie Griffith as Galatea (in this case, more pastiche than appropriation).

In 1990 Fran Murphy continued this tradition with *Anatomy of a Painting: (Pygmalion and Galatea)* (Figure 14.5), which was appropriated from Jean-Léon Gérôme's painting of the same subject. Interestingly, while Murphy appropriated the image from Gérôme, Gérôme, it seems, had appropriated his painted image from himself. For before he painted the painting, he "created" a marble statue of the subject.

Allen Weller— the first professor to demonstrate to me the importance of art history to the studio artist—tells us that nineteenth-century French sculptors never carved their own marble nor cast their own bronze. They worked exclusively in clay (1985, 55). From the clay original, a plaster model was cast (by either the sculptor or a stone carver). Then, by means of an elaborate process of measuring in three dimensions called *pointing*, some anony-

mous stone carver translated this plaster version into marble. So all those exquisitely carved nineteenth-century French marble sculptures—with their soft, fleshy, translucent marble surfaces, exquisite, softly felt transitions between the hair and the face, and lifelike, glassy eyes watching passing viewers—that are attributed to nineteenth-century French sculptors like Houdon and Gérôme are actually sanctioned appropriations executed by anonymous stone carvers. They were fabricated from the sculptors' clay version. The sculptors who modeled the original clay, of course, took quick and exclusive credit for the finished work. (I had always wondered why the statues done by Houdon in France were so exquisitely, almost miraculously, carved, while those he did in America look so harsh and sharp.)

In his book on Gérôme, Ackerman informs us that the artist probably modeled the painting after the plaster cast of the clay original (1986, 268). This is consistent with the facts that the painting was done in 1890 and the marble is dated 1892. So Gérôme's painting was modeled after a plaster cast of his own clay sculpture. With these facts in mind, it is easy to reconstruct the order in which the separate works were executed: Gérôme modeled the life-size clay version of the two figures, then cast (or hired someone to cast) the clay figures in plaster; he used this plaster version of the two figures as a model when he painted at least three paintings of Pygmalion and Galatea; later a stone carver made a marble copy (Figure 14.2) from the plaster copy of Gérôme's original. One remarkable thing about this sequence is that the two originals (or one and a half originals?)—Gérôme's clay version and the direct plaster cast of it—are the only versions that were destined to be destroyed. The only purpose of the two originals was to generate copies.

Fran Murphy then began a late-twentieth-century restructuring of Gérôme's painting of a cast of his own sculpture. Murphy told me that the multiple steps and numerous versions through which the image was processed (in myth, sculpture, painting, reproduction, photography, mixed media, and finally painting again) represent the elaborate process of purification in alchemy. The idea of transmuting the base elements of inert canvas and paint into the living soul of art (gold) is another alchemy-related concept that postmodern artists consider relevant.

First, Murphy, spouse, and child created a *tableau vivant* by posing (garbed and ungarbed) in states and poses similar to those assumed by the figures depicted in Gérôme's painting. Then a photograph was taken (Figure 14.3)—a photograph of a *tableau vivant* from a photograph of a painting of a plaster copy of Gérôme's original clay sculpture. The Galatea in Murphy's photograph is posed on a sculptural plinth, as is the Galatea in the original sculpture and painting. Her feet and legs are even whitened with grease paint to indicate that she is still in the process of changing from marble to flesh. (Gérôme himself painted his marble in the same lifelike colors, though the statue as it now exists at the Hearst estate has been bleached to a blinding white.) In the Gérôme sculpture, of course, the color of flesh was applied over

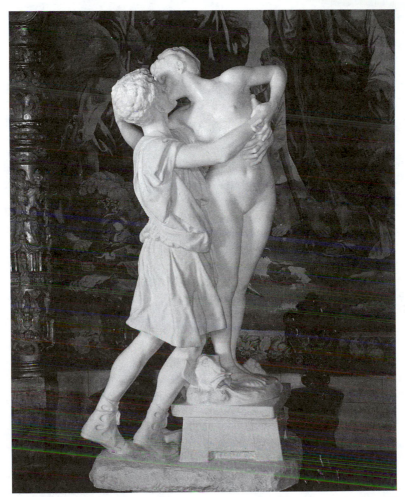

FIGURE 14.2 Gérôme, Jean-Léon. *Pygmalion and Galatea* (1892). Marble 77" high. Hearst San Simeon State Historical monument, California.

the white marble. So Murphy's *tableau* is an obversion of the original: white was applied over the reality of flesh. The purpose of the marble fragments at the bottom of Murphy's photograph, which match those in Gérôme's painting, is to make an obvious connection to the carving process in Ovid's version of the myth, as well as to the carving of the marble copy of Gérôme's original sculpture.

The Cupid in the background is Murphy's child, echoing the Cupid on the right side of Gérôme's painting. The mask on the right also echoes the prominent mask in Gérôme's painting. The Pepsi box at the bottom is very like the box Pygmalion stands on in the first painting and, along with the

FIGURE 14.3 Murphy, Fran. Source photograph for *Anatomy of a Painting (Pygmalion and Galatea)* (1989).

added space heater on the right and the dynamic diagonal slash of the flo-
rescent light above, is intended to signify the tradition of using anachronistic
contemporary elements in paintings of events from the distant past. This tra-
dition was established by earlier painters such as Masaccio and Caravaggio.
The gridded wainscoting in the background is actually two industrial palette
skids that were originally designed as mobile platforms to hold stacks of
manufactured products so they can be easily lifted and moved about by fork-
lift trucks. The palette grid serves as a translation of the rectangular cabinets
and objects visible in the background of Gérôme's painting, and is also in-
tended to signify the Cartesian grid so pervasive in traditional painting.

Murphy then worked this photographic image into a six-foot mixed-media version of the photograph (Figure 14.4). Using this large version as a model, a painting was started on two four-by-eight-foot sections of door skin—a thin plywood about one-eighth of an inch thick. The two plywood sheets, forming an eight-foot square, were then attached to the two palette skids, and Murphy worked seriously on the painting.

After working on the image for several weeks, Murphy decided the square solid rectangle was strangling the image, so the two panels were

FIGURE 14.4 Murphy, Fran. *Study for Pygmalion and Galatea* (1990). Mixed media (76″ × 48″).

stripped off the palette skids. Parts of the background were cut away from the figures to leave open spaces in the middle—which, in turn, rendered visible large sections of the palette skid grids. The yardsticks were then added to represent the utility of tools. They are intended to function as a sign of linear measurement, and hence are a metaphor for the modern concept of linear time, as well as the Cartesian grid, so dominant in Gérôme's era.

After the restructured cutout flat image began to gel, the three-dimensional mask image was attached to the structure. The smock worn while posing for the photograph was hung on the left, and the Pepsi box, hammer, and the shoes that were worn in the photograph were also added. These three-dimensional elements represent the role of sculpture in the development of both the myth and Gérôme's statue and painted image.

Finally, the small rectangles of photographic gray scale references and color separations that were used to fabricate Murphy's mixed-media version were added at the top. These are intended to represent the processing of the image from one state to another, as in alchemy. They also indicate the importance of the vocabulary of photography as a source of iconic signs (as once advocated by Bacon and Pound) in all of Murphy's work. Moreover, including these photographic artifacts calls attention to the fact that Murphy has replaced the tradition of free-hand drawing and painting with a mechanical photographic technique that undermines the modern emphasis on training and skill, as well as the once-favored personal and expressive qualities of the hand.

Sensing that the image was now near completion, a passage from Kierkegaard began to dominate Murphy's thoughts. Believing (correctly, as it turns out) that an ideal use for them would present itself someday, Sören Kierkegaard had carried a slip of paper in his pocket for years with the following arrangement of words written on it:

THE BOUNDLESS	SPLIT THE PAST
FEELING OF THE	AND THE PRESENT
MOMENT THAT	GIVING A GLIMPSE
	OF ETERNITY

Well versed in philosophy, Murphy, too, had envisioned a future use for these words, and so had also carried them around for years on a similar slip of paper. The words are arranged so they can be read in different sequences (reminiscent of the Rhetoricians's *chessboard* arrangements in Bosch's era that allowed lines of verse to be read in different sequences). The lines bore no significance to Gérôme, according to Murphy; they had, however, been quite important to the nineteenth-century signing painter Edvard Munch. Across the bottom of the painting Murphy stenciled: "THE BOUNDLESS SPLIT THE PAST/FEELING OF THE AND THE PRESENT/MOMENT THAT GIVING A GLIMPSE/OF ETERNITY" (Figure 14.5). Kierkegarad's

FIGURE 14.5 Murphy, Fran. *Anatomy of a Painting (Pygmalion and Galatea)* (1990). Oil, alkyd and shellac on wood with mixed media (82" × 120").

words, Murphy feels, reinforce the timelessness and the recurrence of events in cyclical time.

Murphy's role in the endless process of unraveling the fabric of the ancient myth and image of Pygmalion and Galatea to reweave yet another new and current fabric from the same fibers is an exemplary demonstration of the use of photography as the primary tool of appropriation. It is also a demonstration of the process of recursive destructuring and restructuring in order (as Derrida recommended) to treat all ideas and images since Plato as "'one great discourse.'"

15

Bindings[1]

Members of technological societies tend to confuse photographs with reality.

Modern societies have favored sight over the other four senses: "Seeing is believing." It is often estimated that eighty-five percent of what we learn comes to us by way of the eyes. More than half this information is absorbed from one or another form of photograph: in magazines, books, television, movies, and advertising. Consequently, approximately half of our image of the world in the late twentieth century is generated by photographs—a magnification of the situation in that prophetic Dutch culture that advocated learning about the world through pictures.

We know, not only how things look, but also how they ought to look, because of photography. From this pervasive medium we have stored mental images of camels, duck-billed platypuses, Tokyo, Vietnam, warfare, the burning of Kuwait, the Taj Mahal, the dancing of Mikhail Baryshnikov, and the works of numerous major artists. We know intimately the Four Horsemen of the Apocalypse. Our most moving experiences often come to us first through photographs. Our first experience of people entirely different from ourselves usually comes to us through photography.

Many of us have watched our first death on television—the real thing, as well as convincingly feigned death. Decades later, our collective memory has not purged the image of the South Vietnamese officer blowing the visible brain matter out of a Vietcong soldier. On television. During our dinner hour. Many adolescents encounter their first sexual experience through pho-

[1]Part of this chapter was previously published under the title "Reflections on Time" in the *Journal of Aesthetic Education* 26 (Spring 1992): 93–99.

tographs; some even come to favor photographs over the real thing. We firmly believe we know things that we have experienced only through photographs. But photography so permeates our lives that—following the rule of blindness to linguistic supplements—its limitations, and the influences it exerts on our world view, remain invisible to us.

A photograph is not reality.

A movie is not a camel.

The camels we see portrayed on the silver screen as docile, Bambi-eyed servants act nothing like real camels. Camels are not like pet horses, dogs, or cats. Camels are giant animals, much larger than horses, and often uncontrollable. Furthermore, it is the male camel who comes into season ("in rut"), like male goats—whose perverted-looking practices at puberty have earned them a position as symbol for the Devil and profane sex. Probably nothing on earth smells or acts worse than a male camel in rut. He is an immense, foul-tempered, red-eyed boil of an animal. It has often been reported that camels "spit" at people when they are mad. But "spit" is a euphemism for projectile vomiting—a stream of half-digested, rotting, sulfuric vegetable matter that they spray accurately for a distance of eight to twelve feet upon those who irritate them. And these red-eyed, obsessed, foul-tempered beasts demand constant vigilance from their handlers. Their favorite trick is to suddenly twist their head around to the rear and bite off(!) the kneecap of an unwary handler.

Though a photograph may seem to us an accurate representation of a scene, it actually flattens objects and compresses unoccupied space. When taken through a telephoto lens—as are most photographs of Las Vegas, for instance—it squeezes the unoccupied space between signs and buildings even more than a normal photograph does. A photograph or a movie of Las Vegas is nothing at all like the town itself. The first time I visited Las Vegas I was struck by the fact that it was not one great basket of neon. In reality, there is more hot, dusty space between one casino and another, one neon sign and another, than is obvious in photographs. The signs are much farther apart than photographs make them appear. The real main street in Las Vegas actually looks like a hot, dusty desert street with some large neon signs. Photographs often add a heavy layer of romance to the real experience.

Still, photography offers a glimpse of reality that is not possible through other media. A painting of a nude or a death or an extraterrestrial is not as credible, and therefore not as convincing, as a photograph. Photography is the perfect vehicle for propaganda. Even in this age, when it is fairly well known that photographs can be manipulated in any way imaginable, they are still often accepted as incontrovertible evidence in court: both court trials involving the treatment of Rodney King are good examples.

The surface of a photograph (the picture plane) is transparent to the point of being invisible: when we look at a photograph, we are not aware of the effort or the skill it took to make it, or the imperfections in its execution.

Even trained photographers are often blind to discrepancies between the photograph and what it represents. We seldom perceive the photograph itself as an object. We see, instead, the objects depicted in the photograph; and furthermore, we believe them.

Even now that photographs can be manipulated and computerized so easily, we offer them our trust in a manner we can never choose to offer a painted image, no matter how "realistic" it may seem. Steven Spielberg's *Jurassic Park* proved we can no longer believe what we see in photographs. To reiterate a statement from Chapter 5, maps and photographs convince more efficiently than paintings precisely because they appear to be objective and thus immune to subjective concerns.

During a recent discussion among bright, well-read senior art majors in my seminar, one student asked another: "What is reality to you?" The questioned student named a recent movie (which one is not important): "That's the way the world is," she said. "That's reality." Another student disagreed and countered with the title of another movie: "That's reality," he insisted. One student after another countered by nominating one title after another as their candidate for "reality." I counted eight nominations. Apparently, each of these students felt his or her piece of the elephant was best defined by a movie.

Viewers cannot achieve the same level of erotic fantasy from drawings or paintings of members of whichever gender interests them that they do with photographs. If they could, art books might sell as well as *Playboy*. Perhaps that explains why there have seldom been attempts to censor paintings at the same level as photographs. Remember, the uproar over censorship in government sponsored-art exhibitions at the end of the 1980s was ignited by photographs taken by Maplethorpe. Photography has, perhaps, become the "natural language" of pornography. A photograph *signifies* a real person, while a painting signifies fiction; and what viewers know about a thing highly colors the way they perceive it.

Photographs are signs.

Photographs simultaneously function at three intertwined signifying levels: they are real objects; they are shadows, permanently preserved; and they are signs.

The photograph is a real object: it can be held or wrinkled or burned—saved, bought, sold, or exhibited.

Photographs are shadows: they are legible because they capture and record the light and shadow that renders an object visible at any particular instant. A movie is merely a changing series of shadows created as light passes through transparent shadows on a moving film. Thus light reconstitutes itself in an eternal cycle, and the past exists in the present. The living light in the projector sets free in the present the captured light from past events.

Photography creates shadows that can be mistaken for reality, almost in the sense that the shadows in Plato's cave were destined to be mistaken for the objects that cast them. And the signifying effect of a photograph also shadows in the Wittgensteinian sense explained earlier.

Photographs substitute (perhaps better than anything else) for absent objects. Thus they function as both symbol and sign—indexical, iconic, and sign proper.

First, they function as indexical signs in the sense that they are created (caused) by the object they represent: photographs are caused by the represented object and the light reflecting off it, as undeniably as a paw print is caused by the animal that left it. (But technically, should we consider a photograph an index that signifies the *object* that shaped the shadows or the *light* that created the photograph? Or both? Which left the footprint, as it were?)

Second, photographs function as iconic signs. They signify an object because they bear a resemblance to it.

Third, photographs can easily function as sign proper. We can agree that any image will represent anything else. Thus a photographic image of a black cat can signify bad luck—or laziness and lust, as did the image of a cat did during the Middle Ages and the Renaissance.

And fourth, photographs can function as symbols. Television news programs, for instance, may use a photograph of someone wearing a blindfold as a symbol of justice or a hostage situation, according to the context.

In short, photographs can function at the level of real object, shadow, symbol, sign, metaphor, metonymy, or allegory. Their flexibility and ease of execution makes them an excellent vehicle for communication. Imagine a deck of playing cards, each with a photograph of a different object, that could be dealt in the correct order to signify whatever the "speaker" wished. Francis Bacon would be in ecstasy.

In spite of the impact and the strong potential for visual communication inherent in photography, the medium did not hold a favored position in modern art. Painting, sculpture, and architecture (in what might be called an "edifice complex") were considered the "major arts," while everything else was relegated to the supposedly inferior position of "minor art."

One of the most important issues on the postmodern agenda has been the revolt against traditional positions of privilege and favor granted to specific media, social groups, strategies of thinking, and elements in art, science, philosophy, and government. This revolt, sometimes referred to as the breaking down or inversion of hierarchies, is another important element in the foundation that supports postmodern pluralism.

"Pluralism" implies an acceptance of the fact that there is not just one valid group, idea, art form, style, method of thinking, or concept of reality. There are many equally valid alternatives. The opposite to pluralism is solipsism. Solipsists might be said to concede no validity to any experience or re-

ality other than their own. What Euro-Americans once considered reality was not the same as what other cultures considered reality. And what we consider "truth" is not the same as what some other cultures consider "truth."

Hence postmodernists no longer accept Cartesian logic and the rationality of the Enlightenment as the single "true" or universal method for understanding the universe. They argue that what appears to be true to us is merely our societal convention, and, like our language and our photography, this convention simultaneously structures and limits our understanding and world view. They further argue that the structure itself, and the extent of these limitations, remain invisible to us. The postmodern ambition is to render these invisible elements visible.

The rational Renaissance system of perspective seemed once to be self-evidently true, and its limitations were so invisible that for four hundred years artists could find no viable alternative. But during the nineteenth century the new paradigm of n-dimensional non-Euclidean geometries rendered these once-invisible limitations suddenly visible and generated a multitude of possible realities. Artists were suddenly free to envision many possible alternatives to the Euclidean world view. Non-Euclidean geometry must be recognized as one of the necessary paradigms in the evolution of postmodern consciousness.

In 1925 Erwin Panofsky published an article, "Perspective as Symbolic Form," that offered convincing arguments that linear perspective—though it may be an effective, even a desirable, strategy for unifying pictorial space—did not demonstrate how sight actually functions to describe our "psychophysiological space" (1924–1925, 1). He further argued convincingly that linear perspective should be considered just another European convention—a sign used to communicate, perhaps no more "true" than iambic pentameter in poetry.

Modernists accepted as natural and true the following seven doctrines: (1) vision is the most important of the five senses; (2) painting is superior to photography; (3) high (or "fine") art is superior to low art; (4) unique objects are superior to readily available objects; (5) personal creations are superior to copies; (6) hand-made objects are more valuable than machine-made objects; and (7) (one of the most significant to Barbara Kruger) masculine is superior to feminine.

Postmodernists reject such hierarchies as neither natural nor true. They consider such established relationships mere societal conventions, like perspective or iambic pentameter. Consequently, photographic and "appropriated" images, posters, commercial art, the mass produced, and the feminine are now accepted as equal to painted, original, high-art, hand-made, masculine images.

Though there have been many excellent women artists throughout history, few were well known before the postmodern period. There were excel-

lent women artists during the modern period, but despite the freedom promised by the popular modern image of the "New Woman," they were seldom as well known or as highly respected as male artists.[2] The fur-lined cup by Meret Oppenheim, for instance, was one of the best known surrealist images; yet even in an age that lionized the "genius" behind such works, few people knew her name. Several excellent women artists were acknowledged only as the wives of male artists: Dorothea Tanning was "the wife of" Max Ernst; Frida Kahlo was "the wife of" Diego Rivera; Lee Krasner was "the wife of" Jackson Pollack; Elaine de Kooning Only recently has critical interest focused on women artists. One of the most important elements of the postmodern agenda is the recognition of art done by the other.

Barbara Kruger (born in 1945) started her career as a designer at *Harper's Bazaar* and *Mademoiselle*, where she discovered the potential of photographs. She has worked as editor, curator, and teacher. She also wrote the monthly film criticism and the television column for *Artforum* for several years. Consequently, she is at home with both the written and the visual—the sign proper and the iconic sign.

Kate Linker believes these experiences taught Kruger to select images for their rhetorical potential. She learned to crop out the irrelevant in order to focus the impact. Advertising's ability to orchestrate, seduce, and entrap viewers taught Kruger to "hail" and engage the viewer with an elegant economy of image and text. "I learned to think," Kruger once said, "about a kind of quickened effectivity, an accelerated seeing and reading which reaches a near apotheosis in television" (from Linker 1990, 14). Her first large woven hangings reminded viewers that weaving, stitching, and crocheting were among the few expressive activities that women were traditionally allowed (15).

Kruger, like many postmodern artists, began to appropriate images from the media and other sources. She reproduced them, then changed them to intensify their rhetoric. Chadwick explains that Kruger intended to appropriate the entire language of the mass media and advertising that dominates society. Consistent with the opinion of many critics, Kruger contends that tradition can only be criticized by using elements of that tradition (1990, 356). Suzi Gablik supports this contention: "The history of art begins with tradition. Traditions give us something upon which we can operate: something . . . we can criticize and change" (1977, 167). And John Dixon has argued that

[2]Whitney Chadwick insists the image of the "New Woman" was internationalized after the First World War, but this new image applied only to the way woman's "image was appropriated for ideological purposes": "In the end, the image that promised a new world for the modern woman in twentieth-century industrial society would exist as a reality only for wealthy and privileged women. As it filtered to masses of working women, it functioned more and more as a fantasy . . . strenuously asserted through media campaigns as a means to promote consumption—selling youth, beauty, and leisure along with the latest fashions" (1990, 264).

a radically new vision—even as it destroys old traditions—must be realized within the bounds of those established, disintegrating, old traditions (1984, 293).

Kruger combined words with visual images, and her manipulated images no longer fit any standard aesthetic category. In the purest spirit of postmodernism, Linker argues that Kruger's work demonstrates an alternative to the traditional Cartesian concept of the autonomous individual: it both represents and discusses a concept of "self" that is generated by society in general and the media in particular. Because the postmodern focuses on the social forces that shape each member of society, it denies the possibility that individuals, as separate entities, might exercise control or autonomy of thought. Kruger's work demonstrates the individual's lack of control and autonomy by illustrating that our identity is now defined by a barrage of representations in the media (1990, 12–13). Kruger's works are allegories that attempt to make visible the normally invisible impact of advertising and the photographic language.

Kruger's work is so dependent on the integration of words and images that it has little meaning without the polemic of the word. According to Craig Owens, the integration of two representational systems, the visual and the verbal, purposely *undermines* rather than *underlines* the "truth" value of each system (1983, 68). It also challenges the modern claim that vision is the most important of the five senses in our search for truth. To some extent, the dominance of sight over smell, taste, touch, and hearing diminishes the possibility of sensual physical relationships: when sight dominates, "the body loses its materiality": it becomes nothing more than image (70).

Because Kruger integrates word, concept, and photograph, she demonstrates how thin the line is between art and theory today. Kruger, like so many postmodernists, constantly probes the aporetic area between oppositional categories such as: theory and practice, word and image, high and low art. In doing so, she establishes tensions that often generate more power and impact than works that may be clearly defined as one thing or another, works that "keep their place."

In 1977 Kruger published *Picture/Readings*—photographs of residential buildings in California. She juxtaposed these photographs with short narratives that seemed to suggest the thoughts and actions of each building's inhabitants. Linker believes the juxtaposition of image and writing here suggests that the architecture controlled the social activity of the inhabitants (1990, 16), as Charles Burchfield earlier implied in his paintings of houses. Kruger's *Picture/Readings* also echoes an idea formulated by Foucault in *Discipline and Punish:* society has used geometry, especially in architecture, to control the populace.

Artists who write are, of course, nothing new. Some modern artists wrote books about their work, but their writing was separate from that work. The writing merely explained or advocated their visual work (and usually

none too well). But Kruger and others in her group integrate writing with the visual image. Owens, among others, points out that integrating the visual with the written is a postmodern phenomenon, and that this integration negates the modern tendency to separate practice and theory (1983, 63). The combination of writing and the visual also denies the modern artist's assumption that the immediacy of the purely visual is superior to the word.

A picture is not worth a thousand words.

Postmodernists maintain that nature is dead. They would have you understand that we no longer live in a world of rivers, lakes, clouds, sunsets, mountains, and wild animals. We work inside, and are seldom aware of the weather unless it impedes our weekend recreation or our commute back and forth. When we do notice that a day is particularly hot, rainy, or foggy, we no longer know if that weather is natural or caused by human pollution and global warming. Our postnatural world is composed of buildings, streets, and automobiles, all of which are organized, controlled, and manipulated by signs: advertising, street signs, and freeway signs. Signs command us to turn here, not turn or park there, buy Camels, beware of bad breath and body odor, buckle up, "break glass in case of fire," "this is your brain on drugs," "rub don't blot."

In order to survive, tribal cultures had to learn to read signs created by nature and other animals. We learn to read signs of our own creation. We all can, and often do, make signs. We make them with crayons, felt-tip pens, Magic Markers, and computers. We sign by the items we choose to purchase and the clothes we wear. In the small ten-faculty art department where I work, I counted seven hundred and thirty-two signs in the elevators and hallways on Thursday, February 11, 1993. And remember, Las Vegas is a city of signs—the buildings are overengineered expressly to support giant signs.

Advertising has transmuted even our mode of transportation into a sign of our identity. Automobiles have connotations beyond their simple function of moving a body from one place to another. Thus commodities become signs and create their own demand and their own value. They are sold with a guaranteed ready-made identity (another variation on Duchamp's Readymades?). A sports car constructs a different driver (a different identity) than does a four-wheel-drive pickup or a four-door sedan. A Rolls-Royce, at a quarter of a million dollars, delivers a different message than a twenty-thousand-dollar Toyota, though the latter may be the superior performer. We pay more for the signing value of the commodity than for its use or exchange value.

Young men and women in high school are exceedingly discriminating about what car they will drive and what shoes they will wear. They may work for months and sink more money than they can afford into buying or customizing a car in the hope that those around them will then see them as they think they are. The feeling that they are "cool" cannot long survive the ownership of a Ford Pinto or Brand X shoes. The car they drive signifies their

identity, not only to others, but to themselves as well. Perhaps they are obliged to wait to see what kind of car they drive before they can know who they are. Thus the post-Cartesian divisible self who drives a Porsche shares a portion of its identity with every other driver of such a Porsche. Many Harley-Davidson owners advertise this shared identity with a logo on a T shirt or a jacket. Some even sport a permanent "Harley" tattoo: that is real commitment.

Signs are our reality and our meta-reality.

Artists have always sought to capture the real in one way or another. Egyptian painting depicted each part of a figure or an object in its most recognizable shape or position: the eye in front view; the face in profile; the arms and hands in profile; the torso in front view. A glass had a round top and a flat bottom because they knew the top to be round (they drank out of it) and they knew the bottom to be flat (it sat flat on a table). The Egyptian image had more in common with an engineering drawing than with a photograph. It was in many ways a better description of things in the world than was the Renaissance image. It described things the way they were *known* to be, not the way they *appeared* to be. If detailed descriptions were the highest priority, the most favored image might well be engineering drawings, X rays, or medical illustrations rather than photographs.

The Renaissance artists' attempt to capture the appearance of the three dimensions they saw in the real world finally culminated in Courbet's nineteenth-century realism. But abstract expressionists rejected this real*ism* in favor of the *real*. Red oil paint on canvas that looked like an apple on a table, they reasoned, was not as real as red oil paint on canvas that looked like what it was—red oil paint on canvas. Abstract expressionist painting was what it appeared to be.

Abstract expressionists eliminated the gap between appearance and reality.

Postmodernists continue this tradition, but nothing in their world is so real as a sign, a word, a letter, or even a photograph. An illusion of a figure on a flat surface is an illusion, but a photograph of an "X" or a painting of an "X" on a flat surface is a real "X." A painted "X" is as real as the "X" in the alphabet or on the real signs in the real world. Is there an original alphabet? Or are all alphabets copies? If they are copies, what are they copies of? Another alphabet? Or an idea?

The word "human on a flat surface is a *real* permanent sign (often called a "material sign"), not just an illusion of something in the real world. Consequently, when postmodernists include photographs, letters, words, and phrases, they infuse their work with a new reality. All these elements are just as real on their flat surfaces as they are in the exterior world. Still, we search for the motivated signs so avidly sought by Comenius, Bacon, and Ezra Pound.

Signs are our environment and our reality.

Suzanne Bloom and Ed Hill agree that we are trapped by our language and the structure of its signifiers, but they believe this same language brings us into contact with our world simultaneously with sealing us away from it (1982, 13). Again, language simultaneously structures and limits our view of that world. Furthermore, Jean-François Lyotard tells us signs destroy materiality and physicality. What is replaced by a sign "is itself another sign, and so we no longer have anything but signs" (1989, 2).

Mark Poster insists the sign has been replaced in the twentieth century by the "signal." The signal is structured to elicit a Pavlov-like reflex in the viewer. In commercials, for instance an underarm deodorant may be associated with sexual prowess, so the target receives the intended message in a manner that short-circuits the normal process through which we make a conscious decision to agree or disagree with received messages (1989, 133). This technique is used to market commodities from toilet paper to automobiles.

In order to eliminate the materiality of the hand or the "fingerprint" of the individual artist, Barbara Kruger began to appropriate words and images from mechanical sources. This practice echoes the shared ambition of Duchamp and Warhol: both insisted they wanted to become a machine. This pervasive desire to become a machine, of course, reflects once again the connection between postmodern art and schizophrenia. In Deleuze and Guattari's words: "Everyone knows that a schizo is a machine; all schizos say this" (1977, 381).

In a vein similar to Fran Murphy's photographic process, Kruger's conscious choice to reject the mastering of skill and technique negates the traditional concept of personal quality and style of the skilled, or "genius," artist. In the spirit of collaboration—expressing collective rather than individual ideas—Kruger associated with other artists in a group that included Cindy Sherman, Jenny Holzer, and Sherrie Levine. At the California Institute of the Arts they were all encouraged to explore semiotics—the study of signs, symbols, and systems of communication—in the tradition of Peirce, Saussure, and Roman Jakobson. Linker says this group learned their strategies from media presentations: furthermore, they explored the extent to which photographs, billboards, posters, advertisements, and the glut of signs throughout society affect and shape the reality of individuals (1990, 17).

There can be no meaningful discourse on postmodernism without acknowledging the powerful effect the feminist movement has worked on art. Susan Suleiman contends that a symbiotic relationship developed between feminism and the postmodern movement: feminism brought to postmodernism the respectability it needed to validate its claim to be the cutting edge of theory; and postmodernism, in return, included feminist concerns in traditionally male-dominated, highly theoretical discussions (1993, 174–75). Consequently, during the 1980s, discussions of postmodernism in the visual arts began to feature women's work, and the suddenly increased status of photography was related to this growing feminist movement. Linker insists

women turned to photography because its simple mechanical techniques were in direct opposition to the traditionally masculine-dominated physical skills of painting and sculpture—particularly in heroically proportioned modernist works (1990, 59).

Kruger's generation came to believe that the characteristics associated with gender in our society are merely constructs created by the manner in which men and women are represented in that society and its media. Echoing the earlier sentiments of the surrealists, they regarded sexual identification as an effect of conventional signing rather than biology, and this suggested a possibility for changing the narrow, traditional definitions of gender. What had once been considered masculine and feminine personalities and activities came to be perceived as adaptations to social standards and expectations that were determined by signs (Linker 1990, 59). Rosemary Pringle and Sophie Watson, however, tell us that more recent perceptions acknowledge there are risks as well as gains in such a strategy. A focus on gender as a signified construct threatens to trivialize more important concerns about gender domination (1992, 54).

This doctrine—that signs construct our image of gender and sexual identity—stems from Freud's theory that gender was perceived as an "assignment" instructed through signs. Freud's theory was later extended by Lacan's contention that sexuality was constructed through language itself (Linker 1990, 59–60).

Briefly, Freud believed children discover the difference between men and women by the act of looking. The visual prominence of the male genitals implies that women are missing something and therefore are less than males—leading to Freud's famous (or infamous) "penis envy" theory. Lacan extended Freud's metaphor by insisting that the phallus was a favored sign in our culture and, as such, signified privilege. As Linker explains, "human sexuality is assigned and, thus, lived, according to the position one assumes as either having or not having the phallus." No phallus, she reasons, means no access to society's symbolic structures (1990, 60).

Consequently, women have not been allowed a public voice. They have not traditionally done the representing; they have instead *been represented*— "hence the prevalence of images of women in our society" (Linker 1990, 60). In Lacan's well-worn words, women are "objects of the male gaze." Linker quotes John Berger's observation: "*Men act* and *women appear*. Men look at women. Women watch themselves being looked at*" (61). I perceive a direct relationship between this tradition and Pygmalion's inability to love anything other than his own creation.

In short, men speak. Women are spoken for.

Owens explains that feminists link the previously mentioned favoring of vision with the many privileges males enjoy. Freud identified the origin of the patriarchal society with the child's discovery of gender difference through the act of looking. The favoring of sight is also connected to the male

tendency to favor vision in sex, which simultaneously devalues the role of the olfactory sense.

Kruger and the others are not so concerned with what representations "say about women; rather, they investigate what representation *does* to women (for example, the manner in which it invariably positions women as objects of the male gaze)" (1983, 70–71). Because the female has traditionally been relegated to a subordinate position, and is thus invisible, these artists have adopted the medieval adage: "Render the invisible visible" (72).

This direction echoes the concerns of Michel Foucault. Throughout his body of writing, Foucault illustrates one principal idea: he demonstrates that discourse empowers one group at the expense of another. A member of any discipline (particularly an academic discipline) is the "subject"; and the subject studies another group from some particular point of view, treating each member of that group as an "object" of its study. This is the thrust of the "subject-object" relationship mentioned so often in poststructuralist writing. A discourse focused on the results of the subject's study is then published. This discourse, rendered from a single point of view, changes the way readers perceive the objects of the study. This control over society's perceptions endows the authorial subject with power over the objects studied. Thus does society empower the subject of discourse and render the objects of the discourse powerless.

Applying Foucault's construct to art reveals that traditional art historians and critics who spent their lives studying art developed a language of discourse that controlled a major portion of society's perception of artworks. Because most of these historians and critics were male Europeans, they developed a language of discourse and theories that validated art done by European male artists—who were apt to express sentiments and experiences that were shared and understood by the historians and critics. This discourse tended to deny success—and thus media access—to those outside the privileged group. But when a group that has had no previous access to discourse in the media discovers a route of access, that group then becomes the subject rather than the object of discourse and is suddenly "empowered" (another familiar term to many current audiences).

Foucault and the poststructuralists feel that the Anglo-American tradition of clarity in writing comes from the traditional language of the Enlightenment and reason that has so successfully established this subject-object relationship. Therefore they believe that clarity in speech and writing is exclusionary and totalitarian, and inappropriate to pluralism and postmodernism. Foucault, for instance, was so wary of assuming a totalitarian stance that he avoided conceptual clarity and systematic argument to a fault. He said he admired the writing of Deleuze and Guattari because they "care so little for power that they have tried to neutralize the effects of power" by using linguistic games, snares, and humor so readers are led to believe that "something essential" is nothing more than "fun and games" (1977a, xiv).

When groups such as feminists and African Americans began to counter the traditional stereotypical images of themselves created by authors of the discourse of reason, they established their own method of discourse and thus found access to the media. They were given a voice and suddenly empowered. Now they look upon the previous subjects—the sociologists, anthropologists, historians, art critics, and so forth—as objects of their own study and say, in effect: This is how *we* perceive *you* and your traditional discourse. This new perception is usually not flattering—and often it is just as exclusionary and totalitarian as the perception it hopes to replace.

Rebelling against a situation she found intolerable, Kruger attacked society's representations of women as objects for men to stare at. She felt this objectification was the source of all the crippling "bindings" imposed upon women: the bound feet that crippled Chinese women for centuries, the bound breasts once fashionable in European society, and all the other crippling fashions (high heels, bustles, corsets, hobble skirts) that are the historical consequences of the male gaze. She says she intended to "welcome the female spectator into the audience of men" (from Linker 1990, 62). In short, she began a new method of discourse that gained access to the media.

Kruger does not construct a single-viewer location through perspective and geometry in the traditional Renaissance and modern manner. Like medieval painters, she constructs instead a viewer who is more like the reader an author may construct. That is, she does not construct a spatial location for the viewer so much as she addresses the relationship of the viewer to the subject matter or invites the collaboration of the viewer in her discourse (as opposed to her early narrative direction).[3] She recognizes viewers' rights to accept or refuse their role as the target of her argument.

Linker reasons this concern is evident in Kruger's habitual use of the pronouns "I," "me," "we," and "you." These pronouns change or "shift" (Roman Jakobson labeled them *shifters*) in conversation to identify first one person, gender, or group, then another (1990, 62). Incidentally, Jakobson and Lübbe-Grothues note that the poets Scardanelli and Hölderlin typically and abruptly ceased to use shifters in their otherwise still excellent poetry after their psychotic breaks into the world of schizophrenia (1985, 138).

"I" and "me" signify the speaker. When I say "me," I signify me the speaker or writer. When you say "me," the pronoun shifts to signify you the

[3]Louis Marin tells us that Émile Benveniste holds that narrative, as opposed to discourse, purposely intends to erase or conceal the signs of the narrator and narrative propositions, and thus excludes all "autobiographical" forms of enunciation, such as "I," "you," "here," "there," and "now," as well as the present tense. Narrative tends to depend on a "well-defined past tense, the preterite, and the third person 'he,' 'she,' 'they'" (1988, 65).

speaker. Note that the four shifters "I," "me," "we," and "you"—as well as "they" and "them"—are not gender specific. Children have long played games with the idea of the shifter:

Pat: Tell me you like me.
Lee: You like me.
Pat: No! Say, "I like you."
Lee: Okay. You like me.
Pat: You know what I mean. Say, "Pat, I like you."
Lee: Pat, you like me.

Linker contends that Kruger uses these pronouns as a demonstration that the viewer's place or gender can shift. Our language has the ability to establish gender and conversational place as ambiguous, indefinite. Kruger reasons that if sexual roles can be constructed according to how they are represented, they can be revised and restructured by changing the manner in which they are represented. The feminist approach to art attacks rigid identity and gender roles by establishing alternative linguistic positions for viewers. It criticizes the manner in which identity is signified (1990, 62–63).

Artists have a unique opportunity to manipulate, for they control the construction, distribution, and reception of one particular kind of information dissemination to one specific subculture. This is doubly true for artists who traffic in photographs because photography is the primary vehicle for persuasion and sexual fantasies (Linker 1990, 74). Consequently, artists can, if they are so inclined, manipulate sexual or even gender identity to one degree or another. When such manipulation is built into the symbolic order, it is negligent to refuse to recognize this fact: if the manipulation is there, it had better elicit the right effects through ethical concerns.

Woven through the fabric of Kruger's interest in feminism are the threads of the postmodern interest in how commercialism and consumer identity influence the artist's purpose, image, and identity. Much of her work renders visible the manner in which the consumer's self-image is affected by the acquisition of objects, and she also exposes what she considers the unethical aspects of commercial investment in the gallery world.

Our society, not unlike that of the early Dutch, makes a fetish of commodities, from clothes to automobiles to artworks. Fetishism is generated when advertising markets commodities by relating them to a collective identity. We are captured, seduced, and ravished by the allure of commodities we do not need. In 1987 Kruger produced a photographic image of a hand holding a card with the words: "I shop therefore I am." This twist on the familiar Cartesian proof of existence and identity signifies that a collective consumer has replaced the individual as the important element in society. Kruger implies that consuming has become the "hallmark of identity" (Linker 1990, 78). She also gives a broad interpretation to "merchandise," including in it the en-

tire realm of commercial images: the news, politics, and the manipulations of talk shows (77).

Kruger has often stated her desire to destroy the stereotype of the genius artist who exhibits only in galleries. To this end, she displays her work through different avenues. She displays her photographs and signs around New York, intimately in books, and publicly in places like billboards and the Times Square spectacolor sign (which is perhaps seen by more people every day than any other human-made object). She set out to appropriate the most efficient purveyors of persuasive power, and to exploit them as her gallery (Linker 1990, 18).

Kruger calls attention to the pervasive presence and influence of the market by scrolling messages across electronic advertising screens: "Can I help you?" "Can I interest you in something in red?" (Linker 1990, 78). Letters and words on electronic screens are not "material signs," for these screens have no permanence or physical substance. They are as transient as the spoken word, and they are generated by an electronic memory process that is somewhat akin to the human brain. Hence the physical mark that signified the presence of the absent artist—as in abstract expressionism or handwriting—is itself absent. Once again, any trace of the artist as a unique individual is eliminated.

Kruger attacks both the stereotype of the genius artist and the artist's role in the marketplace. Across the representation of a woman in the act of drawing, she posts the printed words: "You produce an infinite sequence of originals." Linker translates this as Kruger's concern with the fact that we favor (and pay more for) scarce items, which has led the art market to create the illusion of scarcity by valuing only original artworks. A reproduction or a multiple, no matter how faithful, has little value (1990, 79).

When Kruger appropriates an image from someone else, she is rejecting the significance of "originals" and simultaneously illustrating the postmodern contention that ideas and language belong to no one because the very concept of ownership depends upon an obsolete or mythical concept of the self. Linker notes that the mechanical process of reproducing appropriated images negates the unique quality traditionally expected of artworks. The "hand" in Kruger's work is thus collective, never personal (1990, 79).

When Kruger reproduces a photograph of Michelangelo's "God Creating Adam" (Figure 15.1) from the Sistine Chapel ceiling, and prints the polemic "You invest in the divinity of the masterpiece" in large letters across the middle, she is addressing all these concerns in an elegant and complex mix of words, image, and meaning. She is simultaneously attacking the concept of the artist's exclusive rights to an image, the myth of the divine inspiration of the genius, the artifact value of art (that it has value because it is old), the commodity investment value of original art as a scarce resource. She is also, Linker contends, exposing the history of art as a masculine legacy—a tradition handed down from fathers to sons (1990, 79).

FIGURE 15.1 Kruger, Barbara. *Untitled (You Invest in the Divinity of the Masterpiece)* (1982). Unique photostat (71 3/4" × 45 5/8," with frame 72 7/8" × 46 3/4"). The Museum of Modern Art, New York. Acquired through an anonymous Fund.

Owens agrees with this assessment and adds that Kruger's image also parodies our reverence for art. The thrust of Kruger's work, and that of other postmodern artists, attacks foundational categories. After works like those of Duchamp, Fran Murphy, and Barbara Kruger, it is no longer possible to separate works into such categories as: original and copy, authentic and inauthentic, structural and decorative (1983, 77). Kruger appropriates a photograph that someone else has taken of yet another's work of art; she changes its appearance and function, and reproduces the image by the hundreds. Can it then be considered an original and authentic work? Roland Barthes was

once moved to conclude that there were no longer separate categories of literature and criticism: there were, he insisted, only writers now. With artists like Barbara Kruger producing polemics that feature both visual images and words, it is tempting to conclude that there are no longer separate categories of visual and verbal art: now there is only the message.

Kruger's advocacy of feminist concerns is illustrated by the photograph of an amateurish sculpture of a female head from a photo annual of the 1950s. Chadwick insists that Kruger's images always convey the message that something is wrong (1990, 356). The message printed across this photograph—"Your gaze hits the side of my face" (Figure 15.2)—refers to Lacan's concept of "The Gaze"—society's encouragement of the "distanced and controlling gaze" of the male that relegates women to the category of objects and implies masculine dominance. Linker insists that representing women as the object of masculine attention invites voyeurism and offers men pleasure, while simultaneously encouraging women to become exhibition-

FIGURE 15.2 Kruger, Barbara. "Untitled" (1981. Your gaze hits the side of my face). Photograph (55" × 41"). Photo: Zindman/Fremont. Courtesy: Mary Boone Gallery, New York.

ists. Such habitual representation motivates women to seek a position as object of that gaze (1990, 61).

Kruger demonstrates more of this feminist concern in her abortion-centered work "Your body is a battleground" (Figure 15.3). She prepared this piece for the march on Washington during the Supreme Court hearing of a case that might have overturned the *Roe v. Wade* decision. Linker explains that splitting the face into positive and negative images implies conventional oppositions like black versus white and good versus evil (1990, 87).

Consumerism shapes society and the individuals within it. Frederic Jameson believes rampant consumerism linked to multinational capitalism is the primary cause of the postmodern attitude (1983, 125). The marketing techniques of consumerism have been so successful they have created mega-companies that expand far beyond national boundaries: Chrysler Corporation builds cars in Canada, Mexico, and Japan; Toyota builds many of its cars in the United States. What were once American companies, like

FIGURE 15.3 Kruger, Barbara. "Untitled" (1989. Your body is a battleground). Photographic silkscreen/vinyl (112" × 112"). Photo: Zindman/Fremont. Mary Boone Gallery, New York.

Motorola, are now producing Japanese radios and televisions. Standard Oil is a world wide corporation. Shell Oil is Dutch owned. American city governments attempting to pursue a "Buy American" policy when purchasing trucks, tractors, and automobiles have been hard put to decide what is American. For instance, the Kubota tractor turned out to be more "American-made" than the tractor made by International Harvester. Corporate identity today is as divided as the identities of the post-Cartesian workers who run them.

Jameson insists that postmodernism echoes the structure of this new social system. He demonstrates this by calling attention to our loss of history. Precisely because this society and its multinational corporations and media can disseminate (or dissemble!) information so efficiently, our entire late-twentieth-century social system is losing its ability to remember its own past (1983, 125). When the myth makers in the news media exhaust their supply of information, they constantly repeat the same (current) news items again and again. CNN repeats each item forty-eight times in a single day. Jameson reasons that this continual dissemination of new information by the media forces us to forget old information. Relatively recent figures in history like Nixon and Kennedy have been relegated to what now seems like the distant past (125).

World War II is a dim memory preserved only by mythic movies: John Wayne has replaced Paul Bunyan and Roanoke, and he is fading fast. No one in my classes now has any idea who Adolf Schicklgruber is—the most infamous man in modern history. And thirty percent of Americans either do not believe, or are not certain, there ever was a Holocaust.

Constant change in a perpetual present destroys tradition. History is dying because we now transform our reality into media images, sound bites, and fragment time into unending pieces of an eternal present. Like that of the schizophrenics described in Chapter 10, our behavior is influenced by our most recent experience.

The postmodern tendency to live in a cycle of eternal presents evolved over a long period of time because of improvements made on the clock. The clock was precisely the instrument that first created a society that existed in linear time.

Early hunters and gatherers—preagricultural humans—had little thought for, and no interest in, time. Thus they were never pressed for time. They had all the time in the world, until a compulsion for tool-making enticed them to quantify and measure this elusive element.

The gentle hunter-gatherer, who felt so keenly the presence and the enduring support of a living, loving God, measured cycles of time dimly, in years: the length of a life might be measured as forty summers. We learn from Richard Leakey that hunter-gatherers led so affluent a life they needed to work only ten to thirty hours each week to support themselves well (1978, 105). They had no bad seasons, so they did not need to store food. They had

few wants. They were peaceful. Their minds were not focused on material things. They had little reason to fight, and few close neighbors to engage in battle (97).

Then they learned to plant seeds, and they quickly learned to break the year into seasons: Spring, Summer, Autumn, and Winter. Their workload increased significantly. They had more children, and they began to overpopulate (Leakey 1978, 116–18). They prayed for rain, and they were compelled to store food from the good seasons against the dry and the lean. They blamed the inevitable bad seasons on the wrath of their vengeful gods. They suddenly had territory to defend, and neighbors to raid if their own crops failed. They learned the art of serious warfare (97, 279). Yet those who measure time in seasons still live in cyclical time. They know each season will soon return. What they plant this year, they will plant again next year.

In order to predict the gestation and harvest times of their crops and to accurately pick the best days on which to plant seeds, they invented calendars. They learned to break the year into smaller increments: months (the phases of the moon), weeks, even days.

By the time of ancient Egypt and continuing through the period of the Greek and Roman empires, sundials measured the daylight hours—but inaccurately, and only for the privileged. Expectations for punctuality were still low: people were endowed with certain "freedoms," which we seldom consider within the narrow limits of our twentieth-century understanding of the word "freedom." A serf's child was born a serf and, barring a miracle, could never be anything but a serf. Women (both serf and noble) were destined to become wives. A cobbler's son would always be a cobbler. But he was free to cobble at his own relaxed, unambitious tempo. Each person was free *not-to-succeed*. People felt no pressure to be anything other than what they were; and they could be that at their own sweet pace.

Such cultures still understood time as cyclical. They envisioned seasons, even months, as returning, cycle after cycle, time after time, forever. Different societies constructed cycles of different lengths: some perceived a one-year cycle; the Aztec calendar calculated cycles of fifty-two years. Those who understood time as cyclical never felt that important events were out of touch or relevance in the distant past or future. They did not feel themselves removed from their beginnings, their ancestors, or their descendants. They knew everything would come around again. Those who survived through many cycles were respected—even venerated. Such cultures recognized that people who had managed to endure fifty summers or more had learned valuable lessons about their immutable world.

Then, during the fourteenth century, clever men in the Church made the first all-mechanical escapement clocks to help monks keep to their rigid spiritual schedules. These first folliot clocks were not accurate in our sense of the word: they were apt to err by as much as an hour during the course of a day. But his new mechanical time-keeping was the bellows that fanned the

spark of a burgeoning new materialist capitalism, which was rapidly converting harvested crops into money—rather than vice versa. This new capitalism simultaneously metered and demanded a still longer work week.

A crude punctuality came to be expected.

Local time was announced with loud chimes and great bells.

Then, in the seventeenth century, Galileo and Christian Huygens developed a more precise pendulum clock that measured apparently accurate seconds. This clock would initiate the twenty-four-hour day and fan embryonic capitalism into a raging industrial revolution. But with each successive gain in its ability to measure, society lost more and more precious time. Industries required strict punctuality and long hours of their work forces. Time itself became a commodity: "Time is money."

The work week expanded to more than sixty hours, until it was finally shortened after workers banded together in violent unions to resist this unnatural torment. Years of training were required to produce such workers. Schools were not intended to *educate* so much as to *condition* the young to spend long hours at monotonous chores. Consequently, schools were instituted, and boys (mostly) spent their youth in stressful boredom—sedentary, in rooms of cadaverous silence, under hostile and violent teachers.

Because of the influence of the seventeenth-century pendulum clock, art, literature, science, and philosophy developed a sudden and strong new interest in the element of time. Measurable time. Linear time. Baroque art shifted its focus from the classic, timeless, eternal image to depict specific moments—such as a painted puff of smoke frozen like a baroque sculpture in the air. Impressionists learned to depict the very moment of an experience by sharply focusing one specific area while progressively blurring details that were farther from the climax of focus. This was an attempt to mimic peripheral vision. This use of a central area of focus implies that fraction of a second that our vision rests on a particular area before resuming its constant search for new areas of interest. John Steinbeck offered his viewpoint of the modern concern with time:

> The split second has been growing more and more important to us. And as human activities become more and more intermeshed and integrated, the split tenth of a second will emerge, and then a new name must be made for the split hundredth, until one day, although I don't believe it, we'll say, "Oh, the hell with it. What's wrong with an hour?" But it isn't silly, this preoccupation with the small time units. One thing late or early can disrupt everything around it, and the disturbance runs outward in bands like the waves from a dropped stone in a quiet pool. (1987, 688–89)

E. A. Burtt tells us that since the beginning of the twentieth century, Galileo's notion "that the temporality of motion could be explained in exact mathematics, has also been of fundamental importance—it means that time for modern physics becomes nothing more than an irreversible fourth di-

mension" (1954, 96). At the beginning of the twentieth century, Einstein argued eloquently in his mathematical language that the fourth dimension—about which there had been so much interest when Hinton first popularized it in the nineteenth century—must exist only in the relationship between time and space. Simultaneously, and apparently independently, artists in their *Search for the Real* (as Hans Hofmann so aptly titled his book) began to wonder how they could hope to depict our world from a single viewpoint and in three dimensions—height, width, and depth—when our reality could obviously be viewed from many different and equally valid viewpoints. And furthermore, this new reality now seemed to exist in four dimensions, not three. Time and space were no longer absolute. They were suddenly relative to the position of the observer.

Modern art, as early as cubism and constructivism, came to focus on space as relative to time. Modernists perceived this fourth dimension as the very fiber from which the fabric of the universe was woven. The artist's cardinal concern with space-time was stated early in the twentieth century by Gabo and Pevsner in their published *Constructivist Manifesto*:

> The "fundamental bases of art" must rest on solid ground: real life.
> In fact (actuality) space and time are the two elements which exclusively fill real life (reality).
> Therefore, if art wishes to grasp real life, it must, likewise, be based on these two fundamental elements. (from Goldwater and Treves 1966, 454)

Picasso—perhaps after discussions with Apollinaire—painted a faceted planar representation of objects in several simultaneous views, suggesting either the movement of the painted object or the movement of the viewer. Since there is no movement without time, it might be concluded that implied movement equals implied time. Duchamp's *Nude Descending a Staircase* further emphasized this element of movement and time.

The modern interest in punctuality and time accelerated rapidly during the twentieth century. Finally, under the guise of the fourth dimension and relativity, it united in a relationship with space to become an absolute obsession in modern art, philosophy, and science. Such men as Einstein, Picasso, and Stephen Hawking gave their lives to the study of the meaning of time.

Those seconds so accurately measured by the old pendulum clocks were suddenly split into one hundred thousand tiny increments by the modern electric clock and quartz crystal. The margin of error of the best of these clocks was less than one second per decade. Still not satisfied with even this achievement, we learned to measure lives in yet smaller increments, increments as small as the vibrations of the cesium atom—the atomic clock. We have learned to split the *second* into thirty billion increments; and we can accurately measure just one of these infinitesimal increments—increments so small they are beyond our ability to contemplate in verbal signs.

As we learned to manipulate time and make it our servant, time became our master and manipulated us. We feel starved for time, like people stuffing food into their mouths with both hands, unable to eat enough because provisions are administered in portions of a billionth of an ounce. We habitually say: "I don't have enough time." But this is self-evidently false. Linear time extended from infinity to infinity, and cyclical time abides forever.

It is this fragmented life we have not enough of.

Adaptable humans, in an effort to cope with such demanding expectations and fragmentation, turned to medicine and drugs. They grew cunning and perhaps more violent toward their own kind—particularly toward those in power who had snatched their leisure and reaped obscene profit from the commodity of their once-halcyon lives.

Human lives became commodities.

Nowadays, with the aid of an elaborate mechanical contrivance of intense light, fast film, and spinning mirrors, we can take sharp photographs of the apparently frozen white sculptural splash made by a tear falling into a glass of milk. The exposure time for such a photograph is measured in nanoseconds—billionths of a second (perhaps pronounced with the drama and emphasis of Carl Sagan: "bi-ull-yunths of a second"). These whirling mirrors and contrived nanoseconds fragment our lives into ever smaller measurable increments. And in many jobs—like those in the post office that are monitored by omnipresent observers with poised stopwatches—each of these puny increments must be accounted for . . . and quickly resented.

RAT-A-TAT-TAT-TAT (to quote Lichtenstein).

These quickened moments generate higher and higher expectations. We have less and less time in which we feel compelled to accomplish more and more. Tense workers are used more and more efficiently. Their jobs become more specialized. They spend much of their life in school, training for this specialization. Their childhood is artificially extended, far beyond puberty: hence they resent their parents. Their lives are compartmentalized, repetitious, stressful. They are allowed to see nothing through from beginning to end. They see only meaningless fragments of what they may help to create: teachers may touch their students for only one class. Yet we feel compelled to "accomplish" something—said in a voice of "quiet desperation": Thoreau's lament, it seems, has become the phrase for our age.

Clocks first taught us to conceive of time as linear. The clock ticked off individual seconds and imprisoned them in the inaccessible matrix of the past. We struggled to imagine time extending from an incomprehensible infinity in the past to an infinity in the future. We measured our lives in seconds ticked, and seconds yet to be ticked—the ghost of time past, and the specter of time future. Constructing time in such a fashion convinced us that beginnings were irrelevant. We felt far removed from people and events of the past—and for that matter, obvious and inevitable events in the not-too-distant future.

As we measure time in smaller and smaller increments, the length of time required to relegate events to the "distant past" grows smaller and smaller. What was once considered yesterday or tomorrow suddenly seems far removed, of no importance. Within my memory adults once planned for their great-grandchildren, and beyond. Many now hope the world will just hold together till they themselves are gone.

Use the resources. Let the children fend for themselves: "We are spending our children's inheritance" is a proud bumper-sticker often seen (appropriately) on motor homes. This rapidly accelerating rate of change renders obsolete the now useless wisdom of the old ones. We see them as ridiculous relics, out of step, tune, and rhythm with today's reality. They are quaint, even ludicrous—or vaguely threatening. Aged family members become the agents of our vulnerability—impediments, millstones. They frustrate our plans for the future.

Today we have the "freedom" to become—in the Aristotelian sense of potentiality transformed into actuality—anything we wish. But with this *compulsory* freedom comes the certain knowledge that if we do not "become something," it is our own fault. Then our teachers, our families, and our acquaintances label us worthless, unambitious, underachievers . . .

"Scum!" as the children nowadays are wont to say.

We see portents of the advent of that mythic God who destroys corruption. We frequently hear references to Sodom and Gomorrah.

If, as we now believe, the prevailing art of any period is perceived as a mirror of that society—a code to its resentments as well as its ideologies—then we cannot rightly evaluate any *accepted* style of art as being inchoate. If we do not see value in the art of a specific period, perhaps it is because we find the concerns of that period distasteful. We may, for instance, perceive the art of the eighteenth century as exploiting women and focused on the aristocracy; and we might criticize a society that grants high status to that which we consider frivolous or even immoral. We may perceive such art as an aberration, a sensibility out of tune with our own.

Time has become so fragmented in the postmodern period that we see it in pieces. We cannot think of it as cohesively linear as we did for four hundred years. We can work up little concern for the infinity in which it once existed. We avidly seek the cyclical, but it eludes us. We insist on instant gratification. Time has become so fractured, like a hapless Humpty-Dumpty, that we cannot put it back together again. We cannot imagine a temporal whole, either linear or cyclic. Change takes place so rapidly that our plans for the future are constantly thwarted: Social Security may disappear; inflation, bankruptcy, bank failure, or shenanigans of one kind or another may render our promised pensions worthless. We live for today, in fear of tomorrow, in the eternal postmodern present.

During this consumer age, so grudgingly metered out in tiny increments of a billionth of a second, Rauschenberg's work may seem fragmented;

Chia's painting may seem hastily executed, even slipshod; David Salle's complex paintings may sometimes seem thinly conceived; it may take little skill to reproduce the photographs of Barbara Kruger or to commandeer the Readymades of Duchamp. But if our art demonstrates deep resentment, perhaps with some reflection we can perceive significant grounds for such attitudes and methods.

A hastily executed or mechanically produced work may signify a scarcity of time in a society that places too many demands on each minute segment: thus we lack, not just the time it takes for careful execution, but even the time it takes to learn such a skill. Artists can no longer just paint, sell their work, and spend the money. They must record each sale; educate themselves on tax averaging, tax deferments, and tax credits; pay taxes on any moneys realized for the work; and find, send for, fill out, and mail endless applications for grants and commissions. An artist, like a plumber, a carpenter, or a mechanic, must now be more crafty bureaucrat than expert at craft. Small wonder today's college-educated well-read time-starved artist philosophically scorns hard-won technique and skill.

Work that at first seems thinly conceived might now be interpreted as a statement about those aptitudes that society seems most disposed to reward: a tall freak of a man who can jump and put a round ball through a metal hoop again and again—perhaps eight to twenty times per evening—earns more than the combined *lifetime* salaries of twenty or forty or a hundred hardworking middle-class families. Nonproducing intermediaries make more than producers: galleries, brokers, and collectors realize more profit from the sale of "original" artwork than the artists themselves.

If painters systematically refuse to compose their paintings—in the traditional sense of creating a cohesive monolithic image—if they "change voice" often in each work, if they insist on fickle viewpoints and fractured images, we may perhaps come to perceive such practices to be as relevant, as consistent, as well structured as any past practice. We may conclude that the postmodern image is appropriate to this society—as Renaissance perspective was appropriate to the burgeoning rational-materialist-capitalist society of the early fifteenth century. We may yet decide—indeed, we have already done so—that such a fragmented-pluralist-mechanical image is the only rational response to our time, divided as it is into a multiplicity of awarenesses and a profusion of splintered shards.

Kruger's work, like that of some other postmodern artists, might be called meta-meta-meta-art, or meta-art three times removed or abstracted: if a tool that is used to make a tool is called a "meta-tool," how do we signify two steps deeper into this process—a tool that is used to make a tool that is used to make yet another tool? When art comments on art, or even when we speak or write about the visual arts, that is meta-language: language about language.

When Kruger's work comments on other art (Michelangelo's for example), it functions as meta-art. When it uses words to comment further on that meta-art, it functions as meta-art twice abstracted. When it comments on art theory (the words) that has been used to comment on the meta-art, it is meta-art abstracted to the third level. Furthermore, when I comment on Kruger's third level of abstraction, does it function as . . . ?

Obviously, this process is sometimes overlapped and layered so deeply it cannot be unraveled and clarified. Perhaps this multiple distancing of our language fits our current multinational economic system, which is now abstracted to the third level and beyond into obscure multiple layers—sometimes so distanced it is beyond our ability to unravel or to decipher the true source or location or even country of monies or goods.

16

Conclusion

No single text can cover a topic such as the origins of postmodernism. Furthermore, no such pluralist topic can be explained with deterministic clarity. Wittgenstein has warned us in advance that those things which normally exist in a confused or clouded state are not necessarily better understood when resolved into crisp images. For example, a blurred painting is not best described by a sharply defined sketch. He asks: "won't it become a hopeless task to draw a sharp picture corresponding to the blurred one?" He continues: "And this is the position you are in if you look for definitions corresponding to our concepts in aesthetics or ethics" (1958, 36).

Any single text offers little more than a view through a kaleidoscope. Each view, if well presented, may seem complete and consistent, yet a slight twist of the cylinder generates still another image; and that image, too, may seem just as complete and just as consistent. But an exhaustive study of any number of images as seen through the eyepiece offers no clue to the construction of the inner mechanism that generates them. When I was a child I took a kaleidoscope apart and discovered small misshapen lumps of colored glass. I thought I must have smashed the works in the process of taking the device apart: I could not mentally connect those irregular, arbitrary hunks of broken glass with the sharp, symmetrical, geometrically patterned images I had admired through the eyepiece.

This book is intended as another twist of the kaleidoscope. It offers only one of many possible views of painting as sign. This view is an alternative, a supplement, to the understanding of postmodern origins as well as the languagelike relationships between part and whole in a specific selection of paintings. Instead of pointing out relationships between postmodernism and

recent artistic events, I have demonstrated a relationship between postmodernism and ancient traditions.

I tried to avoid establishing parameters around the postmodern paradigm because I hoped to stimulate discussion. For instance, the similarity between the attitudes of scholars and artists in the Middle Ages and those who are considered postmodern has been touched upon by a few previous writers, such as Umberto Eco (1986a). I briefly mentioned some of these similarities in my own first book, but the topic needs more extended investigation.

I have demonstrated that artists and scholars during the Middle Ages share many common concerns with those in the postmodern era: an interest in the reunion of writing with painting; pluralism, the accommodation of opposing ideas and concepts; the artist as the voice for a collective consciousness, rather than artist as genius; the idea that new work should be based on the cumulative work of others, rather than insisting that each work be entirely unique (a demonstrated impossibility); the concept that the voice of madness offers a supplemental source for insight and knowledge; and an abiding interest in finding the invisible in the visible. Furthermore, the interest in alchemy, the Apocalypse, and other examples of myth that permeate the two periods cannot be ignored. This does not imply that the two periods are the same: two periods may share many common concerns, but they are never identical.

It is apparent that seventeenth-, eighteenth-, and nineteenth-century viewers demonstrated little understanding of the image of the carnival grotesque that dominated the Middle Ages and the Renaissance. Such images were perceived as belonging to the dark night of ignorance and the fearsome invisible creatures that lurked there. The ancient antirational tradition of the grotesque was suddenly beyond the ken of Enlightenment thinkers. But in the last half of the twentieth century, artificial light has destroyed the once-rigid distinction between night and day. Many businesses now keep employees working through the night, and many people have come to feel comfortable with the nighttime world. Consequently, the grotesque image seems suddenly revitalized.

The twentieth century offers strong examples of this image in what we once called the high arts: I think of the work of Duchamp, William Burroughs, Francis Bacon, Red Grooms, Frederico Fellini, and Dan Rice. Perhaps the most obvious examples are the work of three photographers; Diane Arbus, Joel Peter Witkin, and Robert Maplethorpe. I might also mention specific works such as Francis Ford Coppola's *Apocalypse Now*, Ingmar Bergman's 1993 New York presentation of Henrik Ibsen's drama *Peer Gynt*, or *Beavis and Butt-Head* on MTV.

Furthermore, examples of monsters, giants, scatology, and exaggerated sexual organs are now rampant in the popular media. Football is rife with steroid giants of three hundred plus pounds; several basketball players tower more than seven feet (in my generation, the incredible Bob Cousy was a tiny

six foot one); Arnold Schwarzenegger, with his exaggerated bulk (a secondary male sexual characteristic), is one of the most popular box office draws, and he has many current competitors; movies about zombies, werewolfs, and the walking dead have long been popular; the movies *Hellraiser* and *Halloween* have each had several successful sequels; what we have come to call "splatter movies" are pervasive; the strange imaginary life-forms generated for science fiction movies might fit this genre; and Madonna displays her underwear outside her clothes with exaggerated breasts and accentuated crotch in an exemplary postmodern version of the carnival grotesque.

Not only is this kind of entertainment gaining popularity, but it is viewed differently by younger than by older people. Earlier generations (especially my own) were perhaps the last remnants of the Enlightenment. They were heir to the romantic perception that such images held dark terror, or they perceived them as disgusting and irredeemably perverted. In short, they took them seriously. But I find that many (though certainly not all) of the young are fascinated by these images and view such entertainment as high camp or Rabelaisian humor.

Images once perceived as perversions are now perceived as hilarious, as entertainment. Once again, many dispel their fear by laughing at it and making it an object of ridicule, as the public once did in the Middle Ages and the Renaissance. I have always had trouble with the images in William Burroughs's *The Naked Lunch;* I took them seriously. But at his last reading in Seattle, he had the audience rolling in aisles of hilarity. Perhaps we are coming full circle.

Signing painters seem to favor the sacred eternal braid of alchemy, the Apocalypse, and the carnival grotesque. It might even be concluded that these three ideas are so closely related that one tends to beget the others. Hence the revitalization of one image during the postmodern era may imply the revitalization of the other two. At any rate, interest in these three sources of imagery is growing steadily.

Establishing categories to label different artists, styles, and directions is useful, but only as a device to facilitate discussion—and only so long as such categories are neither believed nor rigidly adhered to. Like established canons in art and the images of the carnival grotesque, ideas are simply things to be played with and rearranged. This attitude is exemplified by Isaac Newton's often quoted disclaimer: "I do not know what I may appear to the world; but to myself I seem to have been only like a boy playing on the seashore, and diverting myself in now and then finding a smoother pebble or a prettier shell than ordinary." Ideas, though not to be taken seriously, are not to be ignored.

Artificial categories, analogies, and heuristic devices may be more important investigative tools than many realize. Algimantas Shimkunas notes that efforts to treat schizophrenia have met with little success; he suggests that perhaps this failure is due to the fact that psychiatry has not yet discov-

ered an adequate analogy that offers a clear, overall useful image of schizo-phrenia.[1] The schizophrenic manifestation is so foreign to anything in the experience of those outside it that they have more than the usual difficulty in comprehending it.

Rather than extending the opposition of modern to postmodern, the intent in this book has been to point to the fact that society has always pursued two parallel and oppositional traditions: the sensuous, retinal, illusionistic, rational direction versus the cerebral, linguistic, more irrational direction. According to Lilian Feder, the constant pattern of madness in myth and literature demonstrates that reason has always existed in *"combat"* with its opposite. Even at the height of the Enlightenment, reason was challenged, particularly in art: "aesthetic anti-rationalism" constantly questioned and laid siege to the factions of reason (1980, 203).

These two abiding strategies have traditionally offered two different approaches to constructing a world view—and hence two approaches to the disciplines of philosophy, science, and art. The objective, deterministic strategy has produced a manifold of valuable disciplines, including the Greek atomists, classical Newtonian physics, chemistry, traditional Western medicine, psychiatric drugs, linear math, and a scientific aesthetic based on the formal aspects of perception. But even the most rational of these disciplines owes much to the irrational.

The irrational approach, on the other hand, is strongly evident in a variety of other disciplines, including the apparently timeless sacred sciences, several past and current alternatives to mechanistic Western medicine, Freudian and Lacanian psychoanalysis, nonlinear math, dada, the theater of the absurd, quantum mechanics, fractal geometry, and chaos theory. It may be no accident that the very name of this last new science identifies it with the ancient alchemical dragon. We come full cycle. But again, even the most irrational of these disciplines owes a strong debt to reason.

Some who profess a suspicion of reason fail to understand the irrational method; in the name of the irrational, they offer a flawed reason as an alternative to rigorous rational methodology. They confuse the irrational strategy with reason badly executed; thus they may escape accepting responsibility for their words. Umberto Eco explains that the *modus ponens* is the rule of reasoning and thus the foundation of all comprehensible discourse: "If I assert *if p then q*, and acknowledge that *p* is true, then *q* can only follow. In other words, if I agree to define all French citizens as European . . . then if Monsieur Ali Hassan is a French citizen everyone must recognize that he is

[1]Shimkunas writes: "An analogy between the psychological functions of the nervous system and schizophrenic thought appears potentially fruitful. If a global characterization of mental activity as performed by various brain structures can be developed, it may be capable of generating parallels to the process of schizophrenic thought" (1978, 196).

European" (1986b, 130). Eco concedes that this rule does not apply in dreams, poetry, art, or the unconscious in general. But what he finds unacceptable is an adversary who insists that Desire always wins out over the *modus ponens,* then insists upon his or her own definition of Desire; then in order to rebut a rebuttal, "he [or she] tries to catch me in contradiction by using the *modus ponens.*" Such misuse of reason moved Eco to exclaim: "I feel a Desire to bash him [or her] one" (131).

The poststructuralists have felt that because the Enlightenment's tradition of clarity in writing is the traditional language of reason, it is totalitarian and inappropriate to postmodernism. But Poster tells us that even poststructuralists accept the fact that liberal society does demonstrate elements of reason (1989, 32).

Jürgen Habermas—the German counter to French poststructuralism and perhaps the most credible advocate of reason and the Enlightenment tradition—posits two types of reason: "instrumental reason" which is practiced by institutions such as the bureaucratic state and the economy; and "communicative reason," which is characteristic in areas of social action. Only instrumental reason, he insists, supports domination or tyranny. Therefore this is the only reason to which poststructuralists can legitimately object. Habermas argues convincingly that in a democratic context, where everyone is free to challenge the arguments of anyone else so long as each party agrees to concur with positions it cannot refute, communicative reason should be exempt from such critiques of reason (from Poster 1989, 23). Poster insists that no sharper opposition can currently be found than that of Habermas defending reason in the form of consensus (echoing Peirce's collective truth) against "Lyotard denouncing reason as a danger to dissensus" or pluralism (1989, 23–24).

But Foucault—the exemplary poststructuralist who launched a powerful assault on the concept of the autonomous self, the Enlightenment, and reason—reversed his position before he died! Poster explains that Foucault came to perceive that even postsubjective authorial absence—which he had always championed—was too damaging to the author's "self." In an essay written toward the end of his life, "What Is Enlightenment?" (1984), Foucault argued that confronting the present develops an individual self whose identity cannot be separated from the fate of humanity, as determined by history (Poster 1989, 60).

On this basis alone, Foucault argues the *almost* modern position (he still denies that reason has any inherent claim to truth) for the constitution of an autonomous self—an identity that was historically determined, to some extent, by the Enlightenment (Poster 1989, 60). This leading poststructuralist who had once defined himself as against reason, the Enlightenment, and the indivisible autonomous self reversed himself to accept the responsibility of his historical connection to the eighteenth-century French philosophers *(philosophes)* and the Enlightenment (60). We come full circle.

I believe it is important to understand that the inherent danger in reason as a strategy lies, not in its use in the service of explanatory clarity, but in the assumption we inherited from Descartes that the voice of reason is a universal voice. Postmodernists view such an assumption with suspicion because it implies there is no other approach to truth, and thus reason becomes a prerequisite to power.

Those valuable new areas of knowledge and insight that we gain through irrational channels are certainly an indispensable augmentation to conscious thought. Perhaps echoing André Breton and Habermas, as well as the late Foucault, I believe that in order to be convincing—in order to organize and communicate these augmentations to those in society who still conduct their primary exchanges through the medium of reason—these irrational contributions might profitably be structured with "communicative reason" and explained with clarity (fully recognizing that such clarity eludes attempts to disguise and evade and hence exposes gaps and errors and invites a more critical reading). Without such a symbiotic crossover, two efficient and valuable systems of thinking and investigation are destined to remain separate, unable to communicate—a magnificent house divided.

These two dichotomous strategies have coexisted throughout European history, but each separate period has had a tendency to favor one strategy over the other. The only two periods in the history of the world in which reason dominated were limited to Western Europe: reason reigned only in ancient Greece and in Europe from the late Renaissance through the Enlightenment. Leonardo and Bosch died within three years of each other at the end of the High Renaissance. It was Leonardo with his logical, more formalist retinal approach to composition and pictorial space who received most of the critical attention—until the middle of the twentieth century. Then, suddenly, his direction seemed less interesting to us.

The reputations of Duchamp and Dubuffet were well established before the abstract expressionists began to dominate the scene. Critics have always recognized the high quality of the two men's work—which emphasizes irrational elements—yet the abstract expressionists (critiqued and explained by rational formalists) received the lion's share of critical attention. Most of society at the middle of the twentieth century was fascinated by the immediate retinal impact and rationalist explanations of the abstract expressionists rather than by the more irrational issues of the signing painters (which could be easily expressed only in the language of the absurd).

There is also an inverse relationship between painting's ability to communicate on a timeless universal level and its ability to communicate precise verbal ideas. This is, generally speaking, a major difference between the retinal (the formal) and the signing (the linguistic) direction in painting.

Formalists often tend to reject visual images they perceive as comprehensible only at a local or regional level, as well as images they believe are limited to one specific period, culture, or tongue. They search for the univer-

sal, the monumental, the timeless. Often they search for this universal language, this visual "Latin," through the understanding of human perception, for they believe human perception is universal and therefore timeless.

But poststructuralists perceived the universalization of any idea as dangerous, ethnocentric, totalitarian. They accused the rationalists of solipsistically believing: "There is a universal perception, and it is mine." As Poster reminds us, the "universal" and "self-evident" truths of reason "discovered" in the eighteenth century were concurrent with, and inevitably an aid to, the spread of European power throughout the world (1989, 64).

The problem with any so-called universal concept, according to the poststructuralists, is that no idea can ever be understood in the same way by all cultures. The entire context of a culture—its language, belief, custom, and religion—inevitably shapes its people's perception of any image or idea. Hence the poststructuralists condemn the modernists for their refusal to consider context.

Those who pursue the verbal linguistic image are suspicious of claims to universal or timeless meaning. Their images (as in Duchamp's or Bosch's work), by the very nature of their verbal intent, often limit viewers from other periods, or those who speak other tongues, to a fragmentary understanding. Therefore signing painters may communicate with more precision than retinal painters, but their *intended* audience is far more limited. They "speak" best to those specific viewers who share with the artist a particular period, tongue, or geography. The painters of the Middle Ages, van Eyck, Bosch, Vermeer, and Hogarth are excellent examples of this.

Painting is limited to a balance somewhere between these two choices. The retinal formal approach has in general been perceived as better suited to the search for timeless and universally meaningful images—but limited in its ability to communicate precise verbal ideas to anyone, ever. Signing painters, on the other hand, often communicate more precisely to viewers in a specific period, tongue, or geographic location—but their expectations as to any universal comprehensibility are exceedingly limited.

Consequently, reflecting Heisenberg's uncertainty principle, when one direction (for example, the formal) is granted more status, the other direction (for example, the linguistic) must necessarily be deemphasized. In other words, the more universal the meaning, the less precise it is; and conversely, the more precise the meaning, the less universal it is. But these two categories may achieve a balance, for most painters do not fit entirely into one category or the other. They demonstrate some tendencies in both directions.

In short, both the linguistic and the retinal direction have existed for more than two millennia, but critical interest and media attention have shifted back and forth between them. When critics and the media favor one direction, most young artists learn to work in that direction, though there are always some who stubbornly pursue ideas in the other direction. Surely the last important "modern" retinal work of art has not yet reared its ugly head.

Finally, one of the primary functions of a scientist or an artist is to explore and expand concepts of reality. The artists who have proved most valuable to their society have done so by posing new questions rather than by asserting answers, as some theorists are prone to do. Certainly the writer or critic is in no better position to judge, assert, or answer than the artist is. Perhaps the most valuable and symbiotic service that can be performed by those who arrogate to write about (and who thus depend upon) the work of these artists is to recognize, interpret, and further explore the wealth of questions they raise.

Works Cited

ACKERMAN, GERALD M. 1986. *The Life and Work of Jean-Léon Gérôme: With a Catalogue Raisonne*. New York: Sotheby's.

ALBERTI, LEON BATTISTA. 1966. *On Painting* (1956 revised). Ed. John Spencer. New Haven, CT: Yale University Press.

ALCIATUS, ANDREAS. 1985. *The Latin Emblems Indexes and Lists* (annotated reprint from Tozzi's first complete Latin edition, 1571). Ed. Peter M. Daly and Virginia W. Callahan, assisted by Simon Cuttler. Toronto: University of Toronto Press.

ALPERS, SVETLANA. 1983. *The Art of Describing*. Chicago: University of Chicago Press.

———. 1988. *Rembrandt's Enterprise: The Studio and the Market* (Chicago: University of Chicago Press).

ANDERSEN, WAYNE. 1971. *Gauguin's Paradise Lost*. Assisted by Barbara Klein. New York: Viking.

ANTAL, FREDERICK. 1969. "Florentine Painting and Its Social Background." In *Social and Economic Foundations of the Italian Renaissance,* ed. Anthony Molho. New York: Wiley. Pp. 116–22.

ARGAN, GIULIO CARLO. 1980. "Ideology and Iconology." Trans. Rebecca West. In *The Language of Images,* ed. W. J. T. Mitchell. Chicago: The University of Chicago Press. Pp. 15–24.

ARNHEIM, RUDOLF. 1982 revised. *The Power of the Center: A Study of Composition in the Visual Arts*. Berkeley: University of California Press.

———. 1986. *New Essays on the Psychology of Art*. Berkeley: University of California Press.

———. 1989. *Parables of Sun Light: Observations on Psychology, the Arts, and the Rest.* Berkeley: University of California Press.

AURIER, GUSTAVE ALBERT. 1891. "Symbolism in Painting: Paul Gauguin." *Mercure de France* (March). Reprinted in *Gauguin: A Retrospective,* ed. Marla Prather and Charles F. Stuckey. New York: Hugh Lauter Levin Associates, 1987.

AYMÈS, CLÉMENT A. WERTHEIM. 1975. *The Pictorial Language of Hieronymus Bosch: Represented in a Study of Two Pictures: The Prodigal Son, and the Temptations of St*

Anthony, with Comments on Themes in Other Works. Trans. E. A. Frommer. Sussex, England: New Knowledge Books.

BAIGELL, MATTHEW. 1976. *Charles Burchfield.* New York: Watson-Guptill Publications.

BAKHTIN, MIKHAIL. 1968. *Rabelais and His World.* Cambridge, MA: Massachusetts Institute of Technology. Originally published as *Tvorchestvo Fransua Rable* (Moscow, Khudozhestvennia Literatura, 1965).

BALDASS, LUDWIG. 1952. *Jan van Eyck.* New York: Phaidon.

BARASCH, MOSHE. 1985. *Theories of Art.* New York: New York University Press.

———. 1987. *Giotto and the Language of Gesture (Cambridge Studies in the History of Art).* Ed. Francis Haskell and Nicolas Penny. Cambridge, England: Cambridge University Press.

———. 1990. *Modern Theories of Art. 1: From Winckelmann to Baudelaire.* New York: New York University Press.

BARNES, HAZEL E. n.d. "Introduction." In *Jean-Paul Sartre, Being and Nothingness: An Essay on Phenomenological Ontology.* New York: Philosophical Library.

BARTHES, ROLAND. 1982. "Striptease." In *A Barthes Reader.* Ed. Susan Sontag. New York: Hill and Wang (1955). Pp. 85–88.

———. 1985. "Arcimboldo, or Magician and Rhétoriquer." In *The Responsibility of Forms: Critical Essays on Music, Art, and Representation,* trans. Richard Howard. New York: Hill and Wang. Originally published as *L'obvie et l'obtus* (Paris: Éditions du Seuil, 1982).

———. 1988. "The World as Object." In *Calligram: Essays in New Art History from France.* Ed. Norman Bryson. Cambridge, England: Cambridge University Press.

BAUR, JOHN I. H. 1982. *The Inlander: Life and Work of Charles Burchfield, 1893–1967.* Newark, NJ: University of Delaware Press.

BAX, D. 1979. *Hieronymus Bosch / His Picture-Writing Deciphered.* Trans. M. A. Bax-Botha. Rotterdam: A. A. Balkema. Originally published as *Onticijfering van Jeroen Bosch* (Nijhoff: s-Gravenhage, 1949).

BEDAUX, JAN BAPTIST. 1990. "Discipline for Innocence. Metaphors for Education in Seventeenth-Century Dutch Painting." In *The Reality of Symbols: Studies in the Iconology of Netherlandish Art, 1400–1800.* The Hague: Gary Schwartz/SDU. Pp. 109–69.

BEEHLER, KATHLEEN. 1993. "Context for Masaccio's 'Tribute Money' Revised." M.A. thesis, Central Washington University.

BELL, A. E. 1947. *Christian Huygens and the Development of Science in the Seventeenth Century.* New York: Longmans Green.

BENVENISTE, ÉMILE. 1971. *Problems in General Linguistics.* Trans. Elizabeth Meek. Coral Gables: University of Miami Press. Originally published as *Problemes de linguistique générale* (Paris: Éditions Gallimard, 1966).

BERGMAN, MADELEINE. 1979. *Hieronymus Bosch and Alchemy: A Study on the St. Anthony Triptych. Stockholm Studies in History of Art,* Vol. 31. Stockholm: Almqvist and Wiksell International.

BERGSTRÖM, INGVAR. 1957. "Medicina, Fons, et Scrinium: A Study in Van Eyckian Symbolism and Its Influence in Italian Art." *Konsthistorisk Tidskrift 26* (1957): 1–20.

BERNARD OF CLAIRVAUX. 1990. *The Things of Greater Importance: Bernard of Clairvaux's Apologia and the Medieval Attitude Toward Art.* Ed. Conrad Rudolph. Philadelphia: University of Pennsylvania Press (1990).

BEST, STEVEN, AND DOUGLAS KELLNER. 1991. *Postmodern Theory: Critical Interrogations.* New York: Guilford Press.

BEUYS, JOSEPH. 1990. *Energy Plan for the Western Man: Joseph Beuys in America.* Writings by and interviews with the artist, comp. Carin Kuoni. New York: Four Walls Eight Windows.

BILLIG, OTTO, AND B. G. BURTON-BRADLEY. 1978. *The Painted Message.* New York: Wiley.

BILLINGTON, SANDRA. 1984. *A Social History of the Fool.* New York: St. Martin's Press.

BINDMAN, DAVID. 1981. New York: Oxford University Press.

BLANKERT, ALBERT. 1978. *Vermeer of Delft: Completed Edition of the Paintings.* Contrib. Rob Ruurs and Willem L. van de Watering. Oxford, England: Phaidon. Originally published as *Johannes Vermeer van Delft 1632–1675* (Uitgeverij Het Spectrum B. V., 1975).

BLOOM, SUZANNE, AND ED HILL. 1982. "Wringing the Goose's Neck One Last Time or, Painting vs. Photography and the Deconstruction of Modernism." *Afterimage* IX/10 (May): 9–14.

BONK, ECKE. 1989. *Marcel Duchamp: the Box in a Valise.* Trans. David Britt. New York: Rizzoli. Originally published as *Marcel Duchamp: Die grosse Schachtel* (Geneva: Paris and Cosmopress, 1986).

BOORSTIN, DANIEL J. 1983. *The Discoverers.* New York: Random House.

———. 1992. *The Creators.* New York: Random House.

BOSLOUGH, JOHN. 1990. "The Enigma of Time." *National Geographic* 177 (March): 109–32.

BRAUDEL, FERNAND. 1973. *Capitalism and Material Life, 1400–1800.* Trans. Miriam Kochan. New York: Harper and Row. Originally published as *Civilisation Matérielle et Capitalisme* (Paris: Librairie Armand Colin, 1967).

BRAUDY, LEO. 1986. *The Frenzy of Renown: Fame and Its History.* New York: Oxford University Press.

BRENSON, MICHAEL. 1985. "Art." *The New York Times* (9 August): Manhattan edition, Sect. C.

BRETON, ANDRÉ. 1924. "Manifesto of Surrealism." In *Manifestoes of Surrealism*, trans. Richard Seaver and Helen R. Lane. Ann Arbor: The University of Michigan Press, 1969. Originally published as *Manifestes du Surréalisme*, ed. J. J. Pauvert (Paris, 1962).

———. 1930a. "The Immaculate Conception" (excerpts). In *What Is Surrealism? Selected Writings* (1978), ed. Franklin Rosemont. New York: Monad Press. Pp. 49–61.

———. 1930b. "Second Manifesto of Surrealism." In *Manifestoes of Surrealism*, trans. Richard Seaver and Helen R. Lane. Ann Arbor: The University of Michigan Press, 1969. Originally published as *Manifestes du Surréalisme*, ed. J. J. Pauvert (Paris, 1962).

———. 1935a. "Political Position of Today's Art." In *Manifestoes of Surrealism*, trans. Richard Seaver and Helen R. Lane. Ann Arbor: The University of Michigan

Press, 1969. Originally published as *Manifestes du Surréalisme*, ed. J. J. Pauvert (Paris, 1962).

———. 1935b. "Surrealist Situation of the Object: Situation of the Surrealist Object." In *Manifestoes of Surrealism*, trans. Richard Seaver and Helen R. Lane. Ann Arbor: The University of Michigan Press, 1969. Originally published as *Manifestes du Surréalisme*, ed. J. J. Pauvert (Paris, 1962).

———. 1942. "Prolegomena to a Third Surrealist Manifesto or Not." In *Manifestoes of Surrealism*, trans. Richard Seaver and Helen R. Lane. Ann Arbor: The University of Michigan Press, 1969. Originally published as *Manifestes du Surréalisme*, ed. ´ J. J. Pauvert (Paris, 1962).

———. 1953. "On Surrealism in Its Living Works." In *Manifestoes of Surrealism*, trans. Richard Seaver and Helen R. Lane. Ann Arbor: The University of Michigan Press, 1969. Originally published as *Manifestes du Surréalisme*, ed. J. J. Pauvert (Paris, 1962).

BRYSON, NORMAN. 1981. *Word and Image: French Painting of the Ancien Régime.* Cambridge, England: Cambridge University Press.

———. 1990. *Looking at the Overlooked: Four Essays on Still Life Painting.* Cambridge, MA: Harvard University Press.

———. 1991a. "The Politics of Arbitrariness." In *Visual Theory: Painting and Interpretation*, ed. Norman Bryson, Michael Ann Holly, and Keith Moxey. New York: HarperCollins. Pp. 95–100.

———. 1991b. "Semiology and Visual Interpretation." In *Visual Theory: Painting and Interpretation*, ed. Norman Bryson, Michael Ann Holly, and Keith Moxey. New York: HarperCollins. Pp. 61–73.

BURCHFIELD, CHARLES. 1968. *The Drawings of Charles Burchfield.* Ed. Edith H. Jones. New York: Frederick A. Praeger, Publishers.

BURCKHARDT, JACOB. 1958. *The Civilization of the Renaissance in Italy.* Vol. I. Trans. S. Middlemore. New York: Harper.

BURGARD, TIMOTHY ANGLIN. 1991. "Picasso and Appropriation." *The Art Bulletin* 73 (September): 479–94.

BURKE, JOSEPH, AND COLIN CALDWELL. n.d. *Hogarth: The Complete Engravings.* New York: Harry N. Abrams.

BURNHAM, JACK. 1973 revised. *The Structure of Art.* Assisted by Charles Harper and Judith Benjamin Burnham. New York: George Braziller.

———. 1974. *The Great Western Salt Works: Essays on the Meaning of Post-Formalist Art.* New York: George Braziller.

BURTT, EDWIN ARTHUR. 1954 revised. *The Metaphysical Foundations of Modern Physical Science.* Garden City, NY: Anchor.

CABANNE, PIERRE. 1987. *Dialogues with Marcel Duchamp.* Trans. Ron Padgett. New York: Da Capo Press. Originally published as *Entretiens avec Marcel Duchamp* (Paris: Éditions Pierre Belfond, 1967).

CAMERON, DAN. 1988. "Stephen Frailey: Breaking Into Pictures." *Art News* 87. No. 9 (November): 93–94.

CARRIER, DAVID. 1985. "The Deconstruction of Perspective: Howard Buchwald's Recent Paintings." *Arts Magazine*, No. 60 (October): 26–29.

CASSIRER, ERNST. 1946. *Language and Myth.* Trans. S. Langer. New York: Dover.

CAVARNOS, CONSTANTINE. 1977. *Orthodox Iconography.* Belmont, MA: Institute for Byzantine and Modern Greek Studies.

CHADWICK, WHITNEY. 1985. *Women Artists and the Surrealist Movement.* Boston: Little, Brown.

―――. 1990. *Women, Art, and Society.* London: Thames and Hudson Ltd.

CHIPP, HERSCHEL B. 1968. *Theories of Modern Art.* Contrib. Peter Selz and Joshua Taylor. Berkeley: University of California Press.

CLARK, TIMOTHY J. 1985. *The Painting of Modern Life.* New York: Knopf.

COLE, BRUCE. 1980. *Masaccio and the Art of Early Renaissance Florence.* Bloomington: Indiana University Press.

COLLINGWOOD, R. G. 1961 reprint. *The Principles of Art* (1938). New York: Oxford University Press.

COOK, ALBERT. 1989. *Dimensions of the Sign in Art.* Hanover, MA: Massachusetts: University Press of New England.

COOK, WILLIAM R., AND RONALD B. HERZMAN. 1983. *The Medieval World View: An Introduction.* Oxford, England: Oxford University Press.

COWLEY, ROBERT L. S. 1983. *Hogarth's Marriage A-La-Mode.* Ithaca, NY: Cornell University Press.

CRIMP, DOUGLAS. 1990. "The Boys in My Bedroom." *Art in America* 78. No. 2 (February): 47–49.

CULLER, JONATHAN. 1982. *On Deconstruction.* Ithaca, NY: Cornell University Press.

―――. 1986 revised. *Ferdinand de Saussure.* Ithaca, NY: Cornell University Press.

CURIGER, BICE. 1989. *Meret Oppenheim: Defiance in the Face of Freedom.* Texts by Meret Oppenheim et al. Cambridge, MA: MIT Press.

DAVIS, ANN. 1992. *The Logic of Ecstasy: Canadian Mystical Painting, 1920–1940.* Toronto: University of Toronto Press.

DE BRUYNE, EDGAR. 1969. *The Esthetics of the Middle Ages* (1947). Trans. Eileen Hennessy. New York: Ungar.

DE DUVE, THIERRY. 1991. *Pictorial Nominalism: On Marcel Duchamp's Passage from Painting to the Readymade.* Trans. Dana Polan with the author. *Theory and History of Literature.* Vol. 51. Minneapolis: University of Minnesota Press.

DELEUZE, GILLES, AND FÉLIX GUATTARI. 1977. *Anti-Oedipus: Capitalism and Schizophrenia.* Trans. Robert Hurley, Mark Seem, and Helen Lane. New York: Viking Press. Originally published as *L'Anit-Oedipe* (Paris: Les Éditions de Minuit, 1972).

DERRIDA, JACQUES. 1973. *Speech and Phenomena.* Evanston, IL: Northwestern University Press.

―――. 1976. *Of Grammatology.* Trans. Gayatri Chakravorty Spivak. Baltimore: Johns Hopkins University Press.

―――. 1978. *Writing and Difference.* Trans. Alan Bass. Chicago: University of Chicago Press. Originally published as *L'écriture et la différance* (Paris: Éditions du Seuil, 1967).

―――. 1981. *Dissemination.* Ed. Barbara Johnson. Chicago: University of Chicago Press.

————. 1986. *Memoires for Paul de Man.* Trans. Cecile Lindsay, Jonathan Culler, and Eduardo Cadava. New York: Columbia University Press.

————. 1987. *The Truth in Painting.* Trans. Geoff Bennington and Ian McLeod. Chicago: University of Chicago Press.

————. 1992. *Acts of Literature.* Ed. Derek Attridge. New York: Routledge.

DE VORE, NICHOLAS. 1947. *Encyclopedia of Astrology.* New York: Philosophical Library.

DEWDNEY, A. K. 1985. "Computer Recreations." *Scientific American 253,* 2 (August): 16–21.

DHANENS, ELISABETH. 1973. *Van Eyck: The Ghent Altarpiece.* Ed. John Fleming and Hugh Honour. New York: Viking.

D'HARNONCOURT, ANNE. 1989. "Introduction." In *Marcel Duchamp,* ed. Anne d'Harnoncourt and Kynaston McShine. New York: Museum of Modern Art. Pp. 33–45.

DIXON, JOHN W. 1984. "Painting as Theological Thought: The Issues in Tuscan Theology." *Art, Creativity, and the Sacred,* ed. Diane Apostolos-Cappadona. New York: Crossroad. Pp. 277–96.

DIXON, LAURINDA S. 1981. *Alchemical Imagery in Bosch's Garden of Delights.* Ann Arbor, MI: UMI Research Press.

DOBIE, ELIZABETH ANN. 1990. "Interweaving Feminist Frameworks." *The Journal of Aesthetics and Art Criticism 48:* 381–94.

DUBUFFET, JEAN. 1945a. "Notes for the Well-Read, 1945." In *Jean Dubuffet: Towards an Alternative Reality.* Essay by Mildred Glimcher. New York: Abbeville Press, 1987.

————. 1949. "Art Brut Preferred to the Cultural Arts." In *Jean Dubuffet: Towards an Alternative Reality.* Essay by Mildred Glimcher. New York: Abbeville Press, 1987.

————. 1952. "Anticultural Positions." In *Jean Dubuffet: Towards an Alternative Reality.* Essay by Mildred Glimcher. New York: Abbeville Press, 1987.

————. 1954. "Petites Statues de la Vie Precaire (Little Statues of Precarious Life)." In *The Work of Jean Dubuffet,* with texts by Jean Dubuffet. New York: Museum of Modern Art.

————. 1961. "Statement on Paintings of 1961." In *The Work of Jean Dubuffet* (1962), with texts by Jean Dubuffet. New York: Museum of Modern Art.

————. 1978. "Closerie Falbala and The Cabinet Logologique." In *Jean Dubuffet: Towards an Alternative Reality.* Essay by Mildred Glimcher. New York: Abbeville Press, 1987.

————. 1986. *Asphyxiating Culture: and Other Writings.* Trans. Carol Volk. New York: Four Walls Eight Windows. Originally published as *Asphyxiante culture* (Paris: Les Éditions de Minuit).

DUCHAMP, MARCEL. 1973 revised. "The Creative Act." In *The New Art: A Critical Anthology* (1966), ed. Gregory Battock. New York: Dutton.

DUDAR, HELEN. 1993. "The Uneasy Esthetic of Jean Dubuffet." *Smithsonian 24:3* (June): 78–87.

DUNNING, WILLIAM V. 1991a. *Changing Images of Pictorial Space: A History of Spatial Illusion in Painting.* Syracuse, NY: Syracuse University Press.

———. 1991b. "The Concept of Self and Postmodern Painting: Constructing a Post-Cartesian Viewer." *The Journal of Aesthetics and Art Criticism 49*:4 (Fall 1991): 332–36.

———. 1993. "Postmodernism and the Construct of the Divisible Self." *The British Journal of Aesthetics 33*:2 (April): Pp. 132–41.

ECO, UMBERTO. 1983. *The Name of the Rose.* 1980. Trans. William Weaver. New York: Warner Books.

———. 1984. *Postscript to Name of the Rose.* 1983. Trans. William Weaver. New York: Harcourt Brace Jovanovich.

———. 1986a. *Art and Beauty in the Middle Ages* (1959). Trans. Hugh Bredin. New Haven, CT: Yale University Press.

———. 1986b. *Travels in Hyper Reality: Essays.* Trans. William Weaver. New York: Harcourt Brace Jovanovich.

ECO, UMBERTO, R. LAMBERTINI, C. MARMO, AND A. TABORRONI. 1989. "On Animal Language in the Medieval Classification of Signs." In *On the Medieval Theory of Signs,* ed. Umberto Eco and Castantino Marmo. *Foundations of Semiotics.* Vol. 21. Gen. Ed. Achim Eschbach. Philadelphia: John Benjamins. Pp. 3–41.

ELIADE, MIRCEA. 1962. *The Forge and the Crucible.* Trans. Stephen Corrin. New York: Harper. Originally published as *Forgerons et Alchimistes* (Paris: Flammarion, 1956).

ELIOT, T. S. 1962. "Tradition and the Individual Talent." In *The Norton Anthology of English Literature* (4th ed.). Vol. 2. New York: W. W. Norton. Pp. 2293–2308. Originally published in *The Egoist* (1919).

ELKINS, JAMES. 1991. "On the *Arnolfini Portrait* and the *Lucca Madonna:* Did Jan van Eyck Have a Perspective System?" *The Art Bulletin 73* (March): 53–62.

FAULKNER, WILLIAM. 1955, 2nd ed. *As I Lay Dying* (1930). New York: Harrison Smith & Robert Haas.

FEDER, LILLIAN. 1980. *Madness in Literature.* Princeton, NJ: Princeton University Press.

FELMAN, SHOSHANA. 1985. *Writing and Madness: (Literature/Philosophy/Psychoanalysis).* Trans. Martha Noel Evans and the author. Ithaca, NY: Cornell University Press. Eight chapters translated from the original twelve chapters of *La folie et la chose littéraire* (Paris: Éditions du Seuil, 1978).

FENOLLOSA, ERNEST. 1967. "The Chinese Written Character as a Medium for Poetry." Trans. and ed. Ezra Pound. In *Instigations* (1920), by Ezra Pound. Freeport, NY: Books for Libraries Press. Pp. 357–88.

FERGUSON, GEORGE. 1961. *Signs and Symbols in Christian Art.* New York: Oxford University Press.

FERGUSON, WALLACE K. 1969. "Renaissance Economic Historiography." In *Social and Economic Foundations of the Italian Renaissance,* ed. Anthony Molho. New York: Wiley. Pp. 116–22.

FILIPCZAK, ZIRKA ZAREMBA. 1987. *Picturing Art in Antwerp, 1550–1700.* Princeton, N.J.: Princeton University Press.

FOUCAULT, MICHEL. 1965. *Madness and Civilization: A History of Insanity in the Age of Reason.* Trans. Richard Howard. New York: Pantheon. Originally published as *Histoire de la Folie* (Paris: Librairie Plon, 1961).

———. 1972. *The Archaeology of Knowledge.* Ed. R. D. Laing. Trans. A. M. Sheridan Smith. New York: Pantheon. Originally published as *L'Archéologie du Savoir* (Paris: Éditions Gallimard, 1969).

———. 1973. *The Order of Things: An Archaeology of the Human Sciences.* New York: Vintage Books. Originally published as *Le Mots et les choses* (Paris: Éditions Gallimard, 1966).

———. 1977a. *Discipline and Punish: The Birth of the Prison.* Trans. Alan Sheridan. New York: Pantheon Books. Originally published as *Surveiller et Punir: Naissance de la prison* (Paris: Éditions Gallimard, 1975).

———. 1977b. "Preface." In *Anti-Oedipus: Capitalism and Schizophrenia,* by Gilles Deleuze and Félix Giattari. Trans. Robert Hurley, Mark Seem, and Helen Lane. New York: Viking Press. Originally published as *L'Anit-Oedipe* (Paris: Les Éditions de Minuit, 1972).

———. 1984. "What Is Enlightenment?" In *The Foucault Reader,* ed. Paul Rabinow and Trans. Catherine Porter. New York: Pantheon.

FRÄNGER, WILHELM. 1983. *Hieronymus Bosch* (1951). Trans. Helen Sebba. New York: Putman.

FRIEDLAENDER, MAX J. 1969. 3rd ed. *From Van Eyck to Bruegel.* Ed. F. Grossmann. New York: Phaidon.

GABLIK, SUZI. 1977. *Progress in Art.* New York: Rizzoli.

———. 1991. *The Reenchantment of Art.* New York: Thames and Hudson. García Màrquez, Gabriel. 1982. *Chronicle of a Death Foretold.* Trans. Gregory Rabassa. New York: Ballantine.

GARDENER, NANCY P. 1987. "Dan Rice." *New Art Examiner* (March): Midwest edition, 53.

GARRISON, PHILIP. 1991. *Augury.* Athens: University of Georgia Press.

GAUGUIN, PAUL. 1978. *The Writing of a Savage.* Ed. Daniel Guérin. Trans. Eleanor Levieux. New York: Viking.

GETTINGS, FRED. 1979. *The Occult in Art.* New York: Rizzoli.

———. 1987. *Secret Symbolism in Occult Art.* New York: Harmony Books.

GIBBONS, TOM. 1981. "Cubism and 'The Fourth Dimension' in the Context of the Late-Nineteenth-Century and Early-Twentieth-Century Revival of Occult Idealism." *Journal of the Warburg and Courtauld Institutes 44:* 130–47.

GIBSON, JAMES J. 1950. *The Perception of the Visual World.* Cambridge: Riverside Press.

GIBSON, MICHAEL. 1988. *The Symbolists.* Trans. author. New York: Harry N. Abrams. Originally published as *Symbolistes* (Paris: Nouvelles Éditions Françaises, 1984).

GILMAN, SANDER L. 1982. *Seeing the Insane.* New York: Wiley.

GILMOUR, JOHN C. 1990. *Fire on the Earth: Anselm Kiefer and the Postmodern World.* Philadelphia: Temple University Press.

GLEICK, JAMES. 1987. *Chaos: Making a New Science.* New York: Penguin Books.

GLIMCHER, MILDRED. 1987. "Jean Dubuffet: Towards an Alternative Reality." In *Jean Dubuffet: Towards an Alternative Reality*. New York: Abbeville Press.

GLUM, PETER. 1976. "Divine Judgement in Bosch's 'Garden of Earthly Delights.'" *Art Bulletin 58* (March): 45–54.

GOLDING, JOHN. 1973. *The Bride Stripped Bare by Her Bachelors, Even*. London: Penguin.

GOLDWATER, ROBERT. 1957. *Paul Gauguin*. New York: Abrams.

GOLDWATER, ROBERT, AND MARCO TREVES. 1966. *Artists on Art*. New York: Pantheon.

GOMBRICH, E. H. 1963. *Meditations on a Hobby Horse: and Other Essays on the Theory of Art*. London: Phaidon.

GRAY, CHANNING. 1984. "Apocalyptic Vision." *Providence Journal*, March 2, weekend section.

GUILLAUD, JACQUELINE, AND MAURICE GUILLAUD. 1989. *Hieronymus Bosch: The Garden of Earthly Delights*. New York: Clarkson N. Potter. Originally published as *Bosch: Le Jardin des Délices* (Paris: Guillaud Éditions, 1988).

HABER, RALPH NORMAN, AND MAURICE HERSHENSON. 1973. *The Psychology of Visual Perception*. New York: Holt.

HAGEN, MARGARET A. 1986. *Varieties of Realism*. London: Cambridge University Press.

HARBISON, CRAIG. 1990. "Sexuality and Social Standing in Jan van Eyck's Arnolfini Double Portrait." *Renaissance Quarterly 43* (Summer): 249–91.

HARTEN, JÜRGEN. 1988. "Preface." In *A Book by Anselm Kiefer*, trans. Bruni Mayor. New York: Braziller; and Boston: Museum of Fine Arts.

HARTT, FREDERICK. 1993. 4th ed. Englewood Cliffs, NJ: Prentice Hall; and New York: Abrams.

HASSAN, IHAB. 1987. *The Postmodern Turn: Essays in Postmodern Theory and Culture*. Columbus: Ohio State University Press.

HAWKING, STEPHEN W. 1988. *A Brief History of Time: From the Big Bang to Black Holes*. New York: Bantam Books.

HAYLES, KATHERINE N. 1990. *Chaos Bound: Orderly Disorder in Contemporary Literature and Science*. Ithaca, NY: Cornell University Press.

———. 1991. "Introduction: Complex Dynamics in Literature and Science." In *Chaos and Disorder: Complex Dynamics in Literature and Science*. Chicago: University of Chicago Press. Pp. 1–36.

HENDERSON, LINDA DALRYMPLE. 1983. *The Fourth Dimension and Non-Euclidean Geometry in Modern Art*. Princeton, NJ: Princeton University Press.

HESS, THOMAS. 1951. *Abstract Painting*. New York: Viking.

HOFSTADTER, DOUGLAS R. 1979. *Gödel, Escher, Bach: An Eternal Golden Braid*. New York: Basic Books.

HOGARTH, WILLIAM. 1974. *The Analysis of Beauty* (1753). Yorkshire: The Scholar Press.

HOLT, ELIZABETH GILMORE. 1958. *A Documentary History of Art*. Vol. 2. *Michelangelo and the Mannerists; The Baroque and the Eighteenth Century* (1947). Garden City, NY: Doubleday Anchor Books.

HOLT, JIM. 1993. "The Newer Paradigm: A Plea for Higher Dimensions." *The New Republic 209*(July 12): 22–25.

HUGHES, ROBERT. 1992. "Telling an Inner Life." *Time 140* (December 28): 68–69.

————. 1993. "A Fiesta of Whining." *Time 141* (March 22): 68–69.

HUIZINGA, JOHAN, 1957. *Erasmus and the Age of Reformation.* Trans. F. Hopman. New York: Harper and Row.

IVERSEN, MARGARET. 1988. "Saussure versus Peirce: Models for a Semiotics of Visual Art." In *The New Art History.* Atlantic Highlands, NJ: Humanities Press.

JACKSON, DAVID S. 1993. "Cyberpunk!" *Times 141* (February 8): 58–65.

JAKOBSON, ROMAN, AND GRETE LÜBBE-GROTHUES. 1985. "The Language of Schizophrenia: Holderlin's Speech and Poetry." In *Verbal Art, Verbal Sign,* ed. Drystyna Pomorska and Stephen Rudy, with the assistance of Brent Vine. Minneapolis: University of Minnesota Press. Pp. 133–40.

JAMESON, FREDERIC. 1972. *The Prison-House of Language: A Critical Account of Structuralism and Russian Formalism.* Princeton, NJ: Princeton University Press.

————. 1983. "Postmodernism and Consumer Society." In *The Anti-Aesthetic: Essays in Postmodern Culture,* ed. H. Foster. Port Townsend, WA: Bay Press. Pp. 111–25.

————. 1984. "Postmodernism, or the Cultural Logic of Late Capitalism." *New Left Review,* No. 146 (July–August): 53–92.

JARRETT, BEDE. 1968. *Social Theories of the Middle Ages 1200–1500.* London: Frank Cass.

JAWORSKA, WLADYSLAWA. 1972. *Gauguin and the Pont-Aven School.* Trans. Patrick Evans. London: Thames and Hudson. Originally published as *Paul Gauguin et l'École de Pont-Aven* (Neuchâtel, Switzerland: Éditions Ides et Calendes, 1971).

JOHNSON, KEN . 1993. "Significant Others." *Art in America 81:* (June): 84–91.

JUNG, CARL G. 1953. *Bollingen Series XX. The Collected Works of C. G. Jung.* Vol. 12. *Psychology and Alchemy.* Trans. R. F. C. Hull. New York: Pantheon Books.

————. 1967. *Bollingen Series XX. The Collected Works of C. G. Jung.* Vol. 13. *Alchemical Studies.* Trans. R. F. C. Hull. Princeton: Princeton University Press.

JÜRGENS, H., H. PEITGEN, AND D. SAUPE, 1990. "The Language of Fractals." *Scientific American 236* (August): 60–67.

KAHR, MADLYN MILLNER. 1978. *Dutch Painting in the Seventeenth Century.* New York: Harper and Row.

KLINGAMAN, WILLIAM K. 1987. *1919: The Year Our World Began.* New York: St. Martin's Press.

KROEBER, THEODORA. 1961. *Ishi in Two Worlds: A Biography of the Last Wild Indian in North America.* Berkeley: University of California Press.

LACAN, JACQUES. 1957. "The Insistence of the Letter in the Unconscious." Trans. J. Miel. In *Structuralism* (1970). Garden City, NY: Anchor.

————. 1968. "The Function of Language in Psychoanalysis." In *The Language of the Self,* trans. with notes and commentary by Anthony Wilden. Baltimore: Johns Hopkins University Press.

————. 1977. *Écrits: A Selection.* Trans. A. Sheridan. New York: Norton.

————. 1990. *Television: A Challenge to the Psychoanalytic Establishment.* Ed. J. Copjec. Trans. J. Mehlman. New York: W. W. Norton.

LANGER, SUSANNE, 1946. "Translator's Preface." In *Language and Myth* by Ernst Cassirer, trans. Susanne Langer. New York: Dover.

LEACH, EDMUND. 1985. "Michelangelo's Genesis: a Structuralist Interpretation of the Central Panels of the Sistine Chapel Ceiling." *Semiotica 56*: 1–30.

LEAKEY, RICHARD. 1978. *People of the Lake.* Garden City, NY: Anchor.

LEAVY, STANLEY A. 1978. "The Significance of Jacques Lacan." In *Psychiatry and the Humanities.* Vol. 3. *Psychoanalysis and Language,* ed. Joseph H. Smith, M.D. New Haven, CT: Yale University Press.

LÉVI-STRAUSS, CLAUDE. 1987. "Totemism and the Savage Mind (1960–1)." In *Anthropology and Myth: Lectures 1951–1982,* trans. R. Willis. Oxford, England: Basil Blackwell.

LIEBMANN, LISA. 1989. In *Meret Oppenheim: Defiance in the Face of Freedom,* by Bice Curiger. Texts by Meret Oppenheim et al. Cambridge, MA: MIT Press.

LINDSAY, JACK. 1970. *The Origins of Alchemy in Graeco-Roman Egypt.* London: Frederick Muller.

LINKER, KATE. 1990. *Love for Sale: The Words and Pictures of Barbara Kruger.* New York: Harry N. Abrams, Inc., Publishers.

LONDON, BETTE. 1990. *The Appropriated Voice: Narrative Authority in Conrad, Forster, and Woolf.* Ann Arbor: University of Michigan Press.

LUTES, TOM. 1988. "Gallery Exhibit Promises to Shock. *Quebec Chronicle,* Wednesday, July 27.

LYOTARD, JEAN-FRANÇOIS. 1989. *The Lyotard Reader.* Ed. Andrew Benjamin. Cambridge, England: Basil Blackwell.

MADOFF, STEPHEN HENRY. 1987. "Anselm Kiefer a Call to Memory." *Artnews 86* (October): 125–30.

MARIN, LOUIS, 1988. "Towards a Theory of Reading in the Visual Arts: Poussin's *The Arcadian Shepherds.*" In *Calligram: Essays in New Art History from France,* ed. Norman Bryson. Cambridge, England: Cambridge University Press.

MARKLEY, ROBERT. 1991. "Representing Order: Natural Philosophy, Mathematics, and Theology in the Newtonian Revolution." In *Chaos and Disorder: Complex Dynamics in Literature and Science.* Chicago: University of Chicago Press. Pp. 125–48.

MARZORATI, GERALD. 1993. "ART in the (Re)Making." *Artnews 85.* No. 5 (May): 90–99.

MATTHEWS, J. H. 1965. *An Introduction to Surrealism.* University Park: Pennsylvania State University Press.

McGARRY, DANIEL D. 1962, second printing. *The Metalogicon of John of Salisbury: A Twelfth-Century Defense of the Verbal and Logical Arts of the Trivium.* Trans., intro., and notes by Daniel D. McGarry. Berkeley: University of California Press, 1955.

McGINN, COLIN. 1993. "Logic and Sadness." *The New Republic 208:* (June): 27–30.

McMURRAY, GEORGE R. 1977. *Gabriel García Màrquez.* New York: Frederick Ungar.

McSHINE, KYNASTON. 1989. "La Vie en Rrose." In *Marcel Duchamp,* ed. Anne d'Harnoncourt and Kynaston McShine. New York: Museum of Modern Art. Pp. 125–41.

MEISLER, STANLEY. 1988. "The World of Bosch." *Smithsonian 18* (March): 41–55.

MEISS, MILLARD. 1951. *Painting in Florence and Sienna After the Black Death.* Princeton, NJ: Princeton University Press.

MELLARD, JAMES. "Flannery O'Connor's Other: Freud, Lacan, and the Unconscious." *American Literature 61* (1989): 626–27.

MERCHANT, CAROLYN. 1980. *The Death of Nature: Women, Ecology, and the Scientific Revolution.* San Francisco: Harper.

MEYERS, BERNARD S. 1959. *Modern Art in the Making.* New York: McGraw Hill.

MICHAELS, WALTER BENN. 1980. "The Interpreter's Self: Peirce on the Cartesian 'Subject.'" In *Reader-Response Criticism: From Formalism to Post-Structuralism,* ed. Jane P. Tompkins. Baltimore: Johns Hopkins University Press.

MILLER, J. HILLIS. 1975. *The Disappearance of God* (1963). Cambridge, MA: Harvard University Press.

MITCHELL, W. J. THOMAS. 1986. *Iconology.* Chicago: University of Chicago Press.

MORRISON, TONI. 1987. *Beloved.* New York: New American Library.

MORROW, LANCE. 1992. "Folklore in a Box." *Time* (September 21): 50–51.

MOTHERWELL, ROBERT. 1969. "Introduction." In *Dialogues with Marcel Duchamp,* by Pierre Cabanne, trans. Ron Padgett. New York: Da Capo Press. Originally published as *Entretiens avec Marcel Duchamp* (Paris: Éditions Pierre Belfond, 1967).

MOURE, GLORIA. 1988. *Marcel Duchamp.* Trans. Joanna Martinez. New York: Rizzoli.

NELSON, T. G. A. 1990. *Comedy: An Introduction to Comedy in Literature, Drama, and Cinema.* Oxford, England: Oxford University Press.

ONG, WALTER J. 1982. *Orality and Literacy: The Technologizing of the Word.* New York: Methuen.

OPPENHEIM, MERET. 1975. "Acceptance Speech for Art Award of Basle." In *Meret Oppenheim: Defiance in the Face of Freedom,* by Bice Curiger, texts by Meret Oppenheim et al. Cambridge, MA: MIT Press.

OWENS, CRAIG. 1983. "The Discourse of Others: Feminists and Postmodernism." In *The Anti-Aesthetic: Essays on Postmodern Culture,* ed. Hal Foster. Port Townsend, WA: Bay Press. Pp. 57–82.

PANOFSKY, ERWIN. 1924–1925. "Perspective as Symbolic Form." This English translation is undated, anonymously typed, and available from the shelves of The Warburg Institute. Originally published as "Die Perspektive als 'Symbolische Form;'" in *Vortrage der Bibliothek Warburg* (London: Warburg Institute). Pp. 258–330.

———. 1953. *Early Netherlandish Painting: Its Origins and Character.* Vol. 1. Cambridge, MA: Harvard University Press.

———. 1955. *Meaning in the Visual Arts: Papers in and on Art History.* Garden City, NY: Doubleday Anchor.

———. 1971. "Jan van Eyck's 'Arnolfini' Portrait." Reprinted in *Modern Perspectives on Western Art History: An Anthology of 20th-Century Writings on the Visual Arts,* ed. W. Eugene Kleinbauer. New York: Holt, Rinehart and Winston. Pp. 193–203. Originally published in *Burlington Magazine LXIV* (1934): 117–27.

PASSMORE, JOHN. 1985. *Recent Philosophers.* La Salle, IL: Open Court.

PAULSON, RONALD. 1975. *Emblem and Expression: Meaning in English Art of the Eighteenth Century.* Cambridge, MA: Harvard University Press.

———. 1982. *Book and Painting: Shakespeare, Milton and the Bible; Literary Texts and the Emergence of English Painting.* Knoxville: University of Tennessee Press.

————. 1991. *Hogarth: The "Modern Moral Subject" 1697–1732*. Vol. 1. London: Rutgers University Press.

PEIRCE, CHARLES SANDERS. 1960 printing. *Elements of Logic*. Vol. II. In *Collected Papers of Charles Sanders Peirce*, ed. Charles Hartshorne and Paul Weiss. Cambridge, MA: Belknap Press of Harvard University Press.

————. 1986a. "Lowell Lecture XI." In *Writings of Charles S. Peirce*. Vol. 1. *1857–1866*, ed. Max H. Fisch. Bloomington: Indiana University Press.

————. 1986b. "Some Consequences of Four Incapacities." In *Writings of Charles S. Peirce*. Vol. 2. *1857–1866*, ed. Max H. Fisch. Indiana University Press.

PIRENNE, M. H. 1970. *Optics, Painting, & Photography*. London: Cambridge University Press.

PLATO. 1961. *Republic*. Book VII. Trans. Paul Shorey. In *The Collected Dialogues of Plato: Including the Letters*, ed. Edith Hamilton and Huntington Cairns. Bollingen Series LXXI. Princeton, NJ: Princeton University Press.

POSTER, MARK. 1989. *Critical Theory and Poststructuralism: In Search of a Context*. Ithaca, NY: Cornell University Press.

POUND, EZRA. 1967 reprint. *Instigations*. Freeport, NY: Books for Libraries.

PRINGLE, ROSEMARY, AND SOPHIE WATSON. 1992. "'Women's Interests' and the Post-Structuralist State." In *Destabilizing Theory: Contemporary Feminist Debates*, ed. Michèle Barrett and Anne Phillips. Stanford, CA: Standford University Press. Pp. 53–73.

PRINZHORN, HANS. 1972. *Artistry of the Mentally Ill: A Contribution to the Psychology and Psychopathology of Configuration*. Trans. Eric von Brockdorff from the 1923 German ed. New York: Springer-Verlag.

READ, HERBERT. 1953. *Philosophy of Modern Art*. New York: Horizon.

RICE, DAN. 1987. Letter to author, dated January 25.

RICHARDSON, GEORGE. 1979. *Iconology*. 2 vols. (Reprinted from the 1779 revision of Cesare Ripa's 1593 version of *Iconologia*.) Introduction by Stephen Orgel. New York: Garland.

RICHMOND, JOSEPH. 1968. "Symbolic Distortion in the Vocabulary Definitions of Schizophrenics." In *Language Behavior in Schizophrenia: Selected Readings in Research and Theory*, comp. and ed. Harold J. Vetter. Springfield, IL: Charles C. Thomas.

RIPA, CESARE. 1970. *Iconologia: overo descrittione di diverse imagini catate dall' antichitá, e di propria inventione*. Intro. Erna Mandowsky. New York: Georg Olms Verlag Hildesheim. Reprografischer Nachdruck der Ausgabe Rom 1603.

ROSE, BARBARA. 1969. *The Golden Age of Dutch Painting*. New York: Praeger.

ROSENAU, PAULINE MARIE. 1992. *Post-Modernism and the Social Sciences: Insights, Inroads, and Intrusions*. Princeton, NJ: Princeton University Press.

ROSENTHAL, MARK. 1987. *Anselm Kiefer*. Philadelphia: Philadelphia Museum of Art.

RUDOLPH, CONRAD. 1990. *The Things of Greater Importance: Bernard of Clairvaux's Apologia and the Medieval Attitude Toward Art*. Philadelphia: University of Pennsylvania Press.

SALISBURY, JOHN OF. 1962 printing. *The Metalogicon of John of Salisbury: A Twelfth-Century Defense of the Verbal and Logical Arts of the Trivium*. Trans. with introduction and notes by Daniel D. McGarry. Berkeley: University of California Press.

SANDLER, IRVING. 1970. *The Triumph of American Painting: A History of Abstract Expressionism.* New York: Praeger.

SANOUILLET, MICHEL. 1989. "Marcel Duchamp and the French Intellectual Tradition." In *Marcel Duchamp,* ed. Anne d'Harnoncourt and Kynaston McShine. New York: Museum of Modern Art. Pp. 47–55.

SAUSSURE, FERDINAND DE. 1959. 3rd ed. *Course in General Linguistics* (1915), ed. Charles Bally and Albert Sechehaye, in collaboration with Albert Reidlinger, and trans. Wade Baskin. New York: Philosophical Library.

SCHAPIRO, MEYER. 1978. *Modern Art: Ninteenth and Twentieth Centuries.* New York: George Braziller.

———. 1985. *The Romanesque Sculpture of Moissac.* New York: George Braziller.

SCHWARZ, ARTURO. 1989. "The Alchemist Stripped Bare in the Bachelor Even." In *Marcel Duchamp,* ed. Anne d'Harnoncourt and Kynaston McShine. New York: Museum of Modern Art. Pp. 80–98.

SEARLE, JOHN. 1972. "Chomsky's Revolution in Linguistics." *New York Review of Books,* June 29: 16–24.

SEIDEL, LINDA. 1989. "Jan van Eyck's Arnolfini Portrait: Business as Usual?" *Critical Inquiry* 16 (Autumn 1989): Pp. 55–86.

SEITZ, WILLIAM. 1983. *Abstract Expressionist Painting in America.* Cambridge, MA: Harvard University Press.

SELZ, PETER. 1962. *The Work of Jean Dubuffet.* With texts by Jean Dubuffet. New York: Museum of Modern Art.

SHIMKUNAS, ALGIMANTAS. 1978. "Hemispheric Asymmetry and Schizophrenic Thought Disorder." In *Language and Cognition in Schizophrenia,* ed. Steven Schwartz. Hillsdale, NJ: Lawrence Erlbaum. Pp. 193–235.

SHORT, LARRY. 1991. The Aesthetic Value of Fractal Images." *British Journal of Aesthetics* 31: (October): 342–55.

SLATKES, LEONARD J. 1981. *Vermeer and His Contemporaries.* New York: Abbeville Press.

SLATKIN, WENDY. 1990. *Women Artists in History: From Antiquity to the Twentieth Century.* Englewood Cliffs, NJ: Prentice Hall.

SLOTKIN, RICHARD. 1985. *The Fatal Environment: The Myth of the Frontier in the Age of Industrialization, 1800–1890.* New York: Atheneum.

SMAGULA, HOWARD J. 1983. *Currents: Contemporary Directions in the Visual Arts.* Englewood Cliffs, NJ: Prentice Hall.

SNYDER, JOEL. 1980. "Picturing Vision." *The Language of Images* (1974), ed. W. Mitchell. Chicago: University of Chicago Press. Pp. 219–46.

SOKOLOWSKI, ROBERT. 1978. *Presence and Absence.* Bloomington: Indiana University Press.

STATEN, HENRY. 1984. *Wittgenstein and Derrida.* Lincoln: University of Nebraska Press.

STEBBINS, THEODORE E., JR., AND SUSAN CRAGG RICCI. 1988. "Introduction." In *A Book by Anselm Kiefer,* trans., Bruni Mayor. New York: George Braziller; and Boston: Museum of Fine Arts. Pp. 12–29.

STEINBECK, JOHN. 1987. *East of Eden.* New York: Viking.

STEINBERG, LEO. 1972. *Other Criteria: Confrontations with Twentieth-century Art.* New York: Oxford University Press.

STEINER, GEORGE. 1967. *Language and Silence: Essays on Language, Literature, and the Inhuman* (1958). New York: Atheneum.

STEINER, WENDY. 1982. *The Colors of Rhetoric: Problems in the Relation Between Modern Literature and Painting.* Chicago: University of Chicago Press.

STENGEL, RICHARD. 1991. "American Myth 101." *Time 138* (December 23): 78.

STEPHENS, MITCHELL. 1991. "Deconstructing Jacques Derrida." *Los Angeles Times Magazine* (July 21): 12–31.

SULEIMAN, SUSAN RUBIN. 1993. "Feminism and Postmodernism." In *Theories of Contemporary Art,* ed. Richard Hertz. Englewood Cliffs, NJ: Prentice Hall. Pp. 169–87.

SULLIVAN, MARGARET. 1991. "Bruegel's Proverbs: Art and Audience in the Northern Renaissance." *The Art Bulletin 73* (September): 431–66.

SULLIVAN, RICHARD E. 1978. "The Middle Ages in the Western Tradition: Some Reconsiderations." In *The Walter Prescott Webb Memorial Lectures: Essays on Medieval Civilization,* by Richard E. Sullivan, Bernard McGinn, Bede Karl Lackner, David Herlihy, and Fredric L. Cheyette. Austin: University of Texas Press. Pp. 3–31.

SUMMERS, DAVID. 1991. "Real Metaphor: Towards a Redefinition of the 'Conceptual' Image." In *Visual Theory: Painting and Interpretation,* ed. Norman Bryson, Michael Ann Holly, and Keith Moxey. New York: HarperCollins. Pp. 231–59.

Swift, Jonathan D. D. 1984. *Gulliver's Travels* (1726). New York: Schocken.

TEITELBAUM, S. 1991. "Bart Kosko: High Priest of Fuzziness." *USC Trojan Family 22:* 11–13.

TWINING, LOUISA. 1980 reprint. *Symbols and Emblems of Early and Mediaeval Christian Art* (1852). London: Longman, Brown, Green, and Longmans.

VANCE, EUGENE. 1986. *Mervelous Signals: Poetics and Sign Theory in the Middle Ages.* Lincoln: University of Nebraska Press.

VAN MANDER, CAREL. 1969. *Dutch and Flemish Painters.* Translated from the *Schilderboeck* with Introduction by Constant van de Wall. New York: Arno Press.

VARNEDOE, KIRK. 1984. "Gauguin." In *"Primitivism" in Twentieth-Century Art: Affinity of the Tribal and the Modern,* Pp. ed. William Rubin. New York: Museum of Modern Art. Pp. 179–209.

WAGAR, WARREN W. 1977. *World Views: A Study in Comparative History.* New York: Holt, Rinehart and Winston.

WAGENBACH, KLAUS. 1984. *Kafka: Pictures of a Life.* Trans. Arthur S. Wensingly. New York: Pantheon.

WELLER ALLEN STUART. 1985. *Lorado in Paris: The Letters of Lorado Taft, 1880–1885.* Chicago and Urbana: University of Illinois Press.

WELSFORD, ENID. 1961. *The Fool: His Social and Literary History.* Garden City, NY: Anchor Books.

WHORF, BENJAMIN LEE. 1939. "The Relation of Habitual Thought and Behavior to Language." In *Language Thought and Reality* (1956). Cambridge, MA: The Technology Press of Massachusetts Institute of Technology. Pp. 134–59.

———. 1941. "Languages and logic." In *Language Thought and Reality* (1956). Cambridge, MA: Massachusetts Institute of Technology. Pp. 233–45.

WIESELTIER, LEON. 1993. *The New Republic 209*: (July 19 and 26): 16–26.

WILDEN, ANTHONY. 1968. "Lacan and the Discourse of the Other." In *The Language of the Self*, trans. with notes and commentary by Anthony Wilden. Baltimore: Johns Hopkins University Press.

WILFORD, JOHN NOBLE. 1981. *The Mapmakers*. New York: Alfred A. Knopf.

WILLIAMS, HIRAM. 1963. *Notes for a Younger Painter*. Englewood Cliffs, NJ: Prentice Hall.

WITTGENSTEIN, LUDWIG. 1958. 2nd ed. *Philosophical Investigations*. Trans. G. E. M. Anscombe. Oxford, England: Basil Blackwell.

———. 1969. 2nd ed. *The Blue and Brown Books*. Oxford: Basil Blackwell.

WÖLFFLIN, HEINRICH. 1950. *Principles of Art History: The Problem of the Development of Style in Later Art*. Trans. M. D. Hottinger. New York: Dover. Originally published as *Kunstgeschichtliche Grundbegriffe* (1929).

WOLLHEIM, RICHARD. 1973. *On Art and the Mind: Essays and Lectures*. London: Allen Lane.

ZIMMER, WILLIAM. 1986. "At William Paterson, Larger-Than-Life Religious Visions." *The New York Times*, Sunday, March 23, New Jersey edition.

Index

References to illustrations are indicated in *italics*.

Abstract expressionism 32, 126, 166,
 187–88, 223, 250, 256, 273
Adoration of the Lamb, The, detail of
 Ghent Altarpiece (van Eyck), 33,
 34, 64
Adoration of the Magi (van Honthorst),
 68, *69*
Adoration of the Shepherds (Rembrandt),
 68, 69, *70*
Aesthetic
 Alberti's, 37
 anti-rationalist, 169, 170, 271
 based on perception, vi
 medieval, 5
 modern, 233
 versus beauty, 131–33
Alberti, 16, 17, 37, 190
Alchemy (*see also* Rosicrucianism;
 Theosophy)
 in Bosch, 50–61, 159
 and chaos theory, 271
 in Chavannes, Puvis de, 107
 and composition of matter, 67
 described, 51
 in Dubuffet, 178
 in Duchamp, 132, 135, 137, 139–40, 142

Alchemy (*cont.*)
 and fourth dimension, 175n
 in Gauguin, 95–96, 103–4
 in Kiefer, Anselm, 204–8
 in medieval and postmodern, 269
 and metaphors for Christ, 52n, 54
 and micro- macrocosmic, 3, 214
 in Middle Ages, 2–5, 10, 14–16, 41
 in Murphy, Fran, 236, 240
 and Newton, 80
 in Oppenheim, Meret, 167–68
 as origin of secular sciences, 65–67
 in religion, science, and philosophy,
 210
 in Rice, Dan 214, 221, 223
 and signing painters, 270
 in surrealism, 166–67
 in van Eyck, 22, 43–44
 and women, 167
 why postmodernists are interested,
 208–210
Alchemical Man, The (detail of Hell
 panel, Bosch) 54, *56, 57,* 63
Artist's Studio, The (Vermeer), 73, *74,*
 77–78
Art of the Mentally Ill (Prinzhorn), 175

All Powerful (medieval fresco), 10, *11*, 13

Alpers, Svetlana
 on arbitrary quality of signs, 117
 on displacement of time, 224
 on Dutch perspective, 17
 on eclecticism, 72
 on map-making, 19, 20, 76, 77, 188
 on photography and fragmentation, 190
 on pictures as Dutch reality, 72
 on Rembrandt, 72
 on viewer location, 35n, 45

Anatomy of a Painting (Pygmalion and Galatea), painting (Murphy), 233–35, 239–40, *241*

Anatomy of a Painting (Pygmalion and Galatea), photograph (Murphy), 236–38, *238*

Anatomy of a Painting (Pygmalion and Galatea), mixed-media (Murphy), 239

Androgyne, 135, 167–68

Antal, Frederick, 23–24

Anthroposophy, 167

Anti-Albertian elements in painting, 35

Apocalypse
 and fractal geometry, 215
 in medieval art, 14, 214
 in postmodern art, 14, 40, 214
 in the work of signing painters, 270
 in van Eyck's work, 40

Aporia
 as analogy for deconstruction, 151
 as element of myth and religion, 221–22
 defined, 29n, 151
 in Dubuffet's work, 180

Arakawa, Shusaku, 150–153

Archetypal
 fear of unknown, 208
 image, 204, 206, 208
 unconscious, 4, 206, 233

Aristotle, 2, 29, 67

Arnheim, Rudolf, 119–20, 136, 184, 199

Art Brut, 175

Astronomy, 3, 65

Atomism, 67, 210

Automatism, 165–66

Autonomous self (*see* Self, autonomous)

Aztecs, xi, 116, 197

Bakhtin, Mikhail, 9, 50, 60–61, 88, 136, 139

Ball (Moja), 124, *125*

Barasch, Moshe, 10, 13, 15, 81, 99

Barthes, Roland, 2, 47, 128, 257

Bax, Dirk, 47–50, 54–56, 58–59, 133

Benveniste, Émile, 30, 127, 160–61, 185, 254

Bernard of Chartres, 232

Bernard of Clairvaux, 5

Beuys, Joseph, 132, 206, 207

Bird's eye view 34–36, 38, 61–63, 189

Blavatsky, Helena, 112, 167

Breakfast in Fur (Oppenheim), 168, *168*

Breton, Andre, 149–50, 155, 163–67, 204, 273

Bride Stripped Bare by her Bachelors, Even, The (Duchamp), (*see Large Glass*)

Bruegel, 38, 46, 158, *159*

Bryson, Norman, 7n, 75, 87, 99
 on arbitrary quality of signs, 112n
 on relationship between verbal and visual images, 6–7, 31–32, 64

Buddhism, 112, 166, 202

Burchfield, Charles, 72, 120–30, 177, 248

Burnham, Jack, 138–39, 142, 152–53, 215

Butterfly effect, 216

Camera obscura, 17, 19, 190, 229

Capital financing, 92–93

Capitalism
 corporate, 195
 created a need for realism, 23–24
 encourages abstraction, 26, 42, 92–94
 equated to fascism, 181
 and linear time, 262
 equated with modernism, 180
 multinational, 259–60
 as source of Cartesian self, 24

Cartesian grid, 220, 238, 240

Cartesian self (*see also* Capitalism, as source of Cartesian self; Self, Cartesian; Self, post-Cartesian)

Cassirer, Ernst, 6, 202

Cervantes, Miguel de, 58, 60, 64, 158

Chaos theory, 80, 152, 210–22

Chaplin, Charlie, 61
Chimpanzees (*see* Signing, chimpanzees)
Chocolate Grinder No. 1 (Duchamp), 142
Chocolate Grinder No. 2 (Duchamp),
 140–42, *141*
Chomsky, Noam, 54, 152–53
Clark, Timothy, J., 151
Classic color theory, 97–98
Clio (*See* Muse of History)
Clocks, influence on society, 197, 260–64
Collective (*see also* Self, collective)
 art, 129
 attitudes, 222
 conscious, 71, 106, 109–11, 134, 201–6
 consumer, 255
 economics, 93–94
 fame, 203
 hand in art, 256
 ideas, 106, 163, 227, 251
 identity, 93, 201–3, 255
 insights, 232
 interests, 131
 memory, 242
 personalities, 200
 power, 93
 property, 228
 truth, 163, 272
 unconscious, 4, 208
 voice, 130, 269
Collingwood, R. G., 109–11, 129, 143–44,
 163
Color (*see also* Classic color theory;
 Composition, in warm and cool;
 Perspective, color)
 absence of, 204–5
 in alchemy, 4
 debate of, 39n, 99, 100
 as manifestation of spirituality, 15
 and the Philosopher's Stone, 142
 for psychological impact, 102
 as sign, 96–102, 105–6, 111, 124–28
 signified light in Middle Ages, 5, 12
Comenius, John Amos, 72–73, 104, 117,
 129–30, 250
Comic imagery, 48, 60–61, 88
Communal truth, 162–63 (*see also* Self,
 Communal; and Idea, communal)
Community of inquiry, 29, 163

Composition
 climax in, vi, 224
 congruent, 16
 in dark and light, vi, 16, 33, 38–39
 human centered, 35
 spatial, 38, 39
 spotty, 19
 strategy in, 39
 unified, 73
 in warm and cool color, vi
Compression of past and present, 130
Compression of past, present, and
 future, 86, 89, 192–97, 221–23
Copernicus, 2, 66–67, 207, 231

Da Vinci, Leonardo, viii, 38, 39n, 136,
 171–72, 273
Dada, 133, 136–37, 154, 163, 271
Darwin, Charles, 93
Debat sur le coloris (*see* Color, debate of)
De Kooning, Elaine, 17, 111
De Kooning, Willem, 194, 203
De Piles, Roger, 39, 99
Deconstruction
 analogous to aporia, 151
 as critique, 205, 230–31
 fueled by paradox, 2
 misuse of term, 231
 as recursive cycle, 222, 230
Degas, Edgar, 35, 97, 141
Deleuze, Gilles, and Félix Guattari, 24,
 155, 175–76, 180–81, 251–53
Derrida, Jacques, viii, 2, 25, 100, 114, 133,
 149–55, 160–62, 186, 195–97, 204–5,
 216, 230–31, 241
Descartes, René, 66–68, 99, 144, 160,
 183–86, 273
Destructuring, vii, 207, 230–32, 241
Différance, 195
Displacement of time (*see* Time,
 displacement of)
Dixon, Laurinda, 44, 46, 50–57, 247
Dostoevsky, Fyodor, 145, 227
Dreams
 important analogies, 171
 material from which they are made,
 171

Dreams (*cont.*)
 as preferable to daytime world, 164
 structured like language, 161–63, 169
 surrealists interested in, 164–66
Dubuffet, Jean, ix, 72, 108, 113, 155,
 175–80, 187, 223, 273

Eco, Umberto, 5–6, 9, 59, 184, 269–72
Einstein, Albert, 145, 263
Elegance as synonym for aesthetic,
 131–32
Eliade, Mircea, 65
Eliot, T. S., 183
Emerald Tables of Hermes, 139
Émile Bernard, 102n, 178
 as medievalist, 107
 as source for Gauguin's ideas, 92–94,
 100, 108, 111
En abyme, 216–17 (*see also Mise en abyme*)
Enlightenment
 dominated society, 80
 end hastened by Freud, 198
 Foucault comes to accept, 272
 and madness, 58, 159–60
 opposed by postmodernists, 213, 246
 opposed to the carnival grotesque, 64,
 269
 and the tradition of clarity in writing,
 272
Epimenides, 150–51
Erasmus, 48, 58, 158
Estate (Rauschenberg), 189, *189*
*Étant Donnés: Iº la Chute d'Eau, 2º le Gaz
 d'Éclairag* (Duchamp), 137, 137n,
 139
Euclid, 145

Family resemblances, 72, 111, 147–48,
 174, 187
Fascism, 156, 180–81, 201
Faulkner, William, 143
Fauves, 98
Feast of fools (*see* Fools, feast of)
Fenollosa, Ernest, 119–20, 123–24, 129
Festival of fools (*see* Fools, festival of)
Folly, 58–59, 157–58

Fools, 78, 135, 156–59
 counterfeit, 156
 court, 156–57
 as entertainers, 156, 159
 feast of, 135, 158
 feastival of, 157–58
 and de idiota inquirendo law, 157
 kingdom of, 135
 and lunatics, 58, 156
 as jesters, 58
 mother of (see Mère-Folle)
 and the Philosopher's Stone, 159
 plays, 60
 prince of, 157–58
 professional, 156–57
 for the sake of Christ, 157
 ship of, 159
 tolerance for, 159
Four Seasons, The (Burchfield), 120, *121*,
 122
Fourth dimension, 144–46, 175, 263
Fractal scale invariance, 214–18, 220,
 222
Freud, Sigmund, 227, 161–69
 and gender, 252
 and the irrational unconscious, 98, 161
 and madness as language, 162–63,
 168–69
 and self concept, 198–99, 210
 and structuralism, 169
Fuzzy math, 210, 213, 222–23

Gainsborough, William, 97
Galileo, 66, 67, 72, 262
García Màrquez, Gabriel, 149, 174,
 191–93, 223
Garden of Delights, triptych (Bosch), 33,
 50–56, *53*, 159
Garden of Delights, detail of Hell (*see
 Alchemical man*)
Garden of Delights, exterior (Bosch), 54, *55*
Garrison, Philip, 197, 199
Gauguin, Paul, 92–113, 123, 127–29, 171
Gaze, 9, 76, 252–54, 258–59 (*see also
 Lacan, on the male gaze*)
Geometry
 constructs viewer location, 44

Geometry (*cont.*)
 to control populace, 129, 248
 Euclidean, 215 .
 fractal, 210–13, 215–17, 220–23
 non-Euclidean, 145n, 163, 246
 sacred, 112n
Gérôme, Jean-Léon, 233–38, 240
Gettings, Fred, 57, 104, 112, 159, 214
Ghent Altarpiece (van Eyck) (*see also Adoration of the Lamb*), 18n, 25n, 32–33, 39–40, 61
Gilmour, John C., 198, 201–10
Giotto, vi, 13, 16, 22, 106, 220
Giovanni Arnolfini and Wife (van Eyck), 26, 27, 28, 32, 45
Gombrich, E. H., 31
Gothic cathedrals, 1, 5, 120
Ground plane
 in Bosch, 62–64
 in Duchamp, 141
 in Dutch painting, 35, 39, 77
 in Gauguin, 105
 in Hogarth, 82, 91
 in Italian painting, 35, 37
 in Kiefer, 211
 in Masaccio, 34, 36
 psychological significance of, 36–38
 in Rice, Dan, 220
 in rising perspective, 37
 in signing paintings, 171, 211
 in van Eyck, 33–38

Habermas, Jürgen, 272–73
Halos, 14–15, 104
Hassan, Ihab, 14, 40, 142, 187, 214, 271
Hawking, Stephen, 89, 198, 263
Heisenberg's uncertainty principle, 80, 274
Hell on Wheels (Rice), 221, 221
Hermeneutics, 59, 152, 233
Hess, Thomas, 100
Hindu, 130, 202
Hofmann, Hans, 263
Hofstadter, Douglas, 150–51, 222
Hogarth, William, 81–91
Horror vacuii, 91, 176
Hughes, Robert, 132, 168

Huizinga, Johann, 58
Humor
 anal, 60
 in carnival grotesque, 64, 67, 71, 134, 179, 270
 folk, 64
 in Duchamp, 134
 in Rice, Dan, 224
 scatological, 134, 136
Hunter-gatherers, 103, 260
Huygens, Christian, 20, 66, 67, 77–78, 186, 262

Ideas (*see* Collective, ideas)
Identity (*see* Collective, identity; Self, Cartesian; and Self, identity)
Individual self (*see* Self, individual)
Indivisible self (*see*, Self, indivisible)
Infra-mince, 137, 209, 214
Insect Chorus, The (Burchfield), 122, 122–24
Irrational (*see also under* Reason)
 art of the, 154
 augments reason, 80, 164, 273
 as reason badly executed, 271
 combined with science, 140
 contributes to various disciplines, 271
 and outsider art, 178
 and poststructuralism, vii
 signing images understood through, xi
 unconscious, 98, 161
 versus reason, 1, 67, 271

Jakobson, Roman, xi, 169–70, 186, 251, 254
Jameson, Frederic
 on map-making, 22–23
 on modernism, 195
 on multinational capitalism, 259–60
 on postmodernism vs. modernism, x
 on Saussure, 186
 on schizophrenia, 169, 170n
Joë Bousquet in bed (Dubuffet), 176, 177
Joyce, James, 155, 201
Jung, Carl, 4, 5, 139, 206–8, 233

Kandinsky, Wassily, 112–13, 149
Kant, Immanuel, 100, 144
Kiefer, Anselm, 44, 113, 201–214
Kierkegaard, Sören, 240
Klingon language, 149
Koch Snowflake, 215
Kruger, Barbara, 246–59, 266–67

Lacan
 on feigning schizophrenia, 166
 on Freud and the unconscious, 199
 on the male gaze, 252, 258
 on relationship between language and
 identity, 185
 on schizophrenia, 170
 on schizophrenia structured like
 language, 169
 on sexuality and language, 252
 on unconscious structured like
 language, 169
Langer, Susanne, 166
Large Glass, The (Duchamp), 33, 137–39,
 138, 141–42, 146, 153
Las Vegas, 243, 249
Last Supper (da Vinci), 171–72
Laughter, 59–61
Laurel wreath, 75
Le Brun, Charles, 81–82, 87, 99
Leakey, Richard, 260
Lévi Strauss, Claude, 148–49, 210
Levine, Sherry, 228–29, 251
Light (*see also* Color, signifies light)
 as metaphor, 5, 14–15, 31, 68–71, 159
 as simulacrum of God, 1, 5
Linguistic community, vi, 29, 72, 163,
 172
Lyotard, Jean-François, 2, 14, 152, 225,
 251, 272

Madhouse, 159
Madness, 156, 158–62, 169–79
 and communication, 58
 in combat with reason, 271
 feigned, 156–57
 in literature and painting, 169
Mandelbrot, Benoit, 213–19

Maniac (Rice), 217, 217–19
 detail, *218*
 detail of detail, *219*
Manifesto of Surrealism (Breton), 164–65
Mapmaking, 76–78
Marriage à la Mode (Hogarth), 84–89 (*see
 also Signing the Contract, Marriage à
 la Mode*)
Masaccio, 18, 39n
 and Albertian viewpoint, 33, 36
 used formal elements, 33
 and ground plane, 34, 37
 and narrative, 39
 as originator of Renaissance style, 16
 and simplified images, 22
 and simultaneous narrative, 34
Math-based reality, 80 (*see also* Newton,
 and math-based reality)
Memory
 painting from, 83, 94, 97, 116, 125,
 177–78
 self and the continuity of, 194–95
Mère-Folle, 135
Meta-art, 266–67
Midgard (Kiefer), 208, *209*
Miller, J. Hillis, 93
Mise en abyme, 217 (*see also en abyme*)
Modus ponens, 271–72
Moja (Chimpanzee), 124–26
Mona Lisa (da Vinci), 136
Mondrian, Piet, 112, 228
Monet, Claude, 70, 78, 100, 111, 227
Morrison, Toni, 174, 191–94, 223
Mother of fools (*see Mère-Folle*)
Motherwell, Robert, 132
Multiple viewpoint (*see* Perspective,
 multiple viewpoint)
Murphy, Fran, 233, 235–41, 251, 257
Muse of history, 75–77

Nahualli, 197
Newman, Barnett, 113, 145, 187, 225
Newton, Isaac
 as alchemist, 66, 80
 as inventor of calculus, 149
 and limitations of language, 80
 and linear time, 67, 191

Newton, Isaac (*cont.*)
 and math-based reality, 80
 on his method, 270
Non-Euclidean (*see* Geometry, non-
 Euclidean)
Nude Descending a Staircase (Duchamp),
 126, 146, 263
Oppenheim, Meret, 167–69, 247
Outsider art, 155, 178
Overinclusion, 173, 179–80
Ovid, 29, 235, 237

Palimpsests, 233–34
Panofsky, Erwin
 on "international" style painting, 20
 on Dutch art, 19n, 20
 on early capitalism, 24–25
 on iconography, 41–42, 90
 on marriage and the Church, 28
 on medieval viewer, 9
 on painting as document, 27n
 on perspective, 246
 on van Eyck, 21, 25, 40, 44–45, 217
Pantocrator (Christ), 10 (*see also* All
 Powerful*)
Pars pro toto, 202
Passmore, John, 194–96
Paulson, Ronald, 82–85
Peirce, Charles Sanders, 162–63
 defining signs, 101, 206
 on Descartes, 183–85
 on language and identity, 185–86
 and linguistic community, 29
 versus Saussure, 186
 and semiology, 30n
Pélerin, Jean (called Viator), 17, 77
Perspective
 atmospheric, vii, 16–17, 19, 33, 98, 184
 as Cartesian grid, 219–20
 color, vii, 16–17, 33, 97–98, 184
 constructs viewer location, 9, 41, 186,
 254
 in Dutch painting, 17, 77
 hierarchical, 63
 inversely related to verbal significance,
 83, 105
 linear, vii, 16, 33, 37, 98, 141, 184

Perspective (*cont.*)
 linear, negation of, 35, 98
 multiple viewpoint, 37, 44, 91, 188, 191
 multiple, 191
 Renaissance system of, 16, 21, 66, 184,
 246
 rising, 36–37, 61–63, 105, 141, 171, 211
 sequence of images dictated by, 6
 single viewpoint, 37
 as symbolic form, 246
 unified, 186
Philosopher's Stone, 66
 as allegory of Christ, 4
 in Bosch's painting, 159
 defined, 140
 and Dubuffet, 177–78
 and Duchamp, 140, 142
 and postmodernism, 210
 and surrealism, 166
Picasso, Pablo, 228, 232–33
 and the concept of beauty, 131
 and the element of time in painting,
 263
Pictorial depth, 35, 174, 204, 211
Picture plane
 affirms verticality, 187
 as bulletin board, 190, 211
 flat, 17, 39, 78, 107, 111, 211
 flatbed, 187–88, 194
 fragmented, 189–92
 identified with retina in Holland, 190
 implies horizontal surface, 187
 in photography, 243
 opaque, 203
 post-Cartesian, 188
 relationship to viewer, 17, 45
 undefined, 190
 as window, 16, 184
Pirenne, M. H., 62
Plagiarism, 92, 110
Plague, 66, 71
Plato, 2, 29, 146–47, 175, 230, 241, 245
Point of view
 changes history, 198
 in literature, 191–92
 multiple, 194
 pluralist, 180, 194, 222
 reality dependant upon, 218–20

Point of view (*cont.*)
 same as viewpoint, 184, 194
 single, 213n, 221
 subjective, 227
Pont-Aven (school of), 92–102, 107,
 111–13
Post-Cartesian (*see* Self, post-Cartesian)
Postmodernism, use of term
 explained, 2n
Pound, Ezra, 119–20
Praise of Folly (Erasmus), 58, 158
Prescientific, 203–6
Prince of fools (*see* Fools, prince of)
Prinzhorn, Hans, 172, 175–76
Professional fools (see Fools, professional)
Pygmalion and Galatea (*see also Anatomy of
 a Painting [Pygmalion and Galatea]*)
Pygmalion and Galatea (Gérôme), 233,
 235–41
 painting, *234*
 sculpture, *237*

Rabelais, François, 60–64, 134–36, 179,
 224
Rabelaisian, 270
Rauschenberg, Robert, 187–91, 211, 265
Reason (*see also under* Irrational)
 accomplished through signs, 163
 appeared self-evidently true, 80
 arrogance of, 178
 communicative versus instrumental,
 272
 connection with madness, 58
 and derangement of the senses, 166
 distorts concept of self, 167
 dominated society, 67, 273
 Foucault opposed to, 160, 272
 Foucault supports, 272
 generated by structure of European
 languages, 178
 and the irrational, 1, 164, 169, 271, 273
 language of, 160, 253, 272
 and modus ponens, 271–72
 and mythic reality, 204
 and postmodernism, 160–61, 227
 senses as gateway to, 100
 versus superstition, 67

Reason (*cont.*)
 supports retinal painting, xi
 as truth revealed, 158–59
 tyranny of, 164, 169, 177
 not universal, 274
 user is blind to its limitations, 161
Rebus, 47, 114, 115, 137, 171
Reification, 97
Rembrandt, 68–70, 72
Restructuring, 207, 230–36, 240, 241
 elements of Renaissance illusion, vii
 from memory, 97, 129
 sexual roles, 255
 systems of perspective, 220
 through schizophrenic thought, 173
Retinal paintings
 defined, v–vi, 113
 and Leonardo's *Last Supper*, 171
 opposed by Duchamp, 133n, 148
 and optics, 97
 supported by reason, xi
 versus signing paintings, 271, 274
Revelation (biblical), 10, 14, 40, 61, 213
Rhetoricians, 47–48, 59, 133, 240, 244
Rice, Dan, 9, 212, 214–25, 269
Rimbaud, Arthur, 165
Ripa, Cesare, 73–75, 82, 84, 90
Rose Croix, 140
Rosicrucianism, 50, 66, 80, 95–96, 111–12
Rousseau, Jean Jacques, 106–7
Rrose Sélavy (Duchamp), 134–35, 140

Sacred sciences (*see* Alchemy)
Saint Jerome in his Study (van Eyck),
 42, 43
St Augustine, 6, 8, 116, 183
St Bernard of Clairvaux, 5n
Scale invariance, 20, 214–22
Schapiro, Meyer, 9, 112
Schizoanalysis, 155, 180–81
Schizophrenia, 155–81, 251, 254, 260,
 270–71
 and postmodernism, 155–81
Schnabel, Julian, 229
Self
 autonomous, x, 24, 93, 160, 180, 185n,
 272

Self (*cont.*)
awareness, 227
Cartesian, 21, 24, 93, 160, 169–70
collective, 201
defined by context, 201
defined by language, 210
distorted concept of, 168, 248
divisible, 196–99, 203
-evident truth, 80, 160, 231, 246, 274
expression, 233
fragmented sense of, 198
image, 255
individual, 109, 227
indivisible, 93, 163, 196–203, 233, 272
obsolete concept of, 110, 256
post-Cartesian, 170, 182–95, 201, 235, 250
postmodern, 227–28
private, end of, 195, 196, 203
referential images or systems, 86, 150, 216, 225
similarity, 215–20
split, 199–200
Self-Portrait with Halo and Snake (Gauguin), 107, *108*
Semiotics, viii, 30, 80, 101, 163, 186, 251
Shakespeare, William, 60–61, 64, 82, 109
Shifters, 254–55
Ship of fools, 158
Signing the Contract, Marriage à la Mode (Hogarth), *85*, 87–89
Signing
chimpanzees, 84, 124
images, vi, xi, 7, 105
qualities in Gauguin's paintings, 98
value of commodities, 249
Signing painters
and alchemy, 270
and carnival grotesque, 10
influences, ix, 72
and perspective, 62–64, 82, 105, 211–12
postmodern, 113
and precision of communication, 274
versus retinal painters, 274
Signing paintings, 83, 102, 142, 171–73
defined, vi

Signing paintings (*cont.*)
lack spatial organization, 174
resemble maps, 179
and schizophrenia, 171–76
Signs
animated iconic, 126–28
arbitrary quality of, 30n, 112n, 116–18, 150
generate sexual identity, 252
iconic, 30–31, 47, 63, 77, 101, 114–19, 124–26, 203–4, 245
indexical, 30, 86, 101, 124–26, 206, 245
proper, 30–31, 101, 104, 116, 245
semi-iconic, 119, 124, 128
Southwark Fair (Hogarth), 89–91, *90*
Souvenir of Breakfast in Fur (Oppenheim), 169
Spatial location, 35, 254
Spero, Nancy, 194
Spheres of being, 63 (*see also* Time, zones in painting)
Steinbeck, John, 262
Steiner, George, 203n
Steiner, Rudolf, 112, 167, 206n
Steiner, Wendy, 6, 30, 119
Strange loop, 150–51, 222
Structuralism
defined, viii, 152
and Freud, 169
as foundation of twentieth-century criticism, 186
inadequacies demonstrated, 153
and myth, 215
as topic of concern, 30
Study for Pygmalion and Galatea, mixed media (Murphy), *239*
Surrealism, 155–79
and alchemy, 166–67
and dreams, 164–65
influenced by dreams and madness, 162
and linguistics, 166n
opposed to reason, 169
and unpredictability, 179
and women, 167–68
Swift, Jonathan, 82, 118
Symbolists, 95, 111, 133, 135, 148

Symbols
 defined, 101–2
 photographs as, 245

Taoism, 139, 166
Temptations of Saint Anthony, detail
 (Bosch), 48, *49*, 50
Theosophy, 112, 113, 167, 206
Three-dimensional shadow, 146
Time, 260–66
 cinematic, 130
 compressed, 223
 cyclic, 174n, 191–93, 196–98, 201–3,
 213–14
 cyclic and scale invariance, 217–18
 cyclic in Kiefer, 211
 cyclic versus linear, 89, 113, 198
 cyclic versus narrative, 224
 displacement of, 45, 190, 192
 fragmented, 199, 260
 imaginary, 198
 implied in painting, 34, 128, 146n, 224
 linear, 67, 190, 240, 260
 and space, 145, 151, 221–22
 telescoped, 130
 unified, 41, 170n, 173
 zones in painting, 63
Totalitarianism, 91, 180, 253, 254, 272,
 274
Transmutation, 67
 as allegory, 3, 143
 in Bosch, 51
 and the fourth dimension, 146
 in Kiefer's work, 201, 205
 and modern science, 210
 in Murphy's work, 236
 signifies Christ, 52n
Tribute Money, The (Masaccio), 33, *34*, 37,
 39, 86

Unconscious (*see* Archetypal, unconscious;
 Collective, unconscious)

*Untitled (1981. Your gaze hits the side of my
 face)* (Kruger), *258*, 258
*Untitled (You Invest in the Divinity of the
 Masterpiece)* (Kruger), 256, 257
Untitled (Your Body is a battleground)
 (Kruger), *259*, 259

Van Eyck, 18–44
 and Bosch, 61–64
Van Honthorst, Gerrit, 68–69
Van Mander, Carl, 22, 46
Vanishing point, 37, 90–91
Vanitas, 71, 77
Vermeer, Jan, 73–79, 127, 229, 274
Vermont Almanac, 134
Viator, (*see* Pélerin, Jean)
Viewpoint (*see* Bird's eye view; Worm's
 eye view; Masaccio, and Albertian
 viewpoint; Panofsky, Erwin, on
 medieval viewer; Perspective,
 multiple viewpoint; Perspective,
 single viewpoint; Point of view, as
 viewpoint)
Virgil, 235
Virgin and Child with Apostles (medieval
 mosaic), 11, *12*, 14
Voice (*see* Collective, voice)

Warhol, Andy, 113, 142, 170, 203, 228,
 232, 251
Washoe (signing chimpanzee), 84, 124
*Where Do We Come From? What Are We?
 Where Are We Going?* (Gauguin), *94*,
 102–5, 107
Whorf, Benjamin, 178, 198
Wittgenstein, Ludwig, 54, 72, 123, 143,
 147–53, 268
Wölfflin, Heinrich, 7
Worm's eye view, 189

Zen, 166